# CITY OF WORDS

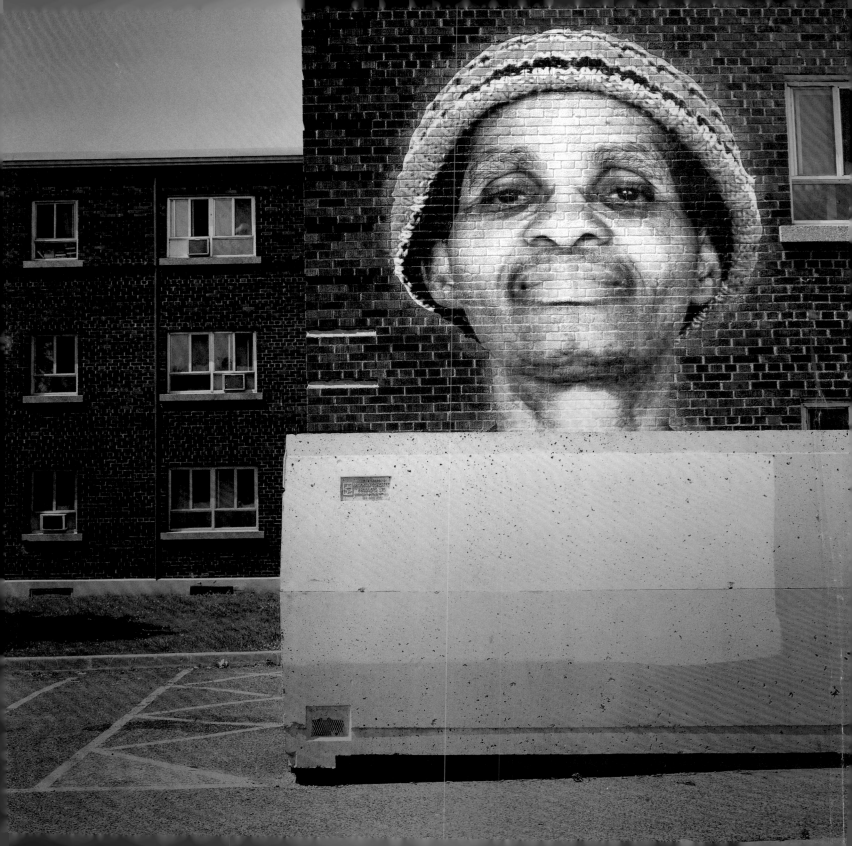

# CITY OF WORDS

## TORONTO THROUGH HER WRITERS' EYES

Edited, with an Introduction by *Sarah Elton*
Photographs by *Kevin Robbins*

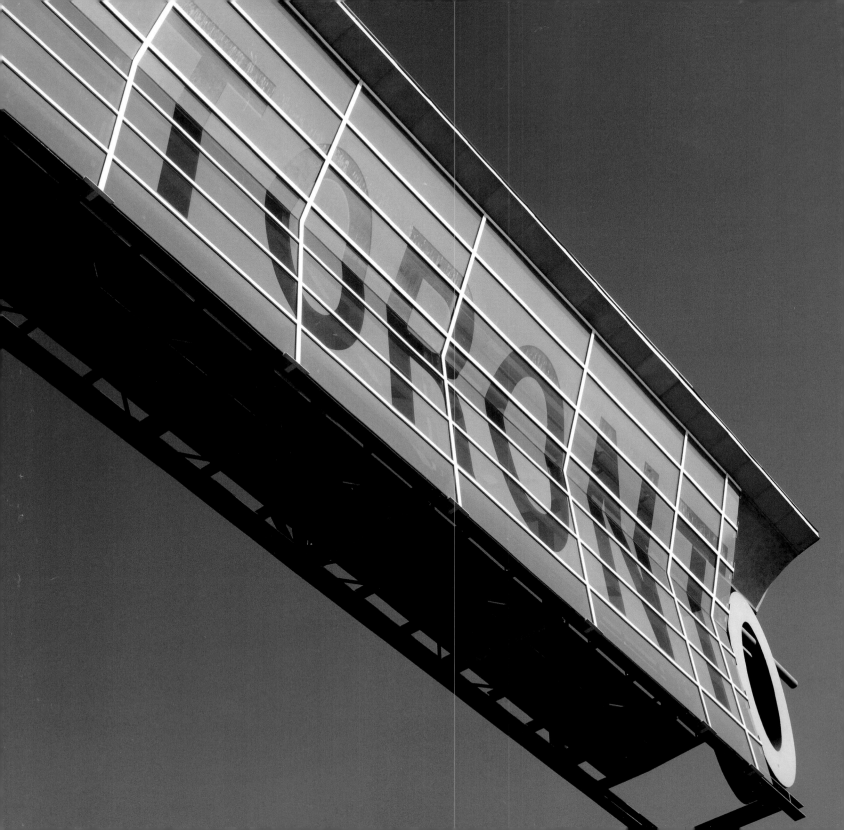

*For my grandmother, Marjorie Abrams*

Canada Council for the Arts — Conseil des Arts du Canada

ONTARIO ARTS COUNCIL
CONSEIL DES ARTS DE L'ONTARIO

The publisher gratefully acknowledges the support of the Canada Council for the Arts and the Ontario Arts Council for its publishing program. We acknowledge the financial support of the Government of Canada through the Book Publishing Industry Development Program (BPIDP) for our publishing activities.

LIBRARY AND ARCHIVES CANADA CATALOGUING IN PUBLICATION

City of words : Toronto through her writers' eyes / edited with an introduction by Sarah Elton.

Includes bibliographical references.
ISBN 978-1-897151-49-5

1. Canadian literature (English)—Ontario—Toronto.
2. Toronto (Ont.)—Literary collections.
I. Elton, Sarah, 1975–

PS8257.T67C58 2009     C810.8 032713541     C2009-903866-8

Cover design: Angel Guerra / Archetype
Cover photograph: Kevin Robbins
Text design: Tannice Goddard / Soul Oasis Networking
Printer: Friesens

CORMORANT BOOKS INC.
215 Spadina Avenue, Studio 230, Toronto, ON Canada M5T 2C7
www.cormorantbooks.com

Printed and bound in Canada

# CONTENTS

Introduction by Sarah Elton    xv

## The City

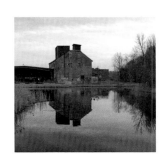

Cary Fagan, *Schmoozing*    3

Dionne Brand, *What We All Long For*    4

Stephen Marche, *Raymond and Hannah*    5

Anne Michaels, *There is No City that Does Not Dream*    7

Earle Birney, *i think you are a whole city*    9

Nino Ricci, *On Toronto Itself*    11

Rabindranath Maharaj, *Is Just a Name*    12

Eric Arthur, *The Village and the Ancient Trails*    18

Dorothy Livesay, *Queen City*    20

Piali Roy, *Bharati*    30

## Downtown

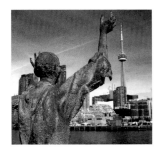

Elise Levine, *Angel*    35

Pier Giorgio Di Cicco, *6 months of the CN tower*    37

Howard Akler, *The City Man*    38

Raymond Knister, *Sidewalks of Toronto*    41

Joseph Boyden, *Painted Tongue*    42

Raymond Souster, *Rainy Evening Downtown*    45

Diana Fitzgerald Bryden, *Tower and Dome*   46

Barbara Gowdy, *The Romantic*   49

Mazo de la Roche, *Ringing the Changes*   54

Clifton Joseph, *\*footnote to the end of a love affair*   57

Clifton Joseph, *Chuckie Prophesy*   58

Matt Cohen, *The Bookseller*   60

Michael Rowe, *Red Nights: Erotica and the Language of Men's Desire*   63

John Cornish, *Sherbourne Street*   66

Crad Kilodney, *Girl on the Subway*   69

Shaughnessy Bishop-Stall, *November: The Invisible Streetcar*   72

Patrick Slater, *Adrift*   73

Grattan Gray, *The Stately Street of Sin*   79

## Chinatown and Kensington Market

Irving Layton, *Varied Hues*   85

Sarah Dearing, *Courage My Love*   86

Shirley Faessler, *Henye*   91

Barry Callaghan, *Crow Jane's Blues*   93

Shyam Selvadurai, *Mister Canada*   95

Judy Fong Bates, *Midnight at the Dragon Café*   100

Charles Pachter, *My Chinatown*   104

## College Street

Gianna Patriarca, *College Street, Toronto*    109

Nino Ricci, *Where She Has Gone*    114

Steven Hayward, *The Secret Mitzvah of Lucio Burke*    119

Stephen Cain, *College Streetcar*    122

Howard Akler, *City Man*    124

Daniel Jones, *In Various Restaurants*    125

Rishma Dunlop, *City of Madness and Love*    129

Michael Redhill, *College & Montrose*    132

Andrea Curtis, *Paper Trail*    135

## The Annex

M.G. Vassanji, *No New Land*    140

Katherine Govier, *Rewriting Brunswick*    142

Rosemary Sullivan, *Elizabeth Smart: A Presence in the Annex*    146

bpNichol, *Chain 3*    152

Dionne Brand, *Bathurst*    163

Lawrence Hill, *Any Known Blood*    171

Joseph Kertes, *Happiness and Immortality near Bathurst and Bloor*    177

Carleton Wilson, *Late Autumn in the Annex, 1997*    180

## Yorkville

Margaret Atwood, *Cat's Eye*    184

Juan Butler, *Cabbagetown Diary: A Documentary*    190

Don Lyons, *Yorkville Diaries*    194

Ray Robertson, *Moody Food*    198

## Rosedale

Wayne Johnston, *Human Amusements*    204

Hugh Hood, *The Swing in the Garden*    209

Scott Symons, *Civic Square*    213

Timothy Findley, *The Wars*    217

Kim Moritsugu, *The Glenwood Treasure*    223

Harry Bruce, *Dawn Raid on Darkest Rosedale*    224

## Cabbagetown

Juan Butler, *Cabbagetown Diary: A Documentary*    229

Hugh Garner, *Cabbagetown*    233

Lawrence Hill, *Any Known Blood*    236

J.V. McAree, *The Store Was Our Home*    237

Hugh Hood, *Reservoir Ravine*    239

## Don Valley

Michael Ondaatje, *In the Skin of a Lion*   244

Elizabeth Simcoe, *Life at York*   250

Ernest Thompson Seton, *Wild Animals I Have Known*   252

Charles Sauriol, *Spring 1956, How It All Started*   256

Maggie Helwig, *The Other Goldberg Variations: Homage to Glenn Gould*   261

## Islands and Waterfront

Michael Redhill, *Consolation*   265

Helen Humphreys, *Leaving Earth*   267

Cecil Foster, *On Centre Island*   270

Margaret Atwood, *The Robber Bride*   274

Hugh Hood, *Reservoir Ravine*   275

Hugh Garner, *Bohemia on Bay*   283

Phil Murphy, *Summer Island*   286

Graeme Gibson, *Gentleman Death*   291

Robert Thomas Allen, Foreword from *I Remember Sunnyside*   294

David Gilmour, *An Affair with the Moon*   297

## Toronto East

Margaret Avison, *Seen* 302

Mike Tanner, *The House, The Home* 304

Sarah Elton, *To Gerrard, With Love* 307

David Chariandy, *Soucouyant* 310

Harry Bruce, *Letter from the Beaches* 313

## Toronto West

Carole Corbeil, *On Christie Pits* 318

Anand Mahadevan, *subzi bazaar* 319

Makeda Silvera, *Around St. Helens* 322

Joe Fiorito, *The Wireless Microphone* 327

Dennis Lee, *High Park, by Grenadier Pond* 330

Anne Michaels, *Fugitive Pieces* 332

## Queen West

Marion Engel, *Lunatic Villas* 338

Timothy Findley, *A Gift of Mercy* 345

Raymond Souster, *Squeegee Kid* 350

Ray Robertson, *Gently Down the Stream* 353

Emily Pohl-Weary, *My Little Box* 356

## Uptown

Catherine Bush, *Minus Time*   362

Harry Bruce, *VE Day on the Yonge Street Hill*   364

Timothy Findley, *Stones*   365

Erin Mouré, *From the highest window of my house on Winnett*   368

Phil Murphy, *In the Winter Before the War*   370

Camilla Gibb, *A Memoir of Merton Street*   372

Dorothy Livesay, *Green Rain*   376

David Bezmozgis, *Tapka*   377

Sesanarine Persaud, *Canada Geese and Apple Chatney*   379

Terry Woo, *Banana Boys*   382

Biographies   386
The Photos   397
Permissions   404
Acknowledgements   411

## Introduction

*Sarah Elton*

I fell in love with Toronto when I encountered it through the character of Patrick Lewis in Michael Ondaatje's beautiful novel, *In the Skin of a Lion*. Patrick, the adventuresome yet observant protagonist, leads the reader through the story set in Toronto of the 1920s. Through the character of Patrick, Ondaatje took me to the Thompson Grill on River Street where a tattooed waitress fried eggs and poured coffee, then on to Eastern Avenue, where Macedonian shopkeepers sold bananas and called to each other, stall-to-stall, a streetscape so different from the industrial one I pass along Eastern today. We visited the Riverdale Library with its "high rafters and leaded windows that let in oceans of light" and, one night, followed Queen Street to its most easterly point to watch workers perform with puppets on a makeshift stage at the Waterworks. I couldn't turn the pages fast enough. Through Patrick's eyes I saw a mysterious and romantic city rise up from the ordinary streets, bridges, bricks, and history of the Toronto I thought I knew.

In his novel, Ondaatje writes, "... before the real city could be seen it had to be imagined, the way rumours and tall tales were a kind of charting." He was writing about me: Before I could see my city for what it is, I had to experience it through its tales, stories, and characters. I had to experience the imagined city, the way the writer sees it, before I could fully appreciate the urban centre I called home.

After *In the Skin of a Lion* came many more literary works to continue mythologizing here, this place, the Toronto of my imagination — Dionne Brand's *What We All Long For*, Margaret Atwood's *Cat's Eye*, David Bezmozgis's *Natasha*, Barbara Gowdy's *The Romantic*, Austin Clarke's Toronto trilogy — to name a few. With every poem or story or novel set in Toronto that I read, this city became more and more like Italo Calvino's Venice in *Invisible Cities*; it is a shimmering created by literature.

My own literary map complements the street grid. In the Annex, I nod to Margaret Atwood's

Tony who sits in her turret in *The Robber Bride*. I see the First World War soldiers milling about St. Paul's, the church near Bloor and Church Streets, just as Timothy Findley described in *The Wars*. Along Queen Street West, I keep an eye out for Findley's Minna Joyce and Stuart Bragg embracing in front of a streetcar stop as they do in his short story "Stones." I can't enter cloistered Rosedale without picturing the family in Wayne Johnston's *Human Amusements* driving through the winding streets, peering at the big homes. Or Austin Clarke's creation, Jefferson Theophillis Belle, whose midnight stroll to the Sherbourne Street house he planned to buy landed him, mistakenly, in the back of a police car.

Sometimes, in the late summer, driving south down the Bayview Extension at night, the Bloor Street Viaduct stretches before me, its awesome structure lit by a constellation of streetlights. And among those lights I see the shadow of a nun, falling, only to be caught by the strong arms of Nicholas Temelcoff.

Why did I not grow up steeped in the mythology of Toronto? Any child in London or New York is nourished on the legends and myths of their cities. It's true that Toronto is not Paris or Prague — but that's just the point. We're Toronto, we have our own culture and with it our own city's literary canon.

There is a widespread misconception that the literature of Canada is largely set in rural areas, that cities aren't deemed appropriate settings for stories and poetry. Specifically, Toronto can't be found in the literature of our country because our authors aren't inspired by the alleyways of Chinatown, by the red streetcars creaking and moaning through the downtown, by the ravines, the lake, its beaches and bluffs. But writers have been engaging with this city for a very long time, from the moment in 1793 when Mrs. Simcoe wrote about life here, before it was called "Toronto."

We need to read the literature of this place. Our children need to be reminded, every time they pass over the viaduct, that this is the bridge where Nicholas Temelcoff caught the falling nun

— just as in Paris, I would tell my daughters that Jean Valjean stood here, on this very bridge, staring at the Seine. Or in Dublin, where Stephen Daedalus stood on a bridge over the Liffey River and shook his fist at the heavens. Our schools need to celebrate the poems of Raymond Souster so that the next time a child crosses to Hanlan's Point she can recite his verse.

The historian Lewis Mumford writes that the city is, along with language, humanity's greatest work of art. "Mind *takes form* in the city; and in turn, urban forms condition the mind." Here, every aspect of life is concentrated and methods of expression are multiplied.

Authors are, among others, the record-keepers of this process. Literature reflects what they see, what they experience, and, most importantly, what they imagine of their city. What Mumford calls humanity's two greatest works of art — the city and language — come together in the form of the urban cannon.

While as a larger community of readers and thinkers we haven't yet celebrated or, likely,

even discovered Toronto's body of work, this city has its own remarkable reading list. This project introduced me to an astounding breadth of writing skill: from the grittiness of Juan Butler to the sexy stories of Elise Levine to the hilarious Sesanarine Persaud and to the lyrical work of a young Dorothy Livesay.

In *City of Words*, you will encounter the imaginary Toronto, the city as it is seen through the writers' eyes. You will see what aspects of urban life here have captured the writer's fancy, and in turn, how the writer has captured the city.

There are things I learned about Toronto while putting this together: the waterfront, stretching from the Bluffs in the east to the Humber in the west, represents for many writers a place of escape. Morley Callaghan's Stanley and Vera in *Strange Fugitive* head down Kingston Road and then over the tracks and into the woods on the edge of the lake for a picnic, some privacy. They aren't the only ones to look to the lake's edge for quiet. As Harry Bruce tells us, we also make love on the city's beaches, hiding in the crags of rocks and the darkness of a summer

night. Romance is found in the reflection of light on Lake Ontario's water in Hugh Hood's *Reservoir Ravine*. The Don Valley continues to exist as a place of wilderness surrounded by the city itself. In contrast, the bleak high rise buildings at Bathurst and Finch and the CN Tower, much farther south, move David Bezmozgis and Pier Giorgio di Cicco to pick up their pens. For many others, the source of artistic and literary inspiration are the populated areas: the Annex, Kensington Market, College Street with its coffee shops, Greek Town on the Danforth.

I found that once I became set on seeing Toronto as a literary city, no place was safe. The imaginary world collided with reality at every turn: west on Bloor Street I saw Matt Cohen's bookseller. Driving along the Don Valley Parkway there, on the other side of the median, was Charles Sauriol tending to his apple acreage, or a First Nations family, as described by Mrs. Simcoe, travelling peacefully by canoe down the Don River, unaware of the din of the highway. In Kensington Market, I swear that Sarah Dearing's *Nova* walked by.

It's an exciting city, Toronto, when you see her through her writers' eyes.

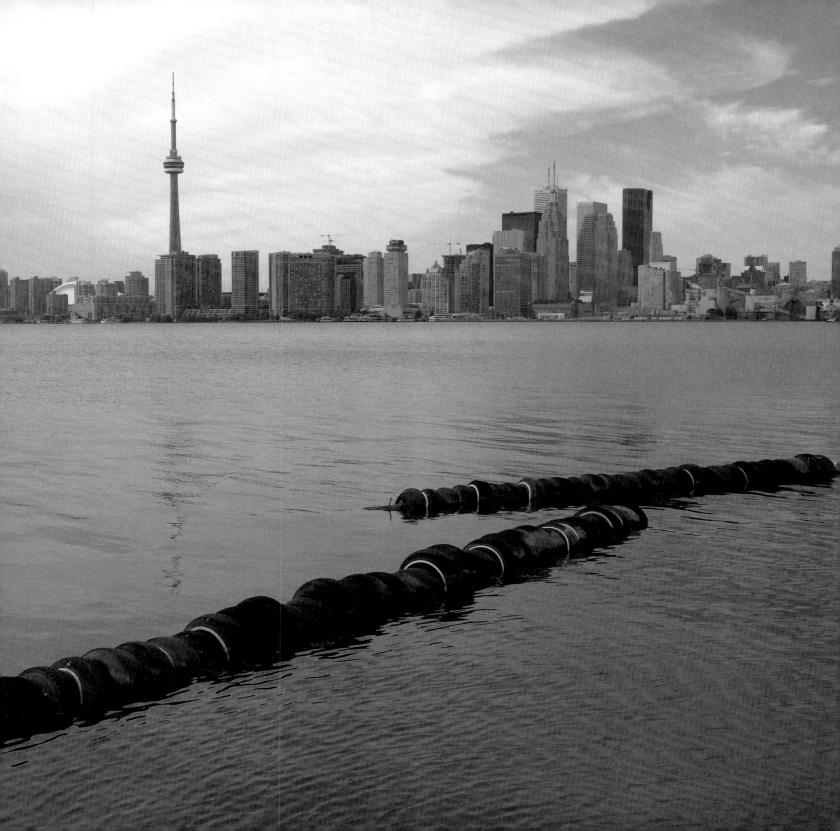

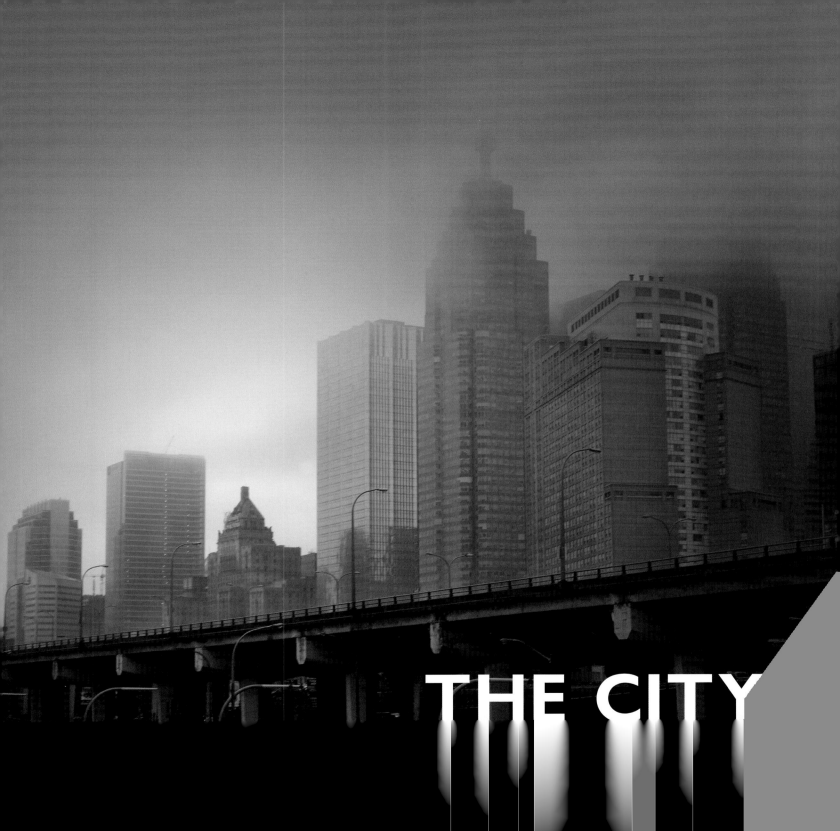

THE CITY

## Schmoozing

*Cary Fagan*

Sliding into Toronto at midnight in a borrowed Pontiac, along the QEW to the Gardiner, when the city suddenly appears against the black reflecting surface of the lake and the curve of the harbour. And the city dark, but strewn with hundreds — thousands — of lights, rising up the towers, tossed across the cityscape.

Swiftly the car passes the illuminated Palais Royale where Benny Goodman and Duke Ellington used to swing. During the war, when Count Basie and his all-black band played the Palais, Toronto blacks had to stand outside to listen. The car slides up University Avenue, past the darkened fronts of office towers and glowing bars, slowing for a man who crosses the street in imitation of Groucho Marx's cigar-pointing stride, trench-coat flapping. Then Queen's Park Crescent, the hushed campus of the University of Toronto, and Bloor Street with a burst of city life — record stores and bookshops and the all-night Super Save. Loud men in university jackets spill out of the Brunswick House to be looked upon with condescending amusement by the habitués of the sidewalk café tables. As always, the grizzled young man with the slow speech is hawking tomorrow's *Globe*. At the corner of Albany and Bloor, a woman steps from the curb, gets honked at, and steps back again with a little dance, whirling her red skirt like a fan.

## What We All Long For
*Dionne Brand*

This city hovers above the forty-third parallel; that's illusory of course. Winters on the other hand, there's nothing vague about them. Winters here are inevitable, sometimes unforgiving. Two years ago, they had to bring the army in to dig the city out from under the snow. The streets were glacial, the electrical wires were brittle, the telephones were useless. The whole city stood still; the trees more than usual. The cars and driveways were obliterated. Politicians were falling over each other to explain what had happened and who was to blame — who had privatized the snowplows and why the city wasn't prepared. The truth is you can't prepare for something like that. It's fate. Nature will do that sort of thing — dump thousands of tons of snow on the city just to say, Don't make too many plans or assumptions, Don't get ahead of yourself. Spring this year couldn't come too soon — and it didn't. It took its time — melting at its own pace, over running ice-blocked sewer drains, swelling the Humber River and the Don River stretching to the lake. The sound of the city was of trickling water.

Have you ever smelled this city at the beginning of spring? Dead winter circling still, it smells of eagerness and embarrassment and, most of all, longing. Garbage, buried under snowbanks for months, gradually reappears like old habits — plastic bags, pop cans — the alleyways are cluttered in a mess of bottles and old shoes and thrown-away beds. People look as if they're unravelling. They're on their last nerves. They're suddenly eager for human touch. People will walk up to perfect strangers and tell them anything. After the grey days and the heavy skies of what's passed, an unfamiliar face will smile and make a remark as if there had been a conversation going on all along. The fate of everyone is open again. New lives can be started, or at least spring is the occasion to make it seem possible. No matter how dreary yesterday was, all the complications and problems that bore down then, now seem carried away by the melting streets. At least the clearing skies and the new breath of air from the lake, both, seduce people into thinking that.

# Raymond and Hannah

*Stephen Marche*

*Raymond smells spring*

And it's March. Papers and nature are due. The crocuses sprout duly at the roots of poplars and pines. The rain is replacing the snow. College Street should burst flagrantly soon, and life will again be rich and fragrant. Any moment now the smell of spring will pour down like an overturned bucket. A hint. Nitrogen? Peasant mud? Pollution slushy smell, premeditating the sweetness of crocuses in gutter dust.

*Raymond looks up*

When he looks down College Street, Raymond wants summer to come. That's when the action in this godforsaken city is. All the women are wearing wool coats or puffy down-filled jackets now. In summer, they will pull the beautiful bodies out of storage, and he will get down on his knees and thank heaven for feminism and multiculturalism.

*Raymond considers feminism and multiculturalism*

Without feminism, there would be no girls in short skirts with bare midriffs and no intelligent women with whom to discuss the meaning of modern drama. Without feminism, there would be only wives and whores and maidens, and no glorious mixture of all three. In every city, they should name a square after Gloria Steinem, and in this square should be a statue (equestrian perhaps) of Germaine Greer. Feminism has made love, or something like it, possible.

And without multiculturalism, glory, glory, hallelujah, there wouldn't be those ultra-polished, bejewelled Italian women lounging half-naked in bar windows, nor those

rafts of Greek women like shots of olive oil and fresh orange afterwards. And what about those Chinese women, like reeds, suggestively handling red peppers in the open markets? None of them.

None of the tough Jamaican women smoking outside the Marxist-Leninist bookstore, as beautiful as stainless steel. Imagine the city before them. It makes you want to weep — no, more, to produce a lamentation. Summer to come. Pierre Trudeau. Yes. Back to Anatomy.

## There is No City that Does Not Dream
*Anne Michaels*

There is no city that does not dream
from its foundations. The lost lake
crumbling in the hands of brickmakers,
the floor of the ravine where light lies broken
with the memory of rivers. All the winters
stored in that geologic
garden. Dinosaurs sleep in the subway
at Bloor and Shaw, a bed of bones
under the rumbling track. The storm
that lit the city with the voltage
of spring, when we were eighteen
on the clean earth. The ferry ride in the rain,
wind wet with wedding music and everything that
sings in the carbon of stone and bone
like a page of love, wind-lost from a hand, unread.

# i think you are a whole city

*Earle Birney*

i think you are a whole city

& yesterday when i first touched
you i started moving
thru one of your suburbs
where all the gardens are fresh
with faces of you
flowering up

some girls are only houses
maybe a strip
development
woman you are miles
of boulevards with supple trees
unpruned & full of winding
honesties
so give me time  i want

i want to know
all your squares & cloverleafs
im steering now by a constellation
winking over this nights rim
from some great beachside of you
with highrisers & a spotlit
beaux arts

i can hear your beat-
ing center        will i
will i make it
are there maps of you
i keep circling            imagining
parks fountains            your stores

back in my single bed i wander
your stranger              dreaming
i am your citizen

# On Toronto Itself

*Nino Ricci*

As a child, Toronto was first for me what a city was: a skyline glimpsed from a distance, what it promised and what it withheld, where the future took place. Then at sixteen the first voyage in, the strip clubs and arcades, the signs: MASSAGES. The thought of what that word hid, its pretense, the money that passed clandestinely, the back rooms where other things happened. At eighteen, a few nights spent in a friend's cousin's apartment that seemed old to me then, seemed a mood the city was, the spice smells, the teas, the stained glass and oak: life felt suddenly possible here, this small private calm seeming something only a city could give definition to.

Those first Torontos, public, delinquent, domestic, were like templates I laid against my later life here, waiting for the truth of the city to somehow emerge through them; yet every experience was not quite the right one, every impression not quite the whole. Whatever informing spirit the city has continues to elude me, whole zones like different countries; each voyage in is a shift, a different moment, each move an emigration. In Chinatown I walk into shops and don't know the names for things, what they are, how to use them, find this foreignness at the heart of familiarity, what my own ancestors might have seemed in their little Italies to the generations they displaced; in my neighbourhood I see layers of different histories like striations, the small peculiar houses, the people who come from them, don't know what they had for supper or what they talked about then.

But never does this diversity seem raised quite to the level of icon, or of the exotic; it remains simply itself, inconspicuous, serving not some idea of the city but only the lives that unfold within it. There seems a freedom to me in that lack of definition, in the city's failure to impose itself on its people, that is perhaps unique to Toronto; and when I think of Toronto now it is not so much its particulars that appeal to me as that freedom I feel here, the illusion, at least, that its contours can shift to hold me, and not mine shift to be held.

## Is Just a Name
*Rabindranath Maharaj*

It took less than fifteen minutes in Canada before UP asked me, "You know what I really like about this place?" We were on our way from Pearson airport and the 401 was lined with busy drivers who did not suddenly stop for impromptu roadside chats like in Trinidad. As I expected he gave no answer but continued to gaze at all the office towers and shopping malls.

During my last visit to Trinidad, UP, who still lived across the road from my parents' house, had bombarded me with the same sort of questions. At first, I had waited patiently for an answer but I soon realized that he was a man of few words and this was his way of expressing interest. Sometimes I tried to fill in the answer myself as when he asked me, "You know what I really like with the Trinidadian manner of talking?" I thought to myself, maybe it is their way of always cutting into a conversation. We had just been visited by a pack of uncles and aunts I had not seen for donkey years. However,

that was just guessing on my part. The only thing I recalled from my boyhood about him was that he had never married and that he would walk away in a fit if anyone used his real name, which was Pundantail. So he ended up with all kinds of strange initials and new relatives, as perfect strangers soon began to add Uncle and Mister and Teacher and once, Señor, before the first letter of his name. I think I should make it clear here that he wasn't my real uncle either. At the end of that visit, UP asked me, "You know what I really like about plane ride?"

Even though the heat was turned high up in the car, UP was still shivering in his silk shirt. I tried to drive quickly so I could put him in a proper winter jacket. Once I had done this, UP pushed his whole neck below the collar like a turtle, looked at the snow outside and with his teeth clattering, asked me, "You know what I really like about this weather here?"

On day two of his visit I took UP to the Scarborough Town Centre that was crowded with teenagers. He gazed at a girl with tattoos on

her arms and shoulders and asked, "You know what I like about children here?" On day three, surrounded by grim and silent commuters staring straight ahead, he asked, "You know what I really like about the passengers in this Go Train?" On day four the question was, "You know what I really like with the news here?" He was before the television staring bewilderedly at some politician answering the reporter's questions in French.

And so it went for the first five days, the halfway point of UP's vacation. But then something strange began to happen: UP started to ask his questions in a different tone of voice, sometimes stopping in mid-sentence as if his tongue suddenly got polio. At first I thought he had run out of "what I like" questions but I noticed his bottom lip trembling and his Adam's Apple riding up and down. It seemed as if he was grasping for something and one night I felt a little thrill with the thought that he might suddenly answer one of his questions. It would be just like the end of a movie when some wizard or the other jumped up and bawled out,

"Abukazam abukabass," and a magic doorway opened.

I believe it was because I had all these high hopes that I was so disappointed when UP finally answered one of his questions. We were on Yonge Street just outside the Toronto Reference Library at the time and around us were people of every shape and shade walking in this busy Canadian way. UP asked me, "You know what I really like about all these people in this city?" Five minutes later in a Tim Hortons, UP pushed half of a doughnut inside his mouth, which swelled his lips as if he was wearing an oversized retainer, and said, "Everybody is the same."

At first I wasn't sure, because his mouth was fully stuffed. I looked around. One table was surrounded by Chinese, another with Filipinos and opposite us, there was a Sri Lankan family. UP himself with his top lip pushed out, was looking like a refugee from Planet of the Apes.

It was a simple thing really but it began to eat away at me, this little observation that UP had made. Was he joking or did he see something

that was miles over my head? I began to feed him with the talk I had heard on television about Toronto being the most diverse city in the world but my baiting was in vain. On day nine of his visit I started to get desperate as time was running out. I took him to Markham and to Gerrard Street and then all the Italian and Portuguese areas. That last night I was so frustrated that the words, "Abukazam abukabass," just flew out from my mouth.

"What the ass wrong with you, boy?"

I was so bothered that I told him, "Nothing, Mr. Pundantail."

His bottom lip began to tremble. I thought he was going to fling the plate at my head but then he settled down and told me, "Exactly." And I could swear a little smile flashed across his face.

I could never be sure that UP really put my mind to rest; whether he finally explained his strange observation. We were about to leave for the airport and I was tagging his suitcases. "Write my whole name." I scratched off "UP" from the tag. He squeezed shut his suitcase and added, "When I land here the customs people start asking all sort of questions about whether these were parcels from some American postal company. They started to get vex when I told them that they shouldn't mind the name 'cause is the same man. Is just a name." It seemed as if he needed to explain this a bit more so on our way to the airport he glanced at his proper name written on his suitcase and told me, "You know, boy. Sometimes we get so used to repeating what other people say that we never stop to think about whether it make sense or not."

## The Village and the Ancient Trails

*Eric Arthur*

The pre-British story of Toronto is stimulating enough for the people of Canada, but it is a moving, almost a personal one for those of us who call Toronto home. We can still tread the principal path of the great explorers. It is broken, it is true, and is no longer a trail, but the basic elements remain unchanged. With eyes closed to the structures that have appeared only in this century, we can stand where Etienne Brulé stood on a September morning in 1615. To the south he would look on the great lake, its waves sparkling in the autumn sunshine, its farther shore remote and invisible. To that lonely traveller, the first of his race to set eyes on Lake Ontario, the sight must have been no less awe-inspiring than that which Cortez saw from his peak in Darien. More so, indeed, because Brulé was alone except for twelve Hurons, and the vast waters stretching to the far horizon had to be crossed or circumnavigated by canoe.

Behind him as he gazed across the lake was the Humber, meandering as it still does between swamps and high clay banks. It was autumn and the ducks, without the blessing of sanctuary that they enjoy today, would be getting ready with the red-winged blackbirds to follow Brulé to the south.

Half a century goes by, and we find people living in a village on the east bank of the Humber within sight of what we know today as the Old Mill. The village, the first settlement of people in the Toronto area, was called Teiaiagon. Its inhabitants first Senecas and later Mississaugas, but its population would frequently be swelled by white men, most of whom would be free traders. The rest were soldiers and administrators under orders to enrich the coffers of the kings of France and to extend the borders of their empire; and that smaller band who were soldiers of Christ — Jesuits, Sulpicians and Récollets — dedicated to the goal of the extension of God's Kingdom in the wilderness.

## Queen City

*Dorothy Livesay*

1

Shaped like a bugle
My thoughts, swarming outwards
In phalanx exultant
Singing for these ones:

For you, young lover
Facing the chasm
And plunging head downwards
"I had not the courage."

For you, girl crying
For love had no wisdom
No warm sleep, jobless
No arms to build with —

For you, forerunner
Outstripping darkness
Your mind sharp as sunlight
Piercing our shadows.

For you, sea of faces
Uniform, solemn
Alert for the warning —
Whom hunger outpaces.

Shaped like a bugle
My thoughts split the framework
Of silence and weeping,
Arise, and send singing
This song to the sleeping.

2

We in a struggling train. Its raw cry rips the air.
The country stubble and the tattered fence flash by
And settle into memory. On rails unseen
We splash into the clouded city's rim, its long
Bare bones stretched out directionless:    suburban houses
Spread like playing cards between garages, hencoops —
Children stiff as splinters saluting the unknown
Waving at these our faces, too far off to put
The fear and strangeness in them — impersonal salute.
Now there are coalyards, runways of smudgy steel, and next
The squat and rounded oil tanks with their vacant eyes.

Here funnels fat with smoke from soot-grimed factories
That stare beyond the bridge, beyond the muddy Don
Down to the blue lake water guarded by the cranes
And churned by tugs, commercial steamers, fishing boats,
Oil-manned tankers, flat red barges dull as freight-trains
— O this the expected city, this the dream!
We see a self-important ferry harried by
The flash of life, the wings of diving gulls, cry shrill
And nose in air for refuse and the cast-off things men stuff
Into a pail and clamp down quick the lid.

3

Take off the lid, scatter the refuse far,
Tear down the "WELCOME" from the city-hall.
For you're not welcome, vagabond, nor you
Old man, nor you, farmlabourer, with sun
Still burning in your face. Burn now with shame
Take to yourself the bread ticket, the bed
On John Street — fifteen cents, GOOD CLEAN
And pluck out all the hungers from your brain.

Hallelujah, I'm a bum
Heading now for kingdom come,

Plugging down a railroad track
Nothing's there to drag me back.

Let the mayor pitter patter
But it really doesn't matter
If he tries to pray
As long as I've a bed tonight
It's a lovely day!

Hallelujah, here's a train
Hallelujah, try again,
Scrambling up a gravel bank —
If I'm dead you've me to thank.

4

Peace in the city's heart, O will you find
Peace in this place again? For not the throb of sound
Nor scurrying bodies darting into doors
Should mar your search, philosopher. The drift
Of light between gaunt buildings should suffice
To blot out grime of brick; your thought alone
Should scrape grey walls until they bleed again.
"Such suffering is good." Look, hermit, how

The pavement aches and strains to be set free
And faces yearn to have their scars removed.
Go, let them suffer! Suffering is release ...
Doctor of souls, empty of heart and mind, show us your peace!

"Only fi' cents
Buy a song"
Only fi' cents
Sing along

Hurry, hurry,
Let us be
Happy like
A rooted tree.

Sing and dance now,
Lover, shake
The fear out from me
Or I'll break —

*Fear of lying*
*On the ground*
*Underneath*
*The feet that pound*

*Fear of whirling*
*With the wheel*
*Crushed between*
*The snapping steel*
*Fear of being*
*Without a bed*
*Asking strangers*
*For your bread.*

"Only fi' cents
Buy a song"
Hurry lover,
Sing along —

<center>5</center>

Now travel east. Move down Carlton Street
Where narrow shadowed rooming houses clamp
The lid down tight on men and women; where
The cry of children is a rare phenomenon.
Barren the streets:    people have overflowed
Into the Allan Gardens — green O green
Yellowed with bodies' sweat, ruffled with talk —
Until you plunge beyond the fountains and beyond

The newspapers grown musty on the ground
To Moss Park hovels, urchins in bare feet
And rags; a slouching shadow down a lane
And splintered floors to trap the feet of rats.

6

But there must be beauty somewheres, somewheres,
Kid yourself, keep telling yourself, Kid.
The steel-helmeted bird, relentless to Honolulu
Pilot spanning blue's outdistance,
They lie low together, loving. They know,
They speed in intimate connection
Pilot in plane, man in woman.
There is beauty somewheres
Not a hard street and a smashing hatred
Enemy shoulders brushing,
Not a fly teasing your face and gasoline in your nostrils.

But somewheres, somewheres
More than this blood branch of rowan berries
More than this wind heavy with hay-scent
Is the warm scent of the breath bent on a woman

Is beauty with connection caught
My fruit content in a warm womb.

<center>7</center>

It's good food for the birds, the old man said
Rifling a garbage can behind the Royal Bank.
His round eyes gleaming under a battered hat
He peered at dried out sandwiches, half-bitten crusts,
And nervous twitches cut across his mouth.
It's good food (where's the cop). Please lady, see
I'm such a benefactor, though I'm poor
(That can't be hid) — But see how kind I am!
Believe, believe! It's good food for the birds ...

<center>8</center>

When I look at the Royal York
Shooting above hunger
Friendly with the sun, up there,
With its elevator heart pumping life
Pumping gold from cellar to summit —

When I look at the Royal York
Being interviewed by The Star
In an intimate, ingratiating way,
When I see the gold braced bell boy, the important clutch
Releasing service; and the dark chambermaid
Forever shaking snow-white sheets forever stained —

When I look at the Royal York
I am a shadow under a cold wall.

But when I look at man again
A thing scarce noticed by the sun, or mentioned in
The social columns; when I see
His legs, his overcoat, his hatless head
His hands held steady and his clearlit eyes —

Then I am tall as the Royal York,
For I built it!
The sun's distance is no chasm, for
I harnessed him with Copernicus
And Karl Marx, years ago!

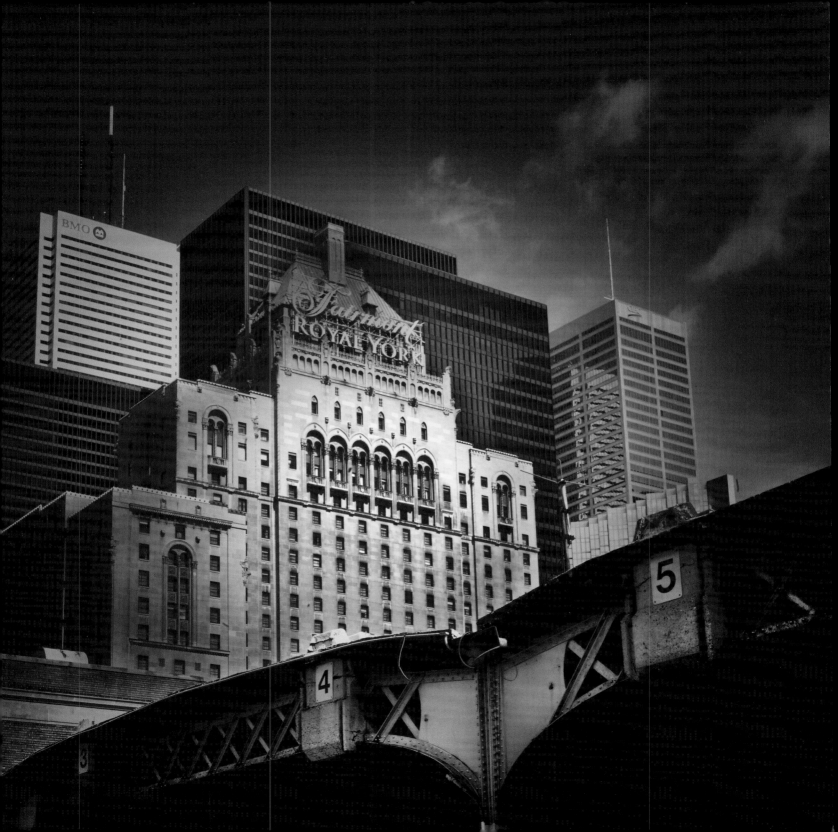

## Bharati
*Piali Roy*

It always happened out of the blue. We'd be in the car, Daddy at the wheel of the ruby red Plymouth, Ma by his side with me in the back, waiting for the light to change at Spadina and College on our way to buy fish at the Jewish Market.

"Bharati!" It was never a shout, just a declaration. On cue, we'd swivel our heads in search of that rarest of birds.

"Kothai?" My father would point and then we would nod in agreement.

Sometimes she would be crossing the street in a multi-coloured sari or he would be at the corner waiting to pack himself onto the Spadina bus. And if he wore a turban, he became, "Sardarji!" All the same, we would nod. I think my parents would smile.

*We are not alone in the city today.*

In the next car over was a similar scene taking place?

"Paki!"

"Where?"

Would they nod in unison, too?

Toronto was the last stop in my father's migrations from Dhaka to Kolkata to London to The Hague, back to Kolkata in search of a suitable Bengali bride, next (the two of them) to Montreal and finally, Toronto the Good. We arrived just as refugees were spilling out of Uganda. This sudden influx was too much for some "Canadians" to handle. A man was pushed into the path of oncoming subway train: we were all Pakis now.

Even on a quiet street in Willowdale. Raw eggs were thrown at our yellow-bricked semi-detached. Children chased me when I rode my bike around the block, yelling the dreaded P-word. And boys from my class would shove me at recess, which wasn't really a problem for a prepubescent girl (Honky, on the other hand, was useless as a tool of intimidation). When I started taking the subway to go to a downtown school, Ma would always warn me in a voice angry with worry: don't stand too close to the edge; be careful. Watching people became my pastime.

As did Bharati-spotting. Even the most obvious encounters struck me as noteworthy. The Steeles West bus, a restaurant, the airport. Wherever I went, I'd scan the crowds and begin to search. It even evolved into a game of fractions and statistics as spotting made way for counting. The subway was best for this. Finch station always launched the game with a good start, then the numbers began a slow descent at York Mills until we hit that fallow stretch of track: Davisville, Summerhill, Rosedale.

As the train would slow down at Rosedale for the handful of passengers waiting on the platform, I'd wonder, "Who are these people and where do they come from?" To me, they existed in the make-believe world of Robertson Davies and Margaret Atwood, on the periphery of what I knew but strangely alive. When visitors came to town, my father would often drive them around Rosedale or Forest Hill to show them how those people lived. The only other homes I ever entered belonged to a few classmates and even they rarely inhabited this world. Most of Toronto was a mystery, save for the one belonging to the

Bengalis, our stand-ins for family here, with whom we celebrated our Durga Pujas and Saraswati Pujas, our annual Christmas Eve party and the picnic at Sibald Point. Bengalis and by extension, Bharatis, I knew.

Now I live in a Riverdale that is no longer the frightening rundown neighbourhood of my parents' memory. I prefer the Withrow Farmer's Market over Kensington. I still drop by Gerrard for an occasional hit of, dare I say it, masala, although I'm starting to do that kind of shopping on my almost weekly visits to Thornhill to see Ma. I still do the same fractions and ratios, not out of necessity, but for my own amusement, trying to gauge the sizes of different ethnic groups, my own little sociology experiment to see how the city is changing.

\*       \*       \*

On a lovely June evening, when the heat that cramps the city has not yet arrived, I drop by the annual Summer Solstice party put on by the local school at Withrow Park, intrigued by what

my future is going to look like now that I have a daughter. It's full of life with kids running around, adults laughing and chatting. I smile and wave at some neighbours and move on. Then, all of a sudden, I feel myself back in a familiar place, scanning with urgency, trying to count, my categories getting broader by the moment.

Brown, no. Black, no. East Asian, okay, one.

Until, that is, she appears.

Nothing marks her as extraordinary, she looks like all the other slightly preppy, slightly hip mums, their look meant to shout Riverdale not Newmarket. No words come to mind, but a small crooked smile.

BHARATI.

I walk towards her.

*I'm not alone in the city tonight.*

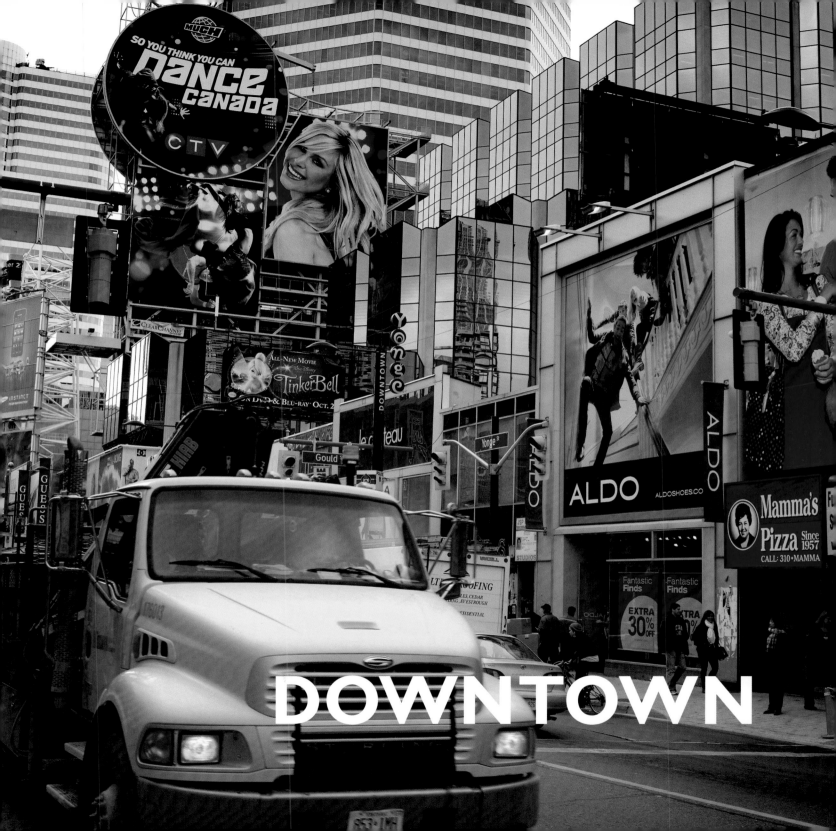

DOWNTOWN

# Angel

*Elise Levine*

It was midnight, Angel, and I'll never forget. We did it in doorways up and down Church Street, my back against rotting wood or my hamstrings hurting, crouched down on grey concrete, the club where I'd cruised you receding as we twisted down alleyways and across half-empty parking lots. You wooed me that night and I could hear my breath whistling in and out of me and when you pulled my shirt up and over my head and tossed it — just like that, in the middle of the street — it was like a ghost floated up inside me and fluttered out of my mouth, my white shirt sailing up over Parliament Street, and the next morning I saw it lying on the streetcar tracks at Queen and Sherbourne.

We were already light-years away from everything I thought I knew (I was fresh off the bus from Owen Sound) and we never stopped once, skidding through the rain-slick streets of Rosedale at three in the morning or standing under the fluorescent hum of all-night pizza joints, hungry (we were so hungry). Or the night you turned a trick and next morning we took the Bathurst Street bus to Starkman's Surgical Supplies. You gave me the guided tour, row upon immaculate row of enema equipment, the smell of the rubber gloves you pressed to my face, and the shiny steel clamp you bought for seventy dollars. That night you pierced my right nipple — for love, you said, as I handed you the surgical steel ring — and that photographer documented it, then threw us out when we ripped through her cupboard for food.

I had walked into the city, Angel.

I never looked back.

# 6 months of the CN tower

*Pier Giorgio Di Cicco*

"By the end of 1974, the tallest self-supporting
structure in the world will dominate the Toronto skyline."

butted from the land when
we first moved in, here on
the 12th floor, as much part
of the room as a lamp, table, book.
it goes up, & one knows time has passed.
it flashes at us now, the streets fall
into it, as if to say, this is what
it all comes to. it fools us / sometimes
people talk about it,   up here.
it reminds us of what it takes up
place for / an absence / something to
occupy us.  in short
it is getting someplace,   under it
the encouragement of a million people
who measure it by where they cannot go.
                              the blue prints
left everything out.

# The City Man

*Howard Akler*

A warm spring sun droops onto the backs of the Fife and Drum Band. They sweat in full ceremonial regalia and spread out at arm's length. Bubbles of nervous laughter flatten into a strict silence for one second, two, three. Then bum-ba bum-ba bum-ba goes the drum major. Bum-ba bum-ba replies the rest of the percussion section, followed by the first notes of the wind instruments. Soon "Vimy Ridge" is in full swing. The band begins to march, moving from the Dominion Public Building, along the Front Street extension and up the westward slant of University Avenue. Pop pop pop go the flashbulbs. In the portion of a second needed for the shutter to open and close, marchers hastily slow into absolute stillness, poses that will linger into the next edition of the papers. Pop pop, they are illuminated. Deep lines in their faces, a fold in the clothes. Pop. Abbott, the photographer, pauses to change a bulb. Beside him, Eli describes the scene. He writes rousing music and packed avenue. He writes failed stretch of sidewalk. In less penurious times, the city had planned for mass construction all the way up the street. The new building of the Parker Fountain Pen Company screamed progress via the perpetual assemblage of nibs. The neon weather beacon atop the Canada Life Building forecast continued prosperity. Back then, Eli quoted an endless parade of black-tie types who boasted of all the expected ribbon cuttings. Then the slump deepened and the hoopla became barely sibilant. Construction stopped. Skeletal forms stood empty and unfinished, so even now, less than three years later, Eli still sees a combination of growth and depression every step of the way.

A long narrow triangle of napes. This is what Chesler sees. Cloche hats and fedoras that advance up the street. Banners above gently ripple the words Toronto 1834 to 1934. From the back end of the line, he has his choice of fat marks, well-dressed men carrying the evidence of three squares above their belts. This crowd is a

real kick in the pants. Six scores in and Chesler can locate by sight. Through the crook of an elbow he catches a left britch impression big enough for a blind man to spot. He restrains a smile, recklessly tossing away seconds now that there seems to be an eternity in the coffers. He shuffles his feet. Offices for a frame.

Everybody begins to inch forward. Contour of the crowd shifts with each step. An elbow juts out of nowhere, profiles bunch and separate. Within this brief rearrangement, Eli spots two familiar faces and hustles after them. Judge Tinker and an attorney named Snodgrass. Two men, imminently quotable, whose frequent appearances in the press belie an ability to construct a full sentence.

These celebrations, you know, says the judge. How important.

Snodgrass nods and nods. Exactly what I was.

Really a showcase.

Spectacle that.

The type of event that can bring our city a little.

A lot.

Yes, a lot of it.

Eli takes notes. They move further up the line, almost near City Hall, when Abbott appears, camera at the ready.

Okay. One picture of all of you.

## Sidewalks of Toronto
*Raymond Knister*

A bright orange balloon floating from the open window of an attic. It hangs there, with no visible means of restraint, bobbing brightly up and down ... A youth in a fur coat and no hat or cap, riding a bicycle swiftly ... A boy running valiantly after truck. He catches it and swings his feet from the ground ... A girl wearing only dark clothes: dark-blue coat with a cape flying as she walks in the wind ... Messenger boy riding a wheel, with rubber hip-boots ... A truck-load of iron pipes, chained so that they do not rattle. Borne by a silent new motor, cushioned by springs, they traverse the city faster and more comfortably than iron pipes would have dreamed of doing a few years ago ... A restaurant opposite a police station. Two burly arms of the law enter and towering above the patrons hunched on the stools, order sandwiches and pots of tea, and carry them across the street to the station ... A man carrying in his hand a nickel model of a horse's hoof ... Sign in Church Street: "Poultry and Produce." ... A truck-load of charcoal in paper bags, a red rag tied to its after part ... A man with a bunch of rhubarb leaves loosely wrapped in paper ... Guns and hunting-knives still filling two large windows ... A man in battered clothes and battered face, on Bloor Street, whistling blithely, eyes raised to the morning sky ... The same man in the afternoon on downtown Bay Street, still whistling as he marches through the crowds ... A tiny woman with blowsy hair and skirts that touch the ground, staring through a plateglass window up at a winter wrap, Sale Price, $650 ... Two automobiles backing out of their parking places on each side of the street. They rush toward each other like charging bulls for a few yards, then charge ahead, without either driver seeming aware of the other.

# Painted Tongue

*Joseph Boyden*

All last spring, summer and winter and again into this spring, Painted Tongue had held onto the chain-link fence and watched the construction workers swarming inside a big pit below him near the waterfront. He'd hum, There are four or five good workers among you. The rest are lazy shits who don't know how to work the foremen, and the foremen don't know how to work a crew. He hummed this until the hum had become a song that he'd moan every day as the construction in the pit reached street level then grew higher with the seasons. Now the building was almost finished.

He'd watched these men from the very beginning, these sunburnt, windburnt workies straying too close to his turf by the railway tracks, these men gouging a huge empty lot until it was a pit, then framing and pouring concrete all last summer, creating a foundation for something too big, it seemed, for the earth's back to bear. Almost every day for this whole last year, Painted Tongue had taken his walk around the site's perimeter, along the sidewalk that circled it like a huge track, stepping slowly so that a footfall was timed to hit the sidewalk every two seconds. I am a well-tuned clock, Painted Tongue hummed. Left foot, stop, one-two. Right foot, stop, one-two. He'd take a long and measured stride, stop and count, then stride again, stop and count. He walked slowly, exactly, to measure the distance around the site. He walked this way to try to slow down the people rushing all around him. Everybody always seemed in a hurry. Every day he walked the same route in his manner, the crowds on the sidewalk parting like a river around a boat's hull. He ignored the odd looks and laughing and catcalls of Whisky Joe or crazy drunk or fruitcake. The people in this city were not capable of understanding.

It took Painted Tongue ninety minutes to walk the site's perimeter. He'd never witnessed so big a job, so huge a building being born from men and cement mixers and steel girders and cranes. Every day over the last few seasons the

walls of the building had grown higher, as if they were being pulled by magic from the tired skin of the earth. Painted Tongue liked to stop after his walk and watch the men work; he recognized the good ones from the lazy at a distance. He was keeper of the secret of their daily progress. Now they were almost finished. The good and the lazy were almost finished.

Today Painted Tongue stood in his usual place at the site, the start and end of his daily walk around the construction, his hands above his head and holding on to the chain-link fence. His nose throbbed from last night's fall. He brought one hand down to his nose as he stared up at the workies scrambling around on the building, the workies straining and shouting and jackhammering the last of the domed roof into place. A large white bandage over Painted Tongue's nose concealed the zigzag of six stitches running the bridge. The pain pills had made him feel almost weightless, like a crow's wing, but now they were all gone.

Last night's fall had been a good thing, he thought. It had loosened up some memories in his head.

That this huge building was round as a medicine wheel was no surprise to him. Nothing in the world existed without a reason. He stared up at the white dome roof, curved like an egg, curved like something he could still not quite figure. The big sign on the other side said in blue letters as tall as a person that this was a stadium, a dome for men to play in and for spectators to cheer. For the last two months Painted Tongue had felt an ugly fear, a wolf spider, creeping up his back. All fear made no sense, and this was no different. Painted Tongue was afraid of the day the men would finish construction, of the day they would pack up their tools and leave this new thing completed. Maybe it was the falling and the pills that were now helping him to recognize just what it was the men were building. His gut tightened in awe and fear.

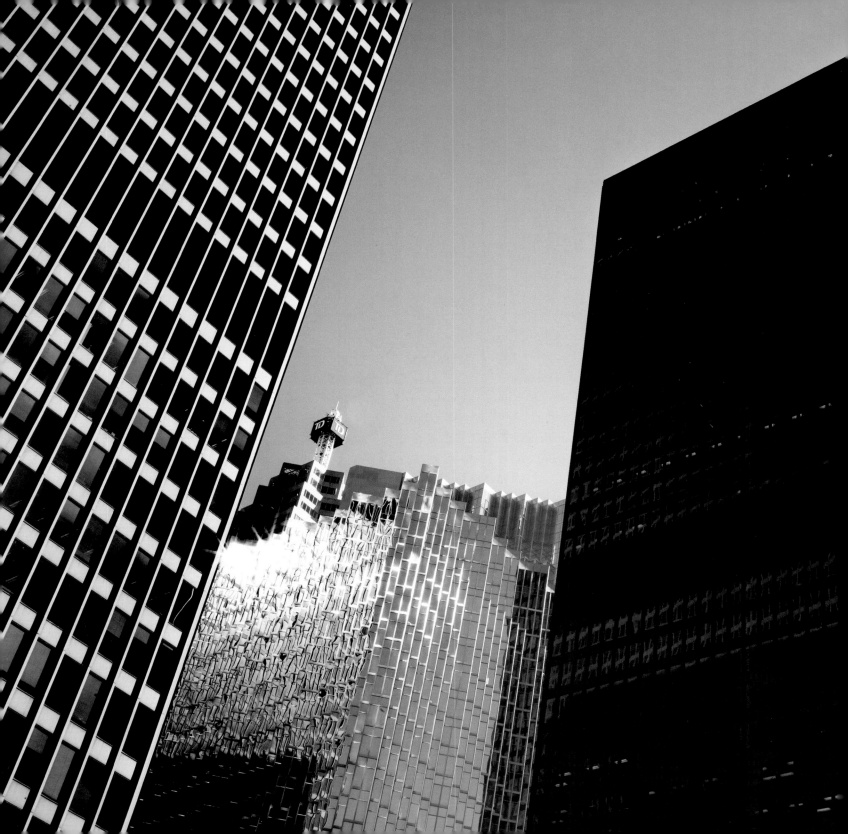

## Rainy Evening Downtown

*Raymond Souster*

The rain that will not turn to snow,
the evening darkness darkening,
the crowds that slowly thicken now
up Bay, on Richmond, along King.

The dripping face of the newsboy,
the warm lights shining from hotels,
the slender figures raincoat-dry.
and out of restaurants the smells.

The twinkling entrances to shows,
the pavements that recall the black
and savage testaments of those
who passed but never will come back.

## Tower and Dome
*Diana Fitzgerald Bryden*

Beside the CN Tower
— that unplunged hypodermic —
a bubble of thin air.

Off-season carnival, dull sun.
So warm. How can it be November?
Planet Hollywood's still packed

with visitors. Theatre-goers
stream to dinner. On Queen,
kids preen by City TV.

Up and down, hot oil
jumping in a pan.
"Pick me, pick me!"

Skip two months. Clouds so low,
the Dome's a sulking shoulder
hunched against its head, the Tower.

Ridged, unimposing stalk
half-visible. Lights cast grainy flares
in mist, scummy pools

of slush at each street corner. Cars
spread icy ruffles when they turn,
pedestrians jump back as if they'll burn, not freeze.

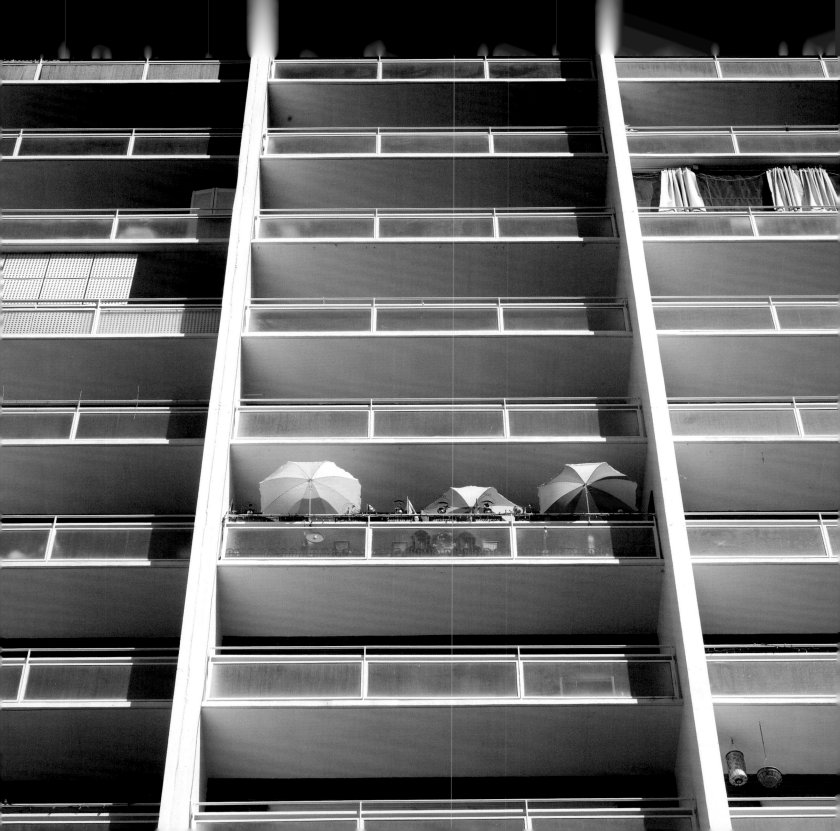

# The Romantic

*Barbara Gowdy*

I start reading the classified ads and making appointments to look at unfurnished flats. Usually I know within two seconds of the landlord's opening the front door that I'm wasting my time. Still, I climb the stairs into realms of heat I can't believe are safe for humans. Cracked plaster, crying baby somewhere, peeling wallpaper, a room under the eaves only a five-year-old could stand up straight in — what the ad meant by "cozy." The whole place painted high-gloss, institutional cream means "newly decorated." "Bright" means not pitch dark. I'd been avoiding basements, but lured by the phrase "high and dry," I end up standing in one, hunched under a pipe whose steady drip the landlord tries to pass off as condensation.

According to Don Shaw I'm never going to find anything, not in my price range, not where I'm looking. He keeps telling me about apartments for rent in this neighbourhood. "You'd love living around here," he says.

I laugh.

"Oh," he says. "The heartless laugh of the young girl."

One day a furnished place comes up for rent in his building. "It would be perfect for you," he says. "Quiet, right at the back. All you'll ever hear is the sparrows in the maple tree."

I tell him to forget it.

"Everything within walking distance," he goes on. "Streetcar stop out front, laundromat downstairs, grocery store on the corner."

"Hookers on the corner."

"That's right. Hookers keeping the sex addicts occupied so that pretty girls like Madame Kirk can walk around unmolested."

Pretty. Except for Abel nobody has ever called me pretty. I feel myself blushing. Don Shaw smiles to himself.

That night, as I'm closing up, there he is, walking through the door.

"Don Shaw," I say, surprised.

"Madame Kirk."

"Did you forget something?"

"I did not." He smiles at his shoes, which are shined. His hair is also shiny, he's used some sort of oil and combed it straight back. And he's wearing cologne — Old Spice. I can smell it from here.

With a touch of unease I say, "What's the occasion?"

He looks up. Pats his hair. "Oh … I, uh, I met a friend, an old friend, for dinner."

I don't believe him. More than once he has described himself as a recluse. I turn and crouch to open the safe, which is recessed into the wall.

He says, "I was on my way home and thought that, since I was passing by, I'd drop in and make you an offer."

My heart launches into a dull pounding. I put the money pouch in the safe, shut the door, spin the combination.

"You are obviously disinclined to view the apartment on your own," he says, "and so I'm here to offer myself as your escort."

I straighten. Still with my back to him, I open the ledger and write down the afternoon's take: seventeen dollars.

"Well?" he says.

I turn around. "Right now?'

He dangles a key. "The current tenant is out of town."

"And you just happen to have the key."

"I'm the superintendent."

"You are?"

"I told you that."

No, he didn't. It doesn't matter. I retrieve my purse from under the counter. "I don't know. I'm really tired."

"It won't take long."

"But I'll miss the ten-fifteen bus."

"The buses run until two a.m."

I sigh. I wonder at my lack of forcefulness.

"Live dangerously," he says.

It's still hot out. On the steps of the Morgan four men, my bald admirer among them, argue over something they keep trying to grab from each other. A deck of cards or a pack of cigarettes. "Slim!" my admirer yells. He stumbles over. His head is a sphere. "I love you!" he yells.

"Go on, get back," Don Shaw says, waving a hand, but the head rides like the moon alongside my right shoulder. At the intersection, it falls away. I look around. He is spooling backwards into traffic. "Marry me!" he yells.

We turn left onto a block of darkened thrift shops and second-hand furniture stores. A store called Bargain Shoes displaying nothing but frilly organza dresses for little girls. Then an empty lot, blue chicory flowers mysteriously vibrant in the gloom. We don't speak. He steps over the legs of a woman lying in a doorway and muttering to herself. I am shocked that it's a woman and that he seemed hardly to notice her.

I glance at him. His expression is strained. His slicked-back hair makes it look as though he's wearing a futuristic helmet.

At the corner we pass two girls in miniskirts and heavy make-up, they're about my age, maybe prostitutes, maybe just a couple of bored girls escaping hot apartments. We pass a coffee shop, light as day inside, only one customer, a wizened version of Brigitte Bardot: the pout, the teased blond hair under a red polka-dot scarf. She sits at the window, smoking.

The building next door is where we stop. It's an old, haphazard brick mansion painted iron red. A laundromat consumes half of the ground floor. "This is it," Don Shaw says. "Willow House."

There is no irony in his tone. There are willows in the yard. I look up at the higher stories and try to spot the charm I must be missing. A couple of turrets, yes, but they're wrapped in brown shingles, and most of the woodwork is lost under aluminum siding.

"Well, what do you think?" he asks.

I see no sense in humouring him. "It's ugly."

"Ugly." He tries to hold on to his smile. "That's not the word that leaps to my mind. But if, to you, living history is ugly, if an accretion of eras is ugly, then ..."

"Then," I say, "it's ugly." I gesture at three possible front doors. "Which one?"

The middle one. Inside, in the large foyer, a dim naked bulb hangs by a cord. Directly underneath, two wooden chairs face each other. "What's this?" I say. "The interrogation room?"

He picks the chairs up and sets them against the wall. "The kids move them around."

"What kids?"

"A brother and sister in apartment three. Good kids, just nowhere to play." He indicates the staircase.

"Go ahead," I say.

I don't want him looking at my rear end. When he starts climbing, I try not to look at his: the womanly girth of his hips. The stairs are the original hardwood, pale and worn to a velvety texture, sagging in the middle, a first indication,

in this house, of its ghosts. I ask how many tenants there are.

"Ten. Six apartments. One on the first floor, mine. Three on the second, two on the third. Yours is on the second at the back."

"Mine?"

"The apartment that uh, that, uh —"

"That's for rent," I finish.

He can't get the key to turn. "Come on," he mutters.

Once we're in, he loosens up, flicking on the overhead light. "Eight-foot ceilings. All the original mouldings. New linoleum." He turns in a circle. "You get a cross breeze with the two windows."

Maybe so, but it must be a hundred degrees in here. And the linoleum has a fake-brick pattern, and there's just this one tiny room, apparently, since everything is in view: a single bed, a kitchen alcove, a brown-corduroy chesterfield, a card table and four chairs.

"Is there a bathroom?" I ask.

"Bathroom!" He strides over to what I took for a closet door and throws it open. "Toilet. Sink. Bathtub. Shower."

"A plumbing extravaganza."

He slides me a combative smile. "I believe I told you it was snug."

"Snug. That's not the word that leaps to my mind."

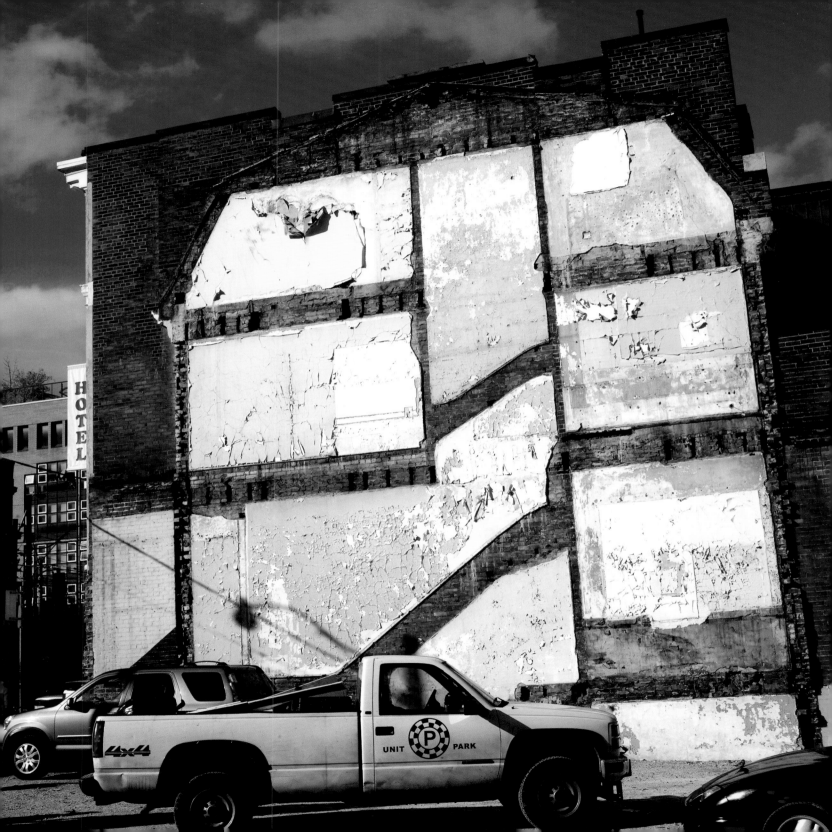

## Ringing the Changes

*Mazo de la Roche*

Remembering the quiet country roads of those days, the exhilarating sights in the city, I feel pity for the child of today with nothing to see but the hideous mechanized traffic, making its stinking way, bumper to bumper, through the gloomy streets, nothing better to do than to learn at sight the makes of different motor cars. How different were the streets in those days! A dray would pass, drawn by a team of powerful draught horses — a butcher's cart, the butcher wearing his light blue apron — a splendid equipage, with coachman in fur cape — horses, horses, everywhere! Women, holding up their long flounced skirts — men who looked like gentlemen. In summer fruit vendors, with their cry of "Strawberry, strawberry ripe! Two boxes for a quarter!" And they were quart boxes, not the miserable little pint boxes we buy today. There was an Italian boy I well remember who pushed his barrow of bananas twice a week to our door, with his musical call of "Banana ripe, fifteen cents a dozen!" I even remember his name, Salvator Polito, and the big red bananas.

In those days everyone who had the use of his legs went for walks. Today nobody walks for pleasure. You may walk for miles and meet nobody but yourself. In the morning and afternoon people walked. In the evening they sat on their verandahs behind the shelter of syringas in flower, the white skirts of the girls billowing over the steps. From indoors might come the sound of a piano. Now and again one heard the clip-clop of horses' hooves. Children went to bed, tired out by their play. Whenever they were free to play they were absorbed in their games. What has happened to the play spirit in the child of the present? Not long ago I had lunch at the Skating Club and, looking down on the ice, saw a dozen earnest children practising figure skating. Over and over the little perfectionists, in their faultless skating gear, repeated the monotonous figures. Nobody was forcing them, nobody was urging them. They wanted to do just what they were doing,

each doubtless picturing itself as a champion of organized sport. I thought of our childhood's helter-skelter skating — hand in mittened hand doing a crack-the-whip across the rink — skates never quite fitting — skirts, flannel petticoats, getting in our way. I thought of the admiring group that would gather to see my father execute the grape-vine or the figure eight — he loftily ignoring them — pretending it was easy!

And the games of summer on the green green grass!

London Bridge is falling down — Here we come gathering nuts in May — The Farmer views his lands — Hide and Seek — Old Witch, this last throwing one into a madness of chase and pretended fear. Afterward the casting of oneself exhausting the grass, staring up at the blue sky or investigating the doings in a tiny ant-hill ... The winds in which one ran, all by oneself, swifter it seemed than the wind, wilder than the tempest.

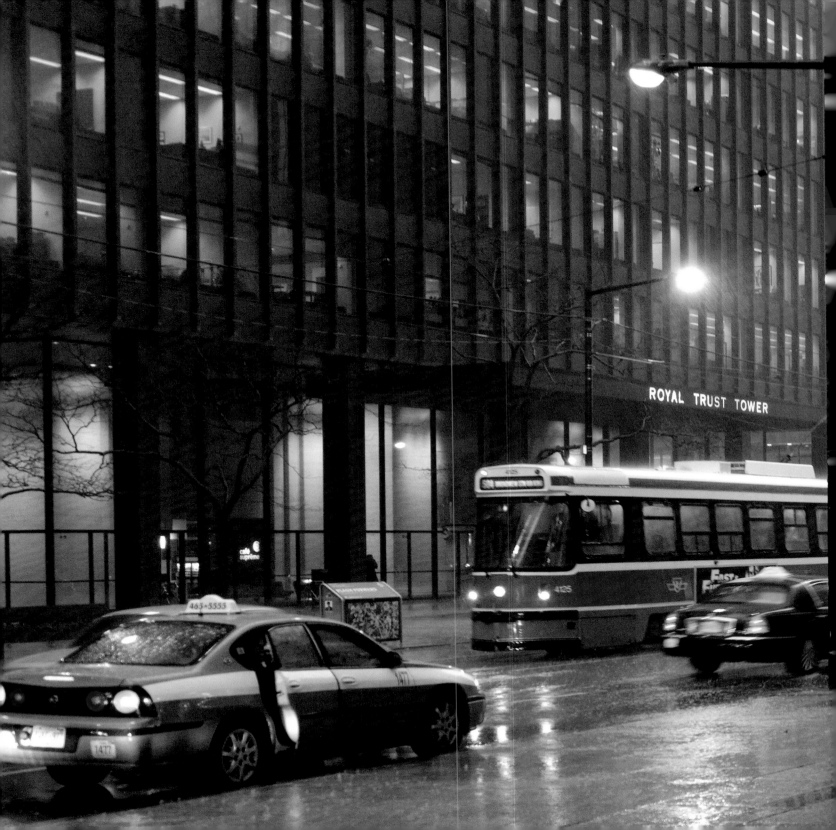

**\*footnote to the end of a love affair**
*Clifton Joseph*

.....and hey
by the way
what about yesterday?
(as footsteps bounce off concrete
away into the now-barren night
skyscraper-washed white
of all delight)

WHAT ABOUT YESTERDAY?

## Chuckie Prophesy

*Clifton Joseph*

im wuk
innah wan smelly
        sweaty
        stinkin'/dutty FAC'TRY
innah de daytime
        nighttime
        earlymorningtime
fuh very likkle likkle money
but come de WEEKENDTIME
BACKSIDE: IM FLASHY FLASHY FLASHY

see im poppin style innah im CADILLAC
watch im pull innah de station
fuh some GAS/O/LINE
hear im as he tips im FEATHERED/FEDORA/HAT:
ayyyyyy Jack: fill she up ...
wid a dollars' worth of GAS/O/LINE
watch im as he digs innah de pockets
of im THREE/PIECE/GAB/ER/DINE
an shift innah im CHICAGO/GANGSTER/LEAN

im cussin like hell
dat MONDAY will come AGAIN
an interrupt im WEEKEND/PARTY
                    CONSOLING/PARTLY
                    DANCING/HAUGHTI-
LY time
in dis here
COLD/COLD/COLD NORTHERN CLIME

TIME WILL COME AROUND
WHEN CHUCKIE'S DISGRUNTLED FROWNS
WILL SEND SKYSCRAPERS/ON/FIRE
TUMBLING DOWN                    \
                    DOWN
                              DOWN
DOWN DOWN DOWN
DOWN DOWN DOWN DOWN
DOWN DOWN DOWN DOWN DOWN
DOWN DOWN DOWN TO THE GROUND
IN THESE HERE NORTHERN BABYLON/TOWNS

## The Bookseller
*Matt Cohen*

If leaving the city I had felt like a fleeing revolutionary, returning, I felt old for the first time, suddenly conscious that all those youthful dreams I'd once had, especially those I'd never really formed, were now in the past instead of the future. Like Flaubert's Frédéric, I needed to go back to the capital, but otherwise I was without plans.

I walked from the train station towards the Savoy Hotel. The season was fall and the city's huge oaks and maples, with their giant overhanging spreads of yellow and golden leaves, added to my elegiac mood.

When I got to the hotel I stood in front of it for a moment. Through the coffeeshop window I could see a few heads bent over the newspapers and coffee. Across one of the front glass doors a wide strip of black tape now made a corner-to-corner diagonal slash. New curtains had been put on the windows of the bottom two floors, which had the "luxury" rooms I had never seen.

The dark red cloth billowed out from the occasional opened window. I walked up the steps as though something was going to happen when I opened the door, maybe a voice calling out that I had no right to be here. I opened the door. Nothing happened. Silence. The deep eventless silence of the lobby of the Savoy Hotel. Then the desk clerk, a woman I had never seen before, raised her head. I crossed the lobby. She offered me a room on the second floor, one of the fancy rooms with new curtains. I shook my head. Before I could ask for something cheaper she turned to the board, then swivelled back with my usual key in her hand, number 66, the Honeymoon Suite.

The view from the window was unchanged. Two long white limousines were ranged on the sidewalk across the street. A tinted window came down. A man whose face was the colour of thick cream was looking straight at me. A developer dreaming of the day a wrecking ball would convert the Savoy Hotel into a pile of broken bricks and plaster dust? Downtown you could make more money with a parking lot than a

run-down hotel. Until you found the right combination, the exact mixture of grease and oil to unlock city hall and give you a permit to put up a shining new office tower, the ground floor set aside for a few of those fancy boutiques with glass shelves that no one ever goes to. His window was entirely open now. I could see his dark suit, the red leather upholstery of his car. He had a telephone in his hand and was punching in the numbers. Maybe he was just one of the pimps who used this place for certain customers. Late at night you would often see them pacing around outside, conspicuously inconspicuous, anxiously smoking cigarettes while they pretended to boast to each other.

In the morning it had been sunny and the light through the leaves had been vaguely exhilarating. Now the sky had a thin shell of cloud and the leaves seemed dimmer. I walked slowly north, zigzagging my way through streets and alleys I knew by heart, then turned west onto Bloor Street. As I walked along Bloor the clouds began to thin. Then the fierce yellow eye of the sun burst out with such a piercing light that people on the street suddenly stopped, averted their faces or shook their heads.

# Red Nights: Erotica and the Language of Men's Desire

*Michael Rowe*

There are certain nights in late August, in Toronto, when the swollen summer sky presses itself down upon the city, making shirts cling damply to backs, and blood rise to the surface of sweaty skin, stroking to life every sensation that we might overlook, or even suppress, on a cooler evening when the heat is less physical. The humidity wraps the street lights in a gauzy aureole, and every sensation seems stronger somehow because of it — sight, sound, taste, touch, smell.

My friend Ron and I called them "red nights" when I was in my early twenties and life was less complicated than it naturally became later. I dream of them today, and even when I am awake and walking though the city at dusk, I will occasionally catch the ghost-edge of some scent or other in the indolent lagoon of summer night air and it takes me back along the paths of memory to the place where I first discovered the pleasure of loving men openly and celebrating what makes them beautiful.

The August heat might have exhausted the suburbanites far beyond the city's core as they sat fanning themselves on their patios, but for Ron and I, walking downtown along Yonge Street in the subtropical dampness of those August nights, there was an erotic call-to-arms implicit in the sinuous warmth, an alertness to the sexual possibilities all around us. Neither Ron nor I had the inclination to describe or discuss what we were feeling. Neither of us were connoisseurs of written erotica, nor were we inclined to verbalize, much less rhapsodize, the particulars, beyond the verbal shorthand of young gay men. Arousal was too specific a word, certainly at the start of the night. Even when we weren't looking to score, the visual buffet was there if we wanted to sample it, or even just admire its presentation. Awareness came closer, but awareness of what? The men in the streets were not all handsome, nor were they all to our respective tastes, which have always been diametrically divergent. Ron and I are able to spot each other's type as only longtime best friends are able to and we often marvel at how two gay men with such different views of what constitutes sexual attractiveness could belong to the same gender, let

alone the same sexual orientation. They all were, however, indisputably male.

On those nights, the most eclectic sexual tastes could be visually indulged.

There were the ethereally handsome gay men, alone or in groups, dressed in Lycra dancing-queen mufti, or leather, or denim. There were the young suburban bulls with K-car muscles and crewcuts, arms draped around their teased and frosted girlfriends who seemed to wear them like bulky bronze jewellery. The boys themselves, firing macho scowls and sweating testosterone, looked everywhere except down at the girls who flaunted them with such passive possessiveness. There were the depleted straight businessmen coming home from late meetings, jackets slung over their shoulders, sweat plastering their white shirts to their backs, hinting at broad shoulders and racquetball triceps. The humidity caused the summer-weight poplin of their suit trousers to cling suggestively in a way that was too well-bred to be overtly lewd, yet was inviting enough to have disturbed (or

intrigued) them if it had been pointed out. There were the men returning from the gym, the ones who wanted to dry off in the summer night air, the ones you could easily imagine naked, who carried with them the faint, clean scent of soap and sweat as they strode home in damp sports gear. Their striated thighs shimmered under a dew of sweat in the refracted neon light, their biceps twitched with exhaustion, and their beautiful, sweaty faces were always, somehow, perfect, no matter what they looked like.

And suddenly, at some point in the night, awareness became arousal. The visual became a language, the flesh made itself word. The men's beauty derived not from any particular aesthetic attribute, but from a gender-based, sexual one. It was enough that they were men. Like us in many ways, unlike us in many other marvellous ones. Their maleness, their oppositeness from women, became a keening red night-song that hummed through our young bodies without a sound. It left us bursting with a soaring euphoria that we were alive, that we were gay, and that we

were able to appreciate the men who stalked through these red summer nights with such assurance, and appreciate them in a way that only a gay man could. My communication with Ron remained non-verbal, but in that parade of heat and sweat on those red nights, most words would have been superfluous anyway when measured against the unspoken, inarticulate language of our desire.

## Sherbourne Street

*John Cornish*

He had visited the trailer and mentioned the tea during the course of a walk up Sherbourne. Nowadays, seeking distraction, he walked about midtown Toronto a great deal. Emmy was too slow (and too boring) for a companion and Martha too crippled; he walked alone. Daily he visited the excavations for the city's first subway where a deep trench extended a mile up Yonge Street. Railed wood sidewalks bordered it, bays led into every doorway. A temporary Yonge of Douglas Fir beams perhaps twelve-by-twelve was creeping north. Napier joined a group of hole-watchers. There danced far back in his mind a tiny flame of professional interest, for this man whose name attached to a symphony in manuscript, who had published short piano works beside cadenzas for five of Mozart's concertos, whose charming if lightweight Back Country Jig, who scored for full orchestra, was heard around the world, who had styled himself the principal of a conservatory, possessed but

one university degree and that one not in music but in civil engineering. The memory of the degree was an old scar and so was its association, the catchphrase of another day: No English Need Apply ...

Pollock was to conduct Britten's Spring Symphony combining forces of the orchestra, the Mendelssohn Choir, soloists, some boys from Grace Church-on-the-Hill, and a cow-horn. In the hot afternoon sun Napier, sweaty under his Norfolk jacket, strolled down Sherbourne. He crossed Carlton, followed the diagonal of a small park and out of the corner of an eye he watched the inevitable pan-handler approach him. He could hardly recall a half-hour out-of-doors in his part of the city without its beggar. Which had come first, the beggar or the Toronto missions? Most were young and reputedly they drank after-shave lotion, these mendicants, and if he passed them by they might call obscenities after him; and partly to avoid unpleasantness, partly because he pictured himself akin to them, in his case brought low by pride — because of this he was ready with silver from his change pocket.

"Thanks, mister."

Napier glanced sharply into an unhealthy face not much past twenty — his son had been older. Now was not this the same lad who, a month or so back, had tried to shock him?

He came out of the park. Approaching Dundas he was detained again. Were the parts of Toronto free of these youths? Why certainly, he reflected. First you had to impose the figure of a wine-glass over a map of the city. King and Front made the base, the stem ran up University, opened out at College; but the glass, widening to Bloor, excluded his Sherbourne altogether.

At Dundas he waited for a green light. A procession of automobiles was turning right through the red, and after the light changed they still scraped past him. The last car circled by; Napier began to cross. He was a third of the way over when the lights again changed, half-way over when the cross-traffic surged forward. He found himself cut off, standing in the centre of the road. He stood waiting while automobile traffic, two abreast, lunged by in front and in back of him. Then the lights changed and he was free to move on. It was not uncommon in his experience to be trapped thus in mid-street, nothing stopping except himself — the driving habits of Toronto being what they were.

## Girl on the Subway
*Crad Kilodney*

I was tempted to say that Arlen was an asshole, but instead I told him, "The only guarantee a writer has is that he'll be misunderstood frequently, and sometimes by the people who ought to understand him best."

"That's for damn sure," he said, finishing his drink.

"You want another? I have plenty of dough today. We might as well, seeing as how we're both feeling so terrific." So I ordered another round for us and tried to convince myself that when nine o'clock rolled around and Laura arrived, I'd be anaesthetized enough to have my head cut off neatly and take it like a man.

"Well, now that I've cheered you up," said Ted with a twisted smile, "why don't you tell me something amusing?"

And then I thought of the girl on the subway. "Well, it's not very amusing, but ..."

"That's okay. I want to hear it anyway."

The waitress brought us our drinks. I waited till she left before I began.

A few nights before, I was on the subway coming home from Laura's. It was quite late, maybe one in the morning. There weren't too many people on the subway. There were two girls across the aisle from me sitting perpendicular to each other rather than on the same seat. They were in their early twenties. One was a mannish blonde with short hair, no make-up, and very plain clothes. The other girl was dark, maybe East Indian or from somewhere in the Caribbean. She was quite pretty —

nice makeup, colourful clothes, a lovely smile. She seemed a bit coy. She did most of the talking, however, and the blond girl was leaning forward to hear her better above the noise of the train. I could see the blonde looking at her very intensely, her eyes travelling all over the coloured girl. The coloured girl made only occasional eye contact with her. Most of the time she smiled bashfully and looked at her hands on her lap or at the floor. I couldn't hear what they were saying, but I got the impression that they knew each other but not particularly well — maybe as co-workers or classmates. I watched them discreetly all the way up from Bloor Street to Lawrence Avenue. At Lawrence the coloured girl got off. She smiled and said goodbye to the blonde and then hurried off, walking briskly toward the exit without looking back.

After that, the blonde's expression changed radically. She just stared at the floor, her hands folded. She looked profoundly sad, and I felt great pity just seeing her sitting there lost in an apparent cloud of inner pain. In that moment, I felt I understood the whole scene intuitively: the blond girl was in love with the coloured girl but couldn't tell her so because the other girl was obviously straight. Perhaps she'd been trying to get up her courage to say something before the coloured girl got to her stop but then realized she'd missed her chance. Maybe I was completely wrong in my interpretation of the scene, but my intuitive feeling about it was very strong.

I kept watching the blond girl out of the corner of my eye. Her gaze wandered to the window, where the wall of the tunnel was rushing past, and I could see her faint reflection in the glass. What a look of sorrow! How I wanted to go over to her and try to console her in some way. But one doesn't do things like that on the subway. Like most people, I'm conditioned to mind my own business.

I had to get off at York Mills, the next stop, and I saw the blond girl get up, too. I deliberately went out by a different door and then walked toward the north end of the station, in the direction of the stairs leading to the bus platform.

When I cast a quick glance over my shoulder, I saw the girl standing at the south end at the edge of the platform. She was looking at the tracks. I became alarmed. In a few seconds we'd be the only two people on the platform. She was obviously thinking about jumping, and it was up to me to do something.

I pretended to go up the stairs and then walked out of her view behind one of the pillars. I was shaking. I walked back in her direction, using the pillars to keep out of her sight. When I finally came close to her, she saw me and stiffened. I went over to her and put my hand on her arm. "I'm sorry to intrude," I said. Wasn't that a ridiculous thing to say! I'm sorry to intrude. Jesus!

"Get lost," she said, pulling her arm away.

This time I held on to her arm more firmly.

"Look, I'm not prepared to see something like this. Why don't you come with me?"

"It's none of your business," she said harshly.

"I know, I know, but please, why don't we just go upstairs, okay? Come on. Please. What do you say?"

She gave me a long, hard look I couldn't interpret, then she turned toward the escalator at the south end, and I followed right behind her, trying to hold gently on to one arm.

"Maybe you'd like someone to talk to? We could go somewhere or I could escort you home. Whatever you want." I was still shaking and felt unsure of what to do.

"Never mind," she said, not looking at me. "You don't have to hold my arm. I don't need that." I felt like an idiot.

We ended up at the south exit, south of the Shell station. I had no idea where to steer her. We were on the wrong side to get on a bus. We just walked south on Yonge Street.

"I sort of got the impression that something went wrong between you and that other girl," I said. She was walking at a steady pace. I don't think she was trying to get rid of me exactly, just ignoring me. It was a very cold night, but I felt flushed and uncomfortably warm. She wouldn't say a word. I kept trying to soothe her, to get her to talk. Did she want to go home? Did she want to come home with me? Did she want to sit down someplace and have a drink? (There was no place to sit down in that area anyway.) Did she want to talk about her problem? Part of me wanted to kiss her out of sympathy, and another part of me felt resentful and foolish because of her coldness.

Right in the middle of my pathetic monologue, she spied a cab coming toward us and signalled. "I think I'll just grab this cab," she said. "Thanks. I know you meant well." And without another word, she got in, and they made a U-turn and headed back south.

I walked home. It was a long walk, and I felt very mixed up inside. I felt ridiculous, but I kept telling myself that at least I had prevented a suicide.

## November: The Invisible Streetcar
*Shaughnessy Bishop-Stall*

November 15
I'd hoped to start writing yesterday, but then the soldiers were coming at us across the field, I couldn't find a pen or paper and I started to shake.

It was my first night in Toronto and I stayed at the Salvation Army shelter down on Sherbourne Street on the east side of Moss Park. On the west side of the park is the Department of National Defence Military Academy. Across from that is an army surplus store where I plan to get my supplies.

The DND trains teenage militia on the turf of Moss Park. Being the Canadian army, they practise strategic advance without even blanks in their rifles. Late at night they charge across the football field toward the homeless shelter, giggling as they shoot each other, yelling, "Bang! Bang! Bang!"

This span of Queen Street, running along the south edge of the park, is covered with junkies, dealers, hookers and cops. And last night I sat among them, smoking and shaking on the Salvation Army steps — trying to alert the others to the attacking soldiers. In no condition to fight, I gave out as many cigarettes as I could and wedged myself in between the toughest and craziest — to my right, 300 pounds of muscle just released from prison, to my left, some guy trying to think of every B word he could and yelling them out in bursts of triumph: "Beer! Beaver! Bread! Bobby Brown!" The soldiers were firing. As if shot, an old man with a nicotine Santa beard lay on his back on the sidewalk singing demonic opera in a dozen voices from falsetto to basso profundo. "O solo frio. Me loony! Me loony! Old man shiver!"

"Barbecue! Blister! Baby brother! Banana!"

"I'm going to kill you, you bitch!"

"Bang! Bang! I got you, dude."

I dropped my head and stared into the dark space between my knees, shivering and shaking.

## Adrift

*Patrick Slater*

Jack Trueman had not bought the dog; nor had he been given the dog. One day, Rover had left the drover's team he was looking after, and had dropped in, casual-like, to inspect the alley at the side and the stable in the rear of the Tavern Tyrone. He fancied the look of the place and the smell of the slop-bucket. Off-hand, he decided he would like to own a boy who lived round an interesting place like that. So the two of them struck up a bargain on the spot — at least they thought they did. There was a mutual misunderstanding so complete that things worked out all right.

Rover was old enough to have sense, but young enough to be full of devilment. He was a regular fellow. He never got into any squabbles with girl dogs; but the body-odours of any gent of his own kind who strayed within a block of the Tavern Tyrone seemed very displeasing to him. And, when he fought another dog, Rover stuck right at the job till he gave a thrashing to the son of a bitch, or enough silly humans ran together to make it a draw. Jack and his collie got into street fights daily. I was their partisan and did a lot of grunting for them. The three of us skylarked that spring about the streets of Toronto.

One June day, we were down to the foot of Berkeley Street to see a double hanging; and that surely was one glorious, well-filled day. There was a high stone wall clear around the prison which stood close to the bay-shore; and the Fair Grounds lay open to the west. Two men, Turney and Hamilton, were to be hanged on a Tuesday morning. To give the public a tidy view of the drops, both before and after taking, a double gallows had been built facing the Fair Grounds and high on top of the prison wall.

Before the early-risers were abroad, hundreds of heavy farm carts and lumbering wains came creaking into town with their loads of merry, holiday-making country folk from far and near. Along the muddy roads came also bands of stalky farm lads, faring stoutly on foot, with stick in hand and bag on back, stepping down thirty miles or so to see the doings. Two men were to

be killed by the law in the morning as an example to the public; and the schools throughout the district were closed that the children might benefit by so valuable a lesson in morals and good living. That day the taverns of Toronto did a stirring business.

"Your soul to the devil!" said young Jack to me. "Let us hooray down and see the necks stretched."

The hangings had been set for ten o'clock in the morning; but an hour ahead of time there was a good-natured throng of thousands jostling one another before the grim prison walls. It was the sort of crowd one sees nowadays at a big country fall fair. Neighbours were greeting neighbours, and joshing over local affairs. Men carried their liquor well in those days; and, of course, mothers had brought the young children in their arms. What else could the poor dears do?

A stir among the men on the prison walls told us the death procession was coming. A hush of awed expectancy fell upon the great throng. And this gaping crowd, stirred with thoughts of human slaughter, was standing in the most

humane and tolerant colony Europe ever established beyond the seas! New England had been developed by the labour of convicts transported to be sold as serfs on an auction-block. We are often told of the Mayflower landing the Pilgrim Fathers on the Plymouth Rock. Oh yes! But we hear little of the fact that for a century every other merchant ship touching a New England port landed a cargo of convicts on the Pilgrim Fathers. The outposts of those colonies were pushed westward by rough frontiersmen who murdered as they went on frolics of their own. The southern colonies were developed by slave labour, and the full wages of that slavery have not yet been paid. One of the first laws passed in Upper Canada, in 1793, provided for the abolition of slavery; and, in dealing with another human, there has never been a time or place in Canada, save in her wretched prisons, that any man could with impunity make his will a law to itself.

You ask what brought thousands of people together to see such a terrible sight as a double hanging; and I answer you that fifty thousand of

the likes of you would turn out any morning to view a well-bungled hanging today. A murderer is a celebrity; and people run open-mouthed to see a celebrity, to hear him speak and see him decorated — or hanged — as the case may be. Every crowd hungers for excitement and is looking for a thrill. Every mob is by nature cruel and bloodthirsty. With all his clothing and culture, man remains a savage, a fact that becomes obvious when a few of them run together.

The breath going out of thousands of throats made a low murmur as the murderer, William Turney, in his grave clothes and pinioned, came into public view and stoutly mounted the stairs of the scaffold platform. A priest walked beside him. Behind them strode a hangman, who was closely masked.

It was a matter of good form — and decently expected in those days — that a murderer make a speech and exhort the public. A lusty cheer went up as William Turney stepped smartly forward to make his speech from the gallows. His was an Irish brogue; and his voice was loud and clear.

"Die — like — a — man!" shouted loud-voiced Michael, the smuggler.

Turney had been working the fall before as a journeyman tailor at Markham Village. He dropped into a local store one dark night to get a jug of whisky to take to an apple-paring bee. As the clerk, McPhillips, was bending over the liquor-barrel, Turney stove the man's skull in with a hammer, and then rifled the till. He turned off the spigot, blew out the candles, closed the wooden shutters, and quietly went home to bed. The dead body was not found till the morning after. No one had seen Turney abroad the night before. He came under suspicion the next day because he rode to Toronto on a borrowed horse, and bought himself for cash money a pair of boots and a leather jacket. But that, you'll agree, was not hanging evidence.

Turney, however, needed money for his defence; and while lying in gaol at Toronto he got a letter smuggled out to his wife. The poor simple woman was no scholar; and she asked a neighbour to read it for her. The letter told her

the sack of money was hidden under a loose board in the floor of their back-house at Markham Village. He bade her get the money and give it to the lawyer-man. So the damaging evidence leaked out. How much wiser to have let the solicitor's clerk visit the privy!

On the scaffold, Turney made a rousing speech. He shouted to us that he had been a British soldier in his day, and was not afeared of death. Turney thanked us all kindly for the compliment of coming to his hanging. It was sorry he was for killing the poor man; McPhillips, who had never hurted him and had treated him as a friend. The crime, he told us, had not been planned, but was done on the spur of the moment. The devil had tempted him, and he fell. He had run home that dark night in a terrible fear. The wind in the trees sounded in his ears like the groans of poor tortured souls in hell. Hanging, he told us, was what he deserved. Let it be a lesson to us all.

Turney's feelings then got the better of him. He broke down and wailed loudly, praying that God would prove a guardian to his poor wife and fatherless child. The crowd did not like the tears. The high-pitched cries of women jeering at the miserable creature mixed with the heavy voices of men urging him to keep his spirits up.

"Doo — ye — loo-ike — a — maa-hun!" boomed Michael, the leather-lunged.

In the pause, Turney got a fresh holt on his discourse. He went on to tell us he had been a terrible character in his day. He had started serving the devil by robbing his mother of a shilling; and, in after years, while plundering a castle, he had helped wipe out an entire family in Spain. He explained that a full account of his high crimes was in the printer's hands. He beseeched everyone to buy a copy for the benefit of his poor wife and child. In the hope of getting a few shillings for them, Turney stepped back to his death with these great lies ringing in our ears.

At the foot of the scaffold stairs, the other felon requested the Protestant minister who walked beside him to kneel and have a session in prayer. The murderer seemed in no hurry to be up to finish his journey. The clergyman tried the

stairs carefully, stepping up and down to prove them solid and sound. But it is hard to convince a man against his will. The hangman waited a tidy space, and then spit on his fist. Retook the victim by the scruff of his neck and waist-band and hoisted him up the stairs, the clergyman lending a helping hand. The crowd jeered loudly; but, once up in open public view, the felon's courage revived. Hamilton came forward with stiff, jerky little steps; and, in a high-pitched voice, he admonished us all to avoid taverns, particularly on the Sabbath.

Then the serious business began. The executioners hurried around, strapping the legs of their victims and adjusting the caps and halters. The culprits assumed a kneeling position over the traps and prayed to God for mercy.

A loud murmur went up from the thousands of throats — "Aw!" — as the bolts were shot. The two bodies tumbled down to dangle on the ropes and pitch about. It took Turney quite a while to choke to death. The other body seemed to drop limp.

This business of hanging folk should be intensely interesting to every Canadian of old-country British stock. The blood strain of every one of us leads back to the hangman's noose. Many a man was smuggled out of Ireland to save his neck from stretching for the stealing of a sheep.

And public hanging had something to justify it. In the olden days, human life was of little more account than it is today; and hoisting bodies in the air, and leaving them to rot on gibbets, was thought to be a rough-and-ready warning to evildoers. What a pity public hangings were ever done away with! Had they continued a few years longer, the horrible practice of hanging men would have passed away under the pressure of public opinion.

## The Stately Street of Sin
*Grattan Gray*

In Toronto they tell the story of a deaf old man who got on a streetcar and asked repeatedly to be let off at Jarvis Street. Finally the conductor shouted: "You won't miss Jarvis Street. There'll be two cops on one corner. There'll be a police cruiser on the opposite corner. There'll be a motorcycle on the third corner. And on the fourth corner there'll be a paddy wagon."

In due time the car stopped at the corner of Jarvis and Dundas Streets. The doors opened. But the old man couldn't get off. The paddy wagon was in the way.

It is perhaps unfair that the fourteen city blocks which make up Jarvis Street should have won the reputation of being the wickedest in Canada. Yet from coast to coast Jarvis is certainly spoken of as the Wicked Street. Did it not nurture Mickey McDonald, Canada's Public Enemy No. 1? Wasn't it the headquarters of the notorious Polka Dot gang (who wore spotted masks)? Isn't it true that Toronto's No. 2 police station handles seventy per cent of the city's crime — half of it from the Jarvis district?

It is. Yet it is equally true that the flamboyant Dr. T.T. Shields' solid brownstone Baptist church stands on Jarvis Street. From this pinnacled edifice a drunk and his mother were once hurled by police who arrived in response to frantic calls from radio listeners who caught the disturbance during the church's Sunday broadcast. The CCF's provincial headquarters is on Jarvis Street and so are the key studios of the CBC's two national networks, housed in a rambling brick structure which was once the prim and proper Havergal's school.

The most expensive flophouse in town (BUNKS — $1 per night) where you hang your clothes on the floor and sleep nine men to a room, is on lower Jarvis. But so is the Canadian Audubon Society, an organization devoted to the examination of birds — queer and otherwise — of which the street has many varieties.

Mixed drinking is legal in all Ontario taverns serving beer — except on Jarvis Street where men may not enter the "ladies" section. For the street has long been known as the home of the prostitute and the procurer. But it is also known as the headquarters of the YWCA, the

South African War Veterans, the Canadian Red Cross, a United Church women's residence, and the Red Spot Nut Co. Ltd.

## Fist Fights are the Fashion

For Jarvis Street is a fourteen-block paradox. Its austere elm-fronted Georgian mansions, with cupolas and towers, stand almost shoulder to shoulder with its leprous yellow warrens of tenements.

From the north end of the street with its Romanesque doorways and wrought-iron railings looks solid, quiet, bland, genteel and bourgeois. From the south end, with its beehive-busy market and its liver-brick factory buildings (floor waxes, soda straws, cured meats, nuts); it has a bustling mercantile look. Between these two extremes lie the cheek-by-jowl rooming houses and the big neon-rimmed hotels where beer flows like water and fist fights are the fashion on Friday nights. In one of these hotels police recently arrested the kingpin of a bogus $10 counterfeit gang.

It is this central area that has given the street its reputation. From these two blocks jovial detective Harry Sutton's plain-clothes squad made upward of 150 arrests last year — book-making, prostitution, bootlegging, and drugs.

The story of Jarvis Street with its stern old houses and crumbling tenements, its old ladies in lace chokers and its young men in peg-cuff strides, is really the story of an expanding industrial town grown too big for its breeches.

In its day Jarvis was Toronto's swankiest street, the home of the Mulocks and the Masseys. Then as industrial growth pushed and shoved its way toward the outskirts, the residential areas moved north and west and the "best" people moved with them. Today Jarvis is to Toronto what Washington Heights is to New York or the West End is to Vancouver. The stately mansions of half a century ago are the office buildings and tenements of today.

It was named after the Jarvis family at the end of the street when it was a cart track with stumps. Old William Jarvis, a husky, six-foot, wealthy slaveholder, was secretary to three

lieutenant-governors of Upper Canada. His son, Col. Samuel Peters Jarvis, took over as secretary when his father died.

As a teenager Sam killed his best friend in a duel and was acquitted (his father was foreman of a jury which acquitted another duelist years earlier). He built a home of solid brick with black walnut fittings at the point where Jarvis and Shuter Streets now intersect in the core of the Detective Sutton's plain-clothes beat.

In those days it was pastoral country. In the immediate area there was a swamp for snipe shooting, a stream for trout and a forest for deer. The house was torn down in 1848 when Jarvis Street was extended north to its present length.

In those days Jarvis was the hub of the city. Toronto's City Hall stood at its lower end. (Said one writer of the day, "It stands upon ground said to be permeated with poisonous matter and some of its rooms and offices are a menace to life.") Its front entrance is today part of the St. Lawrence Market.

At Jarvis and Queen "Wholesale retail Pete MacDoug," a town character renowned for his canniness, ran his emporium. His reputation for marking up his stock was widespread. Burglars once broke into his store. They left a note behind explaining why they hadn't stolen certain articles — "they were marked too high."

The White Swan Tavern stood at the foot of the street facing Market Square. Its built-in national history museum contained stuffed birds and the wax figures of General Jackson and other notables. Wags broke into the museum one night and hung the figures on a tree overlooking the harbour.

Across the way the great corniced St. Lawrence Market did double duty as a public meeting place. Here, in 1834, the wooden galleries were crowded with townspeople listening to Col. Jarvis attack the mayor for increasing the municipal tax. The audience stamped its collective feet in applause and the gallery gave way, impaling many of the applauders on the sharp, upcurved iron hooks of the butchers' stalls.

Several died in agony and dozens were injured, including fourteen-year-old George Gooderham, of the famous distilling family,

whose imposing three-story home was on North Jarvis. Gooderham's son, yachtsman and whisky baron George Horace Gooderham, lived in the home until he died in 1919. Now the turreted mansion is headquarters for the Big Brother Movement.

Young Toronto's most solid citizens lived in the present slum area between Queen and Dundas. The city directory of 1882 lists such bourgeois families as Capt. Charles Perry, insurance agent, R.G. Trotter, dentist, and D.M. McDonald, barrister. The once proud mansion of the French Vice-Consul Charles Rochereau de la Sabliere is now one of the most dilapidated houses on the street — a tenement run by the City Welfare Department.

Farther north lived some of Canada's oldest families, the Kents, Lamports, McColls, Gooderhams and Ryans. Hart Alnerrin Massey, founder of Massey Hall, lived at the corner of Jarvis and Wellesley. He left an estate of $1,700,000.

A few doors away from the Gooderhams Sir William Mullock lived. Others moved away but Sir William stayed stubbornly on until he died in 1944, the last reminder of a gilded age. Today his home with its big Gothic window and square tower is occupied by the Salvation Army.

Now once again, as Toronto enters a new stage, the character of Jarvis Street is changing. It is fast becoming one of the city's main traffic outlets. The pavement has been widened since the war. A $7 million improvement is under way at its north end to whisk traffic into the mushrooming suburbs. Building along its upper length has been restricted to hotels and dwelling houses but property owners are plumping for a by-law revision so that shops and business blocks may replace the brave old rambling homes.

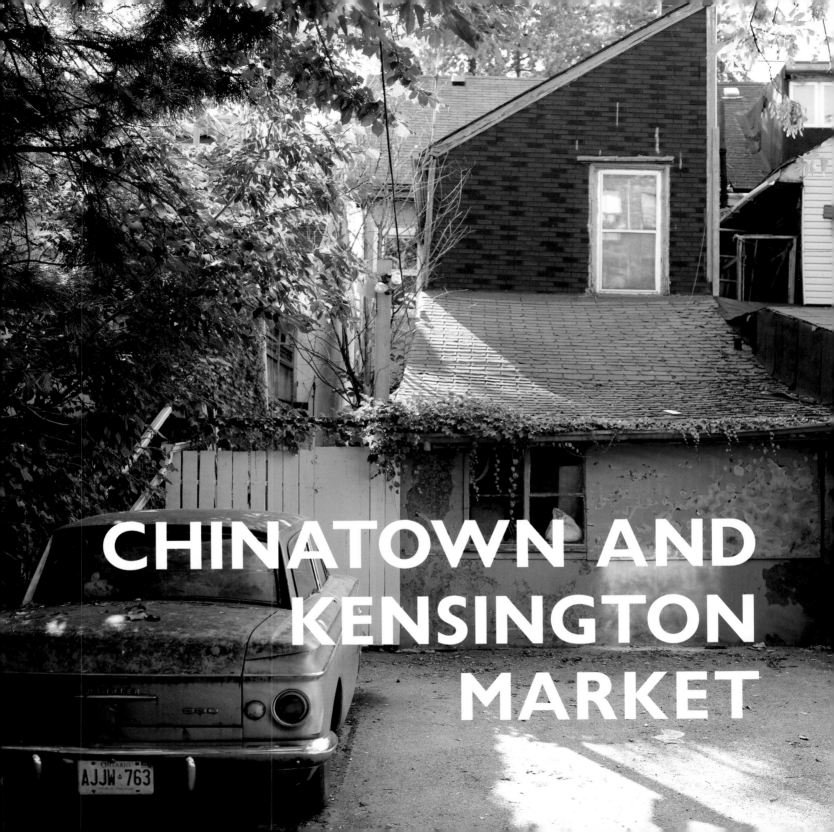

# CHINATOWN AND KENSINGTON MARKET

## Varied Hues

*Irving Layton*

What moves me about Toronto is the TTC. It gets me swiftly to the places I want to see. To Kensington Market with its gusts of cheese and fish smells, old clothes for sale. Opium lacks their magic to stir boyhood memories of places far away and long ago. And O those lovely black corrupt olives. Nowhere else have I seen such generous ones winking at me with the moist eyes of a thousand Fatimas. I lost my heart to them on my first visit and haunt the place ever since. Fondly I gaze at them and the crowds diverse as the maps of the world. They also hunger for sensations only this fabulous realm can gratify. Wordsworth was turned on by daffodils. My flowers are the faces I pluck from Kensington's pavements: Oriental, Jamaican, Slovak, Jewish, Italian, WASP. Nothing so moves me as their varied hues.

## Courage My Love
*Sarah Dearing*

It was a pig of a day: filthy, sweaty and fat. With high humidex and UV ratings at such an early hour, she felt a primal urge to roll around in cool mud and stay thus covered, protected and temperate. It had rained during the night so the pavement steamed up little knee-high whorls as the sun burned down, but it hadn't cooled the air or cleansed it. The air still stank, a choking, feral, rotting stench as though the hospitals were pouring blood and bloody by-products into the sewers to create an urban slurry pit of human waste.

The vista Nova surveyed on the street could have been from any number of markets she'd visited while on business trips with her husband — Madrid, Buenos Aires, Paris — and it didn't fit into the carefully contrived Fodor concept of Toronto, of Canada, thoroughly studied before her arrival. It was neither clean, world-class metropolis nor pristine and rugged wilderness, though it mightn't have surprised her to see a birchbark canoe rolling down the middle of the street.

Mrs. Philippa Maria Donahue's reality had shifted further as she slept, split itself off to play hide-and-seek behind some other lobe of her brain, so rather than succumbing to disorientation or doubt, which would have been logical reactions, her fantasy of a new life prevailed, caused her to float, content in a half-stupor, into her new neighbourhood. Her mood was vacationy, enhanced to a perfect pitch of otherness by the tropical heat and the feeling that she was working as an extra on a madcap television series. CUT TO: parenthetically shaped Chinese elders stocking rickety stalls with dangerous weights of produce. A catastrophic collapse, a regular primavera sidewalk. Perky young woman chases rolling tubers and presents them, laughing, to a tired-but-smiling immigrant.

Nova glanced at the bushel baskets and cardboard boxes set upon stolen milk crates; looked for novelty among creamy new, red and sweet potatoes, Yukon Golds, dirty old

dull-brown bakers. She saw unknown bok choy and Jerusalem artichokes, identified, to her frustration, by price but not name. The shop on the corner had its fruits and vegetables arranged as if by a food stylist for maximum use of colour. Lutein mangos and nectarines with patches of bright red like blood spots, oddly shaped but beautifully ripened field tomatoes, and a dozen varieties of greens were shaded, garnished themselves for a change, by flimsy umbrellas. Flats of perfect plump strawberries lined the back wall inside, too ripe to take any more sun before becoming freezer jam, and mushrooms the size of Nova's hand evoked the descriptive magic. She missed the stores with the stinky fruit and sugar cane, but did stop to sniff a variety of incense sticks on display.

Many shops tuned their stereos to the same station, so a Barry White song from her youth trailed her a few blocks, put a little funky glide in her stride, added a theme song to the morning.

Nova Philip promenaded in her fugue state along the main streets and consumed the sights and smells for breakfast. She thought of an old John Denver song about filling up senses and wondered how long that could sustain her. Since she couldn't pull more than the one line of chorus from her memory, she abandoned the idea, focused on observation while eating a peach.

Here was a derelict rowboat on a roof, converted to a planter above a fish shop. There, plastic cod heads with fierce looks seemed to poke through an awning to stare at their salted and splayed-out bodies stacked beside them. A couple of calamine mannequins, naked on a peaked dormer, looked alive, like they somehow enjoyed straddling burning shingles. Near the top of Augusta Avenue she went into Freshly Baked Goods for a croissant, but the place sold handknit sweaters, not cakes and cookies. A Million Articles did describe its dusty boxes of buttons and threads, and the Kensington Trading Post proved to be an excellent source of outdated appliances and electronics. Nova would have walked right by the Yes, Yes store had a tape deck not been set out front among the hankies and hosiery. Marching music and a recorded

voice chanting "Only twenty-five cents; nothing over fifty cents" lured her under a weary awning into a little cubbyhole of an establishment. The originator of the voice sat inside, wheelchair bound and bereft of huckster spirit. His merchant ventriloquism, spanning both space and time, caused church giggles to wrack Nova's shoulders, and she quickly left. She was able to laugh out loud in front of Courage My Love, and bought herself an amulet of bravery, a brightly braided bracelet she swore she'd never remove.

Sensory overload made her forget to worry about the steps she had taken, made her forget herself. She had always tried to see with wide eyes, but it was still only what she wanted to see, what had been suggested by the guidebooks, or a particular and personal agenda for being in situ. Confronted at each step with signs announcing Dementia; Exile; Noise, even her room above Asylum failed to shout its significance in an audible pitch. Courage My Love was what she needed most and so Courage My Love was what she saw.

She did recognize there was something unique about Kensington Market, some carefully crafted psychic wall or sensory illusion, fabricated over the past century as a magician's sleight of hand: the audience is kept focused on the surface while the woman in the box rolls out the false side to safety. She'd read in her guidebook that the Jews created the Market in the early years of the twentieth century, shut out of the Anglo business community, even here. They traded with each other from their doorsteps and from pushcarts, and somehow that original tradition still survived.

Kensington Market evolved as a clearing house for all manner of refugees. After the Second World War, the Portuguese settled in along with Ukrainians and Hungarians. The seventies saw Chinatown expand, and then the Vietnamese came. Hippies with persistent resolve followed, driven out of their Yorkville apartments, and were soon joined by musicians, painters, poets, and other free-spirited types seeking camouflage from the eighties world. Jamaicans and Latin Americans arrived

and discovered cheap rents for establishing businesses, built once-crazy dreams of autonomy and self-sufficiency.

What her information failed to tell her, what Nova did not yet see, was that the community allowed to exist inside its ten-block box has no significance to an audience that secretly hopes for a bloody and gruesome mistake with one of the magician's blades.

And so, packs of nouveau-hippie chicks ride the subway in from the suburbs with Mom and Dad's credit card safely zipped in knapsacks, and for them the store names mean the best selection of flares or cords, multicoloured beads, airline flight totes to use as purses, compliments at school on Monday morning for finding a perfect pair of vintage Adidas. They don't bother to venture off Kensington Avenue, so they ignore the food, the privilege of abundance, never stop to think that the food nourished the formation of the Market, the way it does all life. Tradition and history and community are irrelevant to these searchers of fun wear. Their parents see a vast selection of cheeses, bread, and cheaper produce but less convenience than a supermarket, terrible parking, crawling traffic. They see dirt and E. coli, Poor-Peopleville, and wish for just a little more regard for their needs please. Kensington Market provides them with once-a-year entertainment shopping, an outing to the foreign-smelling premises of El Buen Precio, Akram's, Segovia, Sam Li. These may be the authentic stores of variety, putting the others to shame for their pretense, but they are out of place, replaceable.

In the spirit of a picnicky treasure hunt, Nova Philip poked around each of the stores that Saturday morning with the intention of determining their contribution to the quality of the Market. She isolated the exotic items particular to each: banana leaves and country-specific styles of chorizo, spicy beef patties, houses of spice or eggs or nuts, herbal remedies and good-luck air freshener.

*Her* Kensington Market had been ordered in an efficient separation of products, and she labelled the main roads, for simplified reference, as Fish Street, Clothes and Vegetable Avenues.

How much easier life could be if all streets had such utilitarian names; a person would always know precisely what to expect from an address. Bay could become Money; University, more accurately, Hospital; and Yonge might easily be Long Street, since Sleaze could really apply only to a portion.

Three hours later, watching the passing lives from a stool at the corner of Fish and Vegetable, Nova drank two cups of black coffee. Her remaining objectivity was as precarious as a snowflake in the heat. If a landscape forms its people, seeps into their souls to define them, it was not the fault of Mrs. Philippa Maria Donahue that she had been cut off from her senses and was now overwhelmed to the point of irrationality. She had bought into the belief that a successful life was measured by the degree of sterility achieved. The world she methodically sought out effectively shut out the sensory as too frequently offensive. Fighting neighbours, barking dogs, and amplified music were other people's aural problems. The smells of exhaust or close foreign body odours were locked out whenever possible in hermetic vehicles scented with dangling pine trees. Unsightly images could be ignored or turned off with the press of a button. Taste alone was controllable, though tenuously, dependent upon the skill of the chef, and even that sense had mutated to mean something entirely different.

But now she thought she could effectively hide, here among the smells and noises and lives lived, escape the layers of lies that had threatened to suffocate her.

## Henye

*Shirley Faessler*

They set sail for the new world, all four, not a word of English among them. Their language was Yiddish. To their work people and to the peasants in the field, they spoke Russian. Not one had been a greater distance than fifty miles (if that) from Chileshea. They brought food on board ship, not knowing for sure if they would be fed. They docked in Halifax, thinking they were in America.

They entrained for Toronto and were met at the station by a gang of people: *landsmen*, relatives, a junto of compatriots who had emigrated years before. The first few weeks were given over to conviviality. Parties were given for them, dinners, suppers; days and nights were spent in nostalgic reminiscence. Their cousin Haskele (called behind his back Haskele the Shikker) toured the twins with their sons around the city in his car. He showed them Eaton's, Simpsons, the City Hall, Sunnyside, the Parliament Buildings, Casa Loma, the Jewish market on Kensington, and the McCaul Street synagogue.

Finally the business to hand — how to make a living — came up for consideration. The brothers were counselled, warned what to watch out for. Toronto was not Chileshea. Plenty of crooks on the lookout for a pair of greenhorns with money in their pocket. It was decided after a succession of councils and advisements that the best plan would be to start small. The name Chaim the *Schnorrer* (gone to his rest a few months since) came up at one of these sessions. He had started small and was rich as Croesus when he died. His investment? A few dollars for a peddler's licence, a few dollars for a pushcart — and the wealth he accumulated in six years!

"Who knew how rich he was getting, the fish-peddling miser. He lived in a garret and slept on two chairs put together and ate *dreck*. We took pity on him. Only when he was dying in the Western Hospital from dried up guts that it came out how much money he had. He grabbed a hold of every doctor who put a nose even in the public ward, and begged them to

save him. 'Save me,' he told them, 'I've got money I can pay.' He showed them bankbooks. A thousand in this bank, two thousand in another bank. In his shoes alone they found over four hundred dollars."

The brothers obtained a fish-peddling licence each, equipped themselves with carts and taking over Chaim the *Schnorrer's* circuit peddled their fish in the Jewish district, the area bounded by College and Spadina, Dundas and Bathurst Streets, and beyond. And made a good thing of it. In less than three years they were able to provide passage for their families.

Henye arrived with their four sons, their daughter, and their niece Chayele. Yudah, his wife Lippa having died a year after his departure, had only his three daughters to greet.

All this happened years before I was born ...

When Chayele came to us as stepmother I was six years old. We lived in rooms over the synagogue on Bellevue Avenue, and Yankev with his wife Henye and their daughter Malke, who was a dipper at Willard's Chocolates and engaged to be married to a druggist, lived around the corner from us on Augusta Avenue. Their youngest son, Pesach, lived with his wife, Lily, in the upstairs flat of his father's house. Their other four sons were domiciled with their wives and children around and about the city.

Yudah lived with a married daughter a few blocks from his brother's place.

Yankev was a social man. He loved company and almost every night of the week friends and relatives would gather at his house on Augusta Avenue. My stepmother too went there almost every night, and I used to tag along with her. I loved going to Yankev's, what a hullabaloo! No one spoke, everyone shouted, Yankev's voice rising above the hurly-burly. "Henye!" he would call out when the full number was assembled. "Where is she, my beauty?"

# Crow Jane's Blues

*Barry Callaghan*

Crow Jane, who was a singer in the local after-hour clubs, was walking down Spadina Avenue, her hands in her pockets. There were chrome studs on the lapels and cuffs of her jeans jacket. It was nearly midnight but there were five bandy-legged boys playing stickball on the sidewalk in front of the Silver Dollar Show Bar and across the street, in the doorway beside the Crescent Lunch, some immigrant women, probably cleaning-women, were huddled around a homeland newspaper. Their warm laughter touched the loneliness that Crow Jane had felt all week, a loneliness that left her with a listless sense of loss, but she wasn't sure about loss of what, and that was why she was out walking around her old haunts, looking into the show bars from the old days, threading her way through the late night street hustlers who were standing half out in the street between the parked cars, and for a moment she felt good, seeing herself years ago the way she used to slow-walk down the street knowing where everything was, the upstairs bootlegger who kept the beautiful Chinese twin sister hookers who put on a show every midnight, and over on Augusta Street, behind the fruit stalls, there was heavy-jowled Lambchops, the Polish-Jewish giant who hired himself out as muscle to the after-hour clubs. But then, watching a tall white girl in front of a hat shop, the way she primped her hair with pleasure as she caught her reflection in the glass, Crow Jane hunched up and put her head down, suddenly disconsolate. When she looked up the girl was gone.

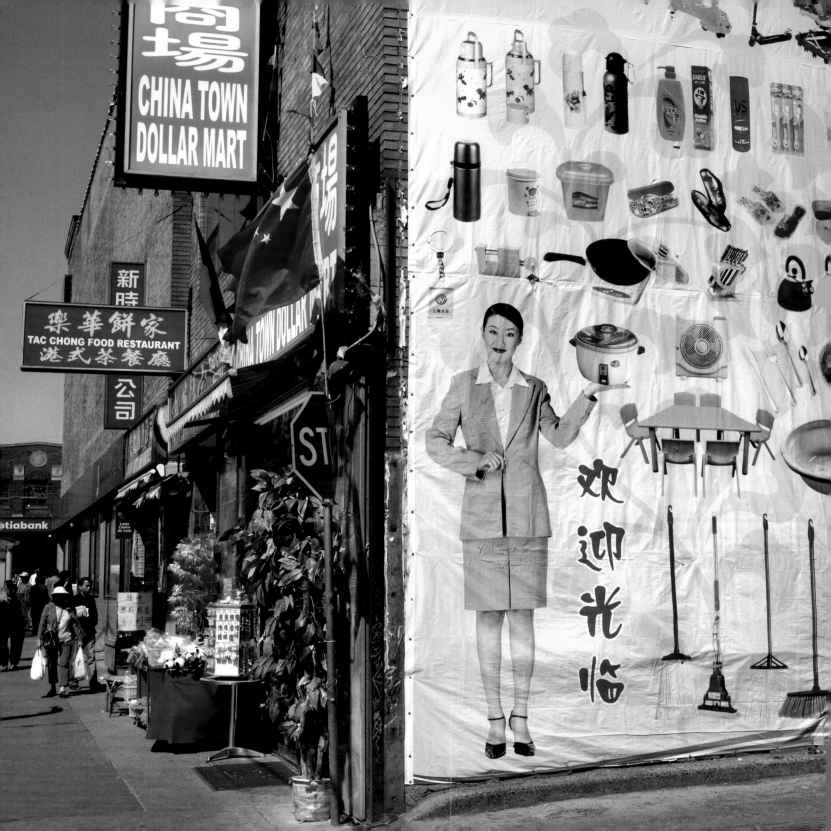

## Mister Canada

*Shyam Selvadurai*

On the bus ride home that day, I
thought about my predicament.
I really knew downtown Toronto
very little. The CN Tower and the
Eaton Centre were about the extent
of my knowledge, and neither place
resembled the Toronto I had
described to Geetha.

In my tales about my life
downtown, I had spoken of two
places that I had heard fellow
students mention — Kensington
Market and Queen Street. I decided
to call the TTC information line and
see if they could assist me. The
young woman I spoke with was very
helpful, particularly when I told her
I was a tourist. She immediately gave
me the location of Kensington
Market and how to get there, but
when I mentioned Queen Street, she

asked, "But, sir, which part did you
have in mind? It is a very long
street."

"The ... the part that has lots of
fashionable cafés and bookshops and
other nice stores," I replied.

"Ah, sir, you mean Queen West."

She then gave me alternate
directions to Kensington Market
that would take me through Queen
West.

The next day, when I arrived at the
hotel, Geetha was waiting for me.
Unlike the drab, old polyester saris
she wore to work, she was dressed in
a crisp white cotton sari with a pink
and gold border. "Oh, Shivan," she
said, when I came into the laundry
room, "I was so excited, I could
barely sleep last night."

She had already set Laura, the
other housekeeper, to do the rooms,
and we went back upstairs to the

lobby. Deepak was behind the
reception counter and, when he saw
us, he began to wring his hands. "Oh,
dearest Geetha," he pleaded, "please
do not go. What if my mother and
brother find out?"

"Why would they, you silly man?"
Geetha replied. "Are you planning to
tell them?" She glared a warning at
him and Deepak cringed.

Geetha patted his arm as if he was
a doddering old man, "Nothing is
going to happen. Shivan is just doing
me a little favour. Bringing a little
pleasure into my life."

She winked at me and I grinned
back. I felt good for the first time
about what we were going to do.

I had carefully memorized the
instructions on where to go. Even so,
once we had boarded the Queen
streetcar going west, I began to feel
anxious as I gazed out at the tall,

dour, concrete buildings all around us. But the streetcar passed University Avenue and we left those buildings behind, and I saw that we were in "Queen West."

Geetha was staring out with unconcealed curiosity and, trying to keep my demeanour casual, I too looked around avidly at the quirky shops we were passing, the second-hand bookstores with their wooden floors and large windows, the whimsical shoe shops, a comic-book store. I was surprised to see something that I had never expected to find here in Canada — pavement stalls. They were lined up on the sidewalk, selling jewellery, gloves, scarves, strange foreign clothes, incense and shawls from India, tie-dye shirts. Two black men with dreadlocks and red, yellow and green tams were playing a drum and a guitar, singing a reggae song. The sidewalks were full of pedestrians, strolling, buying from the stalls, a man and a woman dancing to the music. Here it was, the America of our dreams.

We got off at Spadina Avenue and walked north, then turned onto Kensington Avenue.

We were in the market and stood gazing at the scene before us in wonder. The stores on either side of the road had stalls on the pavement, and so most of the shoppers were in the street, strolling along, ignoring the beeps of trucks and cars trying to get through. I felt as if I was back in Colombo, in the bazaars of Pettah. And moments later, as we walked down the road, I smelt the odours of home — the earthy raw beef and chicken in the butcher shops, the tang of salted fish hanging on hooks outside a Chinese shop, rice in large gunny sacks. The grocery stores had vegetables I had not seen in over a year — thin long brinjals (unlike the fat round Italian ones we made do with from Price Chopper), okra, bitter gourd, snake gourd, yams and — I stopped to stare, a wave of homesickness rising in me — rambutangs and mangosteens.

Geetha too was regarding them with delight. She insisted on buying us a half dozen rambutangs, ridiculously expensive at $3 each, which we sucked on as we continued deeper into the market. Along with the grocery stores, there

were also bakeries, and we paused frequently to gaze at the window displays of pastries we had never seen before. There were also a few tiny cafés, packed with young people who were dressed in outlandish clothing and sported various types of hats from bowlers to tams. Some of them were completely in black, their face covered in white make-up.

Turning a corner, we found ourselves on a street that sold second-hand clothes. So far, I had lacked the courage to go into any of the shops, but these clothing stores had their wares on racks out on the pavement. Geetha and I began to go through them, any reticence we had overcome by the cheapness of the garments. We rifled through the jackets and scarves and shirts. When Geetha saw me trying on a hat in front of a mirror that had been propped outside, she said I looked great in it, like one of the singers in Duran Duran. This was the exact image I had in mind. Geetha insisted on buying the hat for me and I wore it for the rest of our day.

In the market, we discovered a bakery that sold Jamaican patties and we bought ourselves one each and walked along munching them. When Geetha was done, she slipped her hand into the crook of my elbow. "So, this is your first time here too, Shivan."

I turned to her surprised and she laughed. "I saw your jaw dropping open a few too many times." She squeezed my elbow. "What is your life really like, Shivan?"

She asked with such goodwill, such openness, that I found myself telling her about my loneliness and my inability to make friends at school. When I told her how I used to visit the American Centre in Sri Lanka, and how the university prospectuses had made me imagine a splendid campus life here, she threw back her head and let out a peel of laughter. "Oh, Shivan!" She kissed me impulsively on the cheek. "You're such a silly boy." But then she admitted that she too had visited the American Centre in Bombay and been seduced by fashion and lifestyle magazines. Now it was my turn to tease her about whether she had hoped to be a fashion model or a bohemian artist here.

We had been walking in the direction of Queen Street and, when we reached it, we continued towards the pavement stalls we had passed before. Geetha was particularly taken by the silver jewellery at one of them and, in consultation with the Chinese woman who sold them, she tried on a pair of earrings. As I watched her, I felt a warmth of affection towards her. It felt good to have finally confessed my loneliness to someone. Geetha, aware that I was looking at her, smiled at me and moved her head from side to side to solicit my opinion on the earrings. I nodded my approval and she promptly bought them and wore them for the rest of our trip.

On our bus ride back to Richmond Hill, we were silent, staring out at the dreariness all around us — a wasteland that was being prepared for a townhouse complex, construction vehicles with giant teeth gouging muddy earth; an electrical field crisped brown in the summer sun, detritus scattered about it — an over-turned white plastic chair, some abandoned pipes, a gaping Styrofoam box.

Once we got off the bus we made our way along High-Tech Road to the motel. The moment we reached the parking lot, Geetha let out an exclamation and clutched my arm. I followed the direction of her gaze and saw the Lalvanis' van. We looked at each other, then hurried around to the back of the motel and slipped down the stairs to the basement.

Haresh and Deepak were waiting for us in the laundry room. On the table in front of them was Geetha's son, lying in his car seat asleep. With a cry, she rushed to her son and took him in her arms. He awoke and began to cry. She turned to Deepak, "What happened?"

Before he could respond, Haresh let out a bark of a laugh. "What do you care, you unfit mother, gallivanting about while your son was sick.'

"He ... he had a bladder infection so they had to turn around and come back." Deepak gave his brother a cowed glance.

"Has he been to a doctor?" Geetha demanded, rocking her son to calm him down.

Again Haresh laughed. "Don't worry. We love and care for your son, even though you might not." He turned his gaze on me and his lips curled in anger. "I want you to get out of here before I break your arm."

I glanced quickly at Geetha, who nodded. I hurriedly left.

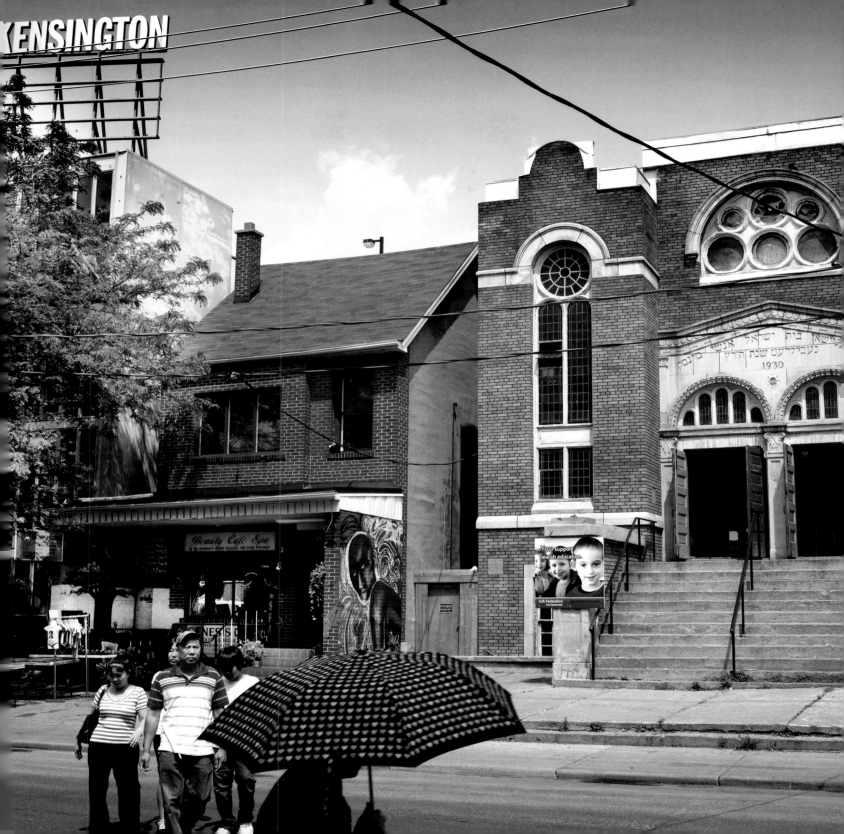

# Midnight at the Dragon Café
*Judy Fong Bates*

Aunt Hai-Lan and Uncle Jong lived on D'Arcy Street in Chinatown, in the centre of Toronto. The first things Aunt Hai-Lan showed my mother were her refrigerator and electric stove. I didn't know anyone else who owned such luxuries, but Aunt Hai-Lan told us that in Canada all the *lo fons* had them in their homes and that most of them even owned cars. When I asked my mother if my father had a car, Uncle Jong laughed and said, "Only *lo fons*. We Chinese are too busy saving every penny we make. Your father would never spend that kind of money on himself. He's the only person who could make a monk look like a spendthrift. But now that you and your mother are here, Su-Jen, maybe things will be different."

While the adults sat in the kitchen and talked late into the night, I went to sleep in the sitting room on the couch that Aunt Hai-Lan folded down and covered with sheets and blankets. It wasn't quite flat, and when my mother came to bed, I kept rolling into her, into the long crease where the back and the seat of the sofa met. She tossed and turned for most of the night. At one point, I woke up and found myself alone on the couch. My mother was standing by the front window, gazing into the street below. I got up and stood beside her. She put her arm around me and together we looked at the strange landscape. The solid row of houses across the road was dark and there was not a person in sight. The street was coated with white. I had never seen snow before. It looked so smooth and even that I wanted to run out and touch it with my hands. I wondered if something was wrong with the trees, all those bony-looking branches without leaves. Everything was so still except for Uncle Jong snoring in the next room on the other side of a heavy cloth curtain.

In the morning my mother put on one of her new dresses. Uncle Tong and Aunt Hai-Lan took us for dim sum at a restaurant down the street. The yards in front of the houses were still white, covered with snow. I bent over and scooped

some up in my hand. It was cold and light. I tossed it in the air, surprised by the way it fell apart and fluttered to the ground.

Although the walk from their house was only a few blocks, my mother and I shivered in our thin wool coats in spite of the extra sweaters we wore underneath. She looked around at the grey sidewalks and the piles of snow. "It's so cold, how can you stand it?" she asked.

"I felt the same way,' said Uncle Jong. "*Ay see gun*, it takes time, but you get used to it."

She pursed her lips. "I suppose you're right," she said, then added, "It's so quiet here. So few people on the street compared to Hong Kong." In Hong Kong my mother had always held my hand in a tight grip whenever we walked down the street. People pressed in so closely that we were both afraid of losing sight of each other and being separated.

"It gets more busy in the centre of Chinatown. But the cities in Canada are never as crowded as the ones back home," said Uncle Jong. "Here, there's plenty of space and room to breathe. Wait until you get to the small town, it's even quieter and not many people or stores. It's more like the village back in China, except much more modern, of course."

"And it's safe here," said Aunt Hai-Lan, "Not like in China, where we worried about bandits in the country and pickpockets in the city. Here, there are no bandits, not even beggars. *Eeii — yah*! Those ones in Hong Kong, with the gouged-out eyes and the bad smell. Makes me queasy just thinking about them."

I thought of the men we used to see, in their filthy, ragged clothing, some with missing limbs, and I was glad to be far away.

"*Mo sow*, you don't need to worry about beggars here, Su-Jen," said Uncle Jong. "There are no beggars in Canada. This is a safe country and a good place to grow up. When I came I was sixteen, too old to go to school, but not too old to learn English. You, though, are especially lucky to arrive so young."

## My Chinatown

*Charles Pachter*

The Chinatown neighbourhood around Dundas and Beverley just west of the AGO and Grange Park has been home to me for over thirty years. I bought an abandoned grocery store and blacksmith shop here in 1978, renovated it into a spacious live-work environment where I resided for twenty-seven years. My painting studio faced the rear of the Toronto Chinese Baptist Church on Beverley.

A faithful mirror of Toronto's multicultural strength, this venerable old neighbourhood has been home to immigrants for over 200 years, from the Boultons of the Grange, and the Willcockses and Baldwins who came from Cork to York in the 1790s to Ukrainian, Jewish, Italian and Polish families, and more recently East Indian and Chinese students in rooming houses or modest apartment buildings converted to condos.

Situated behind my current home and studio is a former warehouse that I named the Moose Factory, my gallery and art storage space. It was originally built as an immigrant funeral home around 1900 in what was then known as The Ward, home to impoverished families from all over, but especially Eastern European Jews. Later it became a taxi depot, and when I purchased it, a Chinese food warehouse.

Through its different incarnations the currently renovated building, now a contemporary show space, residence, and event centre, reflects the changes the neighbourhood has experienced through the ages.

Today the neighbourhood is at the geographic epicentre of Toronto, and although it isn't obvious, it is changing faster than you can swallow a dim sum. It still has a long way to go, thankfully, before it becomes homogeneously sandblasted and gentrified like Yorkville or Cabbagetown. The Victorian semis from the 1880s are a mishmash of garish styles reflecting their owners' ethnicities. But with the spectacular new AGO as the eastern gateway to the neighbourhood, and the bustle and chaos of Spadina Avenue on the west

where grand bland hi-rise condos are sprouting up and down the Avenue amidst the cacophony of sidewalk food stalls, Chinatown is beginning to transmogrify. It's a pulse-quickening glimpse of the city at its most imaginative.

A lumpy white brick office building (designed by Frank Lloyd Wrong?) at the southwest intersection of Dundas & Beverley now boasts an upscale Chinese supermarket on its main floor, called "Lucky Charm Moose Village." It looks out over the porticoed yellow brick Italian consulate, formerly Chudleigh House, the grand nineteenth-century mansion of Sir George Beardmore, one of many stately aristocratic abodes that lined both sides of Beverley Street when it was the western-fringe suburban Post Road of the gentry of the old town of York.

Why do I love Chinatown? Having grown up in quiet mostly WASP north Toronto around Yonge and Lawrence in the fifties, later in nouveau affluent mostly Jewish Bathurst and Eglinton, then living in France as a student,

I came back to witness Toronto's downtown explode with immigrant zeal and diversity. I loved it then and love it now.

Next door to my glass and steel contemporary residence is a shabby house owned by a Chinese poker club where a gaggle of older gents passes the day on the porch playing cards and schmoozing, quite oblivious to the well heeled visitors to my gallery and studio. Their front yard is a mishmash of trash cans, bicycles, assorted bits of junk, and incongruously, flower boxes full of pansies. In 2004, when I showed them the design for my new house, the president looked at the architect's scale model thoughtfully and then with a big smile remarked, "You smart guy VIP Yuppie Renovator, make everybody property more valuable!"

The best part of living here for me is Location Location Location. It's five minutes from the Group of Seven, Tintoretto, the Renaissance, and Henry Moore at the AGO, it's across from the green gem of historic Grange Park, a stone's throw from familiar vendors selling

fresh strawberries at 99 cents a box. Packages of conveniently peeled garlic, exotic sea creatures, loonie bins; Chinese food shops now selling cottage cheese, yogurt, and other Western staples. And then there are those cute hole-in-the-wall neighbourhood cafés where you can get a tangy bowl of hot and sour soup and a plate of steamed chicken with ginger and onion for ten bucks, and then take home barbecued duck, pork and other assorted culinary treats for the last-minute dinner guests. All cheaper and faster than cooking at home.

Diversity, convenience, exotica, colour, unexpected simple treats — an invigorating acupuncture massage for $50 on a cold winter day — in sum, a benign and accepting neighbourhood of industrious, hard-working people who make daily life pleasurable and memorable.

COLLEGE STREET

## College Street, Toronto
*Gianna Patriarca*

I have come back to this street
to begin a new chapter of my inheritance
my Canadian odyssey.

for my father it began in 1956
in the basement of a Euclid Street
rooming house
with five other men
homeless, immigrant dreamers
*bordanti*
young, dark
handsome and strong
bricklayers
carpenters
gamblers.

they cooked their pasta
by the light of a forty watt bulb
drank bad red wine
as they argued the politics of
the country they left behind

avoiding always the new politics.
late in the evenings they
spent their loose change
in the Gatto Nero, the Bar Italia
pool, espresso
cards and cigarettes.

while in all the towns
from Friuli to Sicily
postponed families waited
for the letters, the dollars
the invitation.

then the exodus
of wives and children
trunks and wine glasses
hand stitched linens in hope chests
floating across the Atlantic
slowly
to Halifax
To Union Station
To College Street.

1960
my sister and I
cold and frightened
pushed toward a crowded gate
into the arms
of a strange man
who smelled of tobacco.

Crawford Street
three small rooms
in a three storey house
dark and airless
smelling of boiled fish.
Rose and Louis Yutzman
lived downstairs

Louis died in the middle
of a frozen January night
Rose's screams were nails
driven hard into my eardrums.

my fearless mother
touched his silent face
held his limp, large hand

as she closed his eyes
while my father and I
barefoot and trembling
hid petrified
behind the door

we learned the language quickly
to everyone's surprise
my mother embraced her new life
in long factory lines
while my father continued his pleasures
in pool halls thick with voices
of other men in exile.

1981
the Italians are almost all gone
to new neighbourhoods
modern towns.

my father is gone
Bar Italia has a new clientele
women come here now
I come here
I drink espresso and smoke cigarettes

from the large window
that swims in sunlight
I think I see my father
leaning on the parking meter
passionately arguing
the soccer scores.

How strange this city
sometimes
it seems so much smaller
than all those towns
we came from.

# Where She Has Gone
*Nino Ricci*

There was something wrong in the quality of the day, a strange conjunction of the sultry, springtime warmth, the bitter sun and an uncertain slowness to things. I wandered into the market and instead of the usual Friday bustle the streets were deserted; it was as if the apocalypse had come, as if time had ended after all, and the slowness I'd felt was the world's mechanism winding unnaturally down to a stop. There were packing crates piled at the curbside, green garbage bags, heaps of rotting vegetables and then just the desolation of empty sidewalks and closed shops. Up ahead a door shot open at a café, a hole in the wall where the market's derelicts and dealers collected; for an instant laughter rang out into the street, but then a hand pulled the door closed again before anyone had emerged.

At Bathurst Street, I came on the straggling fringes of a crowd that seemed to be converging on Little Italy. A police cruiser was angled across College, two burly officers in sunglasses and shirtsleeves lazily redirecting traffic. In the cleared street beyond, people were moving in twos and threes toward some kind of gathering further up. Past Manning, barricades had been set out along the curbsides, people lined up behind them apparently awaiting a procession or parade. From a distance came the deep, mournful sound of a brass band, a sound of singing; but the procession itself hadn't appeared yet. I moved into the crowd, seeking a vantage point, open space. But the further in I moved, the more the crowd thickened, until the passageway through it had narrowed down to a single person-wide corridor.

I stopped, finally, near the steps of a church. People were tiered up behind me on the steps, craning to watch as the head of the procession rounded onto College from a side-street. The procession was led by four men on horseback dressed in the armour of Roman soldiers; behind them came a line of men in ragged robes, their hands bound and their waists linked by rope. For an instant I thought I'd stumbled onto

a film set, so incongruous did this vision seem amidst the shops and coffee bars of Little Italy. One of the horses balked at the sight of the crowd as he rounded the corner, whinnied, took a step back; a suited man came in from the sidelines to calm him, and the procession continued.

It was Good Friday, I remembered now; this was a Passion play. I had seen them in Italy as a child, had a sudden vivid recollection of the smell of horses on the air, of the clatter of hooves against cobblestone. In my father's town the procession had ended on a windswept hill above the cemetery — I had an image of a half-naked Jesus actually roped to a cross and raised up there. That couldn't be right, the barbarism of that. But still the image persisted, the grunting heave of men as they lifted the cross into its hole and Jesus splayed and sweating against a background of graves.

The first grouping of prisoners had passed. Behind them came a small brass band and a choir of mainly older women in widow's black, an island of village anachronism within the greater anachronism of the Roman procession; and then children dressed as angels, parish groups, floats, more choirs and bands. The floats formed representations of the Stations of the Cross — the condemnation to death, the meeting with the Virgin, Veronica wipes the sacred face.

Two more prisoners came into view, these bearing crosses, their robes torn to leave exposed patches of shoulder and thigh; and then Jesus. Three soldiers preceded him bearing lances and three trailed him with whips, holding back an entourage of wailing women and children in peasant's kerchiefs and robes. He seemed an unlikely Christ, slightly balding beneath his crown of plaited twigs, his features the plain, grizzled ones of some local factory worker or mason; but an odd intensity radiated from him. His cross was two planks of rough wood crudely bound together with rope; he looked genuinely strained beneath the burden of it, his muscles taut, his face beaded with sweat. Next to me I saw a girl of sixteen or so make a sign of the cross as he approached, and was moved by this depth of belief in someone so young.

Coming to the intersection of Grace Street, Jesus fell. An audible gasp rose up from the crowd. Some of the women following behind had rushed forward to help him, but the soldiers held them back; and as the crowd looked on Jesus struggled slowly upright again beneath his cross. The hem of his robe was dirtied where he'd fallen — there was a stain of asphalt there and then what seemed a stipple of blood at one knee. He continued on several more paces and then fell again, fully this time. Once more the women rushed forward, keening; once more the guards held them back. The crowd craned to see what had happened, pressing up against the barricades, and for an instant then it all seemed real, the keening women, the crush of the crowd, and Christ lying prone on the asphalt among the streetcar tracks of College.

The crowd had pushed in. I felt elbows, limbs, pressing against me, but there seemed no individual they were attached to, only this shapeless mass that stretched unbroken now for several blocks in either direction. People closed in in front of me, cutting off my view of the procession, and then something happened up ahead — perhaps he'd fallen again — and the whole crowd surged forward an instant and then back like a wave, a single entity. A panic took hold of me again, a nausea like a forced submersion under water.

"You okay?"

It was a woman in front of me; I had stumbled against her. I must have blacked out for an instant.

"A little dizzy."

"You need some air." Focused, no-nonsense. "Maybe the church is open. You should sit down."

She led me up through the crowd on the church steps, keeping a distance between us but with one hand in the crook of my arm to guide me. A few heads turned toward us as we passed, then away. I had the sense that we were invisible somehow, that this was a thing that concerned only the two of us.

She tried the church door. It opened.

"I guess they wouldn't lock up a church on Good Friday," she said.

She was in her thirties perhaps, a bit matronly, with short-cropped blond hair, blue eyes, dressed in jeans and a bright purple windbreaker. The windbreaker seemed like a marker, something setting her apart.

"I really appreciate this," I said.

The noise and glare of outside had given way to dim stillness. Dots of colour swam before my eyes in the sudden shift from brightness to dark.

She led me to a back pew.

"Are you feeling any better?"

"Yeah. Thanks."

The church was deserted. She seemed uneasy now at the sudden intimacy we found ourselves in.

"You should just sit for a while."

"I'll be okay."

"You sure?"

"Yes. Thanks again."

I was left alone. The dizziness had passed, leaving only a faint taste of bile in my throat like the metallic aftertaste of fear. There had been something about the crowd, about being caught like that in its collective energy. In Nigeria, once, when I was teaching there, I'd seen a thief chased down by a crowd in one of the markets — they had beaten him until his clothes had been reduced to bloody rags, overtaken by a kind of frenzy, an impersonal rage that was like a contagion the air had bred.

The church was a cavernous place in Gothic style, though overlaid with ill-considered renovations — dull grey carpeting on the floor, acoustic ceiling tiles above the entrance hall and side aisles — as if someone had tried to scale down its largeness to the proportions of a suburban rec room. But up around the chancel, an older dignity remained, the curving back wall ringed with tall, traceried windows made up of little circles of swirling, blue-tinted glass. The light through the glass bathed the altar beneath in an eerie bluish glow. It was the colour I would have imagined that God would take, not the God of my childhood, the smiling old man in the sky, but the one who knew the crooked byways of things, the back alleys and half-open doors, the mix of darkness and light. I had a sudden sharp pang of regret for the loss of that older God, the

simpler one, for my stories of sinners and saints, the hope of some sudden flash that could cleanse things, make them right again. At bottom I had never quite ceased to believe in these things, had only grown distant from them like some subtle turning I'd missed, the point on a path between wandering lost and going home.

Somehow the sun had arched northwards to come to shine directly through the western curve of the chancel's windows, minute by minute the light increasing there to cast a silvered radiance of direct and reflected light all along the deep well of the nave. Then, as I watched, because of some passing cloud or of some particular angle the sun had reached, there was an instant when the church seemed to take all this silvered light back into itself like a breath, then exhale again. The thing happened so quickly that I wasn't sure afterwards if I'd only imagined it.

# The Secret Mitzvah of Lucio Burke

*Steven Hayward*

There were two parts to the training. The first part involved learning how to operate the streetcar controls; the second part involved memorizing the rules and regulations of the Toronto Transportation Commission. Neither was difficult. There was not much to be said about streetcar controls, and there was only a single rule.

"Rule Number One," Cobb told him, "the driver never leaves the streetcar."

"Got it," said Andrew.

"There's no Rule Number Two," said Cobb. "There's no leaving the streetcar, and that's the end of that."

"That's not hard to remember," said Andrew.

"We'll see," said Cobb, ominously.

Having started as a driver himself, Cobb knew from experience that it was not easy to adhere to Rule Number One. For in a streetcar you are neither here nor there, but hurrying through the middle of things. Known and strange things pass, said Cobb, and come at you sideways and catch your heart off guard, and blow it open.

In the eight years Andrew Burke drove the College streetcar, he disobeyed Rule Number One only twice.

The first time was when he met Lucio's mother, Francesca.

At the time Francesca was living on Clinton Street, and on her way back from the Bucci Brothers Bakery on Cecil where she had gone to buy flour because her mother's friend Michelangelo — who was in those days the kind of man who always had something on the boil — had arranged it so that Guido Bucci would sell it to her for fifty cents cheaper than she could buy it anywhere else. The transaction was completed, as usual, in the alley behind the bakery, and Francesca lifted the twenty-pound bag onto her shoulder and walked out onto College Street, where she waited for the streetcar. As she heaved the bag up she noticed that it had a slight tear in it, and that some flour had spilled

out onto her dress. She pinched the tear closed with her free hand, and kept walking.

By the time she boarded the streetcar, the wind had blown a good deal of the flour out of the bag and into her hair. She got on the streetcar at the back, giving the conductor a dime for a nickel fare. Cobb accomplished the operation of giving her change with a swiftness that was nearly robotic, holding out a nickel before she had produced her dime, so that Francesca got nervous and attempted to give him her dime and take his nickel simultaneously. This caused her to lose her grip on the bag of flour, which began falling forward. Francesca chased it, and very nearly had it, when the driver put the streetcar in motion. It lurched forward and then backwards, causing her to fall backwards, and the bag of flour to fall on top of her. The people on the streetcar laughed. Covered with flour, and not knowing what else to do, Francesca picked up the bag and sat down in the seat behind the driver.

The streetcar moved west along College, and at every stop Andrew Burke looked at her in the rear-view mirror, wanting to see at which stop the flour-covered girl would get off. She did not. Not even when the streetcar reached the end of the line and changed direction at Dufferin.

At some point, Francesca began to cry.

"Excuse me, ma'am," said Andrew, turning around. "Which stop?"

"Clinton," she told him.

Her face was covered in flour, white except where her tears had been.

"Don't worry," he said.

At Clinton, Andrew applied the brake and opened the front doors. He picked up the bag of flour and started walking. Francesca followed him, and soon they were walking together down Clinton Street. It took Cobb nearly a minute to realize what was happening, but when he did, he got off the streetcar himself and yelled out that Burke was in direct contravention of Rule Number One.

"Are you going to be fired?" asked Francesca.

"I might," he said.

"You can't do that," she told him.

"Too late," he said.

The two walked down Clinton toward the house and, one by one, all the boarders in all the houses came out and watched as Andrew carried the bag of flour up the front steps of the house. The unmarried Greico brothers were playing *scopa* down the street, but even they put down their cards and looked as he got down on one knee and laid the flour at Francesca's feet, as if he were proposing.

"Thank you," she said.

"I'm Andrew," he told her.

"I'm Francesca," she told him.

"I should get back," he said.

To Andrew's surprise, the streetcar was right where he'd left it.

"You get one chance with Rule Number One," Cobb told him.

The next day, the flour washed out of her hair, Francesca went to the streetcar stop. She brought Andrew a bowl of spaghetti with tomato sauce. These were the last tomatoes of the season, she told him, and she had made the sauce and the pasta herself. Andrew Burke uncovered the bowl, and for a long moment said nothing. He had never seen pasta before.

"This is lovely," he said, picking up a strand with his fingers.

Francesca took a fork out of her pocket.

"This," she told him, winding the pasta around the end of the fork, "is pasta."

Francesca was twenty-four, with big dark eyes, and when Andrew took the fork from her she ran her hand through her dark hair, which she wore loose, down to her shoulders. Andrew watched her, and Francesca saw that she was being watched, and looked straight back at him.

That was the first time he left the streetcar; the second would be the day of Lucio's birth.

## College Streetcar
*Stephen Cain*

First it was there that time when over here hold it near or was it inside or look it's next to that under this moved to everywhere then on top of him nowhere else she was there we saw it here outside then right here then there see this it's here now it's nowhere everyone notices it's so there it will be here find it everywhere it's not gone it's inside here there always.

## City Man
*Howard Akler*

He covers a labour protest at College and Spadina. Almost at the intersection before folks are suddenly shoulder to shoulder. Feet on the march and placards held high. A gathering of the local needle trades, shmatte workers filing from the west and the south toward the grass-and-stone nexus of Queen's Park. Eli gets pushed toward a presser named Nodelman.

We want someone who is with us square!

Uh.

Not these gonifs what all they do is take and take!

Okay, says Eli.

Nodelmari gesticulates with his index finger. His mouth opens but his next words are lost to labour's growing discord. Voices Yiddish and Ukrainian squish together in the sparse wiggle room of protest, a polyglot glut of tongues that needs nearly a whole minute to ease into harmony.

FAIR WAGE!

FAIR WAGE!

FAIR WAGE!

FAIR WHHH-eeeeeeeeeeeeeeeeeeeeeeeeee!

First come the police whistles and then the quartet of cops who jump down the front steps of the station. Others follow. Push and shove, push and shove. Eli gets grabbed by the collar and spun around.

*Star* man, says Eli. Star man!

What're you doing here?

Trying to get a story.

The officer draws his truncheon, knuckles going white at the ridge. Well, he says, get it and go.

Again, Eli files his story fitfully. Then heads home, where he slouches in his armchair with the funnies open in his lap. After a week of newspaper ruckus, he has trouble settling into his own silences. He shifts his weight. Through his tiny apartment window, the setting sun leaves a scar of light across his neck and chest and legs.

## In Various Restaurants
*Daniel Jones*

Outside the Bar Italia, it is no longer snowing. The sun has come out, though only barely. Nicola wants to take my photograph. She has begun a class in photography at the Ontario College of Art.

Nicola stands on the edge of the sidewalk and focuses the lens of her camera. I am standing on the damp sidewalk in front of the Bar Italia in my polished, black Dr. Martens shoes. I am wearing my black leather jacket, dyed black jeans, and my black beret. My hair is tied back in a ponytail. I am thirty-three years old. Nicola's finger presses down on the button and the click echoes against the storefronts along College Street.

I have no photographs of Nicola. She would never give me one.

I watch as Nicola pedals her bicycle away from me and disappears into the traffic.

What I had wanted to say was: What if I wrote in my story that you had an affair *with me*? But I did not say that. It is not what I want. Perhaps I think it is what I want. What I want I do not know. It is possible that what I want has nothing to do with Nicola.

Clint Burnham comes past the next evening, and I take him to the College Street Bar for dinner. Clint has recently separated from his wife, and he has no money. The waiter brings a plate of sautéed black olives to our table. Clint takes an olive in his fingers and rips the flesh from the pit with his teeth. Then he tells me that he is gay. He drops the pit back onto the plate and takes another olive.

I do not know what to say. I am surprised, but hardly shocked. Rather, I am jealous that he knows what it is he wants, and that it is something different.

"I am happy for you," I say. Then we discuss Clint's new manuscript, a collection of poetry that he has recently finished.

Later, Clint and I walk along College Street to the Bar Italia to play pool. But it is crowded and we cross the street to play at the Oriental Recreation Centre instead.

As we pass the Unity, the windows are dark. There is a piece of paper taped to the door. It is a bailiff's notice.

Toronto is like that. I find a place I like to eat and then it closes. Last week the windows of Viva, the new restaurant on Bloor Street, were covered over in newspapers.

There will be new restaurants, other cafés. I will sit in them in the afternoons and evenings, drinking coffee and smoking cigarettes, testing new dishes, learning the names of the waiters. It is all that I know of Toronto. All that I can understand, all that I can grasp onto.

I do not go to movies, or to the theatre. I avoid literary events. I have not been inside a museum since I was a child. I do not travel. I have few friends, and none whom I am close to. The thought of having close friends frightens me.

Nicola and I will continue to meet every few months, always for lunch, in various restaurants. We will not talk on the telephone, except to arrange our meetings. We will never meet in the evenings or on weekends. We will always meet alone. When we part, we will not kiss or touch. I will walk with Nicola to the street. She will unlock her bicycle and ride away. I will walk somewhere else for coffee and to read the newspaper, or to my postal box to collect my mail.

It has been this way for nine years now. I am not sure that I would want it to be any other way. Nicola and I will be friends. We will never be close. It has taken us nine years to come this far.

It has taken me nine years.

Toronto is the only city in the world where people will sit outside on the patios of cafés in late autumn, when it is barely above ten degrees Celsius, or in early spring, when it is just above zero. There is always the slightest glimmer of sun. There are so many things to talk about, so many things to say.

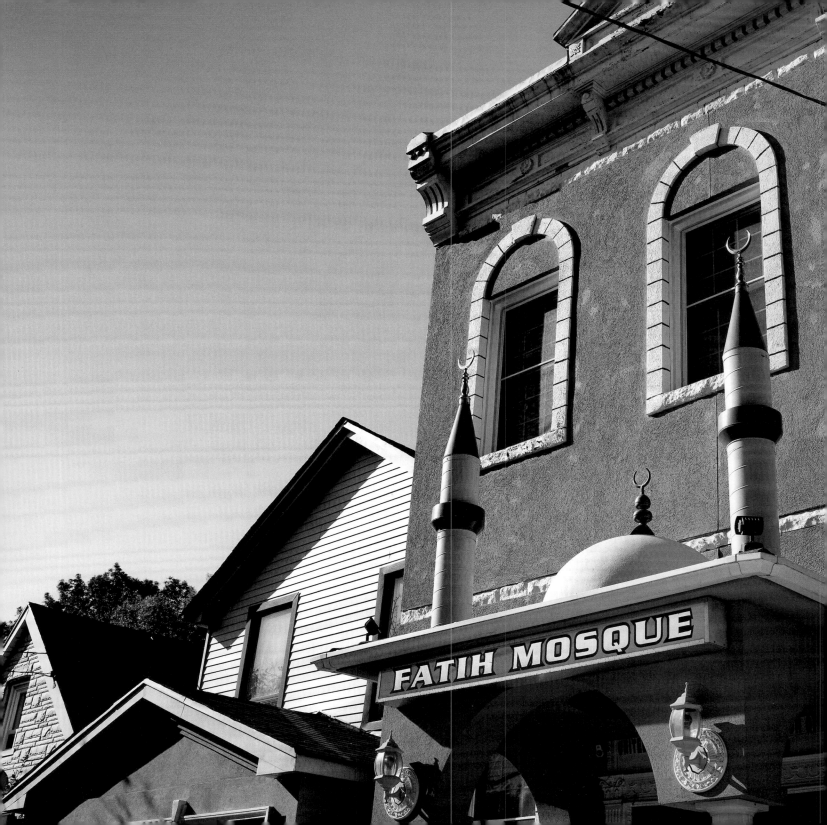

# City of Madness and Love
*Rishma Dunlop*

In the alleyways of the city
                some seek the deliverance of heroin.
Others sit in bars, lives anaesthetized in the smoke fume of scotch,
nicotine-stained fingers on the highball glass.
Someone is always having a hard time of it.

Everywhere, grim forecasts, the heart worn down.

———————

What then of love,
               of putting things badly
               our fallibility?
Do we believe we will do better next time?

Schopenhauer writes of the *dissatisfied*, *egotistical state*,
the world as will and representation.
We are terribly agitated.
              No hope in good works.

What then of love, of desire,
                    of endless appetite, carnal urgency
                    tasting it everywhere
when according to philosophy, life is suffering, death a promised land.

———————

Some days in the city nothing really touches us.
Everything is transparent, black-curtained government cars
cast their shadows along the avenues.

Even in sleep, life is confusion,
petal-strewn sidewalks
ecstatic thoughts, simple phrases, the
mind pushed beyond what it can take.

The worst is the inconsolable.
The insomniac, *soirs vole's*, *nuits blanches*,
                    each night exchanged for something
                    darker than he imagined.
Nights of screaming.
Of this he speaks to no one.
A man stunned at the power of his own rage.

Sometimes you don't want to speak to anyone,
the grip of solitude necessary. You buy an espresso
at the Italian coffee shop, speak abruptly to the
man behind the counter. You walk away afraid, believing
harshness is a sin of magnitude.

On the corner of College and Euclid you see a woman
                                        with a red-stained mouth.
Her hands smell of reproach.
You watch young couples walk hand in hand
                                        limbs entangled.

You want detachment but there are moments when you want
to stop them, tell them *I have been in love once*, *like you*
then you feel some divine expression moving through
the gathering of old Calabrian men on the sidewalk.

You notice gold
sunlit scars on a man's forearm,
children playing in the Clinton schoolyard.
You swear there is something euphonious in
doves crying stupidly in the trees.

## College & Montrose
*Michael Redhill*

Elsewhere, the city fathers
debate where to put the bridges —

and my mother, in a yellow slicker,
walks up College Street, crosses
in the skin-warm air
to the movies.

On her neighbour's lawn
an electron fires and a peach-blossom
opens.

It rains at four o'clock, but my mother,
as a young girl, is inside the cinema

where a woman cries for help
beneath the swinging
silver blade. Then the lights come on.

My grandfather, still quick in his grey suit,
meets her, they walk to the bakery

near Montrose. They cross the buried river
that every living thing
drinks from, that runs
in their bodies — once

there, once on the way home,
my mother waiting while he buys the rye,
the narrow railings inside
scare her, and the fact that her father
holds a number while he waits.

She stands squinting in the May sun, turning
a red wooden ball in her hands.

Then they go home with the bread
hot as a baby in swaddling. After, there are
the moves, the marriage and children, death,
the bakery and cinema gone, no photos.
But the peach tree. The river. This window
that looks out on it.

# Paper Trail

*Andrea Curtis*

The house seemed to appear out of nowhere. It was early spring and I was on my regular bike route northbound not far from the gritty stretch where College and Dundas veer close and then embrace. I was flying down one of downtown Toronto's rare hills, and found the house planted on the corner like it had always been there. Clad in smog-tinted red brick, it had wood trim painted a wistful green, the colour of grass in August, and a solid if slightly derelict presence, like a proud old ship still in service. There was a for sale sign out front and by summer, the house was ours.

Although I threw myself into the move with enthusiasm, when we finally got settled in, I had the haunting sense that we'd made a terrible mistake. The new house just seemed wrong: too big, too noisy, too dusty, too exposed. The cooking smells wafting up the floorboards from the basement tenants we inherited turned my stomach, their canned soup and fried hamburger making everything feel slick with grease. Even the sweet scent of the chocolate factory one street over was cloying, like cheap perfume, and I actually found myself thinking fondly of the antiseptic barnyard smell that wafted from the slaughterhouse near our old place off Queen Street West. I wouldn't have admitted it then, not even to myself, but I began to feel that we'd lost something when we left our old Victorian rowhouse, the place where we'd fallen in love and brought home our first child.

Sensing our ambivalence, perhaps, our neighbours kept their distance. A mixed bag of solitary older immigrant couples, college-age renters and second generation families — mostly Portuguese and Italian, but also Caribbean, Chinese and a smattering of Poles, the extended families all ensconced on the front porch — plus a handful of distracted-looking newcomers, it seemed impossible to infiltrate, like high school with a language barrier and a passion for higgledy-piggledy front yard gardens.

It wasn't long, though, before we attracted the attention of the neighbourhood curmudgeon. A recently retired Portuguese contractor with a penchant for power tools — leaf blowers, lawn mowers, electric mulchers, hedge trimmers — he came by to lean on the fence and tell us everything we were doing wrong. He considered our push mower a personal insult and the fact that I was doing the mowing while my

husband played with our son not just baffling but a clear indication of the sorry state of my husband's manhood. He grumbled when we refused his offer of a fume-spewing old gas-mower and forced his hedge trimmer into our reluctant hands like an Italian nona with cannoli. But I thought he was going to wash his hands of us entirely when we mentioned we were planning a wooden replacement for the sloping porch that hung off the front of the house as if waiting to dump us back on the street.

Yes, the porch is terrible, he agreed (his look implying that it wasn't the only part of the house that needed some work). But wood? He threw up his hands at our complete and utter stupidity. Painting and repainting! Warping! Concrete and metal are the only sensible solutions, he said. For weeks, he hectored us relentlessly, suggesting ominously that it was impossible to predict what we were in for — plagues of termites? divorce? — if we chose wood.

We did it anyway (our neighbour punished the poor carpenter who agreed to do the construction by standing at the fence and sighing loudly at regular intervals). Rotten and ancient, the old verandah disintegrated at the first touch of the crowbar. When the dust cleared, there was a knock at the door. It was the carpenter, his hands outstretched. He'd found a treasure trove beneath the door stop.

The stash was blackened and covered in spider webs and insect eggs. A shard of blue and white china, a calling card, a fifty-year-old bill for a new refrigerator, a Guinea Gold cigarette tin. A letter sent from Cobalt, Ontario, in February 1925 was still in its envelope. "Dearest girl," it began. Reading something that the intended recipient hadn't even seen felt illicit, but thrilling, like eavesdropping on your parents' conversation when you're a child. The writer described the social whirl in the remote Northern town, how pleased she was with her teaching job, saving money, meeting new people, but it read as if she was trying to convince herself as much as anyone else. Nearly eighty years later, her longing for Toronto and her home was palpable in each word of her slanting cursive.

I read and reread that letter, as if it was some sort of divining rod, and found to my surprise that it changed everything for me. The realization that our house was also full of the presence of others — lectures attended, bills paid, passions shared — solidified our own place there, made me feel as if we, too, could stake our claim. I even grew fond of the chocolate factory, imagining that I could tell the kind of bar being made by the taste of the wind.

It took a little longer for our neighbours to come around. It wasn't until the birth of our second child the following spring that we were accepted as bona fide residents. He, in fact, has become something of a local fixture. He likes to perch himself on that wooden porch greeting everyone who passes: *Hello lady! Hello old man!* he calls out, as if he's always been there. He shares a particularly close bond with the curmudgeon — who still hates the porch, but has a soft spot for the boy.

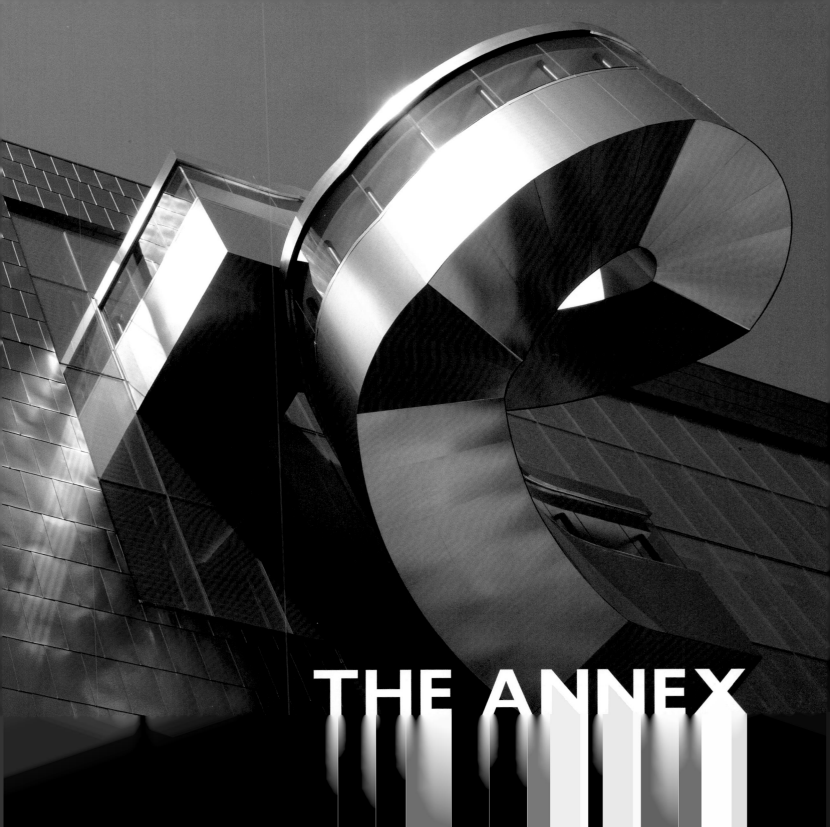

THE ANNEX

# No New Land

*M.G. Vassanji*

What would immigrants in Toronto do without Honest Ed's, the block-wide carnival that's also a store, the brilliant kaaba to which people flock even from the suburbs. A centre of attraction whose energy never ebbs, simply transmutes, at night its thousands of dazzling lights splash the sidewalk in flashes of yellow and green and red, and the air sizzles with catchy fluorescent messages circled by running lights. The dazzle and sparkle that's seen as far away as Asia and Africa in the bosoms of bourgeois homes where they dream of foreign goods and emigration. The Lalanis and other Dar immigrants would go there on Saturdays, entire families getting off at the Bathurst station to join the droves crossing Bloor Street West on their way to that shopping paradise.

The festival already begins on the sidewalk outside: vendors of candy, nuts, and popcorn; shop windows bright and packed; shoppers emerging, hugging new possessions; and bright signs with all the familiarity of hookers clamouring for attention. "Come in, don't just stand there!" shouts a sign wickedly. "Come in and get lost!" winks another. And in you go, dissolve into the human tide flooding the aisles and annexes. You enter a crowded bright tunnel of a passageway lined with record jackets and throbbing to a loud, fast rhythm, the tide draws you in, the music lulls your mind, sets you in the mood, deeper and deeper you go into the tunnel, which opens onto a large cavern busy with the frenzy of buying. After a lifetime of waiting, it is easy to get drawn in blindly, forgetting what you came for, lured from every side by cheeky price labels and imagining new needs for the home. Buying is a narcotic, so you have to be quick and know your business, pick out the genuine sales from the spurious, think of your budget and your needs. Many times you'll catch yourself in temptation: A bargain, but do I need it? No, you steel yourself, you put it back. Several times at this and you're one of the pros, walking easily up and down the aisles, into and out of the annexes, from the basement to the top

floor and back ... in this place so joyous and crazy where people give free unasked advice, and just as freely demand it.

The first few times they would stand in wonder before the racks, piles, and overflowing boxes and crates, fingering perfectly good clothes for sale for peanuts, as it were: shirts for $1.99, dresses for $1.99, men's suits for $14.99! Compare with the headaches you could buy in Dar with such difficulty: size sixteen shirts with size fourteen sleeves, pockets sewn shut, flies too short, shoes not matching, zips not closing. Even after converting dollars into shillings, at black-market rates, you couldn't beat these prices. Cheap, cheap, cheap, as the sign said. No more haggling over prices; you just had to know where to go. And this was it. They began to buy. Business runs in the blood, they are former shopkeepers after all, and the thrill of chasing a bargain is irresistible, a pleasure which sharing can only enhance. News of special bargains, the not-to-be-missed sales. passed by human telegraph from aisle to aisle — Bai, the women's underwear is on special, way over there behind the coats, you won't get such sizes anywhere at any cost, so-and-so has dropped one on the floor for you, just in case. Beats sewing your own.

Where else could you stock up your kitchen, buy your winter wardrobe, add the luxury of a few ready-made clothes, while looking for a job?

From Ed's to Knob Hill Farms for groceries, by subway and bus, clutching coupons, purses, bags, and kids, running up and down aisles gritty with spilled grain and discarded peanut shells, hunting down specials, past boys and girls tasting and filling up with as much as they could. For limited quantities whole families appeared, toddler to grandma, emerging each with a can of oil, a bag of sugar, whatever.

And later still, if there was a job in the family, and money flowed a little more easily, a stop at Consumers Distributing: a TV stand, a toaster, an iron.

## Rewriting Brunswick

*Katherine Govier*

Once, Brunswick Avenue was my world. I lived there for seven years, at three different addresses, in the 1970s. Coming from Edmonton as grad students in English at York University, my then-husband and I sublet a professor's house in Don Mills. But soon we got smart and moved into a 3rd-floor apartment at 398 Brunswick. I published a book review in *Books in Canada* and the editor, Val Cleary, told me that famous writers lived on my street: Marian and Howard Engel, Sylvia Fraser, Dennis Lee. But for literary chat I settled for James, the guy downstairs, a would-be playwright who feared that learning grammar would spoil his style.

I leaned against the third floor window and watched for the postman. In the days before email, postmen were key. They brought the news of whether you got the grant, or had a story accepted by *Grain* magazine. If I looked out the back I could see, next door, Myrtle the landlady's backyard rabbits, destined for dinner.

Myrtle owned all the houses around. She became a character in one of my stories. She also appeared in deep disguise in one of Judith Thompson's plays. Judith lived upstairs in Myrtle's house.

A few years later, husbandless, I crossed the street to the third floor of 409, which had a rounded window like a porthole. Next door, at 411, was Karen Mulhallen, diva of *Descant* magazine, who entertained while sitting wrapped in bubbles in her claw-foot tub. When Karen moved on I inherited her second-floor apartment, with its bathtub, and its two sun porches and a fireplace. There I wrote the stories that became *Fables of Brunswick Avenue*.

But before my time Brunswick already had cred as the street of writers. Morley Callaghan had lived there in the thirties and decades before that, Ernest Jones, biographer of Freud. In my time, the seventies, our neighbours were photographers and filmmakers. Leigh Field was a medical student who made macramé hangings from my dog's hair. My upstairs neighbours were Paul Kennedy, later to become host of

CBC's *Ideas*, and his wife, writer Patricia Bradbury.

We barbecued and sang folk songs in a gravel square behind the house. We drank beer at the Mug and spent long nights in the smoke-filled Blue Cellar. We shopped at the Elizabeth Delicatessen & Meat Market or had wiener schnitzel at Hungarian restaurants like the Tarogato. We sometimes went over to Markham Street where you could actually sit at a table on the sidewalk. We read the first chapters of new books at Book City while standing at the display tables.

Joy Kogawa came to visit me for a weekend and stayed for a month, starting to write *Obasan*. Myrna Kostash also bunked in. In her women's column for *Maclean's*, she caused a huge furor by saying she didn't want to have kids and get "a vagina as wide as a barn door." When Myrna left, Matt Cohen moved in. Rick Salutin lived one street over. Ian Adams — *S, Portrait of a Spy* — was at the corner of Lowther, in a great apartment he later rented to Elizabeth Smart.

But I keep coming back to the image of myself hanging out the window, or sitting on the porch. It was the seventies: for entertainment we didn't watch television, we watched the street. Everyone walked by, heading down to Bloor, with their guitar cases, their film equipment, their backpacks. Straight kids with short hair from the Church Army read the Bible in front of their huge house two doors down, and asked for money. Converts to the Maharishi Ji jangled by, shaking tambourines, talking reincarnation. The odd belated draft dodger slept on my beanbag chairs. Ray, a fellow grad-school dropout, came by to say farewell. He was driving to New Brunswick to build a geodesic dome. Even the men were feminists, if they knew what was good for them. It was the time of Canadian nationalism. There was a culture being defined here; there was a "we." No matter how we expressed it, we were working on the same project; we were coming alive in this place.

A revisit tells me that Brunswick, like most streets of memory, runs one way now: I

remember it, but it does not remember me.

The street is still as patchy as ever. One or two absentee landlords have let their properties lapse. Number 407 has a front yard filled with empty bottles and a window decal declaring "Everyone is a Suspect." It's a rooming house. As I stand outside gazing, Frank the roomer appears. He has lived there for longer than he can remember; he tells me each of the twenty-two rooms is "smaller than a decent jail cell in Budapest."

But renovation goes smartly, surgically forward. The new residents are young families: lawyers, bankers and professors, with the odd media type. They orient themselves northward, spawning a series of upscale shops on Dupont. They have a civilized depository of kids' toys in Sibelius Park, and hold public classical-music concerts under the stars.

No one walks down the street now. In fact you can't even drive it; a traffic-redirection plan makes you turn around in circles. The Elizabeth Meat Market is gone. The adjacent merchant tells me about it: the owner just locked the door one evening and didn't come back. "She even left the sausages hanging from the ceiling."

But Loretto Abbey, the massive old Catholic girls' school, is still standing, minus the Sisters of the Blessed Virgin Mary and the girls in uniform. The building now houses thirty-eight condo units, with thirteen luxury townhouses behind it. I wander into the sales office. I take a close look at the choice of finishes and discover you can order bathroom tiles in the retro "basket-weave mosaic." They look familiar. I realize that they are exactly like the ones in the bathroom at 411, home of the famous claw foot tub. The condos are all sold, to locals who, the saleswoman says, are tired of the big old houses but want to stay in the 'hood. Trust Brunswick to have an archival version of itself, where ageing former residents will have a doorman, parking, new tiles — and Frank, over the fence.

But the magic: Is it still here? The place even now has the air of an encampment. It's restless, ramshackle and grand, with an air of possibility, sublime to ridiculous with lots in between.

"Everyone lives on Brunswick Avenue sooner or later" may be the truest line I ever wrote. Former dwellers on the street crop up everywhere I go from Tokyo to Taber. It is the opposite of the Bermuda triangle. Everyone appears here, rather than disappears.

It survives, too, as the street of writers; Susan Swan, and Leon Rooke live south of Bloor. And the news is that every single person seated at Future Bakery, on the southwest corner of Bloor and Brunswick, is writing. Scribbling, then gazing off, then going at it again; no doubt a literary work is under construction. It's too expensive for these guys to live here. They live at home with their parents and come to hang out.

## Elizabeth Smart: A Presence in the Annex

*Rosemary Sullivan*

A city is only real once it is haunted. For a long time nobody was keeping a map of sightings in Toronto, but now, there's hardly a place that isn't resonant with the echo of lost voices. My favourite place to go looking for loved echoes is the Annex. There are many writers who lived and worked here — I think of Gwendolyn MacEwen, bpNichol and Matt Cohen — but when I'm in the Annex it's the ghost of Elizabeth Smart whom I encounter most often.

I first met Elizabeth in 1979, when I had taken up residence in London. I was following the imperative of moving to a foreign place to turn myself into a writer. Over that year, we became friends. When she wrote in 1983 to tell me she had accepted the post of Writer-in-Residence at the University of Toronto, I immediately said I'd find her a place to live. I soon discovered that Ian Adams was vacating his apartment at 192 Lowther. Ian was notorious for his novel

*S, Portrait of a Spy*. When an ex-RCMP officer launched a defamation lawsuit against Ian, claiming he was the original for S, the entire literary community rallied to his defence. The apartment would have the right vibes for Elizabeth, I thought. She loved to tell about her own dealings with the FBI. As she and her lover, the poet George Barker, were driving to New York in 1940, they were stopped at the Arizona border. He was a British citizen of draft age. What was he doing meandering across America while his country was at war? Claiming to be a poet could be an ingenious cover for a Communist or a Fifth Columnist. The two were initially held under the Mann Act, an archaic law designed to apprehend gangsters. If an unmarried couple were caught in a motor car crossing a state border and the woman was under the age of twenty-eight, they could be arrested. As Elizabeth delighted in putting it: "You could fornicate in any state legally, but not cross a state line for the purpose." George was soon released. His papers were in order and his fortuitous habit of using fictitious names in

hotels meant that fornication couldn't be proved. But it was discovered that Elizabeth's passport had not been properly stamped for entry into the US and she was held in jail for three days. While she made light of it afterwards, the ordeal was harrowing. However, she got her revenge. In *By Grand Central Station I Sat Down and Wept*, she reproduced her interrogation by phrasing her responses to the FBI agents in terms of the *Song of Songs*, a litany of love to confront unscrupulous authority. When I came to write Elizabeth's biography a decade later, I discovered the FBI still had a three-page file on her which they refused to release to me in the "interests of national security." I was sure she and Ian would get on well.

When Elizabeth came to Toronto in August of '83, she brought a trunk of books and clothes. Ian's place wasn't ready so she stayed with me for two weeks in my apartment on Bernard Avenue. As a parting gift, she opened her suitcase and pulled out a green silk designer dress. It had a lovely blouse braided with gold and decorated with cut glass beads and a long skirt shaped to imitate harem pants. She looked at it ruefully and said: "I guess I won't be needing this anymore" and insisted I take it. I remember thinking admiringly that Elizabeth, aged seventy, had carted this beautiful dress all the way from England as part of her essential wardrobe. I eventually donated the dress to a silent auction to raise funds for a Timothy Findley scholarship. Ah, the distance Elizabeth's clothes could travel.

Ian's apartment was a third floor walk-up in a crumbling Victorian house. The musician Milton Barnes lived downstairs. Elizabeth had always been nomadic and so refurbishing an apartment was nothing new. She hired a painter and a carpenter to build bookshelves. To find furniture, she visited the Nearly New and the local yard sales. Yard sales were a completely new thing for Elizabeth and she loved them. Even now, when I see a yard sale in the Annex I think of her. All it took for Elizabeth to make a home were flowers, rugs, and a few pieces of cloth for throws. Standing on her small balcony, she was enfolded by a huge Sumach tree. "The Tree of Heaven" she called it.

At Elizabeth's I remember the endless parties. An evening would begin with a superb meal: a leg of lamb or *sole bonne femme*. (Elizabeth was a great cook and had even published a cookbook called *Cooking the French Way*.) Once her brother Russell arrived from Ottawa. He was devoted to Elizabeth and that night we sang songs as Russell played the ukulele which he'd brought along to entertain her. And Norman Levine showed up to reminisce about his days in England. Once it was Aviva Layton and her husband Leon Whiteson and a young writer Kitty Hoffman. They sang old Jewish labour songs. Elizabeth knew them all. The actress Nancy Beatty often visited. She had decided to dramatize Elizabeth's masterpiece: *By Grand Central Station I Sat Down and Wept*. Nancy told me: "I remember thinking Elizabeth was this beautiful, vulnerable flower. You had to give it room, to water and feed it. She was so shy."

I remember Elizabeth's reading at Passe Muraille. Michael Ondaatje introduced her by quoting Leonard Cohen. As a writer, he said, she was "riding the chaos like an escaped ski."

Dressed in her black velvet jacket and black pants, a flower in her lapel and her little black Chinese slippers held by elastic bands over white socks, she stepped shyly to the microphone to read her poem "The Muse: His and Hers." With that face, Audenesque, lined and lived-in, she was a Presence. In so many ways she was outrageously courageous, but she was equally haunted by her demons. There were black days at Lowther when she drank too much. She was still mourning her daughter Rose who had died in March 1982 at the age of thirty-five. Elizabeth recorded her grief in her diary: "The fragile vulnerability because of the Rose blow ... Pain crouches everywhere, in ambush, as I totter, unprotected, by. Which makes any plan to stand wobbly. Which makes lying down in sobriety dangerous."

When no one phoned and Elizabeth felt caged and lonely (she did not often call others because she didn't want to impose), she would walk down to the "Donut Shop" at the corner of Bloor and Walmer Road to sit into the small hours of the morning. It's gone now and I only

have a vague memory of motley booths and tables lined up against the windows and a Formica counter that ran against the wall. Elizabeth was used to her sojourns in London's Soho where she could commune with old friends — the rogues and rascals, she called them — where they would drink and gossip, attack each other mercilessly with witticisms and tell scurrilous stories about each other. In Toronto, she felt judged for her drinking. She wrote to her son Christopher: "The way they drink and don't drink, seems particularly confusing. The word alcohol is never mentioned unaccompanied by the word problem." At the Donut Shop they called her Betty. Among those who were out of work, homeless, or alone, Elizabeth found refuge. She would sit with the unnamed strangers and listen to their stories and jokes. And she never judged. After Elizabeth left for England, her friend, the young writer

Alice Van Wart moved into the Lowther apartment. One night Alice received a phone call. The call began with a litany of sexual expletives. When she asked whom the caller wanted, he replied "Betty." When she explained that Elizabeth had moved back to England, the caller cried out: "But she can't have. I paid her." It is a measure of Elizabeth's generosity and outrageousness that, without being judgemental, she would have helped out a lost soul by listening, while allowing him the dignity of paying.

My last Toronto memory of Elizabeth was walking with her along Bloor Street, past Dooney's and Book City. What were we talking about? I scarcely remember. Writers? George Barker? But I do remember how she turned to me and said, with a fierceness and sense of deep satisfaction: "I had my vision."

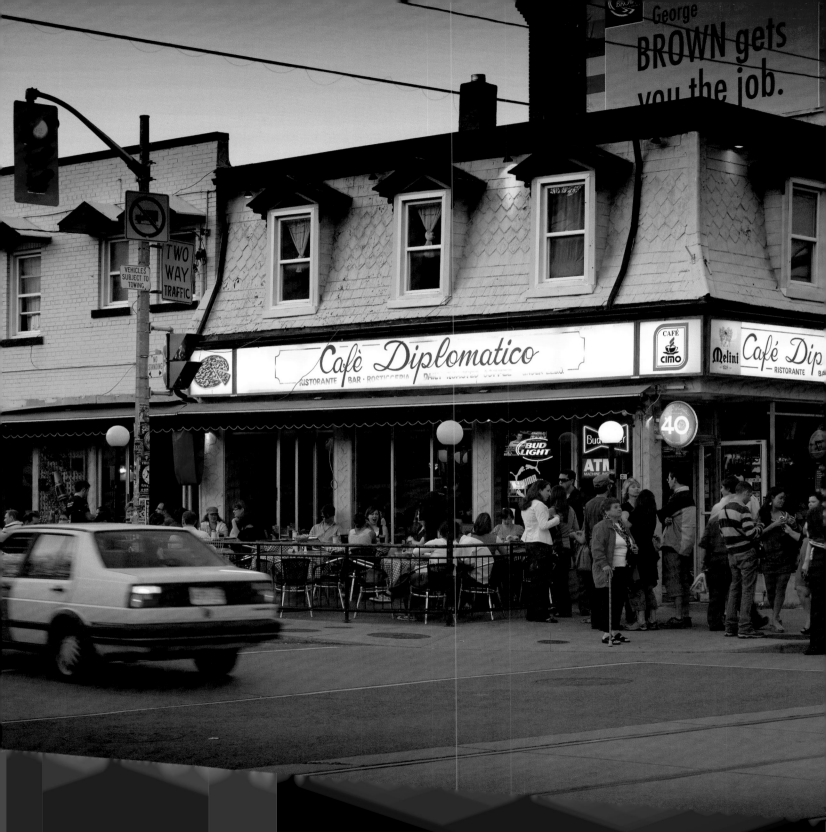

## Chain 3
*bpNichol*

frag/
   /ments re
 /turn

/complete
the sense

read the lines straight down
'ken'd al[l
cross sea'

                the glyph
(outline of a y or
 sceptre that some sea god might be holding)
 symbol of what power
 rises out of bluer strait
 inseparable from the sea that holds its shape

(geomancy of the streets

one-way patterns that insist automobility

foot's ascendant now

                      reading's

slowed

        (desired's mobility of text

flex in the flux of what's actual)

translations of literal ambiguities)

below the curve of Kendal Walmer wavers

forms the sea a reading can reveal

an act u all are privy to

('a' 11 times      raised to that power

   aaaaaaaaaaa

              interpreted different ways

              1) a sigh (as in lovemaking)

              2) a sigh (as of relief)

              3) a scream (as in the murder scene

                  — long &

                        lingering)

takes us where?

this multiplication
attention to a visual duration
comic stripping of the bared phrase
the pain inside the language speaks
ekes out meaning phase by phase
make my way thru the maze of streets & messages
reading as i go
creating narratives by attention to a flow of signs)

each street branches in the mind
puns break
                words fall apart
a shell
sure as hell's
ash ell
when i let the letters shift sur face
is just a place on which im ages drift

life's a sign
beneath which signifieds slide
away from Wal Mer
Doll Town's just a step along
wade Bluer Strait

southern climes & reaches
rimes that don't make 'sense' cohere
'false' sound versus 'pure' logic
caught voicing the contradictions
hesitations
proofs of moments things aren't clear
poetry's reverse or
re-assessment of the role
rejections of pose
                              i don't know

'too much is said from ignorance'      'SHUT UP!'

creates a movement's air
air's movement's claire            a T
mer
          L E
'the' versus 'a'
specificities of place
                              of mood

Brun's wick's an isthmus
so named

conjuring an image of Brun
teutonic shock of brown hair
falls
his massive cock hangs off the bridge
pisses gainst the wal to fill le mer
casually
       hand resting on Casa Loma
pissing languidly

like the man i saw in Heathrow Airport London
spring of 75
           unzip his fly &
pee
  light his pipe with both hands
at the same time &
gaze around the washroom casually
giving a separate intelligence to the thing
'a mind of its own'
           like the dinosaurs
carried an extra brain in their tails
as if the body were
too great a distance for thot to travel

Brun's wick ken'd all there was to know
an eye stared out the head of his prick
& that stream of yellow was the knowledge flowed
down into Bluer Strait
mind freed for other things

i read here how Brun's wick went to College
like St George
                          graduating possibly the same year
but the brain his skull contained
moved in the upper reaches
far from this plane of gross physical realities
he was the embodiment of the many ways
containing as he did levels of consciousness
yet its his dick we revere
remember in a name
caught up as we were in more primitive aims
back there in our many beginnings

St Orm was born
out of the coupling of Brun & Dina Madi
twisting in her passion
outline you can still trace

Lake Ontario north to Forest Hill
writhing in the midst of Wal Mer
we're heading back there
underground
                    into that womb St Orm came down from
down to earth

Brun: 'sky goddess
      it was good to know you'
                              (grins)
      stretches out beside her
underneath the bridge i cross
to work
            analyzing dreams
un rêve du pont
                  'i'll sleep on't'

living this last week with James T
lies down three times a day to dream
waits for the vision to come
unbidden from the unfettered mind
seeks to lose control of what he can
so what controls can rise

out of that regioned memory we know third hand
reflected back in waking
structures of the everyday
constraints & chains we do not question
till they choke us
                              bind us in
& we are screaming for our freedom
as only unfree men & women can

to treat with respect what sleep brings
the pure moment's seeing
& the seer's role
                              to read aright the brain's light
freed from constraints of consciousness
residues arise
                              what cannot be absorbed
we needs must deal with in our daily lives

sitting down today
map of Toronto spread before me
Warren Road ends at Kilbarry
did i read there a warning of my death
a sign

              realized i could read it either way
walk out the front door
turn then left or right
north to where Kilbarry takes my life
south to clear Clarendon 'n down
town tow
to Lake Ontario
or go straight ahead
thru Lyn Wood
over Poplar Plains to the Avenue
& up then to talk to      St Clair

living as i do there is that choice of confidants

St George lives under the bridge
like some billy goat gruff or common troll
waist deep in the Bluer Strait
he waits for you
feigning sleep

(when tiredness sets in
the urge to write disappears
i dsappears

ds appears
dsultory
dspairing
(dis for des?
dese for dose?
'i'll trade you two verbs for a noun'
dstnct but unntellgble))

fragments

                    bursts of song or thot

'more like static on a radio'

my life
& then these fits of sound

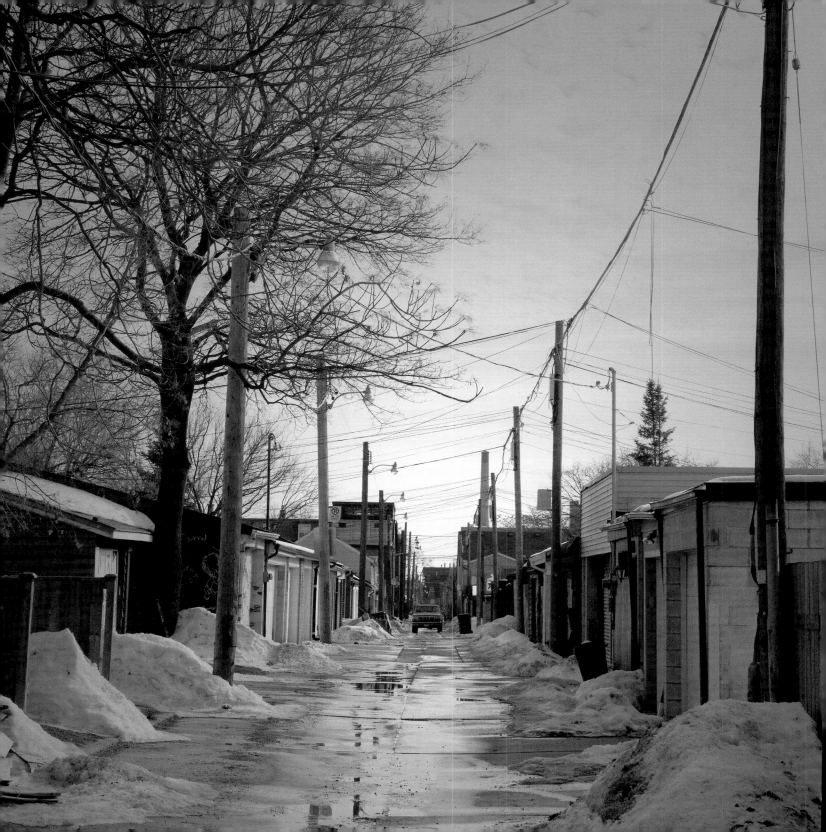

## Bathurst

*Dionne Brand*

Bathurst Subway. I say it like home. It's an uneasy saying, as uneasy as the blue-grey walls, rattling trains, late-laden buses and shrieking streetcars. But when I first came to this country, this city, at seventeen, it was a sign of home.

Funny how home is the first place you look for even if you are running from it, you are nevertheless always running toward it, not the same spot but a spot you're sure that you'll know. Maybe home is an uneasy place so Bathurst felt like it, not the trains or the grey walls but the people who passed through it that year, the feeling of common purpose, the intensity of new Black pride, the possibilities for justice and the joy in these. It was 1970, the Civil Rights Movement, Black Power, Black Consciousness. Martin Luther King's passivity had been repudiated; joining the system, assimilation, was out; armed struggle was a much debated possibility. The computer takeover at Sir George Williams University had awakened the Black Power movement in Canada. The new generation here, a mix of those from old families and new immigrant ones, did not respond to the subtleties of Canadian racism with the same patience and reticence as their elders had.

Bathurst Street was the centre of the Black community in Toronto. As soon as you got here, if you were an immigrant, you made the pilgrimage to Bathurst Street. Wherever they took you after the airport, whether it was an apartment on Westlodge or Palmerston or Dupont or in St. James Town, the next morning they took you to Bathurst Street. It must have been this kind of place for the Black people before the Caribbean Blacks came, too. Around Bathurst was where most of the community ended up, pushed by jobs and prejudice to where they could rent a place. I heard that only the Jewish people would rent to Blacks here in the forties and fifties, that they themselves had been pushed by jobs and prejudice to Spadina. And in the sixties, a Canadian economy hungry for cheap labour brought flocks of Black labour to Bathurst Street and its surroundings.

They first took you to Bathurst and Bloor to locate you, your place, the point from which you would meet this country. And your relationship to it was clear since this was the only oasis of Blacks in the miles and miles to be learned of in the white desert that was the city. They took you here for you to get a sense of your new identity, the

re-definitions you knew were coming but could never have anticipated though you had some sense when you gave yourself up to the journey that you'd emptied a place for them. Bathurst was the site of new definitions. To a woman thirty years earlier, this is where she walked out of her maid's dress and into the hairdresser's and her day-off best dress to the Thursday night dance, the streetcar to the Palais Royale to jump the jive to Count Basie, the United Negro Improvement Association socials and raffles. This is where young women like me thirty years later walked out of the conservative, keep-quiet, talk-right, act-like-a-lady-even-though-nobody-considers-you-one, get-a-nice-job, find-a-husband, know-your-place, you-can-only-hope-for-so-much-as-a-Black-woman, pull-in-your-lips, corset-your-hips, smile, take-what-you-get dream that society laid out for us and our mothers urged on us, and walked into our naturals — no make-up, no bra, no corset, no European idea of beauty — walked into the Afroed and African no-bullshit-rhetoric beauty of ourselves.

In 1970 Bathurst Subway was filled with dashikis, African wraps, gold big-hooped earrings, Panther blue shirts, black leather jackets, Black Power fists raised in greeting and the murmur of sister this, brother that, the *salam aleikum* of the Nation of Islam. We memorized Malcolm X's autobiography, heeding his hard lesson, and Fanon's *Wretched of the Earth* we quoted with biblical humility. We were lucky that year to have the Movement, and even if the white community around us pretended bewilderment and thought as they still do that it was all something from south of the border, we were living it, the Movement I mean, and Bathurst Subway was the passageway, the nexus from which we all radiated, the portals through which we all passed, passing from Negroes into Blacks, from passive into revolutionary. The stakes were high for us. We were never going to be able to cut our hair and join brokerage firms twenty years later, we would never be able to shake our heads and pass it all off as youth, we didn't go to Woodstock, we couldn't stand John Lennon and the Beatles,

we couldn't care less if Elvis lived or died, he was just another culture-vulture to us, and though we loved Jimi Hendrix we felt him a lost brother. Our children would never have the floating televised-out Generation-X-only-means-white-folks angst; theirs would be a deathly desperation. There was no comfortable identity to fall back on, no suburb waiting, it wasn't our mothers and fathers we were defying, it was history. We watched hippiedom crowd our destiny with freedom off the TV screens. We said, Ain't that just like white folks. What we were leaving was hell, and we could not later boast about what fun it was or, turned conservative, how naïve we were. This was for keeps, no excuses to our children, no forgiveness from racial history.

Just outside at Bathurst and Bloor, I was one of a troop of pamphleteers steadily working this corner from 1972 to 1978. I had spent the first two years getting the hang of the city, drudging it out at several dead-end jobs and raising my consciousness in arguments, at study groups, in a Black students' organization, at community events and partying, which ended up being the same as studying. Whatever the event, I always ended up on this corner or in the subway, waiting for a sister, waiting for a brother, waiting for a group of sisters and brothers, going to a meeting, a party, a picnic. Whatever. We seemed to like the way we looked there in full African regalia, affecting the seriousness and righteousness of our movement. It was our new station, the capital of our new country I cannot recall any actual music playing on the corner or in the subway, but there seemed to be music, we seemed to walk to some music, and I know that we deliberately made the noise of our greetings press the spaces between the walls and move into the street. I know that our new awareness needed affirmation in public display because we were waking up from the dead. So I know there must have been music, and in those days, if you can call a mere twenty-five years ago "those days," there were no beat-boxes so it must have been us singing a cappella, calling the *orishas* to Bathurst subway. Rather, summoning the *orishas* brought here since 1600.

"You say that by baptism I shall be like you: I am black and you are white, I must have my skin taken off then in order to be like you." That very astute brother, Olivier Le Jeune, whose real name nobody remembers, dissed the Jesuit missionary Paul Le Jeune in 1632. Now here we were in another century come to call him on Bathurst Street.

In 1972 it was busy with the traffic of the Black People's Conference, just south at Harbord Collegiate, when Imamu Amiri Baraka came to town with his entourage, and the Harambee singers opened the plenary; their a cappella filling the auditorium until the walls seemed charged with righteousness and imminent freedom. Bodyguards for Baraka lined the stage, looking terrible and exciting. In 1973 it was for the Free Angela Davis Campaign. Then I was also a dancer. I was also a writer. Well, then I thought I could do anything. So the day Fania Davis, Angela's sister, came to town to talk at Henson-Garvey Park, I was not only helping with the food but dancing with the Sans Aggra Dance Group in orange and black

to the theme from *Shaft*. I'm not sure that I didn't do a poem, too. I was that frontish, as my grandmother used to say, and that energized, that committed to the struggle that I thought that I could do anything.

Bathurst Street led to College, to 355 College Street where the UNIA hall was, and there my education began. The Sino-Soviet split drew a line down the middle of the hall on African Liberation Day meeting nights and "Soviet imperialism" and "Sino opportunism" were flung across the borders even as the African Liberation Day celebration got organized. The first day I walked in as a representative for the Black Education Project, not fully comprehending that my organization was on the Soviet side, I agreed with some proposal of the Maoists, not fully comprehending their cunning. I got drawn up by a veteran. Well, I had as much of a good feeling for Mao as for Lenin. That hall is where Dudley Laws was pushed into service as a compromise candidate between the old guard conservatives and the new radicals in the community. Laws was really a moderate,

somebody the radicals could be frank and persuasive with and the conservatives comfortable. So when I hear the Metropolitan Toronto Police call him a radical it makes me want to chuckle. I can still see Laws' harried face trying to hold the Black Education Project back from encroaching on the whole hall, trying to control the unruliness at the ALD meetings, trying to stop the disrespect for the elders, keeping some insensitive meeting-goer from sitting in the sacred chair Marcus Garvey sat on. Shows you how rightwing the backlash is when a moderate gets called a radical. That time the hail was full of police spies; you knew them the way they always raised the question of security for the march or rally, introducing a deadly tone in the room's otherwise eager buzz.

In 1978 we were working the four corners of the intersection just after the killing of Albert Johnson by the cops. Only months before they had killed Buddy Evans down on Spadina Avenue. And those who could have saved his life had said that he was just a nigger and left him to die. Now Albert Johnson was shot on his staircase in his house on Manchester. A Jewish sister and I were flyering the corners, she on the south-west, I on the north-east. It was for the rally to protest the killing of Albert Johnson. The rally would start on Manchester, go to Henson-Garvey Park (in 1978 some of us called Christie Pits the Henson-Garvey Park), then up Oakwood to the police station on Eglinton near Marlee. Suddenly some MLers appeared on the north-west corner, giving out another flyer about another rally on the same day. The MLers were ruthless opportunists. It didn't matter that their rally had no support from the Black community groups, it didn't matter that we were trying to bring all the groups and support groups together — they had the right line and could represent the masses of Black people better. They weren't even Black, though their new strategy was to organize groups of people of colour into 'people's' organizations. Well, we got into a shouting match on the corner, the Jewish sister and I yelling that they were deliberately misleading the people and that they must be working for the police. They,

yelling that they had a right to organize their own rally and that we were Soviet pawns. We called them a distraction, accused them of trying to sabotage the rally and went back to flyering furiously. At some point I think they left. The day of the rally not a cop showed up in uniform and the police station was locked and ghostly. We wanted to break down the doors but Dudley said no. When Albert Johnson's sister sang "By the Rivers of Babylon," water came to our eyes. We've been weeping ever since. One killing after another, one police acquittal after another.

By 1978 the African liberation wars — Angola and Mozambique — were over and the local brutalities took a hold of this corner. Now we're fighting a rear-guard action against the cops and the newspapers here.

The juke box at Wong's, just up the street from the subway, I swear has the same hits playing as twenty years ago. I can still go there, punch in A73, and Aretha Franklin will sing "Respect." The juke box never changes and the cooking never changes; it's always good. From

time to time, Mrs. Wong (I've never seen Mr. Wong) changes the plastic on the tables for new plastic or tries to redecorate in some other *cosquelle* wallpaper. It always ends up looking like Wong's, where you don't go for the decor but for the food.

The barbershops are diagonally across from the subway, and on any given day you can listen to the most fascinating and ridiculous conversations. All of the rhetorical tropes of the Diaspora are in lavish display against the designs of geometric buzzes and high fades. The barbershops and hairdressers, too, are a passageway. From Afro to gheri curl to OPH (other people's hair — no girl, this ain't nobody else's hair, I paid for it) to weaves to fades and back, back to Afros. Lesbian dreads. The new political statements get made here in the way we cut our hair and cut ourselves a bright figure against the pull of the dark suits and pale dresses the rest of the subway crowd offers. We can't stand drabness no matter what our sex.

Across and up the street, the Home Services Association is more venerable. This is where

Black veterans of the wars found support and solace when racism denied them the respect they deserved; this is where the Library of Black People's Literature used to be until 1977, and today uniformed cadres of children take classes on the weekends to heal them from the weekly racism in the mainstream educational system.

The arteries of Bathurst subway carry Black life and industry along its bus and streetcar routes up to Vaughan and St. Clair, Oakwood and Eglinton, and down to Alexandra Park. All those faces, worried, anxious, waiting, eating, approving, disapproving, hurrying, wondering where the hell the Vaughan Road bus is and what to cook for supper tonight and why is that child in those big clothes and his mother must be working damn hard to pay for that leather jacket ... all of that is home for me.

The full press of Black liberation organizing has ground down to a laborious crawl. We're now battered by multicultural bureaucracy, co-opted by mainstream party politics, morassed in everyday boring racism.

But just as we took over this subway, I notice other takeovers. The city is colourizing beautifully. In a weird way this is a very hopeful city. When you think of all the different people living in it — the Chinese, the Italians, the Portuguese, the South Asians, the East Asians and us — you've got to wonder how all of that is happening. And you've got to be hopeful despite people. They all may not know what they're doing, and they may hate each other's guts, and Black folks know that we're on the wrong side of that shit all the time, but something's happening. People make room and people figure out how to do the day-to-day so that life's not so hard.

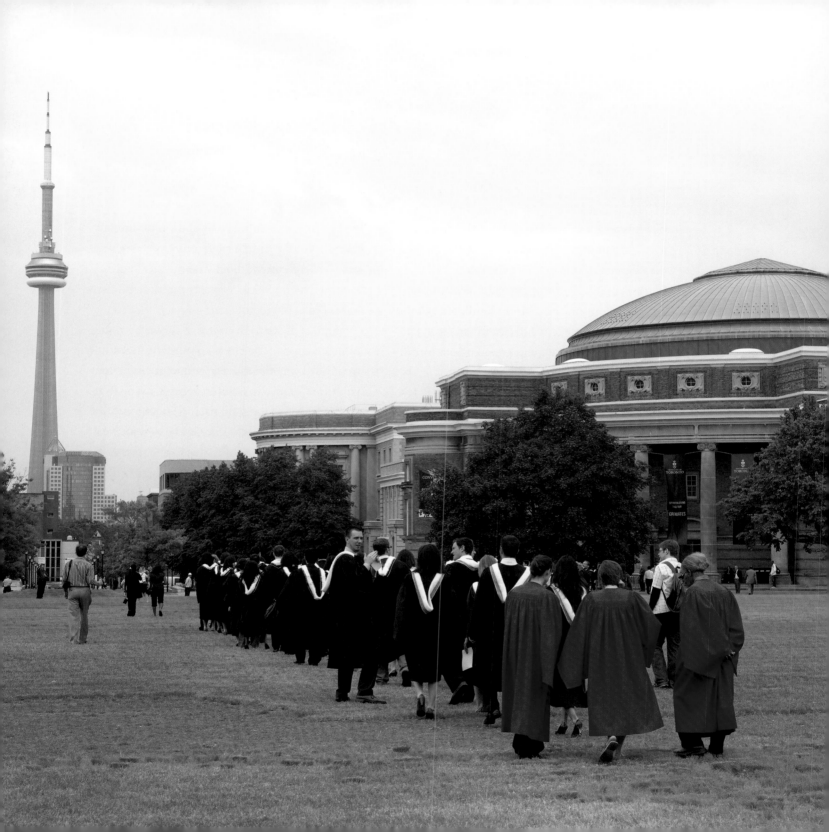

# Any Known Blood

*Lawrence Hill*

After my parents' honeymoon in Quebec City, they decided to move out of their rooming house and rent a flat together. Dad was in his last year of medical school, and my mother had finished her studies and taken a job with the Toronto Labour Committee for Human Rights, and it fell upon her to head out on her lunch hour to find a place for them to live. They both wanted to rent part of a house.

After rejecting a few flats that had cockroaches or that demanded princely rents, Dorothy found the perfect flat on the second floor of a house on Palmerston Boulevard. Langston could walk to the university in twenty minutes. There were shops all along College Street, and Kensington Market was close by. As an added plus for Langston, there was even an Italian coffee bar just a few blocks west on College. The flat itself was perfect. Clean, small, cozy, well lit, and on a quiet street. Trees outside the front and back windows. It was advertised for fifty-five dollars a month, which they could afford on Dorothy's salary and Langston's GI money — $75 a month, plus all tuition and book costs, for having served as a private and then as a non-commissioned officer in World War II.

The landlord was Norville Watson, and he lived on the first floor. He was a tall blond man, only five or so years older than Langston. He had a habit of pulling at his slender fingers and speaking in endless sentences. He informed Dorothy that he was a graduate of the University of Toronto medical school, and that he was on the verge of completing his residency in urology. A tad pompous, Dorothy decided, but who cared? He seemed impressed when she let it slip that her husband was a medical student, also at the University of Toronto. They agreed on the rent. Dorothy offered to pay for the first month then and there, and to take the key and come back the next day with her husband and their possessions.

"I don't usually like to rent until I have met both tenants," Watson said.

"My husband, as you can appreciate, doesn't have much time on his hands these days. He's preparing for —"

"Yes, of course, of course. I'll tell you what. I'll hold the apartment for you. Come back tomorrow, and we'll sign the contract and exchange the keys for the first month's rent. You have my word. I'll hold it for you."

"All right, then. Tomorrow at seven in the evening?"

"Fine."

They shook hands.

The next day, Dorothy parked her 1946 Plymouth on Palmerston Boulevard. As she walked with Langston up the steps to the house, Dorothy noticed the red and white For Rent sign still on the door.

"How come that's still there?" she said.

"Not a good sign," Langston said. He rang the bell. Watson opened the door and stepped out onto the porch. He had to bend his neck to meet Langston's eyes. Langston extended his hand and introduced himself.

"Well, we're here," Dorothy said. "We'd like to sign the contract, pay you, and bring our things in from the car."

Langston watched the man open his mouth, close it, stop, pause. People had looked at Dorothy and him in the streets — in fact, people looked at them every day — but this was the first time that they had tried to rent a place together. Langston instantly knew that they would not get the flat. The coming refusal was as certain as the sunset — but Langston sensed that it would come in a distinct way. This wasn't the United States. Nobody would swear at him, or wave a gun. Langston waited for the refusal, Canadian-style.

"I'm so sorry," Watson said, looking only at Dorothy, "and I hope you haven't been overly inconvenienced, but I have made other arrangements. A retired couple came by yesterday, after you left. They needed a quiet place, and they were prepared to take out a two-year lease, and I'm sorry, but I couldn't refuse them."

"Yes, you could have," Dorothy shot back. "And you still can. You can simply tell them that you had given me your word — your word, I remind you, Dr. Watson — that the flat was mine. Ours."

"And you had given me your word, madam, that your husband was a medical student at the University of Toronto."

Dorothy raised her voice. "I'll have you know, Dr. Watson —"

Langston put his palm on Dorothy's forearm. "If I understand correctly, Dr. Watson, you would prefer not to rent to us."

"Preference has nothing to do with it. I have entered into an agreement with another couple."

Dorothy could not restrain herself. "Then why haven't you taken the sign off the door, you asshole?"

"Oh, nice," Watson said. "Very nice. Quite elegant. A medical term acquired, no doubt, from your husband. At any rate, forgive me for leaving the sign up. It escaped my thoughts." Watson removed the tack from the door, took down the sign, and stepped back inside.

"Good luck with your apartment search," he told Dorothy. "And," he said, meeting Langston's unmoving eyes, "with your studies."

Dr. Norville Watson closed the door.

"I can't believe you stood there and said nothing," Dorothy screamed at her husband. "I can't believe you just —"

"Shh," he said. "Come on, let's go."

"No! I'm not moving off this goddamn step. That sonofabitch is a blatant —"

He squeezed her arm and whispered, "I have an idea. Come on."

They drove south on Palmerston, turned left on College, parked at Bathurst, and walked to the Mars Café. Stella and her husband, who were tenants in the Pembroke Street rooming house, worked in the café. It was the best greasy spoon in the area. Langston liked it because they knew him well in there. During his first year in Toronto, he had made it his breakfast haunt. From Monday to Friday, between six and eight a.m., they had an all-you-can-eat scrambled eggs, toast, and coffee special for seventy-five cents. Plus, they had unbeatable bran muffins. Stella had served him there a hundred times — and undercharged him whenever the owner wasn't looking over her shoulder.

Stella came up to their table. "You two look good together. Real good. So what'll it be for the newlyweds?"

"I'm too pissed off at him to eat right now," Dorothy said.

"First fight?"

"You've got to hear this," Dorothy said. And she told Stella about it. Stella's husband came over to listen.

"We can help you find a place," Stella said.

"Harry and I know some landlords who don't discriminate."

"I don't want to find another place quite yet," Langston said. "I want to make this guy uncomfortable. I want to make him regret what he did for a long, long time."

"You know, Doc, they'll lift your license if you start busting kneecaps."

"That's not quite what I had in mind."

An hour later, Dorothy and Langston drove by the house. The sign was still off the door.

"Maybe he really did rent it out," she said.

"I doubt it."

They drove by another hour later. The sign was back up.

An hour after that, Stella and Harry Williams skipped their usual dinner break. "Shouldn't we go home and get some nice clothes on?" Stella asked.

"No, it'll be better this way," Langston said. "More convincing." Langston and Dorothy drove them to the corner of Palmerston and College and had them walk to the house from there.

Stella rang the bell. Watson answered it. *That man's so tall it's unnatural*, she said later. *He must have to request a special bed every time he sleeps in a hotel.*

"Excuse us for troubling you, mister, but my husband and I noticed your sign. We're just on our break. We work over at the Mars Café, you know, Bathurst and College."

"You're interested in renting the flat?"

"Yes. Could we see it?"

"Sure. Why not?"

They viewed the living room, which looked out onto Palmerston, and the kitchen, which gave out onto Ulster Street. They checked the bedroom. Stella even flushed the toilet. "Hope you don't mind. I like to make sure a place is in good working order."

"My wife," Harry said. "She's picky. But she's neat. She's a real neat freak."

"I am not a neat freak," Stella shot back. "I just don't like dirt. I don't like filth, I don't like dust, I don't like dirty floors or anything like that. If he didn't have me," she said to Watson, "he'd live like an ape."

"The apartment is fifty dollars a month. I also require a twenty-five-dollar damage deposit, which will be returned to you when you leave if nothing is broken or damaged."

"Damage deposit," Stella said. "I've been renting for eight years and I've never had to pay a damage deposit before."

"Well, I require it."

"Stella, he said he'd give it back when we left."

"All right. Who lives downstairs?" Stella asked.

"I do."

"You don't have children, do you?"

"No."

"That's good. They make a lot of noise. How about pets? Do you have a dog?"

"I find it odd that you are inquiring of me what I have in my apartment. I should be asking these things of you."

"I don't like dogs, or cats, you don't have to worry about that. It's just that I have allergies. Lots. So if you had a dog or a cat, I'd like to know."

"No, I don't."

"Good. Can I ask you what kind of people live in this neighbourhood? Sometimes I have to walk home from work at night, and I need to feel safe."

"This is a very safe neighbourhood. My family has owned this home for the better part of thirty years, and I don't recall ever hearing of anybody being troubled or harassed on the street."

"What about immigrants?" Stella asked.

"Some Italians and Portuguese live around here. But they're the best neighbours you could ask for. I will say that they tend to shout and to hold all sorts of family functions. But they're the first ones to call the police if they see someone trying to break in your house. They give you wine at Christmas and Easter. They treat you like one of the family. You won't have any trouble with Italians or Portuguese. And I can reassure you that I know of no neighbours who are Negroes. I would draw the line there. As a matter of fact, a Negro posing as a medical student tried to rent this apartment today, and I would have nothing to do with it."

"Good," Stella said, "That's what I wanted to hear. Is that what you wanted to hear, Harry?"

"Yeah. Great."

"I don't have my cheque book with me, or a lot of cash. Can I just give you twenty dollars to hold the apartment, and you give me a receipt? We'll come back tomorrow to take care of everything."

"Fine. That will be fine."

Back at the Mars Café, Langston told Stella to write it all down. To put every detail on paper. But she was too excited, so Dorothy, who knew shorthand, took down Stella's statement.

The two couples returned to Watson's house an hour later. Langston rang the bell.

Watson opened the door. He stared at the four of them for a minute.

"Howdy," Stella said with a grin.

"What is going on here?" Watson said.

"Dr. Watson," Langston said, "you refused to rent us that flat on the basis of my race. You told our friends as much. If you give them back their twenty dollars, and you give my wife and me that apartment, I'll consider the matter settled. But if you don't —"

"You'll what — call the police? This is my house. I can rent to anybody I want. Take your money, you clowns." Watson threw a twenty onto the porch. "Now get out of here before *I* call the police."

"Good-bye, Dr. Watson. You can expect to hear from me again. The name is Cane. Langston Cane the Fourth."

Norville Watson slammed the door.

Dorothy slipped her arm around her husband's waist. "That's the man I married," she said. "Now what?"

"I don't know, exactly. Let's sleep on it."

Stella giggled. "Langston Cane the Fourth. That's quite the name."

## Happiness and Immortality near Bathurst and Bloor
*Joseph Kertes*

Back in 1956 when our father told my brother Bela and me that we were leaving Budapest for Toronto, Canada, he said we'd be safe there and wouldn't likely be shot dead. He said, in fact, that we weren't just leaving — we were escaping the Russians — and we did. We crossed into Austria by foot, by night with what we could carry: some clothes, some photographs and a few opera records my grandmother took. We kept hearing what my brother and I thought were bombs falling not too far away, but it turned out they were other fleeing Hungarians, much like us but unlucky ones, those who'd stepped on landmines.

Canada was safe. Toronto was safe. The Annex of Toronto, and more specifically our home at 139 Howland Avenue, was more than a refuge. It was elemental to me, like prairie and sky. It was park, school, store, temple, rink, yard, trees, home.

And it was an open neighbourhood, more or less receptive to Hungarians moving in, between the Polish family on one side in Number 141 and the Finnish family on the other in 137. And it was receptive to our putting our stamp on it alongside theirs. Hungarian restaurants sprouted up on Bloor Street: the Continental, the Country Style, the Korona and the Tarogato. There was no veal for schnitzel when we got to Toronto. Soon schnitzel was everywhere, as were cabbage rolls, and veal and chicken paprikash. Paprika and poppy seeds and kolbasz could be had at Elizabeth's, the first Hungarian butcher shop and food emporium. There was a medical centre over on Spadina that housed a Hungarian doctor and a Hungarian dentist, and Allen's Drug Store was opened by the first Hungarian pharmacist.

The houses in the Annex were spectacular, roomy boxes, thick and chunky with brick and oak — like Edward Hopper houses with immense wooden verandahs, some of them — houses built in the twenties, the light coming into them through leaded glass. Ticking

city of words ● 177

radiators warmed the homes in winter and tall, old trees cooled them in summer.

Our favourite spot, my brother Bela's and mine, was the rink around the corner on Kendal Avenue in the park we used to call Sibelius Park because, for some reason, a bust sculpted in bronze of the Finn Jean Sibelius stood at one end, mounted on a granite pedestal. I loved that Sibelius did watch over the park because it suggested a far away presence brought to this little park and big open land. But I wonder how many statues commemorating Canadians stand for no good reason in Finland or anywhere else outside this country.

Honest Ed's discount department store deserves its own paragraph. This wonderful garish behemoth rose and broadened to fill out a square block at the southwest corner of Bloor and Bathurst Streets. It was a monument to bad taste and good prices, yet it was reassuring to us as new Canadians, its warm, creaking wooden floors, its vats of boots and sweaters and canned goods, its vats of plenty. The growth of the store seemed to parallel our own as a

community within the varied communities of Toronto.

My brother and I went to Christie Pits, a couple of blocks west, to swim in the hot summer or to sit on the green slopes to watch the Toronto Maple Leafs Triple-A baseball club practise and play before heading off to their home games at Maple Leaf Stadium down on Lakeshore Boulevard. My brother Bela caught a ball once, and I took one on the side of the head.

Some weekends we went to the Metro Theatre on Bloor to watch triple bills, plus cartoons, and sometimes twice through, which meant we sat through six movies and twelve shorts in a single day and came staggering out of the place to get home for dinner.

Today, my grandmother and parents are gone, my brother Bela and I, and another brother Peter, whom my parents added in Canada, have all moved to different ends of the city, along with many of the neighbours we grew up with in the Annex. The threshold seemed to be university. You graduated, settled

down with someone and moved away to the suburbs.

— Ironically, actually, because the Annex has been taken over by university types, as if they were anthropologists who settled here to study the immigrant communities that had started here and then scattered.

Only one Hungarian restaurant, Country Style, remains. But the area still holds its charms and has added new ones: bookstores, cafés, Korean and Indian restaurants. And the indomitable Honest Ed's still stands and calls out to us, loud as Las Vegas.

## Late Autumn in the Annex, 1997
*Carleton Wilson*

That Fall day landed heavy like a hangover, its dawn fraught
with all kinds of violations. We arrived at class early, enough
time to commiserate with each other about our lack of fortitude,
that understrung-out need for caffeine; how it sunk through
the veins, a persistent detritus.
                                    You, of course, decked out in
your red boots, put forth the argument for the mystical nature
of knee-length leather; why the metaphysics of the high-heel
held its own kind of salvation, each patent sole a promontory
into those other realms. But what was I to argue? Schlepping
about in my beaten-down Doc Martens, scuffs deep as hell,
praying that the dark clouds overhead that morning didn't
mean rain, the horsehair of wet wool socks yet again.
                                                        Soon,
we discovered our class cancelled; took stock, and strolled
up to Bloor Street, its midday pandemonium hitting us hard
as we emerged from Philosophers' Walk. Silent as we went,
I remembered our short history, how our time together had
encircled moments in corners of Hart House, where we'd talk
poetry, spinning apart from the crowd, the floorboards creaking
underneath our quiet revolutions. Your pixie haircut, then,

glowed black as crushed eyeliner, head weighted with questions
concerning life, art, any particular manner of hanging, display.
Always the sophisticate, I'd been astonished by your knowledge
of ancient crockery, knew you could believe the streetscape now
before us into an achievement of art, view in the muted light
buildings frescoed against the walls of the horizon, just as if
Michelangelo himself had set to work on them these decades
past.

So let it be known that I led us astray that day, dragged you
into the Future Bakery for an afternoon pint, the sun persistent
behind the cloud cover, hermetical above us. But beneath it all
we were heartened, knew we'd soon see light break through, set
the top of the foliage across the Annex aflame, the canopy erupting
around us like fireworks, our foothold on all we'd lost quietly regained,
regaining.

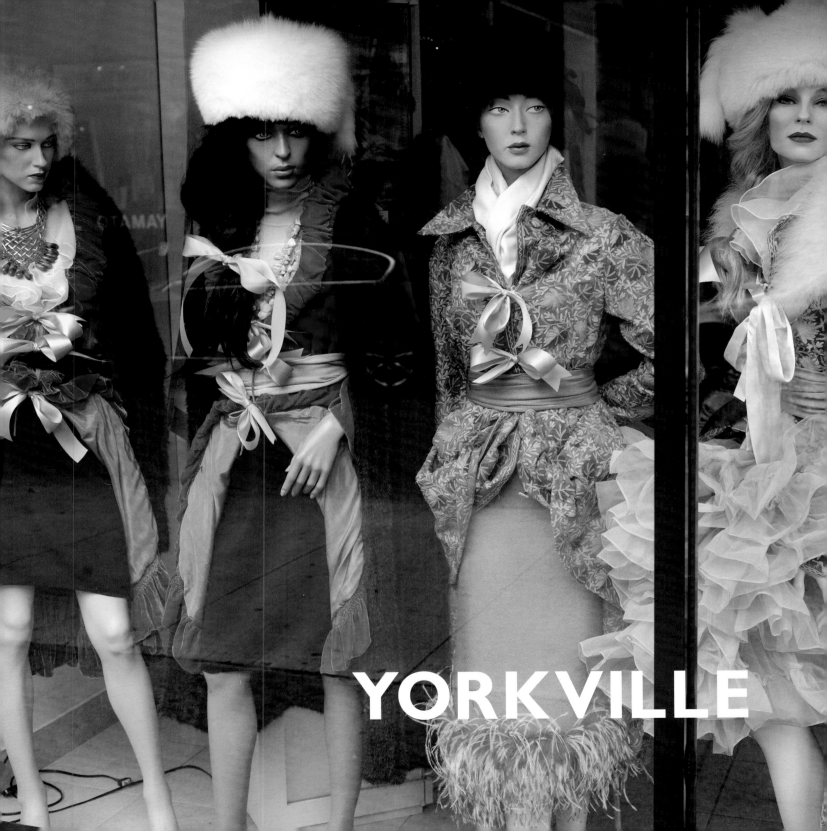

YORKVILLE

# Cat's Eye
*Margaret Atwood*

I sit in a French restaurant with Josef, drinking
white wine and eating snails. They're the first
snails I have ever eaten, this is the first French
restaurant I have ever been in. It's the only
French restaurant in Toronto, according to Josef.
It's called La Chaumiere, which Josef says mean
"thatched cottage." La Chaumiere, is not
however a thatched cottage, but a prosaic, dowdy
building like other Toronto buildings. The snails
themselves look like large dark pieces of snot;
you eat them with a two-pronged fork. I think
they are quite good, though rubbery.

Josef says they aren't fresh snails but have
come out of a tin. He says this sadly, with
resignation, as if it means the end, though the
end of what is not clear; this is how he says
many things.

It was the way he first said my name, for
instance. That was back in May, in the last week
of Life Drawing. Each of us was supposed to
meet with Mr. Hrbik for an individual evaluation

to discuss our progress during the year. Marjorie
and Babs were ahead of me, standing in the
hall with take-out coffees. "Hi kid," they said.
Marjorie was telling a story about how a man
exposed himself to her in Union Station, where
she had gone to meet her daughter on the train
from Kingston. Her daughter was my age, and
going to Queen's.

"He had on a raincoat, would you believe,"
said Marjorie.

"Oh God," said Babs.

"So I looked him in the eye — the eye — and
I said 'Can't you do any better than that?' I
mean, talk about weenies. No wonder the poor
boob runs around in train stations trying to get
somebody to look at it!"

"And?"

"Listen, what goes up must come down, eh?"

They snorted, spewing droplets of coffee,
coughing out smoke. As usual I found them
slightly disreputable: making jokes about things
that were no joking matter.

Susie came out of Mr. Hrbik's office. "Hi,
you guys," she said, trying for cheer. Her

eyeshadow was smudged, her eyes pinkish. I'd been reading modern French novels, and William Faulkner as well. I knew what love was supposed to be: obsession, with undertones of nausea. Susie was the sort of girl who would go in for this kind of love. She would be abject, she would cling and grovel. She would lie on the floor, moaning, hanging onto Mr. Hrbik's legs, her hair falling like blond seaweed over the black leather of his shoes (he would have his shoes on, being about to walk out of the door). From this angle, Mr. Hrbik was cut off at the knees and Susie's face was invisible. She would be squashed by passion, obliterated.

I was not sorry for her, however. I was a little envious.

"Poor bunny rabbit," Babs said behind her retreating back.

"Europeans," said Marjorie. "I don't believe for a minute he was ever divorced."

"Listen, maybe he was never even *married*."

"What about those kids of his?"

"Most likely his nieces or something."

I scowled at them. Their voices were way too loud; Mr. Hrbik would hear them.

After they had gone it was my turn. I went in, and stood while Mr. Hrbik sat, going through my portfolio, which was spread out on his desk. I thought it was this that was making me nervous.

He flipped through the pages, hands, heads, bottoms, in silence, chewing his pencil. "This is nice," he said at last. "You have made progress. This is more relaxed, this line here."

"Where?" I said, leaning my hand on the desk, bending forward. He turned his head to the side, towards me, and there were his eyes. They were not purple after all but dark brown.

"Elaine, Elaine," he said sadly. He put his hand over mine. Cold shot up my arm, into my stomach; I stood there frozen, revealed to myself. Is this what I'd been angling for, with my notions of rescue?

He shook his head, as if he'd given up or had no choice, then drew me down, between his knees. He didn't even stand up. So I was on the floor, on my knees, with my head tilted back,

his hands caressing the back of my neck. I'd never been kissed that way before. It was like a perfume ad: foreign and dangerous and potentially degrading. I could get up and run for it, but if I stayed put, even for one more minute, there would be no more groping in car seats or movie theatres, no skirmishes over brassiere hooks. No nonsense, no fooling around.

We went to Josef's apartment in a taxi. In the taxi Josef sat quite far apart from me, although he kept his hand on my knee. I was not used to taxis then, and thought the driver was looking at us in the rear-view mirror.

Josef's apartment was on Hazelton Avenue, which was not quite a slum although close to it. The houses there are old, close together, with frumpy little front gardens and pointed roofs and mouldering wooden scrollwork around the porches. There were cars parked bumper to bumper along the sidewalk. Most of the houses were in pairs, attached together down one side. It was in one of these crumbling,

pointy-roofed twin houses that Josef lived. He had the second floor.

A fat older man in shirtsleeves and suspenders was rocking on the porch of the house next to Josef's. He stared as Josef paid the taxi, then as we came up the front walk. "Nice day," he said.

"Isn't it?" I said. Josef paid no attention. He put his hand lightly on the back of my neck as we went up the narrow inner stairs. Everywhere he touched me felt heavy.

His apartment was three rooms: a front room, a middle room with a kitchenette, and a back room. The rooms were small and there was little furniture. It was as if he'd just moved in, or was moving out. His bedroom was painted mauve. On the walls were several prints, which were of elongated figures, murkily coloured. There was nothing else in this room but a mattress on the floor, covered with a Mexican blanket. I looked at it and thought I was seeing adult life.

Josef kissed me, standing up this time, but I felt awkward. I was afraid someone would see in

through the window. I was afraid he would ask me to take off my own clothes, that he would then turn me this way and that, looking at me from a distance. I didn't like being looked at from behind: it was a view over which I had no control. But if he asked this I would have to do it, because any hesitation on my part would place me beneath consideration.

He lay down on the mattress, and looked up as if waiting. After a moment I lay down beside him and he kissed me again, gently undoing my buttons. The buttons were on an outsize cotton shirt, which was what had replaced the turtlenecks now that it was warm. I put my arms around him, and thought: he was in the war.

"What about Susie?" I said. As soon as I said it I realized it was a high school question.

"Susie?" Josef asked, as if trying to remember her name. His mouth was against my ear; the name was like a regretful sigh.

The Mexican blanket was scratchy, which did not bother me: sex was supposed to be unpleasant the first time. I expected the smell of rubber too, and the pain; but there was not as much pain, and not nearly as much blood as everyone said.

Josef was not expecting the pain. "This is hurting you?" He said at one point. "No," I said, flinching, and he did not stop. He was not expecting the blood either. He would have to get his blanket cleaned, but he didn't mention this. He was considerate, and stroked my thigh.

Josef has gone on all summer. Sometimes he takes me to restaurants, with checked tablecloths and candles stuck in Chianti bottles; sometimes to foreign films about Swedes and Japanese, in small uncrowded theatres. But we always end up back at his apartment, under or on top of the Mexican blanket. His love-making is unpredictable; sometimes he is avid, sometimes routine, sometimes absent-minded, as if doodling. It's partly the unpredictability that keeps me hooked. This and his need, which seems to me at times helpless and beyond his control.

"Don't leave me," he says, running his hands over me; always before, not after. "I couldn't

bear it." This is an old-fashioned thing to say, and in another man I would find it comical, but not in Josef. I am in love with his need. Only to think of it makes me feel suffused, inert, like the flesh of a watermelon. For this reason I've cancelled my plans to return to the Muskoka resort, to work as I did last summer. Instead I've taken a job at the Swiss Chalet on Bloor Street. This is a place that serves nothing but chicken, "broasted," as it says on the sign. Chicken and dipping sauce, and coleslaw and white buns, and one flavour of ice cream: Burgundy Cherry, which is a striking shade of purple. I wear a uniform with my name stitched on the pocket, as if in high school gym class.

Josef sometimes picks me up there, after work. "You smell of chicken," he murmurs in the taxi, his face against my neck. I've lost all modesty in taxis; I lean against him, his hand around me, under my arm, on my breast, or I lie down along the seat, head in his lap.

Also I have moved out of home. On the nights when I'm with him, Josef wants me to stay all night. He wants to wake up with me

asleep beside him, start to make love to me without waking me up. I've told my parents it's only for the summer, so I can be closer to the Swiss Chalet. They think it's a waste of money. They are racketing around up north somewhere and I would have the house to myself; but my idea of myself and my parents' idea of me no longer belong in the same place.

If I'd gone to Muskoka I wouldn't be living at home this summer either, but not living at home in the same city is different. Now I live with two of the other Swiss Chalet girls, student workers like myself, in a corridor-shaped apartment on Harbord Street. The bathroom is festooned with stockings and underpants; hair rollers perch on the kitchen counter like bristly caterpillars, dishes cake in the sink.

I see Josef twice a week, and know enough not to try calling him or seeing him at other times. Either he won't be there or he will be with Susie, because he hasn't stopped seeing her, not at all. But we are not to tell her about me; we are to keep it secret. "She would be so terribly hurt, he

says. It's the last one in line who must bear the burden of knowing: if anyone is to be hurt, it will have to be me. But I feel entrusted by him: we are in this together, this protecting of Susie. It's for her own good. In this there is the satisfaction of all secrets: I know something she doesn't.

She's found out somehow that I'm working at the Swiss Chalet — probably it's Josef who's told her, casually, skirting discovery, probably he finds it exciting to think of us together — and once in a while she comes in for a cup of coffee, late in the afternoon when there's nobody much around. She's gained a little weight, and the flesh of her cheeks is puffy. I can see what she'll look like in fifteen years, if she isn't careful.

I am nicer to her than I ever have been. Also I'm a little wary of her. If she finds out, will she lose whatever grip on herself is left and go for me with a steak knife?

She wants to talk. She wants us to get together sometime. She still says "Josef and me." She looks forlorn.

## Cabbagetown Diary: A Documentary

*Juan Butler*

Yorkville Avenue. Two blocks of discotheques with the music blaring out onto the street; sidewalk coffee houses where you can watch people who watch you as you drink a fifty-cent coffee; art galleries full of modern painting that looks like the stuff we did in grade one; a poster store where George got his posters; and about half a million people and cars moving up and down like a permanently flowing river.

Teeny boppers — ten to fourteen-year-olds who make the street look like a nursery corner. Hippies sitting on the sidewalk or on the steps of houses, their blank faces disappearing behind a curtain of hair. Beads, bells, buttons, tied and pinned onto the blankets and rags they call clothes. High on speed, LSD, grass and anything else they can lay their hands on. Black with dirt. Broads and guys all looking alike. Incense in the air. Getting up to walk slowly a few feet down the street till they find a new place to sit down. Tourists taking photographs. Greasers looking for a fight — black leather jackets and boots — (most of them are from the suburbs). Cops walking in pairs while a paddy wagon waits at the corner of the street. College kids walking hand in hand and pretending they're part of the scene. A man and a woman with a photo in their hands approaching the hippies and asking them if they've seen their daughter who's only fourteen and who ran away from home last week with her girlfriend who's fifteen.

A roar of motorcycles and a gang wheels up the street, *Satan's Choice* written in red on the back of their shirts or jean jackets. Tough babies who'll stomp you if there's nothing else to do. Riding their cut-down bikes in groups of five or six and never looking to right or left. It's you who's got to move, not them. Sometimes I dream what it would be like to ride with them, the hair tied with a scarf, leather boots and swastikas and a broad riding behind me.

But then, they're always getting busted by the Man, and most of them are stupid as hell. They want respect, but the only way they can get it is by acting tough. And their pigs look like they all got VD.

Yorkville's a great place to come looking for tail, though. But you got to watch out who you're conning. Most of the chicks here are jailbait. One night we picked up one who looked at least seventeen, built like a brick shithouse, and just when we get her into the car she comes out saying that she's thirteen. We dumped her on the sidewalk again. Man, no broad's worth getting arrested for, especially when they don't take a pill or nothing and next thing you know she's a mommy. They throw the book at you for that.

We thread our way through the people and Terry's holding my hand so that she won't get lost. Something with hair down to his feet walks by.

"What was that, a girl or a boy?" she asks.

I look back and I can't even tell by looking at the ass, and it's got bare feet so no telling there either.

"Don't tell me he's a hippie too!"

A little old guy with a hat full of feathers walks by with a button on his shirt saying 49ers. He looks like the winos at Allan Gardens.

"He's a pippy." I answer, laughing at my own joke.

The coffee houses are full and the dance halls are jammed wall to wall. The street's full of cars and the sidewalk's crammed. This is enough for me. Not much use sticking around here, since the only reason I've ever had for coming is shot to hell because of Terry.

We walk back towards Bloor Street and it takes a few minutes to get used to the quiet again.

Terry's going on about how dirty they are and how they dress. I don't say anything, but as far as I'm concerned personally, they can do whatever they want. Hell, they're the only people in Toronto who'd rather give you a flower than a sock in the kisser, and that's all right by me. Live and let live, that's my motto.

Even though she's bitching about them, 1 can tell she got a real kick out of going to Yorkville cause she's talking a mile a minute and her eyes are wide open with excitement.

Later in bed she holds on to me real tight and says, "You know, they reminded me of George." Then she adds, "I'm glad you don't have hair like that."

Silence for a while, then, "But even if you did, I'd love you just the same."

## Yorkville Diaries
*Don Lyons*

Jan 1966

Yorkville seems to be the magic word when it comes to getting laid or punched out.

Tonight I'm ambling along Yorkville Avenue, looking through the crowds for Larry (crowds? yeah, everybody's back now that the snow's melted) when suddenly I hear, "Hey, jerk! Want a haircut?"

I turn and see this goofball greaser hanging out the passenger window of a yellow sixty-five Ford Galaxie 500. He's got scissors in his hand and he's snipping the air. I let the whole thing pass on account of there was six of them. They were around twenty-five years old and looked like weightlifters.

That's some idea of entertainment for a Saturday night: drive down from Scarborough and pick on an innocent fifteen year old high school student whose only wish is to fuck every girl in Toronto. I used to run into these creeps in Parkdale and in New Toronto, but in Yorkville?

Actually, he asked me: "Know where I can buy some pot?"

"That's against the law," I answered.

This got the poor guy apologizing like crazy "Sorry! I thought you were a Yorkviller." ... (a Yorkviller?) "We don't want to buy a lot. We don't want to get hooked."

I broke up laughing and the guy's red in the face, centre-shoted in front of his friends, so I felt bad about it and handed him a joint. His eyes almost fell out of his head. He quickly slips the joint in his pocket and pulls out a five. "Is it enough?"

"Forget it," I said, but the guy insisted, "No? Well, let us buy you something to eat." (everyone thinks we're starving to death down here).

I okayed it, cold night and everything, also, I knew that what the guy really wanted was to know how to smoke the thing. (Which end do I light? Should I hold my breath? Should I blow it out my ear?)

We ended up at the Mont Blanc in two booths. Marlene, the best looking of the pretties, made sure I was sitting beside her and the

boyfriend was in the other booth, which is what tonight's diary is all about: the fact that Yorkville is the magic word. You can believe it that for her boyfriends in Forest Hill, this girl is no go. At best, it's six weeks of steady dates before boyfriend gets to cop a feel. But mention Yorkville and anything goes, ready to unbutton before you've decided are you even in the mood. Seen it happen a thousand times, well, maybe ten. Which is okay with me. In fact, what the hell am I complaining about? Maybe I've got the flu, I have been tired the last two days.

"Why don't you come down tomorrow night by yourself?" I said low to Marlene.

"Okay," she whispered as I dropped my hand to her corduroy-jeaned thigh. I love copping a feel in a public place like a restaurant or a sub-way, really turns me on.

Sometimes I get so excited I feel like my heart is twice as large and still expanding.

I felt this way last night. Marlene is a looker: maybe 5'10", stacked, long black hair, a pretty face, creamy skin, and those corduroy jeans.

There's something special about corduroy, the feel of it. Or maybe it's what's underneath.

Anyway that was last night. Tonight our cheerleaders were back, without the boyfriends, talking to Larry who was leaning against the Riverboat (Larry and I hang out in front of the Riverboat a lot but seldom go in).

Larry must have worked everything out because after hello, hello, hello, we headed for fifty-two but the place was packed with a hundred and ten people so we walked around the corner to forty-eight. We were sprawled out in the sofaroom talking about high school dances, how the teachers won't let you book the groups you want, goof-off stuff like that, when Larry undoes Petra's blouse, deep kiss on the mouth, not a sound in the room, the rest of us looking at the carpet, pin-drop quiet, only Petra breath-ing heavy and the sound of her zipper unzipping.

"Why don't you girls go in the bedroom and get ready while Leo and I look for an ashtray?" says Larry.

Larry and I were going to give them two minutes but after thirty seconds loud laughing

was exploding out of the bedroom. So we walked in. Petra, Marlene and Muffin (her real name she says) were flat out on my huge double bed having the time of their lives, holding the whiter than white sheet up to their chins and kicking their feet so the sheet's floating in ripples two feet above their beautiful bods. Larry and I stayed at the door and grooved on the under-the-sheet view: legs kicking and three pairs of bright blue panties flashing, also a bit of boob visible. They ended up letting go of the sheet and, still kicking, floating the sheet across the room. Must have practised the move a hundred times to get it that smooth.

Larry and I jumped on top and got our clothes pulled off. Marlene threw my shoe out the window. Almost hit a doper walking along Bedford. The guy scooped it up off the lawn and tossed it right back through the window (perfect shot, had to be a basketball player). So I pulled off Marlene's panties and tried for the window but they just floated four feet and landed on the floor.

"You've all got the same panties," I said.

"They're a special kind, real thick and warm. We wear them under our cheerleader uniforms." (I was right) This gives me an idea and in ten seconds Larry and I are lying back watching a cheer:

go team go, charge and buck 'em
get in there and really fuck 'em
hike!

What a rah-rah riot (raw/raw actually). I love cornball. Athletic girls too. I yelled for cartwheels but our cheerleaders jumped back on top of us, Muffin kneeing me in the balls but I was okay in thirty seconds. Petra was pissed off because she was the odd one out, still she came around pretty quick when Larry told her to slip him in Muffin. Petra was really getting off on Muffin, sliding her thumb all the way in plus a few back and forths. I was next and got twenty yanks. Thought I was going to come in Petra's hand. The fingers of Petra's other hand were buried in Marlene who was going crazy under both of us. Petra fits me inside Marlene. Marlene's soaking wet. Twice on purpose I pull back too far and

slip out. Felt great having Petra slurp me back in. Man, Petra was really going, sitting on the bed, both hands on Marlene's bod, couldn't take her eyes off Marlene's face. I grabbed Petra's blond head and pulled her in between us. Marlene throws her arms around Petra's neck and they're deep kissing like there's no tomorrow.

Talk about a turn-on: moving in the groove, moving slow and smooth so it will last (Sue's lessons finally sunk in), digging the threesome and Larry and Muffin are bouncing one foot away. A ten-ton bomb could have gone off and no way we would have heard it.

## Moody Food

*Ray Robertson*

Okay, just a little background music: Toronto, 1965 in particular.

For anyone starting to let his hair grow long and wanting to hear some good music and maybe even check out some of that free-love action you'd read about going down in places like California, that would basically mean Yorkville, just north of Bloor Street. No more than three blocks in all, Yorkville was our very own city within a city, every street, alley, and low-rent hippie-converted building bursting with the sounds of loud music and the sweet smell of incense and overflowing with like-minded friendly, freaky faces. There was the Inn on the Parking Lot, the Riverboat, the Mynah Bird, the Penny Farthing — coffee shops and folk clubs, basically — where you could listen to Joni Mitchell and Ian and Sylvia and a million others no one has ever heard of since. Every one drank lots of coffee and smoked plenty of cigarettes and you could play chess

outside if the weather was nice and there was pot if you wanted it and all the girls, it seemed, were eighteen years old and tall and thin with the kindest eyes and long dark hair and none of them wore bras even if there really wasn't all that much love going on, free or otherwise.

But maybe that was just me. As a University of Toronto second-year dropout of no fixed major working part-time at a second-hand bookstore with no guitar-strumming ability of my own, I wasn't on anybody's love-to-love-you-baby list. At least not until Christine showed up one day at Making Waves.

The Making Waves Bookstore wasn't much more than the entire first floor of a paint–peeling Victorian house near the corner of Brunswick and Harbord crammed to the walls with the owner, Kelorn Simpson's, own book collection, most of it accumulated over twenty years of academic gypsydom. Kelorn was a fifty-something psychedelicized Ph.D. in English literature with a framed degree from Oxford and dual portraits of Virginia Woolf and Timothy Leary hanging over the front counter to prove it.

She was also near-messianic in her need to educate, physically and otherwise, the young female undergraduates who would drift into the bookstore from the university just a few blocks away, as well as reluctant as hell to sell any of her books. Which is how I started working for her in the first place.

After she saw how disappointed I was when she barely even looked at the cardboard box I brought by full of an entire semester's worth of practically new books, and then how pissed off I became when she wouldn't sell me her City Lights Pocket Book copy of *Howl* (a cute girl in black leotards with jet-black hair and no makeup in my Modern American Poetry class told me to read it when I'd asked her out to a Varsity Blues hockey game; she also declined my invitation to the hockey game). Kelorn made me take off my coat and gloves, poured me a cup of mint tea, asked why I needed money so badly that I wanted to sell all my books, and why I wanted to read Allen Ginsberg.

After I told her about the cute girl with the jet-black hair and how I'd dropped out of U of T

a few months before and how the bank was calling in my loan and how I'd have to move back in with my parents in Etobicoke soon if didn't get a job, Kelorn asked me if I wanted to work at the bookstore.

"Doing what?" I asked.

"Nothing."

"You want to pay me to do nothing."

"Practically nothing," she said. "Open and close up when I'm busy. Brew a pot of tea now and then. Help out the customers."

"But you don't sell anything. How am I supposed to help out the customers?

Kelorn set down her cup of tea on the counter. "You're not buying anything and I'm offering to help you, aren't I?"

"So when people come in you want me to offer them jobs working here?"

Leaning a heavy arm on the countertop, the massive collection of beads, religious medallions, and junk jewellery hanging around her neck set swinging and crashing against each other as she shifted her weight, "I thought you said you needed a job," she said. At an even six feet and

with a figure that now — thirty years on and my own 28-inch waist as much a memory as my 8-track collection — can be charitably called Rubenesque Kelorn, I came to find out, had a way of stopping the talking when there just wasn't anything worth left to say.

I told her I'd take the job. Told her thanks.

On my way out the door she called out my name and fluttered the copy of *Howl* across the room. "An advance against your salary," she said.

I put the book in my pocket and said thanks again.

"And one more thing, Bill?" she said.

"Yeah?"

"Beatnik girls don't go to hockey games."

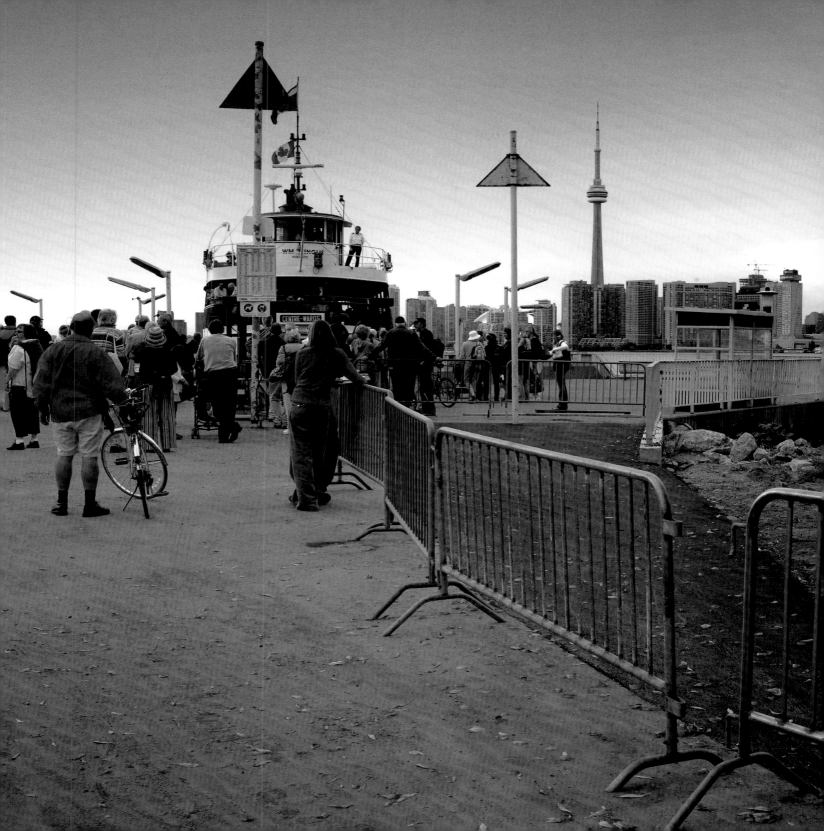

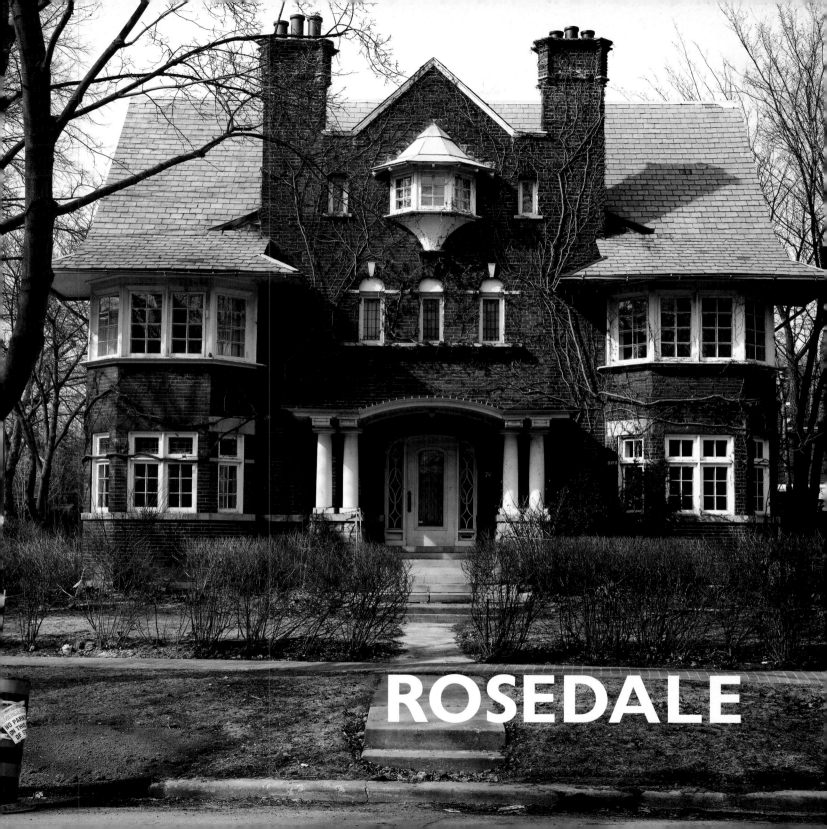

ROSEDALE

# Human Amusements

*Wayne Johnston*

She said that, now that we could afford it, we ought to buy a bigger house with a bigger yard, a house with "grounds," for that was the only way we'd get any privacy, but my father was against it, saying the house we had was big enough, especially now that there was no one living in the basement.

We could live in a nicer neighbourhood, my mother said, but my father said the one we lived in now was nice enough.

My mother said he was acting as if nothing had changed. We had bought this house because it was the sort of house we could afford back then, not because we thought it was the best house in the city. Now, as recent events had made plain, we needed to move.

My father said that, while it might not be the best house in the city, it was the only one he had lived in for the past ten years and therefore his favourite. He was just being sentimental, my mother said, not to mention stubborn. My father told her he had no interest in upward mobility, downward mobility, or even lateral mobility.

He realized, he said, that this would be a nuisance to those who operated guided tours, that, when they were conducting tours of the homes of the rich and the famous, getting to our house would involve quite a detour and they might have a tough time convincing people that we lived here, but that was their problem, he said, not ours.

He remembered the rich and famous from his childhood, he said, coming through his neighbourhood on that "Tour of the Homes of the Poor and Obscure" that had been so popular back then, gawking at him from the windows of the bus, taking pictures of him.

My mother wondered what he thought we should do with the extra money we were making. Burn it?

"Only when the furniture runs out," my father said.

"I'm serious," my mother said. When my father said that we should buy a better cat and

put behind us forever the days of having to make do with Cooper, my mother lost her temper. She wondered if it was making money, or her making money, that he objected to. My father nodded, humbly, penitently, as if, now that his secret was out, he might as well own up to it. He threw up his hands as if to say, "That's it, you've put your finger on it."

He was either jealous of her or ashamed of her, she said, she couldn't decide which. Perhaps he just didn't want to spend money made from something so crass as television, was that it?

My father said they should compromise. We would stay put, he said, but we would renovate, redecorate, refurnish, refurbish, remake, reconstitute, replace the house bit by bit so that, in the end, while we'd still be on the same site, not a stick of the old house would remain. That way, they'd both be happy.

My mother persisted, however. She said that, according to her real estate agent, with whom she had recently had a lengthy consultation, we were able to afford "something" in Rosedale.

"Rosedale," my father said. "Why in God's name would we want to live in Rosedale?"

"What's wrong with Rosedale?" my mother said.

"What's wrong with it? It's Rosedale, that's what's wrong with it," my father said.

"Could you be more specific?" my mother said.

"I'd feel out of place there."

"Why?"

"Why? Because the number of people in Rosedale who made their fortunes from substitute teaching is at an all-time low, that's why."

My mother said that, until we had taken a look around, we shouldn't rule anything out. So take a look around we did. On the weekends, we would go for drives around the city, wondering where we should live, looking for that elusive neighbourhood that both my parents liked. It reminded me of going hazard hunting in the early days of "Rumpus Room," the three of us in the car, my parents in the front, me in the back. My mother was still in the habit of looking back every so often as if to make sure

that I was still there. We could live anywhere we wanted to, my mother told me. According to her real estate agent, there was not a neighbourhood in Toronto that was not within our means.

"Just because we can afford a place doesn't mean that we should live there," my father said. It wasn't until our third time out that my mother got round to insisting that we take a drive through Rosedale, just to see what it was like, she said. We drove along Roxborough Drive, my mother and I craning our necks to get a glimpse of some tree-shrouded mansion while my father, as if he wouldn't deign to look, kept his eyes on the road. We took a wrong turn into what proved to be the driveway of a sprawling grey-brick house that, because of a palisade of blue spruce, was invisible from the street. The house did not come into view, in fact, until we were nearly upon it, not to mention nearly upon a family having a patio lunch beside their pool. There were some awkward moments while, under the scrutiny of a man wearing tennis whites, who had gotten up from the table and come a few steps forward,

my father turned the car around; there was room enough to turn a truck around, but my father manoeuvred as if we were in a tight spot, or rather, as if the tires of our car must not come into contact, must not be so presumptuous as to take liberties, with one more inch of this man's driveway than was absolutely necessary. I could hear the tires grinding gravel underneath, the brakes squeaking as my father turned the wheel. I could tell, just from looking at the back of her head, that my mother was mortified. I slumped down in the back seat and remained that way until, after alternating half a dozen times between forward and reverse, my father finally got the car pointed toward the street and we set off, at a kind of matter-of-fact, genteel pace, back the way we came.

My father's reaction surprised me, as it did my mother I think. I'd never seen him frantic with embarrassment before; in fact, I'd thought he lacked the capacity to be embarrassed. None of us said anything for quite some time. My father kept driving aimlessly through Rosedale, up one street, down another, but my

mother and I were no longer gawking at the houses.

"I don't want people like that thinking I wish I had what they have," my father said at last, as if one of us had just asked him to explain himself.

"What makes you think that's what he was thinking?" my mother said.

"I don't like being mistaken by someone like that for someone who gets some sort of pathetic, vicarious thrill out of driving through Rosedale on Sunday afternoons. I hate it when someone like that gets the wrong impression of me."

"I don't know what you mean by 'someone like that,'" my mother said. "You keep saying it, but I have no idea what you mean. And I'm sure he didn't get the wrong impression."

"Then who did he think we were, what did he think we were doing? Obviously, he would have assumed we'd come to gawk and gotten lost," my father said.

"We could have been visiting someone in the neighbourhood for the first time," my mother said. "Or we could have been doing what in fact we were doing, which was taking a look at Rosedale to see if we'd like to live here. It's not like the car would have made him think we were tourists or something. It's as good as any car you'll see around here, that's for sure."

"Oh, for God's sake, Audrey," my father said, "why do you care about what these people think?"

"You're the one who cares about what they think," my mother said.

"Do you really think that you — that we — could feel at home here?" my father said.

My mother replied that not everybody in Rosedale came from long-established families. There were people here like us, she said, self-made people who had been poor starting out.

"We were never poor," my father said.

"We were poor," my mother said. "But so were a lot of people who live here. Or at least their parents and grandparents were."

My father said that that was doubtless one of the standard lines that real estate agents fed the *nouveaux riches* to make them think they could be happy in a neighbourhood like Rosedale.

"All right, all right," my mother said, "we're not good enough for Rosedale, you've made your point."

"That's not my point and you know it," my father said. "People who win the sweepstakes don't live in Rosedale, why should we?"

"How do you know where they live?" my mother said, asking, as though as an afterthought, if that was how he viewed her accomplishments, as the equivalent of winning the sweepstakes.

"I was just talking about people who come into money unexpectedly," my father said.

"Well, anyway, there are plenty of other neighbourhoods left," my mother said, her tone clipped to signal that Rosedale was no longer a subject for discussion.

# The Swing in the Garden
*Hugh Hood*

I had to make my best speed home from school on Tuesday afternoons, arriving on our verandah at half past three, when I would find a large, heavy bundle of copies of the *Saturday Evening Post* lying at the door, tied with twine. I had two heavy canvas bags that I slung over either shoulder, sliding perhaps thirty magazines into each bag, which made a cumbersome load. I would pick up my little bike from the garage and set off. This wasn't a full-sized wheel, but a tiny thing of a type you never see any more, called a "sidewalk bike." It didn't, for example, possess a regular brake and hanger. The pedals kept going round no matter how, or at what speed you were pedalling, uphill, downhill. It wasn't a bad little contrivance at all. I rode it for thousands of miles, and it did me good.

I bicycled all the way back up to school to begin my deliveries on Garfield Avenue at the home of some ladies of the parish, friends of my mother, perhaps family connections in some obscure way, perhaps only companions in the Altar Society. They took both the *Post* and the *Journal*, but I only had to make *Journal* deliveries one week in four, to about twenty customers. From Garfield I swung up to Inglewood, and eastward along Inglewood to Hudson Drive where I had to negotiate a short steep ascent on the little bike, which had a very small sprocket, up to Rose Park, home of Mrs. Wickett, mother of nasty stinky Paul Wickett, the class tale-bearer, my customer farthest north. Back down Welland to Inglewood, jog right to the top of MacLennan and thence southward to the hill, riding on the sidewalk except at intersections, where I used to shoot down the nearest driveway ramp and dart across the street without dismounting as I ought to have done.

I crossed the tracks at the foot of the hill and went east along our street, disposing of five customers along our block; by now the bags would be lighter on my shoulders. I used to jettison one bag when I passed our house, over half the route completed. On Jean Street the Forbes family took both *Post* and *Journal*,

though Jakie used to complain sourly that he meant to go into magazine sales at any time and take the business away from me. At the corner of Glen Road, in former times, I had been wont to ring Mrs. Millen's doorbell, thinking that I might persuade her to take the *Post*; this gave me a chance to take a peek at Letty, who often sat in their living-room before a glass-fronted desk, doing her homework. Mrs. Millen took no interest in the periodical press of the day and never became a customer. I suspect that my gradual loss of interest in her fair daughter was mainly because of this obduracy; entrepreneurial instinct often supersedes passion.

I hustled south along Glen Road almost to the bridge, where I reached the southernmost point of my route, quite an extensive circuit, you see, from Rose Park Drive to Beaumont Road on the north shoulder of the tenebrous ravine that gave Glen Road its name. My grandfather Goderich and my uncle Philip were then sharing rooms in a big old house on Beaumont Road; they had the third floor to themselves, sitting-room, two comfortable bedrooms, kitchen of a sort,

bathroom. I looked forward to seeing either or both late Tuesday afternoon; they paid promptly for magazines and were otherwise kind, giving me a chance to rest for a bit, asking how things were over on Summerhill. After this respite, very late in the day, I pedalled hastily westward along Highland Avenue, sometimes passing Mr. Busdriver Smith as I sped along on the last bit of my route. I had a customer where Binscarth leads off from Highland, and another down in the valley on Roxborough Drive. Finally I'd climb back up the side of the ravine, on foot, pushing my little bike. I would turn in toward the west end of Highland, which wound in above Roxborough along the shoulder of the ravine, shaded by the graceful oaks that screened the house from the states of softball players and cricketers in the park. The Skaithe house stood well over toward the edge of the ravine. I had only one other call to make on my way home — at my best customers, who lived on St. Andrew's Gardens — and my feet would be moving slowly as I came to the polished weighty brass-and-black door.

The Skaithes were slow payers, would accept magazines for weeks, a maid coming to the door and receiving a *Post* and a monthly *Journal*, occasionally fumbling in her pocket for change, more often retreating into an invisible parlour to ask her mistress for silver if convenient. When I gave up the magazine route the year we moved to Moore Park they still owed me seventy-five cents; the sum is engraved in my memory. More indelibly marked there was a series of apparently chance encounters with Bea, cagily planned by me. It was no accident that I called on the Skaithes when I did. I knew young Bea would be hanging around outside at 5:15 or so, when it was warm spring.

On one particular afternoon, I sauntered up the walk on the alert for Bea; sure enough there she was, sitting with a tea-set spread out on the lawn beside a big shrub. I noticed that the lid had come off a tiny teapot and hidden itself in a depression beside the sidewalk. I picked it up and handed it to her with a flourish. I was almost nine.

I said, "Don't you ever go to the Beverly on Saturday? I never see you there." All at once I was overcome by a vision of Bea Skaithe running up the gangway with sponge taffy stuck in her lovely tresses, and I knew why she didn't go to the Beverly. She was too good for the place; this was inescapable.

She knew perfectly what and where the theatre was, "My mother would *never* let me go there," she said disdainfully. "Nobody on our street goes to the Beverly. It's just a *neighbourhood* theatre." Suddenly I could grasp that the Beverly smelt bad and didn't run the newest of films.

She said, "Sometimes my mother takes me to the Hollywood." A maid appeared in the doorway without my knocking.

"Time to come in now, Miss Beatrice," she said. This silenced me, and I followed her to the doorway, sliding a magazine out of my pouch and handing it to the maid. I didn't wait to try to collect. I felt obscurely crushed.

But there were always the kind, prompt-paying Angstroms who lived a few doors east of

MacLennan on the north side of St. Andrew's Gardens. They often gave me a cookie or offered a glass of milk. They had no maid; their street was leafy, relaxing, and all that time I half-sensed what I see so clearly now — why that peaceful treed street described the strange circlet with Douglas Drive that it did. St. Andrew's Gardens, which housed the friendly Angstroms and the red-haired Esther Bannon, must have been the primitive site of St. Andrew's College. Certainly. Of course. Removed to Aurora in the season of my birth, the school haunted the district in the name of a realtor's development. MacPherson. Chestnut Park. St. Andrew's Gardens. Highland (because lying above the ravine). Sighthill (because it ended at the brow of the hill above the tracks). They all meant something, concealed some historical secret, if only I knew where to look and what I might expect to find. Glen Road. Edgewood Crescent. Suddenly the names of streets I walked on daily took on resonances and tinklings, ringings, I would say tintinnabulations if it did not seem affected, of historical significance. Why Rowanwood? Why Douglas Drive? What allegiance to legendary Scottish hero was figured in the innocent suburban name? I am perhaps the only living man who remembers why Rumsey Road in Leaside is so called. What is happening to the city?

## Civic Square
*Scott Symons*

<u>Rosedale</u> That's right, D.R. —

where I write you now (WHERE ARE YOU? — you've never come back, nor even written — except after the party, to thank me). Back in <u>Rosedale</u> Heart of Pan-Canadian Snobland

Residence-Royal of the Family Compact (filthy dirty snotty lucrative oligops!) That's us, remember? Club for Squares, and Cubes, and Civic Squares
Real Apex of the Vertical Damned Mosaic (which ain't, we're told relentlessly, fair to Passed-Over Methodists — timid bastards shouting sweetly "hey, wait up for us, or we'll cut off your nuts")
National Seat of the IODE (a bloody big seat, too, fur-lined, by Creeds out of HBCO)

Social heartland of Canadianglicannity (Trinity College, B.S.S., U.C.C., as Finishing Schools — largely, aptly, for non-Anglicans; Anglicans don't need it)
<u>Rosedale</u>, has everything going for it.

Except the streets aren't straight, nor the brains.

Is last hangout of 19th century Canadian Romanticism, unimpeached. as yet picturesque Canada. Still, <u>Rosedale</u>

You can always count on an article or two a year, damning it. Laugh at the British Bourgeois Homes, conglomerated Gothic-Georgian Redbrick (unique in world; nowhere else quite like — must find out why, D.R.

but the funny part, about Rosedale I mean, is that so often now the very people who condemn it live here. You know whom I mean: Them. So many of the Bright Journalists and Glossy Mag Boys, the High By-Liners along with (their intellectual counterparts) the cantankrrous mass-mediated profs (and TV stars), That's it. The New Authorized Establishment (remember Them! — I'll bet <u>They</u> remember us!) — yup: Them's the ones as live here now in <u>Rosedale</u>, oddly enough.

Whereas someone like myself "poor chap, he meant well, good home — Rosedale you know, didn't live up" whose only been around this

block a bare century is disqualified (by these
aspirant new Snobs) I only come back here to
camp or spy (on Them) and hide (Joyce said
"exile and silence and cunning") while I recollect
myself and write. As now, from Chestnut Park ,
a street I know so well, oh every brick of
cobbled walk that now and then I trip up,
happily (snubbed toes but hommage paid to
cobblewalk), winds its carriage curved way
wheels left and right among these fluting roots
of Maple Elm and Chestnut trees top the great
round white- globed lights are really lamps
whose chastity the kids bash leaving fragile
cusps of glass litter the November strawbrown
grass silently through Rosedale abrupt opens
up on Roxborough St., the Esso sign,
Kernohan's, Toronto Subway and the 20th
century is cut off from Rosedale who is to me,
was Home — the whole damned piece of it, is
simply the great single garden wherein I grew till
school was a highroofed mansard tower and all,
a castle outside; and in, those lofty ceilings (war-

winters, no coal, our toes were cold for England
and were proud of it), and a green soft garden
walked by whiterobed women whose faces were
soft under the bleary Willows and beyond these,
the slender rise of Lombardy Poplars, was the
mural in Kindergarten where we first all met and
played clear as bell it all sings back in me

"Good morning little yellowbird
                                    yellowbird
good morning little yellowbird
             who are you?
My name is Johny Vireo Vireeoh Veeree oh
My name is Johny Vireo
             who are you?"

was Rosedale School is gone now replaced
by squat ground-box is incandescent bright
the New School and the New Curriculum
(Education is Progress is Power is Building for
a Better Future and better be glad of it — is get
OMSIP.)

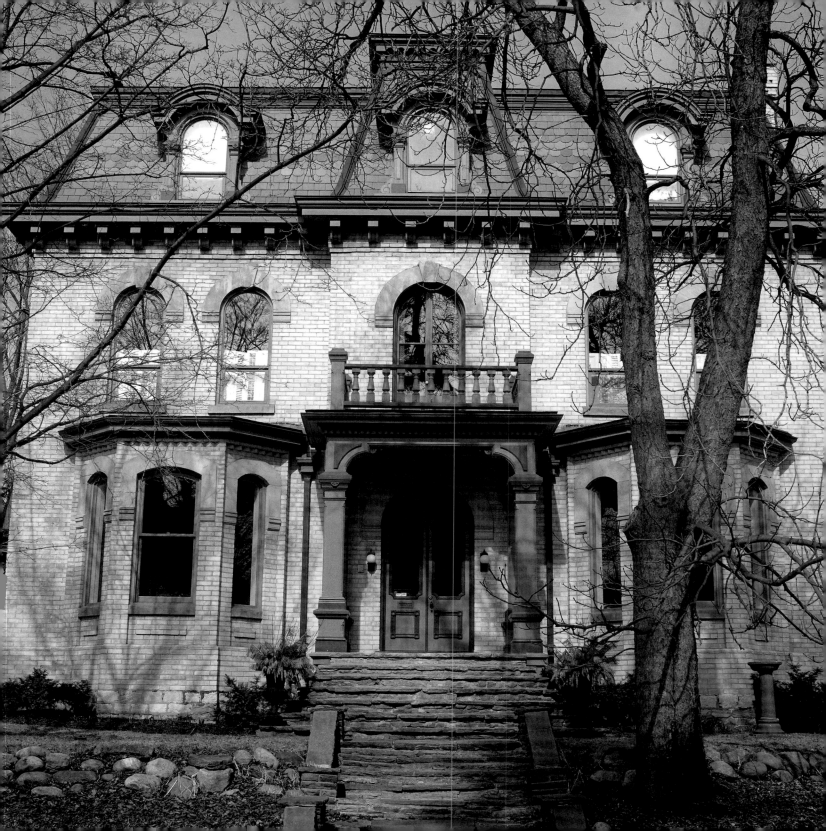

## The Wars
*Timothy Findley*

The 19th of December, 1915 was a Sunday. This was the day after Robert — and, indeed, a whole Canadian contingent — sailed for England. The Ross family went to church that morning, walking through the snow. Miss Davenport went with them. She was more and more a constant companion to Mrs. Ross — who was less and less a companion to her husband and her children. The walk through the snow wound them down Park Road and up through the gulley of wild ravine to the other side past Collier Street to Bloor. They emerged about a block from their destination — St. Paul's — where a piper was standing on the steps piping the worshippers in to the service. His presence meant that some regiment or other was on church parade that morning and the pews would be crowded with soldiers. Mrs. Ross was sorry for this. It meant the tone of the sermon would be militant and more than likely blood-thirsty.

Mr. Baldwin Mull — a neighbour somewhat dreaded for his temper and his habit of accumulating houses — preceded them along the sidewalk in his flowing beard and a tall black hat. Stuart made a snowball, taking off his mitts to warm it in his palm just long enough to let it form an outer coating of ice. As they neared the church, Mrs. Ross became increasingly irritated by the number of acquaintances gathered on the sidewalks and the steps. Miss Davenport wanted to take her arm, but Mrs. Ross refused. "If I fall down — I fall down," she said. Mister Ross heard this, but kept on walking. He and Peggy were busy nodding and smiling. Mister Ross kept raising his hat. Peggy always wore white gloves to church and she rested a white-gloved hand on her father's sleeve. The Rosses were dressed, quite naturally, in black and Mrs. Ross wore a veil that hid her expression but not her features. The Bennetts and the Lawsons, the Lymans and the Bradshaws, the Aylesworths and the Wylies were all there. And the Raymonds. (The Raymonds were Mrs. Ross's cousins and sisters.)

She hated them all. She hadn't before — when she was growing up. But now she did. The only decent person she knew was Davenport. Davenport gave away chocolate bars to soldiers leaning out of trains. When Mrs. Ross accompanied her and stood on the station platform it gave her the feeling she was mitigating bullets.

Standing on the steps, but not quite with her husband, Mrs. Ross eyed the congregation of men and women with whom she had been a child. They had all — she kept thinking — been *children* together. Why were they standing here in this snow, in these black, black clothes and blowing veils, listening to the wailing pipes and nodding at one another — shaking one another's hands as if to congratulate themselves that all their sons had gone away to die? Half the people here — or more — had sons like hers who were on those ships that had left St. John the day before.

Stuart's snowball was melting in his mitts. Mrs. Ross wanted to ask him why he didn't throw it. There were half a dozen people she

would like him to throw it at — but of course that was madness. Slowly, they all went in. A company of Toronto Scottish arrived and filed into their seats, taking up one whole section of the church. The choir came next and everyone stood. Something was sung. They litanized. They sat down — they stood up — they sang — they sat down — they knelt. *God this and God that and Amen.*

Mrs. Ross sat back.

Today, they would be spoken at by the Bishop. He spoke about those in peril at sea. He spoke about landfall. He spoke about flags and holy wars and Empire. He even had the gall to speak about Christmas. This was too much for Mrs. Ross. She stood up. Standing, she leaned down over Davenport's magenta hat and said: "I need you. Come." She pressed past Dorothy Aylesworth's knees and old Mrs. Aylesworth's shins and Mr. Aylesworth's gold-headed cane and made it to the aisle without falling down. Davenport followed and they made their way to the doors — Mrs. Ross walking on her heels to be sure that

everyone heard her and knew that she was passing. The Bishop paused, but did not give up the struggle ...

Out on the street again, Mrs. Ross sagged to the steps and sat in the snow.

"But — we can't sit here," said Miss Davenport.

"I can," said Mrs. Ross and did.

She even lighted a cigarette. Why should it matter? The only people passing were children — and they were all running after motorcars, slipping and sliding on the ice.

Mister Ross, Peggy and Stuart remained inside. Peggy had almost followed, but her father had restrained her. He was afraid for his wife but he knew it was neither himself nor her children that she needed. What she needed was an empty cathedral in which to rail at God.

Davenport sat on her squirrel stole. Her hands were already cold. Mrs. Ross reached inside her sable muff and drew out a silver flask. She drank and offered it to Davenport — but Davenport was afraid of censure, sitting so near the street, and she refused.

Mrs. Ross adjusted her veil but did not put the flask away. "I was afraid I was going to scream," she said. She gestured back at the church with its sermon in progress. "I do not understand. I don't. I won't. I can't. Why is this happening to us, Davenport? What does it mean — *to kill your children*? Kill them and then ... go in there and sing about it! What does that mean?" She wept — but angrily. A child in a bright red tam-o'-shanter stood at the bottom step and stared. Mrs. Ross looked away. "All those soldiers, sitting in there and smiling at their parents. Thank God and Jesus Robert didn't smile at me before he left — I couldn't have borne it." She put her hand on her forehead. The child was watching her intently and Mrs. Ross, in spite of the haze of brandy and the keen lightheadedness of her passion realized that the child was frightened to see her there — a grown-up lady, sitting on the steps in the snow with her furs thrown aside as if they were dead flowers. She realized she had to stand or else the child would think that she was mad — and the world had quite enough adults gone crazy as it was.

She put her hand out for Davenport. Davenport took it.

Mrs. Ross stood.

The child seemed pleased. In standing, reason was restored. She smiled.

Mrs. Ross looked down — throwing her furs across her shoulder — masking the flask and putting it back inside the muff. She treated the cigarette like something she'd found and looked at it much as to say: whatever made me think that this was mine? — and threw it away. "Where are your parents?" she said to the child.

"At home."

"But — should you be on the street alone?" said Mrs. Ross.

"We only live down there," said the child. "And I'm allowed to come and watch the people going in and out on Sundays."

"Oh," said Mrs. Ross. "Well — we're going in. Will you come with us?"

The child gave a look at Miss Davenport. The magenta hat was a little bit frightening since it had wings on either side — but the lady who'd been sitting in the snow had a veil and the little girl liked veils. They blew around your face like smoke. She nodded. Mrs. Ross put out her hand.

The three of them went in and stood at the back and just as they did, the whole congregation stood up and began to sing.

All people that on earth do dwell,
Sing to the Lord with cheerful voice.
Him serve with mirth, his praise forth tell.
Come ye before him and rejoice.

The band that had come with the soldiers played. The organ roared and bellowed. All the people sang.

Know that the Lord is God indeed;
Without our aid he did us make ...

Mrs. Ross tightened her grip on the child's hand to keep herself from singing; but in spite of that, the hymn rolled on.

We are his flock, he doth us feed,
And for his sheep he doth us take.

Somewhere during the last verse, a trumpet began to play. The silver notes wound upward in a high and desperately beautiful descant — gilding the vaulted ceilings — raising everyone's eyes, and even Mrs. Ross looked up to see where they had gone.

For why? The Lord our God is good.
His mercy is forever sure;

His truth at all times firmly stood,
And shall from age to age endure.

There was a long and echoing amen.
The child let go of Mrs. Ross's hand.
Mrs. Ross looked at the whole congregation and the Bishop far away in a haze of candlelight and the high, gold cross beyond. And all she could think was: *I was married here.*

Down on the floor, the snow from everyone's feet had melted. Mrs. Ross was forced to smile. Snowballs can't be made from water.

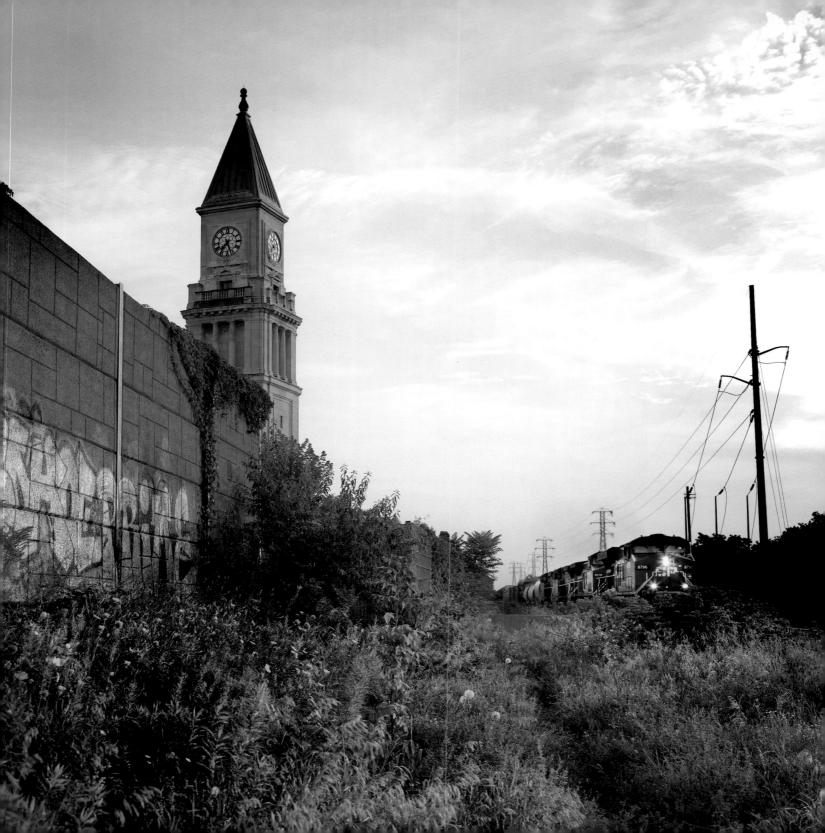

# The Glenwood Treasure

*Kim Moritsugu*

Rose Park is known for its trees. If you look at an aerial photograph of Toronto, you can easily spot, to the northeast of the grey sea of concrete and steel and glass that makes up most of downtown, the green island that is Rose Park. Or rather, the large, flattish hilltop on which Rose Park stands, separated from the surrounding area of the ravines that border it on four sides.

In the mid-nineteenth century, when the city was a small grid of neatly laid out streets clustered around the harbour and named after kings, queens and English market towns, Rose Park was a wooded area ten miles away where rich people built country houses. By the turn of the twentieth century, once-isolated estates had acquired closer neighbours in newly constructed manors. Soon, roads were laid that linked Rose Park to its environs, and bridges were constructed across the ravines. With access came development, the building of more houses, many grand enough to confirm the neighbourhood's reputation as an exclusive enclave, moneyed enclave. Emphasis on old establishment money, of my father's kind.

Dad is a third-generation lawyer. He grew up, as did generations of Morrisons before him, in the large house where he now lives with my mother, a like-minded import from Connecticut. More than a handful of my father's childhood friends still live nearby — fair-skinned, blue-eyed men who attended the same private schools as Dad, summered in the same lake district up north, belong to the same private clubs, support the same political party. But Dad and his ilk aren't the sole inhabitants of the neighbourhood. For every stretch of ravine-lot mansions with multiple car garages (and coach houses), there are a few blocks of modest, 1920s-era four-bedroom boxes. A short retail strip features railroad flats above the few stores. And here and there, on Rose Park's outer, lesser streets, are small one-storey, never-renovated houses built as workers' cottages, some the size of a one-bedroom apartment.

Rose Park is not as homogenous as it may seem, is what I'm trying to say, except when it comes to trees. The trees are everywhere.

## Dawn Raid on Darkest Rosedale

*Harry Bruce*

It is one of those mornings of sudden insomnia that occasionally afflicts everyone past the age of twelve. I am asleep and, then, I am awake. I'm lying there in the darkness and knowing that, even though it's still an hour before dawn, I haven't the remotest chance of falling back to sleep.

So I arise, stuff some bread and cheddar in a pocket and, long before the morning-paper boy has left his kitchen, I am out among the empty streets on a private mission of discovery.

The eastern sky still fails to show the slightest evidence that there's any sunlight closer than the Gobi Desert, but I decide to await the dawn anyway and, then, to invade Rosedale and Moore Park. I will strike at their very heart or, rather, their mutual soft underbelly.

This point of vulnerability is the C.P.R. right-of-way that carries house-shaking freights across the town and, at the same time, separates Moore Park from Rosedale, thereby helping to protect each one from the cultural contamination of the other.

I head for the bridge that crosses Yonge just south of the Summerhill subway station. On the west side of Yonge there's a lighted billboard on which a gargantuan Edie Adams tries to peddle me a cigar. She shrugs her delicate, naked, six-foot-wide shoulders in a deliberately suggestive way, arches her luscious, foot-wide lips, and asks me, "Why don't you pick one up and smoke it some time?"

But I avert my eyes and scramble grimly up the steep embankment behind her to a great black field of railway tracks. Immediately I slip along, snake-like, among the green and red lights that sit beside the rails, keeping among the shadows, moving eastward in the cold and the darkness.

And then — almost before I can duck behind the parked boxcar that says, "Ship it on Frisco!" — I hear behind me a huge freight train coming, this Jack Dempsey of the railroad industry, and it is rattling its way up out of the western night in search of the eastern morning.

Its headlight is brutally white and the noise it makes is enough to drive most commando scouts back to the idle pleasures of Edie Adams. But I hang in there, doing the work I know best, secretly documenting these gigantic wagons as they hurtle toward their thunderous penetration of Rosedale: New York Central ... Norfolk & Western ... Rock Island ... Wabash ... Erie ... Santa Fe ... Union Pacific ... Green Bay & Western ... Chicago & Eastern Illinois ... The Soo Line ... The Burlington Route ("everywhere west") ... hundreds upon hundreds of innocent new trucks and automobiles ... 120 railroad cars, counting the caboose ... thousands of tons, millions of dollars ... and there it all goes, ripping along, testing the bridges, shaking people's beds, turning on Rosedale coffee-pots, and bringing on the morning! It was a great train.

And now that it has passed, I can see a precise line of fiery pink slicing across the clouds of night that sit over Rosedale's horizon.

I'm going swiftly over a bridge that was not designed for pedestrians. It crosses a ravine that's so deep the trees in the darkness below look like cauliflowers, and a stone slanting off toward the whispering stream takes as long to fall as if it were on a parachute. Way off to the south, I hear a lot of sirens getting together to correct something sad.

I linger for a few seconds above Mount Pleasant Road within spitting distance of a northbound taxi and a southbound taxi, and then I plunge eastward again.

On my right there are the back doors of Summerhill Avenue. An old man opens a refrigerator door. A girl sips coffee at a kitchen table. A youth in a blue track-suit jogs down the street toward some kind of distinction. I can hear crickets, and right here in Rosedale, right up against the railroad fence, I discover a white wooden farm-house with green trim, and washing on the line.

On my left, the Moore Park side, there's a row of perfect poplars but these soon give way to a hill that crowds the track.

The hill is so densely wooded that in places it's impossible to see any sign of the rich men's houses up above.

It is a cloudy dawn but the beautiful violence of colour in the trees — the rich, running explosion all along the northern edge of the track — seems to invest the entire sky with a fresh, pearly-pink light. There are a lot of shifty squirrels among the trees, and the squealing of what sounds like birds of the Amazon.

I pass two signs that advise westbound trains they're entering North Toronto, and continue on through the gathering light, past old grocery boxes, a broken hockey stick, a rotten bedroom slipper, a nest of liquor bottles, a dead bird, a ten-year-old licence plate and all the other junk that tends to collect in the path of trains.

But soon I am out on another railroad trestle, above another gaping ravine. I can see the fat backs of pigeons flying below my feet, and the whole sweep of the ravine — this gorgeful of awful, shattering, fantastic colour in which the trees are incredibly distinct and, together, become all the romantic music I've ever heard.

I decide I'll never get that city ravine down properly and, besides, a few moments ago a Rosedale burgher gave me a highly unfriendly look. I was merely peeking hungrily into his kitchen window from a strategic spot on the tracks, but I imagine that, even now, the local security forces are bringing out the dogs.

I climb a nasty wire fence, slope down a brown meadow, and find myself at Bayview Avenue. I grab a bus, vanishing as stealthily as I came, and return to the safety of my bedcovers. It is 8 a.m.

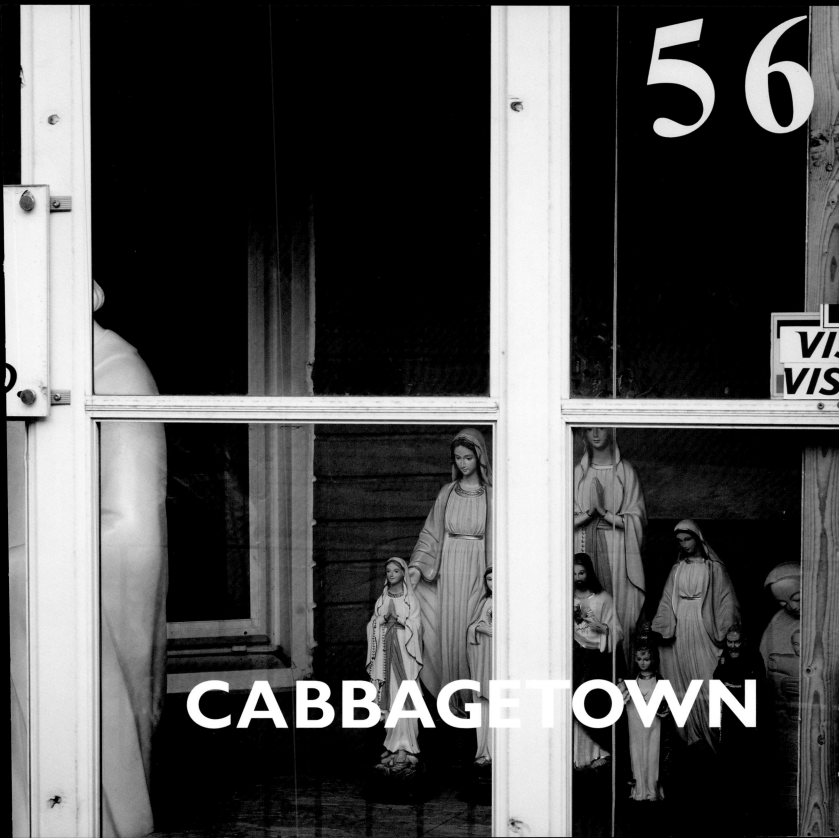

56

CABBAGETOWN

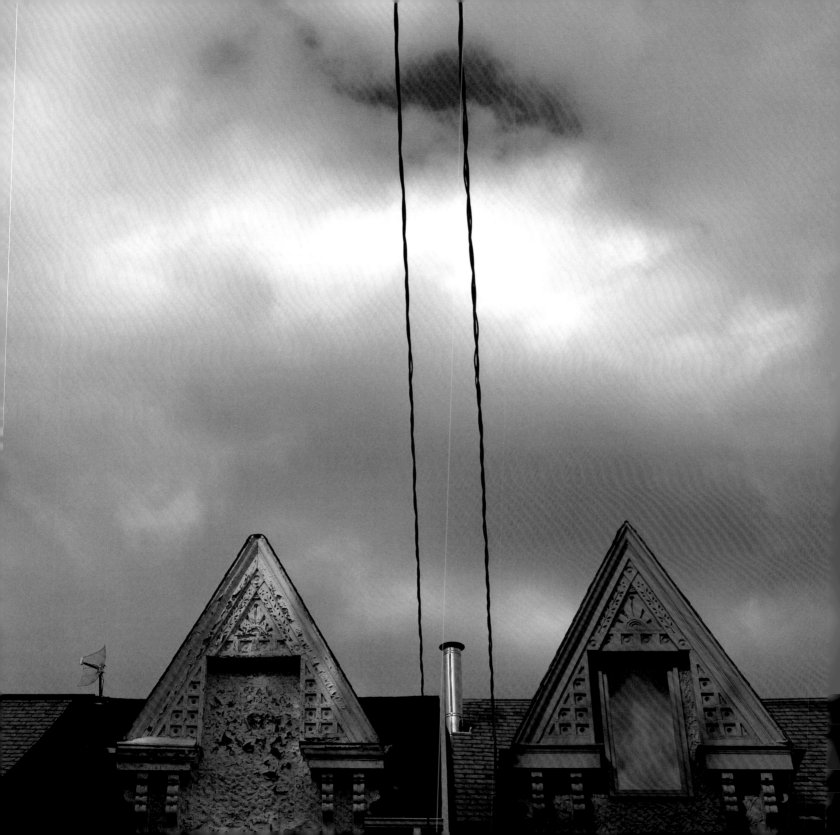

# Cabbagetown Diary:
# A Documentary

*Juan Butler*

Allan Gardens — quite a place to go if there's a lousy show at the movies. It's a slum park, and by that I mean a city block of grass, trees, benches, a drinking fountain and a hothouse beside the public toilets, full of plants and flowers — all that right in the middle of the worst slum in Toronto. The people in Cabbagetown (they say Cabbagetown got its name because the first people to come here were Irish, whose love of boiled cabbage and potatoes is second only to their love of booze) all flock to the Gardens when the midday heat starts driving them out of their grimy little rooms, and by one in the afternoon the place is so full you can hardly see the grass you're stepping on. But even so, it's still better than sitting in some greasy restaurant or frying your feet on the sidewalk.

I live only about a block away from the park, but by the time I get there, my forehead is covered in sweat and fishes could swim in my armpits. Jesus, now I know what Lawrence of Arabia felt like!

And then, what should I see parked on this side of the Gardens but an ice cream truck. I think of cold, creamy Eskimo Pies, and realize that I'm damn thirsty. But when I get there, the truck is surrounded by about ten million dirty kids all yelling at the same time at the driver, who's going mad handing out ice creams as fast as he can scoop them up. Oh well, water's better than nothing. If I don't die of sunstroke on the way over to the fountain.

"Yes. I have sinned, brothers and sisters." That must be Preacher Mouth over there. Hard to tell, though, until I get closer cause there's quite a crowd around him today. "I have drunk myself stupid with cheap red wine ...!" It's the Mouth all right. Nobody else has that booming voice, that face like a slab of raw meat, or that belly the size of a barrel. "I have taken God's name in vain —"

Behind him, his wife, a tall, thin woman with shadows under her eyes and a little pot gut,

stands glaring at the sinners, holding a placard above her head which reads.

REPENT NOW
BEFORE
IT'S
TOO LATE.

If you turned her sideways, she'd look like a pregnant twig.

"— and fornicated with evil —" "Amen," screeches the twig. "Amen," mumbles an old man, no longer able to fornicate. "Amen," echoes a fat woman, wondering what fornicated means.

"— evil women possessed by Satan's lust." roars the Mouth, his eyes threatening to pop out of his head.

"I still do!" roars back a wino who obviously knows what fornicated means. He's sitting with half a dozen buddies under a big pine tree some ten feet away from Preacher Mouth's group of sinners, all drinking themselves stupid out of a giant-sized Coke bottle filled with cheap red wine. They're having a ball drinking that rotgut like it's going out of style and cutting up the Preacher whenever he shuts up to get his breath. Maybe they're having too good a time, for one of them, who hasn't stopped laughing for at least five minutes, suddenly falls to his side and flakes out. The others all cheer. One less mouth at the bottle. I take a good look at him: his face is as filthy and grey as the rags he's wearing, and except for the spit on his beard, you'd never know where his mouth was. Better things than being a bum, I suppose.

"I smoked cigarettes till my soul was black with nicotine!"

I light a fag and watch a couple of old guys playing chess. They're both bent over the board, and looking at them you'd never guess they're surrounded by howling kids, roaring preachers and almost on top of them, a group of Indians yelling out songs at another Indian who holds a guitar in his hands. He has a funny look on his face, and when I get closer, I see it's because he's one-eyed. A real cool, one-eyed Indian. He waits until they all tell him what they want him to

play, and then he plays something none of them has asked for. Every so often he lets out a loud "yippee" and the whole tribe echoes him.

"Yippee! Yippee!"

A real fat chick, so white it's only by her eyes you can tell she's Indian, starts to dance to One-eye's song, a fast Country and Western, but man, she's so fat that all she can do is shake her big boobs around until it looks like they're going to pop right out of her blouse. This really gets the tribe worked up.

"Go, baby, go!"

"Shake them knockers, honey!"

"Yippee! Yippee!"

But, goddammit, they don't fall out, and when the song ends she sits down on the grass, her face and shoulders gleaming with sweat, mouth wide open, breathing in fast, painful gasps, her breasts still bouncing around in her blouse. I feel like telling her not to worry, that even though she'll never make a go-go dancer, the TV could always use her if Flipper got sick. But I don't feel like getting tomahawked by the rest of the tribe, so I keep my advice to myself.

On one of the benches near the fountain a drunk woman is yelling at a passing European family: "You bunch of wops, you think you own the country." A joe sitting beside her puts his hand on her shoulder, hoping to shut her up.

"Take your hands off me, you lousy creep. You guys only think of one thing all the time."

Poor joe, if I was him I'd have put my hand in her yap, knuckles and all. The Europeans (they can't be wops cause none live here in Cabbagetown), all dressed up in their Sunday best, don't even look in her direction. After all, they may not speak English too good, but they got their dignity.

"Lousy wops!"

She burps at them and turns towards the joe, who still has his hand on her shoulder. "Hey honey, you got any beer at your place? We can go over there and have a good time."

"We drunk it all last night, baby," he replies.

"No more beer?" She looks as if she's going to cry.

"Well then, take your frigging paw off me, I told you once already." She slaps at his hand and

gets to her feet, swaying from side to side. "I see Jim over there. I bet he's got some beer."

Now it's the joe who looks like he's going to cry.

"Hey Jim!" she yells in a voice hoarse from years of drinking. You know what I mean, like a car without a muffler.

"Hey Jimmy!" she yells again, stumbles forward a few feet, and crashes on top of a sleeping hippie.

"You're not Jimmy," she mumbles at the surprised hippie, who's trying to get himself out from under her, but she passes out on top of him, and as far as the hippie's concerned, that's the end of his trip this afternoon.

I finally reach the fountain and drink that ice-cold water till I think I'm going to burst. Christ, it feels good, pouring down my throat and splashing over my face and arms. You can really get thirsty watching people.

# Cabbagetown
*Hugh Garner*

With the spring Cabbagetown came outdoors again, and the streets were alive in the evenings with the noise of children. The little girls began their skipping, afraid as yet to do Double Dutches or Salt, Vinegar, Peppers, content to start again with the old single slow-moving ropes.

On Myrtle Street a man placed four heavy pine stakes around his hankie-sized lawn and pulled taut a piece of light wire to keep the children off the new-sown grass. On Upland Street four boys were playing bicycle polo, their crude mallets aimed at an indiarubber ball, and threatening with every swing to tangle themselves in their opponents' wheel spokes. In the public schoolyard a softball game was in progress before a noisy juvenile audience, while a few men leaned on the wire fence and watched the game. Two young men in shirtsleeves were peering under the hood of an old car. One of them had a long screwdriver in his hand and he was arguing and making gestures as he pointed with it at the engine.

In Timothy Place Mrs. Wells, who lived at No. 7, was holding forth to an audience of two other women about the price of foodstuffs, potatoes in particular. "How them buggers expects us to live with them kind of prices, I don't know. A few years ago you could have got three pecks for that money." One of the women turned and chased her little girl into the house before Mrs. Wells really got started on her blasphemous tirade. The other woman, small, tired looking, and wearing a long black skirt and buttoned boots, was nodding as she tried unsuccessfully to get a word in.

Some little boys were threatening to jump into the girls' skipping rope, and the girls were screeching and attempting without success to grab them and push them away. The Gaffeys' simple-minded son sat on his front steps, smiling vacantly at the children. His clothes were clean and neatly pressed, and his thin blue-veined hands clutched at his knees as if

with sudden pain or effort, while his oversized head rolled on his shoulders.

At the corner a group of boys and older youths lolled against an empty store-front, smoking cigarettes and testing their new-found strength against each other — the bigger boys grabbing the younger ones and twisting their arms to make them cry "Uncle!" or trying to trip one another to the sidewalk. A fruit pedlar getting rid of the last of his stock came slowly up the street, noticed the gang of boys, and mounted his wagon and drove by as quickly as his old horse could take him.

# Any Known Blood
*Lawrence Hill*

The Pembroke Street rooming house wasn't clean, or quiet, or well lit. You could poke a pencil through holes in the wall. My father took a room with a dresser, a bed, a desk and chair, a rug, a washbasin and hot plate, and a view of the street. Langston used a quiet but unrelenting poor-student routine to get Betty Sears to drop her rent to thirty-five dollars a month and to let him delay the first month's payment until the eagle shat.

Pembroke Street was downright seedy, and the rooming house was no less so. A prostitute lived in one of the rooms. A string bassist lived in the basement. He practised till one or two every night and never got up before noon and subsisted on crackers, sardines, cigarettes, and beer. Two of the residents were on welfare. Winos slept on benches down the street. Langston concluded that in Baltimore or in D.C., Pembroke Street would have been a black ghetto. But here in Toronto, Pembroke Street was predominantly white. There were a few blacks, but they didn't seem any more beaten up than the others. So where did black people live, anyway?

Langston had no money for streetcar fare, so he walked everywhere. Every day, he headed up Jarvis Street and along Wellesley to the university — and he walked a good deal farther in search of black neighbourhoods. The only one he could find ran west of Bathurst, between King and Queen streets. It was by no means a black area, but Langston was likely to bump into one or two black people as he walked there. On Bloor or Yonge, however, he could walk all day without seeing one black face. That was a strange feeling, indeed. It made Langston feel as if he were truly living in a foreign country, but it wasn't really another country at all — it was just Canada.

## The Store Was Our Home

*J.V. McAree*

Cabbagetown is not to be found on maps nor is it described in surveys. There may have been something slightly illegal about it, which would not lessen the attachment to it of those who lived there some sixty, seventy or eighty years ago. The word was applied to that part of Toronto lying south of Gerrard Street, north of Queen and east from Parliament Street to the Don.

Claims to have been old citizens of Cabbagetown put forth in later years by persons living beyond these boundaries have been properly disallowed and resented. The name was taken from the vegetable itself. In this area, which must have covered a couple of hundred acres, nearly every back yard was a garden of sorts and cabbages were the product most striking to the eye.

The people were mostly of English, Irish and Scottish descent. None of them were rich in those far-off days. Most families were glad to add to the yearly income the sale of fruits and vegetables that could be preserved or stored for winter use. Cabbages we must assume were easily grown, and when growing they had a lush and vigorous appearance which appealed strongly to the residents. Or, it may be that one of the early settlers began growing cabbages and thus set the fashion for those who came later.

# Reservoir Ravine
*Hugh Hood*

Instead of sauntering along Wellesley Street to the walls of the convent — destination suitable for one of very tender years — she would turn south, march deliberately down Sackville, looking around her as she went and drinking in appearances she'd never taken note of before: the fine solid dark-red brick of many of the houses and small stores, an air of the classically European hanging over them, an elusive flavour of Dublin. She knew that her own street took its name from one of the principal streets of the Irish capital, and ultimately from the family name of an ancient noble house.

Ishy couldn't conceive of her own house as an ancient noble house, exactly, but she imagined it as perdurable, homelike, stable, elegant in its way. One of a terrace of five running almost the length of her native block on Sackville, on the east, the sunny side, the middle unit of the five, her home was always warm, an easy house to heat, her father invariably remarked. Immensely roomy, high-ceilinged, a room-and-a-hall wide, like so many Toronto houses of the day, it had three storeys, the uppermost with mansard roof and tremendously pleasing arched window frames, wrought-iron railing topping the whole length of the terrace. A full-bellied bay window projected forward beside the verandah and doorway, rising the full three storeys and conferring much afternoon sunlight upon the floors and walls of broad interiors.

It was much too large a place for the three of them, her mother always maintained; they could have done with much smaller quarters on one of the newer side streets directly to the north, perhaps a workman's cottage on Amelia Street or Metcalfe. But no. Papa required a workshop for his handicrafts, and as the family was enjoying a fitful burst of prosperity at that time, the expense of the large house, rented as all their accommodation was when Ishy was growing up, seemed justifiable. Papa Archambault was at this time employed as a temporary or "supply" teacher by the Board of Education, teaching French to students of Jarvis Collegiate Institute,

ten minutes' walk from his home. He did not run a car, lived very modestly, never saved anything and preferred to indulge himself, his much-cherished wife, and the daughter whom he loved so deeply that he could never really express his feelings, with the tenancy of a house almost demonstratively large. The rooms were many, spacious, beautifully warm — the centre of the terrace received much of the benefit of the other houses' furnaces — ornamented with plaster mouldings and medallions which were picked out in soft, pleasing blues and greens.

Isabelle never forgot the luxurious feeling of room to stretch, room to spare, which life on Sackville Street supplied. She came very slowly to understand that the sense she had grown up with of ease, comfort, time to relax, absence of the impulse to rebel in any but the smallest matters: the wearing or leaving-off of her corset, the colour of her hose, was a perhaps delusive notion of ease. Her father had no possessions and no prospects. He spent all he had on room to live.

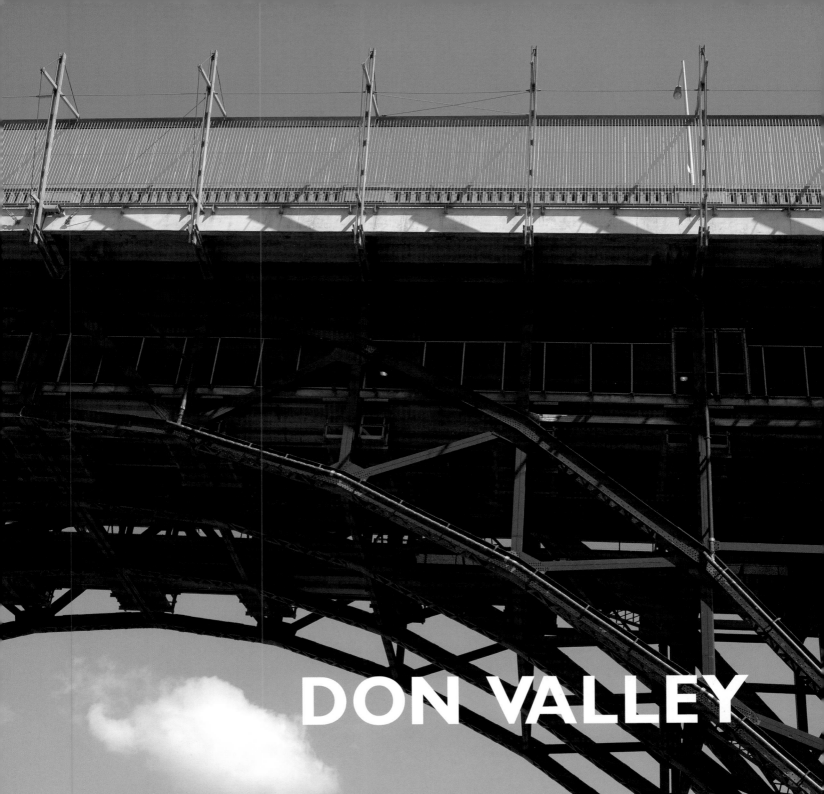

DON VALLEY

# In the Skin of a Lion
*Michael Ondaatje*

The bridge goes up in a dream. It will link the east end with the centre of the city. It will carry traffic, water, and electricity across the Don Valley. It will carry trains that have not even been invented yet.

Night and day. Fall light. Snow light. They are always working — horses and wagons and men arriving for work on the Danforth side at the far end of the valley.

There are over 4,000 photographs from various angles of the bridge in its time-lapse evolution. The piers sink into bedrock fifty feet below the surface through clay and shale and quicksand — 45,000 cubic yards of earth are excavated. The network of scaffolding stretches up.

Men in a maze of wooden planks climb deep into the shattered light of blond wood. A man is an extension of hammer, drill, flame. Drill smoke in his hair. A cap falls into the valley, gloves are buried in stone dust.

Then the new men arrive, the "electricals," laying grids of wire across the five arches, carrying the exotic three-bowl lights, and on October 18, 1918 it is completed. Lounging in mid-air.

The bridge. The bridge. Christened "Prince Edward." The Bloor Street Viaduct.

During the political ceremonies a figure escaped by bicycle through the police barriers. The first member of the public. Not the expected show car containing officials, but this one anonymous and cycling like hell to the east end of the city. In the photographs he is a blur of intent. He wants the virginity of it, the luxury of such space. He circles twice, the string of onions that he carries on his shoulder splaying out, and continues.

But he was not the first. The previous midnight the workers had arrived and brushed away officials who guarded the bridge in preparation for the ceremonies the next day, moved with their own flickering lights — their candles for the bridge dead — like a wave of civilization, a net of summer insects over the valley.

Taylor's Hill, but every month brought its food and its foes. The Mad Moon brought madness, solitude, and grapes; the Snow Moon came with rosehips; and the Stormy Moon brought browse of birch and silver storms that sheathed the woods in ice, and made it hard to keep one's perch while pulling off the frozen buds. Redruff's beak grew terribly worn with the work, so that even when closed there was still an opening through behind the hook. But nature had prepared him for the slippery footing; his toes, so slim and trim in September, had sprouted rows of sharp, horny points, and these grew with the growing cold, till the first snow had found him fully equipped with snow-shoes and ice-creepers. The cold weather had driven away most of the hawks and owls, and made it impossible for his four-footed enemies to approach unseen, so that things were nearly balanced.

His flight in search of food had daily led him farther on, till he had discovered and explored the Rosedale Creek, with its banks of silver-birch, and Castle Frank, with its grapes and rowan berries, as well as Chester woods, where amelanchier and Virginia-creeper swung their fruit-bunches, and checkerberries glowed beneath the snow.

He soon found out that for some strange reason men with guns did not go within the high fence of Castle Frank. So among these scenes he lived his life, learning new places, new foods, and grew wiser and more beautiful every day.

in the air; the height saved them from foes on the ground, and left them nothing to fear but coons, whose slow, heavy tread on the limber boughs never failed to give them timely warning. But the leaves were falling — every month its foes and its food. This was nut time, it was owl time, too. Barred owls coming down from the north doubled or trebled the owl population. The nights were getting frosty and the coons less dangerous, the mother changed the place of roosting to the thickest foliage of a hemlock-tree.

Only one of the brood disregarded the warning "*Kreet, kreet.*" He stuck to his swinging elm-bough, now nearly naked, and a great yellow-eyed owl bore him off before morning.

Mother and three young ones now were left, but they were as big as she was; indeed one, the eldest, he of the chip, was bigger. Their ruffs had begun to show. Just the tips, to tell what they would be like when grown, and not a little proud they were of them.

The ruff is to the partridge what the train is to the peacock — his chief beauty and his pride. A hen's ruff is black with a slight green gloss. A cock's is much larger and blacker and is glossed with more vivid bottle-green. Once in a while a partridge is born of unusual size and vigour, whose ruff is not only larger, but by a peculiar kind of intensification is of a deep coppery red, iridescent with violet, green, and gold. Such a bird is sure to be a wonder to all who know him, and the little one who had squatted on the chip, and had always done what he was told, developed before the Acorn Moon had changed, into all the glory of a gold and copper ruff — for this was Redruff, the famous partridge of the Don Valley.

IV

One day late in the Acorn Moon, that is, about mid-October, as the grouse family were basking with full crops near a great pine log on the sunlit edge of the beaver-meadow, they heard the far-away bang of a gun, and Red found him once more in the Mud Creek Glen, but absolutely alone.

V

Food grew scarce as winter wore on. Redruff clung to the old ravine and the piney sides of

# Wild Animals I Have Known
*Ernest Thompson Seton*

Cuddy lived in a wretched shanty near the Don, north of Toronto. His was what Greek philosophy would have demonstrated to be an ideal existence. He had no wealth, no taxes, no social pretensions and no property to speak of. His life was made up of a very little work and a great deal of play, with as much outdoor life as he chose. He considered himself a true sportsman because he was "fond o' huntin'," and "took a sight o' comfort out of seein' the critters hit the mud" when his gun was fired. The neighbours called him a squatter, and looked on him merely as an anchored tramp. He shot and trapped the year round, and varied his game somewhat with the season perforce, but had been heard to remark he could tell the month by the "taste o' the patridges," if he didn't happen to know by the almanac. This, no doubt, showed keen observation, but was also unfortunate proof of something not so creditable. The lawful season for murdering partridges began September 15th, but there was nothing surprising in Cuddy's being out a fortnight ahead of time. Yet he managed to escape punishment year after year, and even contrived to pose in a newspaper interview as an interesting character.

He rarely shot on the wing, preferring to pot his birds, which was not easy to do when the leaves were on, and accounted for the brood in the third ravine going so long unharmed; but the near prospect of other gunners finding them now, had stirred him to go after "a mess o' birds." He had heard no roar of wings when the mother-bird led off her four survivors, so pocketed the two he had killed and returned to the shanty.

The little grouse thus learned that a dog is not a fox, and must be differently played; and an old lesson was yet more deeply graven — "Obedience is long life."

The rest of September was passed in keeping quietly out of the way of gunners as well as some old enemies. They still roosted on the long thin branches of the hardwood trees among the thickest leaves, which protected them from foes

a fine sight & a study for flame & smoke from our House. At night the flames diminished & appeared like lamps in a dark night in the Crescent at Bath.

*27th*    I walked below the Bay & Set the other side of the Marsh on fire for amusement. The Indians have cut holes in the Ice over which they spread a Blanket on poles & they sit under the shed moving a wooden Fish hung to a line in the water by way of attracting the living fish, which they spear with great dexterity when they approach. The Gov. wished me to see the process, we had to walk half a mile to the place. There was no snow on the ice & we were without cloth Shoes. The Gov. pushed a large limb of a tree before him which kept him steady & with the assistance of Mr. Talbot I reached the spot where they were catching Maskalonge (a superior kind of Pike) and Pickerell. I was almost frozen from looking on, though the apprehension of falling kept me warm while I walked.

## Life at York

*Elizabeth Simcoe*

*York 14th of Jan. 1784*    There is a great deal of Snow on the River Don which is so well frozen that we walked some miles upon it today, but in returning I found it so cold near the Lake that I was benumbed & almost despaired of ever reaching my own house & when I came near it the Hill was frightfully slippery. Near the river we saw the track of Wolves & the head & Hoofs of a Deer. The workmen who reside in a small Hut near the place, heard the Wolves during the night & in the Morning found the remains of the Deer. The Indians do not kill Wolves, they seldom take trouble that does not answer to them, & the Wolves are not good to eat & their skins are of little value.

*Jan. 18th*    The Queen's Birthday. The weather so mild we breakfasted with the Window open. An experiment was made of firing Pebbles from Cannon. A Salute of 21 guns & a Dance in the Evening in honour of the day. The Ladies much dressed.

*Sunday 19th*    The weather so pleasant we rode to the bottom of the Bay crossed the Don which is frozen & rode on the Peninsula, returned across the Marsh which is covered with ice & went as far as the Settlements which are near 7 miles from the Camp. There appeared some comfortable Log Houses inhabited by Germans & some by Pennsylvanians. Some of the creeks were not frozen enough to bear the Gov.'s horse but mine passed very well. He excells in getting over difficult places, & in leaping over Logs which I like very much.

*25th*    Two soldiers went to Niagara. These Expresses are to go at regular periods by way of a Post.

*26th*    We went to the Donn to see Mr. Talbot skait. Capt. Shaw's Children set the Marshy ground below the Bay on fire the long grass on it burns with great rapidity this dry weather. It was

arm. A sway in the wind. She could not speak though her eyes glared at him bright, just staring at him. *Scream, please.* But she could not.

During the night, the long chutes through which wet concrete slid were unused and hung loose so the open spouts wavered a few feet from the valley floor. The tops of these were about ten feet from him now. He knew this without seeing them, even though they fell outside the scope of light. If they attempted to slide the chute their weight would make it vertical and dangerous.

They would have to go further — to reach the lower-deck level of the bridge where there were structures built for possible water mains.

*We have to swing.* She had her hands around his shoulders now, the wind assaulting them. The two strangers were in each other's arms, beginning to swing wilder, once more, past the lip of the chute which had tempted them, till they were almost at the lower level of the rafters. He had his one good arm free. Saving her now would be her responsibility.

Some of the men grabbed and enclosed them, pulling leather straps over their shoulders, but two were still loose. Harris and Pomphrey at the far end looked on helplessly as one nun was lifted up and flung against the compressors. She stood up shakily and then the wind jerked her sideways, scraping her along the concrete and right off the edge of the bridge. She disappeared into the night by the third abutment, into the long depth of air which held nothing, only sometimes a rivet or a dropped hammer during the day.

Then there was no longer any fear on the bridge. The worst, the incredible had happened. A nun had fallen off the Prince Edward Viaduct before it was even finished. The men covered in wood shavings or granite dust held the women against them. And Commissioner Harris at the far end stared along the mad pathway. This was his first child and it had already become a murderer.

The man in mid-air under the central arch saw the shape fall towards him, in that second knowing his rope would not hold them both. He reached to catch the figure while his other hand grabbed the metal pipe edge above him to lessen the sudden jerk on the rope. The new weight ripped the arm that held the pipe out of its socket and he screamed, so whoever might have heard him up there would have thought the scream was from the falling figure. The halter thulked, jerking his chest up to his throat. The right arm was all agony now — but his hand's timing had been immaculate, the grace of the habit, and he found himself a moment later holding the figure against him dearly.

He saw it was a black-garbed bird, a girl's white face. He saw this in the light that sprayed down inconstantly from a flare fifteen yards above them. They hung in the halter, pivoting over the valley, his broken arm loose on one side of him, holding the woman with the other. Her body was in shock, her huge eyes staring into the face of Nicholas Temelcoff.

*Scream, please, Lady*, he whispered, the pain terrible. He asked her to hold him by the shoulders, to take the weight off his one good

One night they had driven there at eleven o'clock, crossed the barrier, and attached themselves once again to the rope harnesses. This allowed them to stand near the edge to study the progress of the piers and the steel arches. There was a fire on the bridge where the night workers congregated, flinging logs and other remnants onto it every so often, warming themselves before they walked back and climbed over the edge of the bridge into the night.

They were working on a wood-facing for the next pier so that concrete could be poured in. As they sawed and hammered, wind shook the light from the flares attached to the side of the abutment. Above them, on the deck of the bridge, builders were carrying huge Ingersoll-Rand air compressors and cables.

An April night in 1917. Harris and Pomphrey were on the bridge, in the dark wind. Pomphrey had turned west and was suddenly stilled. His hand reached out to touch Harris on the shoulder, a gesture he had never made before.

— *Look!*

Walking on the bridge were five nuns.

Past the Dominion Steel castings wind attacked the body directly. The nuns were walking past the first group of workers at the fire. The bus, Harris thought, must have dropped them off near Castle Frank and the nuns had, with some confusion at that hour, walked the wrong way in the darkness.

They had passed the black car under the trees and talking cheerfully stepped past the barrier into a landscape they did not know existed — onto a tentative carpet over the piers, among the night labourers. They saw the fire and the men. A few tried to wave them back. There was a mule attached to a wagon. The hiss and jump of machines made the ground under them lurch. A smell of creosote. One man was washing his face in a barrel of water.

The nuns were moving towards a thirty-yard point on the bridge when the wind began to scatter them. They were thrown against the cement mixers and steam shovels, careering from side to side, in danger of going over the edge.

nights — worst shift of all — where they hammer the nails in through snow. The bridge builders balance on a strut, the flares wavering behind them, aiming their hammers towards the noise of a nail they cannot see.

<p style="text-align:center">*    *    *</p>

The last thing Rowland Harris, Commissioner of Public Works, would do in the evenings during its construction was have himself driven to the edge of the viaduct, to sit for a while. At midnight the half-built bridge over the valley seemed deserted just lanterns tracing its outlines. But there was always a night shift of thirty or forty men. After a while Harris removed himself from the car, lit a cigar, and walked onto the bridge. He loved this viaduct. It was his first child as head of Public Works, much of it planned before he took over but he had bullied it through. It was Harris who envisioned that it could carry not just cars but trains on a lower trestle. It could also transport water from the east-end plants to the centre of the city. Water was Harris'

great passion. He wanted giant water mains travelling across the valley as part of the viaduct.

He slipped past the barrier and walked towards the working men. Few of them spoke English but they knew who he was. Sometimes he was accompanied by Pomphrey, an architect, the strange one from England who was later to design for Commissioner Harris one of the city's grandest buildings — the water filtration plant in the east end.

For Harris the night allowed scope. Night removed the limitations of detail and concentrated on form. Harris would bring Pomphrey with him, past the barrier, onto the first stage of the bridge that ended sixty yards out in the air. The wind moved like something ancient against them. All men on the bridge had to buckle on halter ropes. Harris spoke of his plans to this five-foot-tall Englishman, struggling his way into Pomphrey's brain. Before the real city could be seen it had to be imagined, the way rumours and tall tales were a kind of charting.

And the cyclist too on his flight claimed the bridge in that blurred movement, alone and illegal. Thunderous applause greeted him at the far end.

On the west side of the bridge is Bloor Street, on the east side is Danforth Avenue. Originally cart roads, mud roads, planked in 1910, they are now being tarred. Bricks are banged into the earth and narrow creeks of sand are poured in between them. The tar is spread. *Bitumiers, bitumatori,* tarrers, get onto their knees and lean their weight over the wooden block irons, which arc and sweep. The smell of tar seeps through the porous body of their clothes. The black of it is permanent under the nails. They can feel the bricks under their kneecaps as they crawl backwards towards the bridge, their bodies almost horizontal over the viscous black river, their heads drunk within the fumes.

*Hey, Caravaggio!*

The young man gets up off his knees and looks back into the sun. He walks to the foreman, lets go of the two wooden blocks he is holding so they hang by the leather thongs from his belt, bouncing against his knees as he walks. Each man carries the necessities of his trade with him. When Caravaggio quits a year later he will cut the thongs with a fish knife and fling the blocks into the half-dry tar. Now he walks back in a temper and gets down on his knees again. Another fight with the foreman.

All day they lean over tar, over the twenty yards of black river that has been spread since morning. It glistens and eases in sunlight. Schoolkids grab bits of tar and chew them, first cooling the pieces in their hands then popping them into their mouths. It concentrates the saliva for spitting contests. The men plunk cans of beans into the blackness to heat them up for their lunch.

In winter, snow removes the scent of tar, the scent of pitched cut wood. The Don River floods below the unfinished bridge, ice banging at the feet of the recently built piers. On winter mornings men fan out nervous over the whiteness. Where does the earth end? There are flares along the edge of the bridge on winter

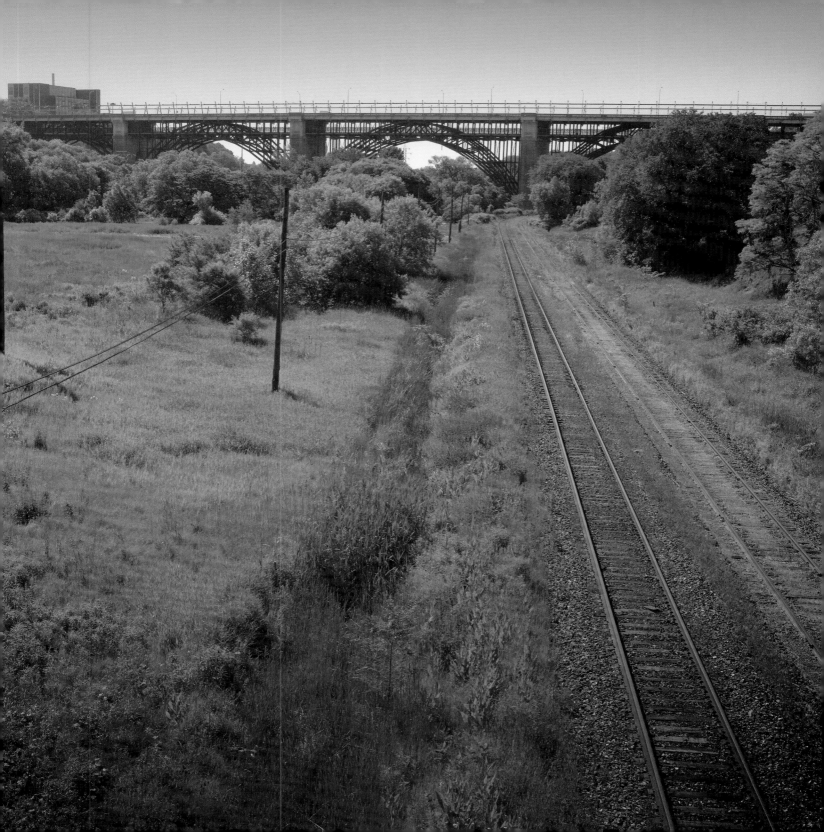

## Spring 1956: How It All Started

*Charles Sauriol*

In support of my interest in the Don Valley, it can be said that I have lived the life; as a boy tramping its wooded reaches, as a youth pitting his energy against five acres of rundown land and a dilapidated farm dwelling; as a man fighting a long hard fight for its preservation.

I first set foot on my acres at the Forks of the Don in January of 1927. From that date on, I thought only to turn them into a place of beauty. Forest trees were planted by the thousands, and an orchard too, which grew to fruitfulness. Rich soil was wrested from sod and twitch grass, and became a garden land in which fine fruits and vegetables grew.

I did just about everything on my place. I gathered the notes which made up my manuscript of the Don Valley. I made maple syrup from trees of my own planting. I canned fruit and vegetables, built a root house, kept a goat, a few pigs, chickens. I made a wild flower garden, established a bird sanctuary, built bridges which floods invariably washed our, dug wells, kept bees, made a log cabin retreat where most of *The Cardinal* was written. I produced several manuscripts, *Fourteen Years on Four Acres*, *Ashes and Embers* (the adventures of a boy in the Don Valley), *One Man's Harvest*. Perhaps it can be said that conservation on the Don stemmed largely from my pioneer conception of the Don Valley's importance as an area to be preserved, a one-man battle that I carried on for many years. The record of those years will support the statement.

As for the dwelling, it became a bower of tranquillity and repose; over the years its physical appearance was entirely changed. The touch of a woman's hand made the place fit to live in.

How I bought my acres is a story in itself and a strengthening of my belief that dreams do come true. Perhaps I bought them because at that time no one had given the Forks of the Don any attention. It was hill-billy country, back-wash of a pioneer day and of no importance.

It so happened that my cottage was erected

in 1899 as a dwelling for a man who worked on the John Hawthorne Taylor farm, just up the pine-clad slope above it, now Parkview Hills. The land had been pioneered by de Grassi, as his Government grant of 1833. Then it went to the Taylors, and from John H. Taylor to the Canadian Northern Railway, when the Company laid a line through the Valley in 1907. The stream which now flows past my place made a wide curve to the north in its original course. The railway changed that, and the severed fragment of the river became the frog pond where de Grassi had a mill dam.

The place went from bad to worse. Successive tenancies at rentals of $5.00 a month left in their wake nails as hooks, doors without locks, a crumbling chimney, porous shingles, cheap wall paper, brown woodwork, and outside walls that had never been painted. As the cottage and grounds stand today there is probably not a prettier spot in the Greater Toronto area. It reflects in a hundred ways the enthusiastic planning of the years.

In 1927, my acres were bare, save for two old apple trees of de Grassi's planting, an ancient willow tree still standing today and the dwelling. No water, no light, no convenience whatsoever. There are many books on the market of the "We took to the country" type. I feel reasonably sure that I have lived my own life of the outdoors of a calibre which would make many of the "back to nature" authors envious — and this on the threshold of a great growing city. Of the thousands of persons who motor along Don Mills Road, few realize what lies behind the sign of the wooden Cardinal which can be seen on the peak of my cottage.

I never gave it a name, although often tried. *The Lily of the Valley* and many other possible descriptions went their way as somewhat poor pictures of the portrait I carried within me, so the place became simply known as the cottage: "Le Chalet" as we say in French. When I used either term it meant everything. It evoked my pioneer days on the place, the cavalcade of events which marched through the years of my occupancy; the memories of a friendly wood stove in winter, of the spiral sparks of flaming

hemlock, of the outdoor fireplace, of the friendly faces so often seen about a living room whose story was one of really being lived in.

And so the cottage stands today, fifty-six years old; companion, one might say, of a lifetime, and for still another lifetime. But, as we so well know, there is nothing surer in life than change. I was standing in a pine grove of my own planting one day last June, when two men came along with maps in their hands. They were trying to locate the position of a roadway in relation to my acres. To any but my unbelieving eyes, the plan was clear enough; the road led across the meadows through my orchard, to the plateau on which stood the cottage. That road as planned would wipe out the work of thirty years. I tried to be reasonable about it, arguing that after all, nothing could go on unaltered forever; the place had served its main purpose in my life. Somewhere other potential beauty spots were waiting for the attention I could bestow upon them.

The route of the Don Valley parkway was made public on November 30th, 1955. I saw the maps during a preview showing of that date. Here again it was a sad blow; the maps confirmed what I had previously suspected. It seemed that my acres and cottage were destined to disappear under a sheet of macadam.

It has been said that happiness is pleasure without regret, that a world lies in the stream which flows through one's orchard, if one has the imagination to fully exploit one's surroundings. I have been somewhat as Thoreau who *"travelled far in Concord."* I have no regrets; and I have travelled intensely in the valley which lay at my door. I have lived of the simple, satisfying things of life in the abundance of successive seasons and their magnificent bounty.

Mine was a philosophy of the fullness of little things, of the need for the feel of the earth, of the companionship of nature. In the realm of the outdoors with its sunsets, woodlands, birds, flowers, fruits of the soil and fruits of the mind. I found all that a nature-loving man could wish for. I knew the fragrance of the balm of Gilead after a June rain; the restfulness of water splashing over stones; of the peeping of the first hylas of spring. It was a simple life, completely

divorced from the things I did for a living. That is why I loved it. It got me away from business. It was a sure refuge from problems renewed daily. "Old Murph," the bee man, started me on bee keeping because he said it would take my mind off my work — and it did.

What the place meant to me and the good it did me is best appraised through twenty-eight years of diaries which record my impressions from day to day all during that time. Whenever I had a problem to solve or tried to sum-up some situation, or myself, I wrote it down. Soon, I was writing about everything. I wrote by the fireside, or seated on a log deep in the woods, or beside the tiny paddle wheel mill I had set up in the stream. I wrote about the chores of the garden, of the tinkle of the sap in the pails I hung onto the maple trees in April. I never travelled without pencil and paper and not infrequently got out of bed in the middle of the night to set some thought to imagery in a prose I wished to retain. I never looked on my place as merely a physical thing. To me it lived. It was a part of me as I had become part of it. A friend once said it was my brain child.

One by one I have seen the landmarks of my day and of my surroundings disappear and the old-timers as well. The farmlands, the trails, the trees, buried in, covered over or chopped down. The stream is not as clear as it used to be. The sylvan aspect of a woodland realm of twenty-eight years ago has been altered, and will change still more.

Yet much of the valley still remains, is still beautiful, is still worth saving.

And in conclusion, a word of appreciation for the companions who over the years beat a path to my door. And a kindly thought too for those men and women who gave unstintingly of their time to save what could be salvaged of the valley for a future generation.

As for my holdings, their fate is in the road planners' hands. They may disappear or they may not. If they do not it is likely that there will be at the Forks of the Don a nature sanctuary of no small importance. If they should be sacrificed, then one more landmark will disappear and with it the bountiful source of *One Man's Harvest*.

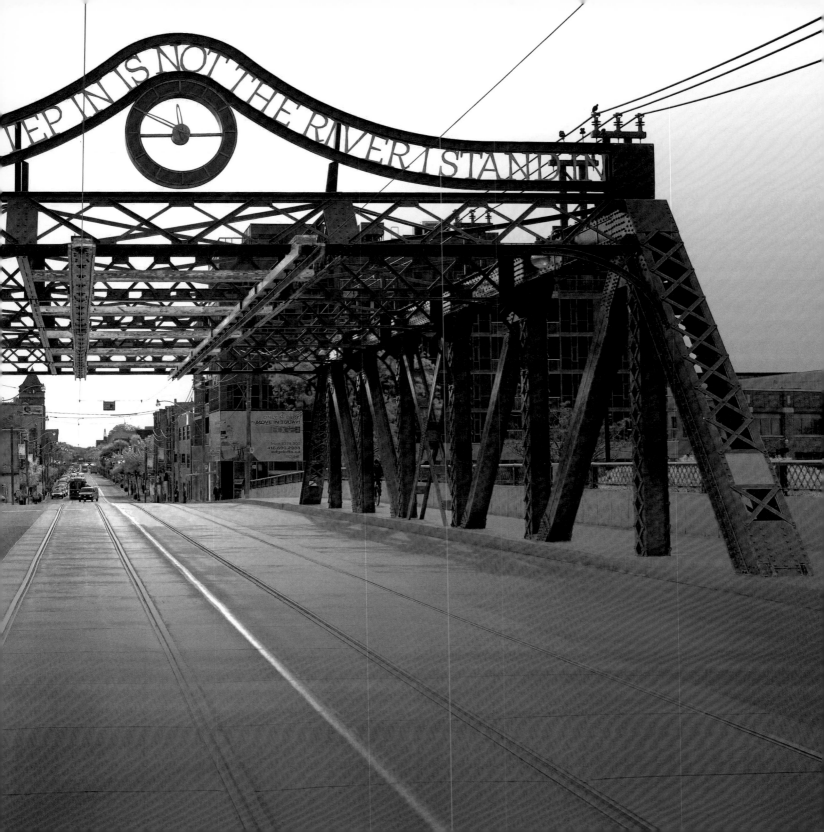

## The Other Goldberg Variations:
## Homage to Glenn Gould

*Maggie Helwig*

Knowing
that I could walk seventeen miles through a ravine
in the heart of Toronto, and never
directly see the city
is of some comfort.

Though I have some fear of snakes.

In a previous life
I lived in a garden of shrunken olive trees.

◊

Goldberg, a boy, playing
a tree of music, luxuriant in
the Russian winter, while

Count Kaiserling lay sleepless.

Outside, the wolves
mused in contrapuntal
preoccupation. Russian wolves
are not like those here.

◊

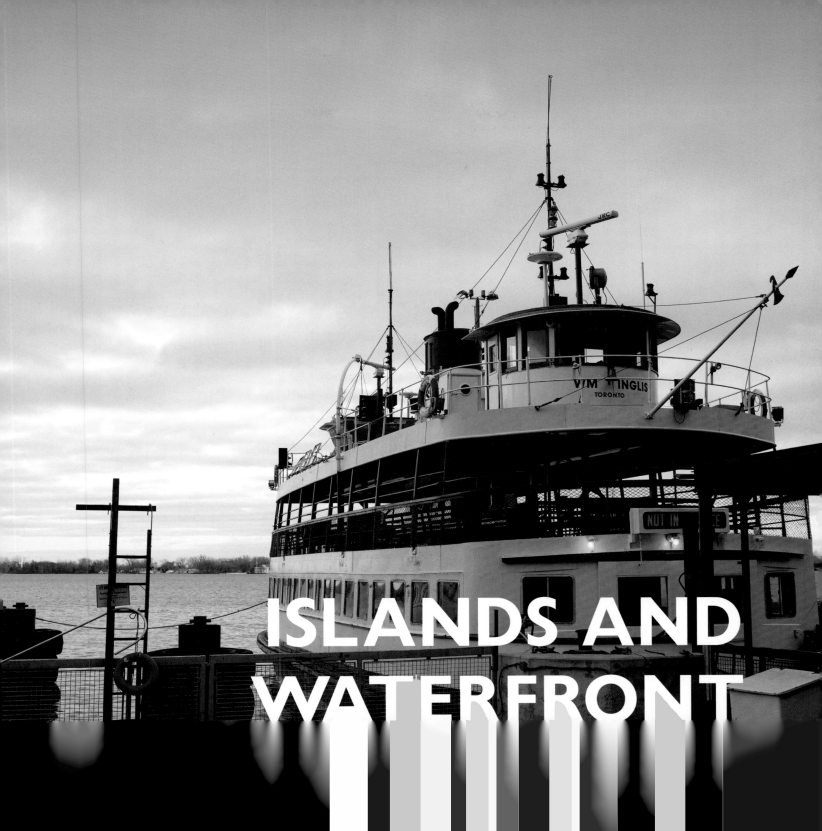

# ISLANDS AND WATERFRONT

# Consolation
*Michael Redhill*

Late summer, the August air already cooling, and some of the migrators are beginning south. Hear the faint booming high up against windows before sunrise, pell-mell flight into sky-mirrored bank towers. Good men and women collect them and carry their stunned forms around in paper bags, try to revive them. Lost art of husbandry. By the time the sun is up, the reflected heat from the day before is already building again in glass surfaces.

A man is standing by thelakeshore at the Hanlan's Point ferry dock. Cicadas in the grass near the roadway, cars passing behind the hotel. The ferry rush hour is over already at 8:15, and the Hanlan's Point ferry is the least frequent of them all, as it takes passengers to a buggy, unkempt part of the Toronto Islands. But it is the most peaceful ride, ending close to wilderness. *The Duchess.* He sees it departing for the city from its island dock, on the other side of the harbour. He stretches his arm out at eye level, like he once taught his daughters to do, and the ferry travels over the palm of his hand.

At the kiosk beside the gate he buys a Coffee Crisp, struggles with the wrapper. He hands it to a woman standing near him at the gate. "My fingers are useless," he tells her.

She neatly tears the end of the package open. Such precision. Gives him the candy peeled like a fruit. "Arthritis?"

"No," he says. "Lou Gehrig's. Sometimes they work fine. But never in the mornings."

She makes a kissing noise and shakes her head. "That's awful."

"I'm okay," he says, holding a hand up, warding off pity. "It's a beautiful morning, and I'm eating a chocolate bar beside a pretty girl. One day at a time."

She smiles for him. "Good for you."

The clocks are two hundred and forty feet out from the lake's original shoreline. Landfill pushed everything forward. Buildings erupted out of it like weeds. The city, walking on water.

All aboard. The woman who helped him with the chocolate bar waits behind him — perhaps politely — as he gets on, but says nothing else to him. There are only six passengers, and except for him they disappear into the cramped cabin on one side of the ferry, or go up front with their bikes or their blades slung over their shoulders. He stays on the deck, holding tight

to the aft lashpost, watching the city slide away.

The foghorn's low animal bellow. The ship moves backwards through the murky water fouled with shoes and weeds and duckshit. This close to the skyline, an optical illusion: the dock recedes from the boat, but tiers of buildings ranging up behind the depot appear to push forward, looming over the buildings in front of them. The whole downtown clenching the water's edge in its fist.

The lighthouse on Hanlan's Point has been there since 1808. It marks the beginning of the harbour, and in the days of true shipping, if the weather in the lake had been rough, the lighthouse signalled the promise of home. He can't see it from the rear of the ferry, but he can picture it in his mind: yellow brick; rough, round wails. A lonesome building made for one person, a human outpost sending news of safety in arcs of light. A good job, he thinks, to be the man with that message.

# Leaving Earth

*Helen Humphreys*

Maddy waits for her father outside their house. It's early morning and the sun angles out of the lake, casting thin wires of light onto the grass. She leans against the wooden side wall, pops scales of old yellow paint off with her thumbnail. In front of her is an open area of grass, a few trees. Beyond that, the fresh concrete flat of the new and deserted Air Harbour, levelling itself out to the small wooden lighthouse, on stilts, at the edge of the western gap. It is because of the western gap, that small band of water between the islands and the mainland, that the new Air Harbour is so far unused. There is no way to get across the channel. Passengers and pilots would have to traipse all the way along the western sandbar, across the park to the Hanlan's Point ferry docks. It's no small jaunt. So the new airport has been empty for over a year, everyone still using the small Air Harbour on the mainland at the foot of Scott Street.

Maddy scowls across at the huge smooth of concrete. What's the good of being the last house on the bar, of having perfect view of the airport, if there's nothing to see?

There's the bang of the front door. Maddy scoots around the corner and falls into step with Fram as he heads down the narrow street. She grabs his hand and swings it in slow arcs as they walk past the rest of the houses on the bar, down towards the main island and then to Hanlan's Point and the amusement park.

The Toronto Islands lie in the shape of a sickle moon, a bracket for the harbour, with the western sandbar at one tip and Ward's Island at the other. In between, nestled in the curve, are Centre Island, Mugg's Island, Olympic Island and Sunfish Island; all connected to each other or the main sweep of land by bridges. There are also several small, unnamed islands in the archipelago, as well as the peninsula of Hanlan's Point, sticking out like a thumb from the slender palm of the western sandbar.

Once there were Native encampments on the eastern side of the islands. In the 1800s, city

dwellers came across in boats to set up tents and small cottages for summer use. Gradually a tent community evolved and ferries began regular crossings of the bay. By 1933, the only summer tent community left is on Ward's Island and, of the one hundred or so families who live on the islands year round, most have some form of wooden cottage and live on Centre Island, Hanlan's Point or the western bar. There is a grocery store on both Hanlan's Point and Ward's Island, but residents depend largely on the services of Centre Island's Manitou Road. Here can be found a butcher, grocery stores, a bank, drugstore, dairies and restaurants — including the pricey, elegant Pierson Hotel and the cheaper Honey Dew, which sells hamburger and frankfurter sandwiches.

Maddy and Fram walk down the narrow western sandbar, past the single furrow of houses, some fronting east, some facing west along the lake towards Hamilton. Each one planted with the same distance between it and the house next door. Each one painted a different colour, so that sometimes when Maddy rides fast past them on her bicycle the smudge of pinks and blues and yellows looks like the swirl at the bottom of a kaleidoscope.

Fram hums and Maddy listens, trying to guess the song. Sometimes they sing on the walk to work, songs they've learned from listening to Miro's new radiogram.

"'Stormy Weather'?" guesses Maddy and her father laughs and squeezes her hand.

Maddy's favourite songs are the musical tributes to the British aviatrix Amy Johnson, who flew a plane single-handedly from England to Australia in 1930. She kicks her feet through the dust on the road to the tune of "Queen of the Air" until she trips and Fram jerks her hard up by the arm to stop her from falling.

They walk up Hanlan's Point, along the sidewalk on Lake Shore Avenue, past the wooden houses and the church, over the grassy flat of park. They are the only people out this early. Squirrels. A dog with a limp skittering lopsided between the trees. Up ahead the rickety hill of "the Dips" offering glimpses of the amusement park through its trestles. The enclosed pavilion

with refreshment bar and live-entertainment hall. The bumper cars and the Whip, Honeymoon Special, roller rink. The small wooden house of Miro, "King of All Fat Babies."

Maddy likes the amusement park best when it's deserted. A few ride operators there, like her father, to maintain and inspect the equipment. Some ducks and gulls pecking at bits of popcorn in the dirt. No noise and shudder of machinery. No hawkers. No crowds of people jostling and yelling; although there have been fewer people this summer than ever before. First it was the mainland amusement park at Sunnyside Beach that diminished the flow of people to Hanlan's. More recently it was the defection of the baseball team, the Maple Leafs, who moved from the athletic stadium on Hanlan's to a new stadium on the city side of the western gap. For the past few years there has been a substantial drop in human traffic and consequently a decrease in amusements. Ned the diving horse is gone. So too is the high wire and the giant swing. Hamburg's Big Spectacular Water Show isn't quite as big or spectacular, although Rose is still performing her popular matinee and evening show as "The Lady Who Takes Her Clothes Off Underwater." Now when Maddy and Fram walk across the expanse of the amusement park towards the ferry docks there are large gaps between exhibits and rides, spaces where things used to be. Everything its own island in the thick brown dust. Even her mother's booth, with the shiny tin stars and moon nailed to the outside walls and the words "Fortune Teller twenty-five cents" painted jauntily above the door, looks derelict. It used to stand in a row of booths, a shooting gallery on one side, a weight-guessing game on the other. Now it props up the emptiness, the sun flashing silver signals off its astral decorations.

# On Centre Island
*Cecil Foster*

Few places have as much sentimental appeal for me as Centre Island. No other place around Toronto reminds me as much of my first arrival in Canada some thirteen years ago, and of a period when I was young, wore a huge Afro hairstyle and was so — innocent.

That was a time when life was full of promise; when I came to Canada from Barbados believing the world was mine to conquer. Most importantly, I was young enough to believe in myself and my dreams and didn't have all those scars of cynicism that could only come from maturity.

But before taking on the world, I had to get to know Toronto, the place that I had chosen as my new home. Some friends suggested a day on the island. Although I have forgotten who first took me there, I will always remember the impact that oasis of beauty had, and still has, on me.

Maybe, it was the fact that it was an island — the water, blue skies, a refuge from the hectic metropolitan life — that made the instant connection, reminding me of warm moments so fresh in my mind about my native island.

Years later, these scenes still have an impact on me. Every so often I take out my photo album with pictures from those early days and disappear into a nice warm world, one replete with enough nostalgia to make my kids embarrassed with laughter.

With these pictures, I escape to an easier and simpler time, when I couldn't even raise a beard, when my companion for the day could easily get her arms around my waist and when I didn't have to worry about the number of hairs in my head and beard turning white.

My kids might giggle at this slim guy holding their mother, standing by beds of beautiful flowers with that well-known Toronto landmark, the CN Tower, in the background. Giggle all they want. They could never deny their dad once had a life.

That's what Centre Island means for me. Memories of an easier and more ambitious period. When I had the chance and time to stop

in the middle of the day and literally smell the flowers; when I was being introduced to a new country and culture; when I was floored by so many flowers growing in one place and so nicely arranged.

I remember sitting under trees and waiting for the final ferry back to the mainland, looking at the lighted Toronto skyline in the distance, watching the various watercraft drift by, seemingly at the foot of the CN Tower.

Generations ago, many immigrants arriving in New York by ship took to their graves first impressions of Ellis Island and the Statue of Liberty. Those were their eternal symbols of a promised new life and hope. Centre Island is the same for me.

# The Robber Bride

*Margaret Atwood*

The view from her bedroom window is there to soothe her. Her house is the end one in the row, and then comes the grass and then the trees, maple and willow, and through a gap in the trees the harbour, with the sun just beginning to touch the water, from which, today, a vapoury mist is rising. So pink, so white, so softly blue, with a slice of moon and the gulls circling and dipping like flights of souls; and on the mist the city floats, tower and tower and tower and spire, the glass walls of different colours, black, silver, green, copper, catching the light and throwing it back, tenderly at this hour.

From here on the Island, the city is mysterious, like a mirage, like the cover on a book of science fiction. A paperback. It's like this at sunset too, when the sky turns burnt orange and then the crimson of inner space, and then indigo, and the lights in the many windows change the darkness to gauze; and then at night the neon shows up against the sky and it gives off a glow, like an amusement park or something safely on fire. The only time Charis doesn't care to look at the city is noon, in the full glare of the day. It's too clear-cut, too brash and assertive. It juts, it pushes. It's just girders then, and slabs of concrete.

# Reservoir Ravine
*Hugh Hood*

The Island Aquatic Club was never a highly formal and exclusive institution, like some of its sister organizations in the Toronto district along the lake shores. It wasn't a rich man's preserve like the Royal Canadian Yacht Club. The Aquatic was melodiously informal, sweetly uncaring, as it were, about attendance at the Saturday night dances. If you were dressed attractively and respectably and were the right age — young — you could attend the dances unchallenged as to membership, guest-status, connection by friendship to some dues-paying eccentric.

It seems just worth clarifying the point. The IAC was but one of several social institutions which flourished on the Toronto Islands at this time. There was first of all the RCYC, the most formal, costly and exclusive — not to say hidebound — of these bodies. At Ward's Island would be found the far less conventional premises of the Queen City Yacht Club, with their raffish charm and peripatetic membership.

Along Long Pond, at Centre Island, were the tennis courts, boathouses and clubhouse of the Aquatic. Beside these, there were smaller associations in great numbers: badminton clubs, tennis clubs, boating groups, musical societies, glee clubs, card clubs. It was a great age of more or less elastic group activity: plays were performed, operettas sung, instruments attacked, in the name of sociability and good fellowship. These activities were much curtailed in the decade that followed, and in the decade that followed that — the 1940s — they came to an end.

In 1923 the splendid age of the social club, bringing together for agreeable and relatively unprejudiced association persons of similar interests and tastes, was at its height. The banks had social clubs for their employees, so did the department stores. The churches supported them largely, and allowed the use of their buildings (except their altars) very liberally for various club activities. It seems strange that this impulse to associate with one another in enthusiastic groups of persons not greatly

different from oneself has vanished as if it had never been. Easy to say that what happened in the ensuing twenty years destroyed the facile assumptions of class-membership that supported the club-system. Hard to document the loss of confidence and faith implied by the experience of those twenty momentous, consequential years.

On the Saturday night in early August when the young Manitoban caught the bass drum on the fly and all the dancers applauded as one, Ishy had received Andrew on the verandah of her summer residence at Miss Saint-Hilaire's, with perfect confidence and innocent faith in her appearance and intentions. She knew she looked bewitching. Even Enid and Emma had allowed this, then disappeared into their rooms to adorn themselves yet more elaborately with ribbons and lace. Andrew was to arrive on the 8:15 boat from the city. He came over on the *Primrose*, as it happened, an augury which made Ishy blush happily, though without offering an explanation of her rosiness. It was still not quite dark at twenty to nine, but only

just. The summer was past its halfway point, and when she saw Andrew come around the corner of Iroquois and start up the block, Isabelle debated with herself whether to put on the lanterns, Japanese in design, electric in impulse, which were strung from the verandah roof. She decided to greet him in the gathering darkness, then put on the soft lanterns at a happy moment. She chose darkness; she was wearing a delicate perfume; she felt certain he could find her in the dark.

Flowers and candy!

"If you don't put the lights on, you won't see the flowers," said Andrew, just the faintest touch dryly.

Isabelle bent her head and inhaled the scent. "I don't care to see them. I like to smell them." She held them up very close to her face, her cheeks against the petals.

"I want to see you with them," he said pleadingly. "May I turn on the lanterns?"

"I can hear the band," said Isabelle with maddening indirection. He could hear her deep inhaling sighs as she considered the roses, and

went with a show of independence to the light switch just inside the screen door. The lanterns were alternately deep yellow and almost turquoise, blue-green. Mixed colours washed across Ishy as he stood looking. She held the clustered stems in her right hand, threw her arms wide apart. Her roses whispered.

"Do you like me in this?"

Andrew said nothing. He agitated the box of candy in his hands. They heard chocolates rattling inside. Then Emma and Enid and Miss Saint-Hilaire and some other girls and two exiguous young men appeared laughing from the interior.

"The candy is for Miss Saint-Hilaire," said Andrew, coming to himself. "Not for you, Isabelle."

"Sweets to the sweet," said somebody superfluously.

"There's a limit," muttered Andrew. He could not move his gaze. The lavender-blue had carried the day before the day began.

"We can hear the band," said the girls in chorus. "We want to dance."

"*Everybody Step,*" came the music, "*Everybody Step.*"

"Carry me over the puddles?"

"You can walk," said Andrew grimly. He felt as if he might run wild with love and joy. If he once gathered those silks in his arms with the woman inside them he might do anything. His fingertips tingled.

Somebody had left the lights on over the tennis courts and by the landing stages, and the scene was bright as day, millions of insects singing and zipping around huge green cymbal-shaped lightshades over the courts, the sound of invisible wings guessable even over the band. Silver slippers stayed dry though walks were wet here and there; sometimes they strayed onto grass. As they ascended the side-door steps, Andrew stayed her with his hand.

"Grass on your dancing slippers. I'll pick it off."

He knelt and removed the five or six blades which had left the glittering insteps unstained. The band played "Alice Blue Gown."

"A waltz," he said thankfully, "I can manage that." He was not essentially a dancing man,

though willing to take certain risks. Conversation was his long suit. Conversation and action. He would hazard kisses when the time was right, did so, often won. "Is your gown Alice-blue?"

"I never really knew what colour that was," said Isabelle, "though I've heard that song for years. How blue was Alice, do you think? And why?"

The band threatened a tango and they withdrew to the sidelines, where they witnessed the on-fly recovery of the bass drum, at which the wide room exploded in applause.

"I believe the tango rhythms excited that drum," said Andrew.

"These tempestuous Latins."

His choice of words made Isabelle gurgle. "Fiery," she said, "languorous, insolent, menacing, sideburned."

"No, you're thinking of sheikhs."

The young Manitoban advanced as if stricken by delight, and begged Isabelle for a dance. "You deserve at least one dance," she declared, and they circled away. The band could manage two-steps, one-steps, the fox-trot, now and then

a tango. Now they played a waltz as Andrew watched, a temporary wallflower. The boy from Manitoba danced as badly as he did, but with more natural rhythm; you had the sensation, watching him, that he might suddenly quit the earth, take surprising flight, end in the rafters. If Andrew had known the expression "May I cut in?" he'd have launched himself forward and used it, but the custom didn't prevail at the Aquatic. In fact the dance-program with attached decorative pencil, in which the young lady inscribed her accepted list of partners, was still in frequent use at those of the club's dances which approached formality: the spring formal, the end-of-season Labour Day weekend festivity. None of these dances was exactly a ball; you didn't come to them in a tailcoat and white tie. Nobody at the Island ever wore a tuxedo.

Well, no, that isn't strictly the case. Tuxedos had been worn at the RCYC, quite frequently, especially when senior members, and commodores of far-flung yacht squadrons voyaged thither in competition during the LYRA events. The Odenbachs of Rochester would wear

black tie, so perhaps would Ray Engholm and his crew and their expensive wives. Not so at the Aquatic. The club by the big lagoon was principally a canoeists' resort; one might see Aubrey Ireland there or any of a fleet of Oldershaws — these were famous canoeing families, Irelands, Oldershaws, Dinsmores, who propagated themselves down the generations for many decades. Hodgsons, Redicans. No tuxedos for them. They would wear blue blazers though, and the conventional white flannel or duck trousers, often with shoes in contrasting black and white, or frankly "ice cream" shoes. Grass stain was a recurring problem.

Andrew fidgeted against the wall, wishing that this was one of the more closely organized dances, where the inscribed card was in use.

He might then simply have begged Ishy to write his name in all the spaces, and so evaded the unwelcome importunities of the Manitoban. He realized however, as he considered this, that Isabelle would never have agreed to such an exclusive proposal — she would not so readily agree to surrender every area of negotiation.

They loved one another. Wonderful, marvellous, final. But they weren't engaged, and they seemed to be some distance from that happy state, she being nineteen, he thought, or barely twenty, and he at least two years away from the completion of his doctoral studies and attainment of some sort of permanent status in the philosophy department. He had thought of proposing marriage next summer, but after seeing his girl tonight wasn't sure that he could restrain himself for so long. When she had stood under those lanterns and thrown her arms so invitingly wide, "Do you like me in this ... in this ... in this?" How it echoed! And the scent of those flowers — he had done wisely to bring them.

The waltz ended and Andrew started out of his corner, but in the same instant Don Romanelli stuck his violin under his chin and led the band in a second, execrable, tango, and to this wailing outcry Isabelle and her partner began to advance and retreat across the floor in what Andrew considered an over-emphasized proximity, a graceless clutch. He definitely did

not like seeing her like this, but knew very well, with philosophic detachment, that there was absolutely nothing to be gained by telling her so. Calm, he told himself, quietude, the contemplative gaze, not the fishy eye. Philosophers in love? We can know nothing of what they feel, unless it be the identical pangs we others undergo. That darn dress. Oh, oh, oh!

Most of the dancers had withdrawn from the floor and only two or three mettlesome couples were doing the tango, among them of course Isabelle and her new beau. She would never ignore a challenge, had never tangoed before, certainly never in Andrew's arms. She might have tried it once or twice with Rosemary, in a room at a cottage. Now she bounded about the floor amid laughter, shining with energy and delight, and the dancers cheered and applauded.

As she and her partner loped toward him, Andrew turned on his heel and left the room by an adjacent exit. They had turned off the lights over the tennis courts, so it was dark next to the clubhouse. He stood in shadow for a minute or so, turning over and over in his mind what it was that he was feeling. He felt surprised that this was what he was doing because he wouldn't have thought that this — whatever it was — could be turned over in the mind. It belonged to some other part of himself, not the mind. And yet he seemed able to get bits of what was happening into his head (or wherever his mind was tonight) and these bits were what he was able to think about. Very strange. He could still think, even make plans, but those parts of him that had nothing to do with planning were vibrating like tuning-forks of various pitches. He stood there and ached. And thought.

More than anything else in the world he wanted Isabelle to come out that door and down these steps so that he could get hold of her and do something to her, with her. Kisses? What good were kisses, he thought? He couldn't go on just standing here.

Down by the landing stages there were two or three lamps lit, nothing decorative, aids to late canoeists. He strolled down there and stood at the very edge of a sagging little wharf which was in such a state of disrepair that the faint

movement of the waters of the lagoon was sufficient to make it rise slightly and fall. He balanced lightly, without difficulty, stood there believing himself to be suffering intensely. Without moving he went on doing a lot of different things at once. The tango came to a stop behind him and there was a longer silence than usual between tunes. Perhaps they were getting at the punch. It was past midnight, and therefore Sunday, when behaviour normally became sedate. He looked down at his feet and saw in the water in front of him a racing kayak, the smallest and lightest of singles' canoes, with a double-bladed paddle lying beside it on the dock. He bent down and grasped the paddle, thinking of Isabelle. He swung it in his arms. Behind him a voice said, "Why not try it? It's the fastest kind of boat." And a loved young voice gurgled and laughed. "Don't tease him, Hal," said Isabelle.

"This thing?" said Andrew dubiously, facing them. He flipped the paddle onto the grass. "I know about small boats. I've sailed catboats in the open Atlantic."

"These are hard to get into," said the other young man. What did she call him? Was it Hal?" "Like a mustang." Damned cowboy, thought Andrew. He stepped to the edge of the dock. "Nothing to it," he said, stepping downward onto the kayak's minute gunwale, and from there into eight feet of water, right on through to the bottom where his shoes glopped deep into mud and lost their whiteness forever. He opened his eyes and kicked his feet free, floating to the surface. The kayak was still spinning, winding up its mooring line like some mechanical toy. It rotated in the water at an unconscionable rate. Frail bark, thought Andrew. He knew without thinking it that he had scored points.

"Oh Andrew," said Ishy breathlessly.

He began to laugh. His clothes hung on him like wet sheets in a Turkish bath, as he did a few movements in a qualified breaststroke which brought him to safety at the edge of the wharf. He reached upward for a handhold, and realized that he had hold of an ankle, not a female ankle. He gave a strong tug and felt

profound satisfaction as the other man lost his footing on the slippery planking, fell heavily on his rear end, then slid into the water. Andrew scrambled out of the lagoon and stood up dripping; his white trousers were turning light blue as he looked at them. He called to Hal, out in the water, "Let me give you a hand," but the other man rolled onto his back, spouted with insouciance, and called, "It's a grand night for swimming."

"That'll cool you both out," said Isabelle.

Then she began to back away in excitement and alarm as Andrew advanced on her. "Andrew," she said, "darling. Andrew. Now don't you dare!"

## Bohemia on Bay

*Hugh Garner*

Situated south of Canada proper, on a sawed-up peninsula jutting out into Lake Ontario from the industrial and business heart of Toronto, lie four miles of foreign territory known as Toronto Island. Like most other things about it, its name is a misnomer, for it is not one island but eighteen, and they are only islands by virtue of several man-made canals or lagoon and of a nineteenth century storm which ploughed a gap through the neck of the peninsula.

The first natives were Indians who set up housekeeping in the Island's pine woods and used the sap of the balm-of-Gilead trees to heal their wounds. Later on, their health resort was usurped by white fishermen and the wives of the British officers who picnicked there while Fort York was burning. The present-day natives are those who have lived there more than ten years, and the conquerors are a transient population who rent beaverboard "apartments" upstairs, downstairs, and along the boarded-up verandahs of the natives' houses. This is the only known island conquest in history where the natives have emerged as the landed gentry.

Like New York's Fire Island, the summer population is much larger than the winter one, numbering around 15,000 in comparison to the 3,000 or so hardy souls who live there all year round. The population, both winter and summer, is a polyglot one, and contains some of the zaniest characters allowed to run around without a leash. One of the older inhabitants has described the Island as, "the only unfenced insane asylum in the world."

Although living conditions are Bohemian in the extreme, very few writers or artists make their homes there for long; they can't stand the pace and there are too many diversions popping up between themselves and their Muse. Many of the inhabitants belong to a half-world that includes chronic alcoholics, wife and husband deserters, beach-combers, dead-beats, and spinsters-on-the-make. The majority of these

live on Centre Island, the biggest island of the chain, and one given over to a peculiar type of Edwardian architecture slightly reminiscent of a Charles Addams cartoon, with wings, cupolas and closed-in porches added to the houses as if thrown at them by a demented tent-maker. The normal fringe of the population is in a minority on Centre Island, as it is on Hanlan's Point, while Algonquin Island is settled by a peculiar stuffy type of water-borne suburbanite who tries to pretend that the less-inhibited Centre Islanders do not exist.

The Islanders have their own kind of snobbery and are prone to think they own their islands by right of tenure. In reality, all the land is classed as a city park and their lots are only leased to them by the City of Toronto. The hordes of picnickers who flock there in the summer by ferry from the mainland, especially the tens of thousands who crowd the streets and beaches on Sundays, are known locally as "Lower Slobbovians." What these people think of the shorts-clad, bicycle-riding Islanders has never been revealed.

In the early days the islands, or the peninsula as it was then, was covered with a forest of pine trees. These were cut down during the nineteenth century, and today the islands are largely planted in willow and poplar trees. Bears and deer were once hunted there, but today the four-footed fauna consists largely of a few muskrat, raccoons, and common household rodents. A few years ago, however, a deer was found wandering around the place. Where it came from nobody knows, but when it was first reported, the Toronto Humane Society ignored the information, thinking, naturally, that the frantic telephone calls were a result of mass alcoholic hallucinations.

Several years ago, one of the natives who was returning to Centre Island from the city in a canoe, thought he was being pursued by a sea-serpent, and he crossed Toronto Bay in the fastest time since the death of Ned Hanlan. The "sea-serpent" kept pace with him and followed him right to the back door of his house, breathing down his neck. After a generous

libation of sea-serpent cure, the Islander shakily parted the kitchen curtains and found himself face to face with a steer that had escaped from the stockyards the day before. Why it had chosen to take a midnight dip is no more a mystery than why other escapees of various types choose Centre Island to hide on.

## Summer Island
*Phil Murphy*

Sunfish Island was a great place for playing Indians. Lying just across the narrow lagoon from us, it was mostly wilderness: the only buildings on it were the yacht-club clubhouse at one end and the abandoned shell of a cookhouse from what had once been a day-camp at the other. In between were thickets of scrub brush, random swards of twitch-grass and wildflowers, leafy stretches of sinister-looking vegetation that was said to be poison ivy (or even more venomous, poison *oak*), dense stands of willow and poplar, open patches of untrodden sand that sometimes bore the tracks of small animals — not quite your forest primeval, perhaps (no murmuring pines or hemlocks, no druids of old), but much the same kind of tangled wildwood that was there when the first white men came. Perfect cover for war parties of braves and chieftains, in fact, and for much of that summer — under the inspiration of a movie-serial version of *The Last of the Mohicans*

that a bunch of us were following every Saturday at a mainland cinema — our gang made frequent crossings of the lagoon in whatever punts and canoes we could commandeer along the shore, then scrambled up the steep sandy bank on the far side and plunged down into the untamed woodland below to become for a while fellow-tribesmen of Uncas and Chingachcook. Most of us would be armed only with homemade bows and arrows, though I had a rubber-headed toma-hawk I was very proud of, and Justin always brought along a fancy store-boughten archery set his mother had brought him from New York (the bow had varnish on it! The arrows were perfectly straight and had *real feathers* stuck on!) that he would generously give the rest of us turns at firing, too. And of course, when it came to lighting the tribe's campfires …

On one particular Saturday, Justin and I, along with about half-a-dozen others, went to the city to take in the latest thrilling instalment of Mohican adventures; he seemed a trifle distracted, I thought. He had enjoyed the show

while we were at the movie-house, but on the ferry-boat on the way home he didn't join in the gang's noisy chatter about the cunning way Natty and Chingachcook foiled the villainous Hurons in their wicked attempt to burn down the fortress with fire-arrows, he just sat and stared out at the passing flotilla of Saturday afternoon yachts. He needs taking out of himself, I thought, using one of my father's phrases, so I kicked him on the ankle in a friendly sort of way. "S'matter, Jus? Something on your mind besides dandruff?"

He looked up at me blankly for a moment and then shook his head. "No — just that I've got to remember to pick some stuff up for Mummy on the way home and I'm trying to remember what it is."

"At the store?" I asked. "Okay, I'll come with you. I've got a couple of nickels left and I'll go next door to the ice cream parlour and get us a couple of Eskimo Pies while you're in the store. Okay?"

I was sitting on the verandah railing outside the Island's general store nibbling at the chocolate coating of my own Eskimo Pie and carefully holding his, still in its waxed-paper wrapper, at arm's length when he emerged. He seemed to be carrying just a bottle of something, but he was holding it rather covertly, down by the side of his leg, so I couldn't really see it.

"What's that you've got there?" I said, proffering his ice cream pie. "A bottle of something?"

He tucked it in a pocket of his trousers to reach out for the pie, but I snatched his away from his hand and insisted he show me the bottle before I passed it over. He looked annoyed. "It's just some stupid cleaning stuff ..."

"Let's see!" I said, and he complied grudgingly.

I couldn't see why he'd been so secretive: it was just an ordinary flat, clear-glass bottle, full of colourless liquid, securely corked. There was a hand-lettered label stuck on it, slightly crooked, which I read aloud: "Naphtha gas — highly inflammable."

"What do they mean, naphtha *gas*?" I said. "Doesn't look like a gas to me, it's a fluid of some kind."

"That's what they call it, I dunno why," he mumbled. "My mum uses it for taking the spots off dresses and things." He reached out and reclaimed the bottle, stuck it back in his pocket and we set off home. I thought no more about that bottle then, but I saw it again the next day — in a very different condition.

That evening at dusk I was down by the lagoon bank, looking for the errant and erratic Sir Joshua, the family cat, who had been missing for a day-and-a-half — I had a hunch he might be somewhere along the water's edge, as aquatic animals and waterfowl and even dead fish had an endless fascination for him. Methodically I was checking every foot of the sloping foreshore, peering under the planking of the little wharves and jetties where Islanders moored their punts and rowboats, investigating the cavernous interiors of the more pretentious boathouses, even poking into long-abandoned muskrat nests, thrusting through stands of bulrushes. So intent was I on this quest that I didn't for once pay any attention to the desultory summer-evening boat-traffic on the lagoon;

not until I heard Mother calling me in from the back porch did I look up — just in time to catch a glimpse of a punt with a single small figure aboard vanishing from view around a sandy point. Had that been Justin wielding the paddle? Was that stick-thing his fancy bow slung over his shoulder by its string? Had he been heading for the Sunfish side of Riley's Bay, down the lagoon there? I couldn't stay to investigate; I had to run up to the house where I found Mother holding the feckless Sir Joshua in her arms, he looking a bit bedraggled and bramble-torn but not in the least repentant ...

As I was getting into bed that night, I chanced to look out my northern windows, which faced down the back yard and across to Sunfish. A flash of light caught my eye; I paused to watch and saw what looked like a tiny meteorite — well, some kind of fiery particle — shoot up into the gathering darkness from somewhere behind the sandbank on the lagoon's far side. But it couldn't be a meteorite, could it, they fall down *from* the sky, they don't zoom up *into* it ... Before I could reach any firm conclusion, the thing had

arced across the evening sky and flickered down out of sight among the trees. What *could* it have been, I wondered: it looked almost like one of the fire-arrows we saw in that movie this morning ...

I don't know whether it was the noise or the glare that woke me. I found I was sitting up in bed looking out my windows into a fierce yellow-and-orange glow that seemed to stretch across the middle of the night sky. Through the open casement came a cacophony of unnatural noises: a series of irregular crackles and hisses, interspersed with sudden staccato poppings and snappings, all accompanied by a funny, scorchy smell ... In the distance, but coming rapidly closer, was the spectral baying of a klaxon siren.

I shook my head to clear it and rubbed the sleep from my eyes; now I could see that the band of lurid light out there was not a solid stripe but wavered and flickered and seemed to mount upwards — flames! Flames that were flaring all across the sky, overhung by a black smoke-cloud lit hellishly from below by that savage glow; all this rising from behind the dark

uneven border that I finally recognized as the sandbank's ridged crest — Sunfish Island was on fire!

Leaping out of bed, I fumbled my way into my moccasins and pulled a coat on over my pyjamas before dashing from the house, along the path and down to the water's edge, where a sizeable group of spectators, adults and children alike, had already gathered. My father's tall figure stood out prominently against the inferno glare from across the way; I stumbled across to him and asked, a bit breathlessly, what on earth was happening.

He looked down at me quizzically. "I should have thought that was fairly apparent," he said. "We are witnessing a conflagration — Sunfish is going up in flames."

But even as he spoke, there came an enormous hissing noise, like the rush of a hundred breakers receding from a shore, and a sudden cloud of dirty-white steam boiled up to meet the smoke-pall; at the same time, the livid glare diminished perceptibly, the wall of flame just behind the sandbank slope seemed to sink, even

the wave of heat beating against my face lessened by the moment.

"Aha!" said Father. "The fireboat must have come up on the far side of the island there: they'll be shooting water all over it from their heavy-duty spray-cannon ..."

More clouds of steam, more gushing and hissing noises — and suddenly I had to suppress a giggle, for it struck me that the firemen over there were making exactly the same sort of noise, on a huger scale, as I had made the other day when I put Justin's fire out for him ... Where was Justin anyway? Not like him to miss a spectacle like this! I looked around, and there he was: he had materialized a bare few feet from me. He was still dressed in his daytime clothes, but this didn't surprise me, I knew that he was allowed to stay up a lot later than the rest of us; what did startle me was the look on his face. In the wild firelight, I could see that little smile of his, yes, but there was also a tilt to his head I'd never seen him adopt before, a glint in his eye that might have been triumph. Was all this a look of *pride*?

I stared at him with my mind racing: Justin and that bottle of highly inflammable naphtha stuff ... Justin and his bow heading across the lagoon at dusk ... that flash of light arcing through the night like a fire-arrow ... And now, just a little while later, this miniature forest fire right on our doorsteps ... Could he have ...?

# Gentleman Death

*Graeme Gibson*

Stretching the muscles in my legs, the tension in my lower back, I walked slowly at first with the city's mournful geometry off to my right; to my left, above the lake where rafts of oldsquaw yowdled and cooed, the sun was indistinct, a giant white moon. Beating low and urgent over water as viscous as oil, five mergansers were absorbed by an icy vapour rising from its surface while bufflehead bobbed and, leaping, dove along the shore. It's funny, isn't it, how the mind works? I've tried composing a Living Will. What this suggests about my ability to fight, to engage (as they say) in a "long battle with illness," doesn't bear thinking on. Leave me alone, okay? Just leave me alone. Waking at night I imagine myself in the North. It is autumn. The woods are empty, the cold lake streaked with wind-foam and the dead leaves of birch and poplar. Sometimes I have a tent, a sleeping-bag. Or else I've found a derelict trapper's cabin. Perhaps like ours before we tarted it up. I'd need painkillers,

good ones too, but what else? Something to drink, a box or two of Cuban cigars. How long would it take, this death by asshole? Too long, I fear, if I had the strength to get up there, to wrestle our orange canoe into the lake. In any event I'd like there to be wolves, their wild seductive voices in the night. What if they devoured me, would they catch it? Although this is a wonderfully interesting question, I've done no research. Can you get cancer by eating a tumour?

Juncos and tree sparrows sprang from the dead grasses of summer and fall as I proceeded without purpose or desire, as if the road had no end. My heart beat as it should. Blue jays cried from a shrouded stand of poplar and cottonwood on the lee side and I had a Thermos of tea in the fanny-pack beneath my coat. From just about here I saw the fox, its brush a flag; from further on I watched an osprey rise triumphant with a silver fish from the poisoned inner harbour.

Although the city is full of ravines and hidden tracks it is here, to the Spit, that I'm drawn for

solace. Year by year the former have become simpler and tidier, with chipped bark jogging paths, with directional signs and picnic tables on mowed grass. On the other hand, colonized by almost three hundred species of plants and refuge to innumerable other creatures from jack-rabbits to an occasional beaver, the Spit has grown wilder and even more complex. They say if you stand on top of the CN Tower and gaze north you will see almost thirty-five per cent of Canada's grade-A arable land. Toronto, its suburbs and satellite towns are spreading like a slow inevitable stain over much of it now, but if you'd turned the other way and looked down at this unlikely promontory you'd have seen, at least until recently, the process reversed. You'd have seen what happens when the earth is left to heal itself.

But it's all a fraud, a snare and delusion. A lost opportunity. They've bulldozed the edges of a triangular pond where night herons once nested. The moist bottomland where I encountered the ecstatic mating flight of woodcocks has been layered over with broken chunks of reinforced concrete, with bricks and the punky wood from nineteenth-century homes. Lagoons along the outer shore have obviously been constructed as snug anchorage for a thousand rich men's yachts. They'll open the gates, whereupon this road I walk with its yellow line will spawn parking lots.

It's only the gulls that resist. Seventy thousand nesting pairs of ring-billed gulls. Sleek mean-eyes as street-fighters, and prolific, they fill the air with flight and noise. In wheeling raucous flocks they descend upon the city's garbage, they perch in the rigging of pampered sailboats and shit all over them. On approaching their nesting site in spring and early summer, buffeted by the clamour of a hundred and forty thousand birds and their young, one can sense those primal clouds of passenger pigeons, of Eskimo curlew, all vanished now ...

Meanwhile I wandered in a chill wind blowing from the lake. The mist had gone, burned off by a sun grown smaller and more intense; spray-ice flamed along the shore. So long as I kept my back to the city I might have been anywhere

in the North. Wildly intimate the voices of oldsquaw drifted like the murmuring of eiders I'd heard off Benbecula. It was a tender, reassuring thing to know that those torn clouds streaming eastward against an empty sky had done so, in just this way, not simply since my own birth, but since before humans recognized themselves as such, that the clustered poplar and willow, the gull crying above my head were the same ones that first appeared on earth. Without self-consciousness they're innocent of death, which is, after all, individuality's ridiculous corollary.

Sheltered below the lighthouse I'd just poured a second cup of tea and was munching my bread and cheese when the owl appeared, a gift for no reason. An immaculate white snowy owl from the tundra, an adult male he was perched on some rubble not twenty paces distant. How did he arrive and why just at that moment? He was so close I could make out the thick warm feathers on his face, the powerful claws protruding from his feathered toes. Bird of Minerva and Athene, the hermit's companion, he stared at me crouching on a rock, the two of us surrounded by dead grasses, by broken shafts of mullein and ruptured milkweed pods. His precise yellow eyes, the eyes of every snowy who has ever been, or ever will be, blinked dispassionately. I averted my eyes from that effortless gaze. If it was the cranes that inspired humankind to make letters, our first alphabet, the owls taught us silence and melancholy; it is from them we learned how peace is inextricably bound up with sorrow — or more precisely, how it is bound up with resignation, that most abstract form of sorrow.

## Foreword from I Remember Sunnyside

*Robert Thomas Allen*

One bright, still, hazy day I walked down past some beautiful willows at Sunnyside to a peaceful spot on the shore behind the bathing pavilion and sat at a battered old picnic table eating a hot dog and watching three kids skipping stones. In the distance I could hear the moan, hiss, growl, and whine of fourteen lanes of fast traffic. The fresh smell of the lake and of warm paint made me drowsy and I began to doze and my thought drifted back to the days of the old amusement park that used to be here and I imagined what I heard wasn't traffic, but the rumble and roar of the rides — the whip, the Derby racer, the roller-coaster — and the ecstatic screams of the girls (they must be all around seventy now).

You'd take a streetcar and get off at the station restaurant, where the *Lakeshore* streetcars headed southwest across a bridge over the railway tracks, and you'd go down a long set of stairs into the smell of gun smoke, perfume, french fries, popcorn, and sparks from the Dodgem, and submerge into a crowd of fellow humans, as relaxing as sinking into a warm tub, and shuffle along past the weight-guesser, the rabbit run, the poker game, and fish pond — the hoarse cries of front men exclaiming over the amazing skill of their customers and how close they were coming to winning prizes. The merry-go-round was a shadows breezy cave of polished brass and mirrors and carved wood where you could ride around on a charger, or a camel, holding onto a brass pole or sit in the Roman chariot one arm over the back like a debauched emperor, lulled by music and the faint breeze, with your worries flung gently outward by centrifugal force, sometimes falling in love with some girl who was waiting her turn, who floated past you rhythmically like someone in a lovely séance. There were two merry-go-rounds at Sunnyside: the Derby racer, now at the Canadian National Exhibition, and the Menagerie merry-go-round, which is now in Disneyland, California. Another magnificent

Toronto merry-go-round that used to be at Toronto Island is now in Walt Disney World in Florida.

We didn't know it then, but we were in something more than a crowd at Sunnyside; we were in the mainstream of major sociological change. Sunnyside came in with the automobile — not with the early models of the 1890s, but with the beginning of the automotive age when cars were to change our cities and our lives. The automobile was a magic carpet that smelled of rubber curtains and gasoline, the new smell of the future, progress, and adventure, and it invoked thoughts of remote country roads and shimmering lakes and far-off wonderful places of an exciting world.

We were still very aware of the marvel of being able to, say, drive down the Danforth or Bloor Street for a brick of ice cream and be back in some fabulous time, like eight minutes; and of the miraculous fact that you could get into your Ford coupe outside your house, and sit comfortably behind a steering wheel until you reached Sunnyside, stop at the curb, pull on the emergency brake, and step out fifteen, twenty feet from, say, the shooting gallery. But Sunnyside created some of the first great traffic jams. There was one cop, with a hand-operated wooden stop-and-go sign shaped something like a living-room floor lamp. It was the first time somebody told you when you could move, and you got the feeling as you sat there looking at the line of cars, moving bumper to bumper about three feet at a time, with people eating ice cream cones stepping between the bumpers, that the whole world had gone mad. Men used to teach their wives to drive in those days and they would make them drive through Sunnyside on a busy warm evening, figuring that by the time they got from the Humber River to the Palais Royale they'd never forget how to change gears again, and I know women approaching their gold wedding anniversary who have never forgiven their husbands for this, and probably never will.

# An Affair with the Moon

*David Gilmour*

Later that evening, I was sitting on the front steps of my house. It was after dinner; a gold light fell across the street. I had the family cat in my lap and she was purring. Suddenly a boy on a green bicycle rode up. It was Harrow Winncup. He had a brown sack over his shoulder. Something heavy was inside it.

"Come on," he said.

"Where are you going?"

"Down to the lake shore."

"My parents don't let me go down there."

He shrugged. The cat wiggled in my lap.

"What've you got in the bag?"

"It's a secret," he said.

I put down the cat and went down the driveway and got my bicycle.

"I'm going to the park," I said to Mother.

We got on our bikes and we rode down through the brown city. It was fall, just getting dark. You could smell it in the streets, that exciting, thrilling smell of fall. Even back then it made me nostalgic, even when I had hardly anything to remember.

By the time we got to the train yards it was dark. We rode over a bridge and came to a stop at the foot of a tall rusted water tower. Harrow leaned his bike against a pole. He stood at the bottom and looked up. The street lights came on. The stars came out. The moon rose. You could smell water on the other side of the railway lines.

"Come on," he said and then he started up the ladder with his sack. We climbed and climbed, hand over hand, the city fell away below us, you could feel the breeze pulling at your pants. We climbed up and up, Harrow holding the bag over his shoulder. Finally we got to the top. I scrunched in beside him. We stood there for a moment, our legs shaking with the strain. From up there, I could see the whole city, I could see an amusement park, I could see the red lights of Chinatown, the tower of our school like a moon in a child's book. Out in the harbour a coal boat sat in the middle of the black lake, a green light blinking on its starboard side.

Then, bracing himself against the ladder, Harrow hoisted up the bag. I peeked inside.

"It's a television tube," he said. "I found it behind a store."

He worked it toward the mouth of the bag, laughing with the effort. Then it came free. I saw something glimmer in the moonlight for just a second and then it fell way into the

darkness, falling down into the giant empty rusted cup. There was silence and then a terrible roar, a thunder like the end of the world, a boom that shook the sides of the water tank.

It roared up out of the blackness, its breath blew against our faces. Its size terrified me, like a train, like a volcano, like God. I could see Harrow. His shoulders shook, tears ran down his eyes, laughter twisted his mouth into a grimace.

"Implosion," he said.

# TORONTO EAST

# Seen
*Margaret Avison*

Pitiless light, dry
air, the snowless
winter day
exposes everything, withers
even high clouds, those
cirrus ones; they
race before the bitter wind.

How other is
the light who
sees all, but is for so
long, so long, compassionate!

But in the night uncompromising light's
clarity befalls
the sleepless who
lie rigid, resolutely
suffering it,

      under how many
city roofs, behind

apartment walls, in dank
half-basement rooms? A
slumbering city is
blind to the half-smiling peace old Noah (and all
outdoors, all winter)
clench on, a
promise.

One day, tea towels will
blow on the line
along a
summer evening lane — hushing the
homegoing rush along
the Danforth — north a bit, then
steadily east, behind those
rosy-brick
Greek walk-up
apartment blocks.

There will again
be amber evening light.

# The House, The Home
*Mike Tanner*

I promised myself I wouldn't walk by the house tonight. Or if I did, that I wouldn't slip down the side and around the back, because if you just pass by on the sidewalk, there's nothing the matter with that — okay, this woman with the dog might look at you twice, and if the dog pauses to sniff at something then the woman might notice that you still haven't moved, stopped on Hogarth staring up at a house — but what could she do, call 911 because a guy carrying hockey sticks is standing in the June night in front of a house?

The lights at the rink are off now, I can see from here; it's darker everywhere. Riverdale is bright — restaurant windows, kids at the daycare, new yellow Vespas parked near stores selling soaps and picture frames — but there's also the shade, the silent alleys, overgrown garages. Ravines, deep ravines.

If those rink lights are done, it's after eleven; but I knew that anyway. After ball hockey we had a few pitchers up at the Fox, and I never said a word about what's been going on, but later, this thing in my chest, this soft kind of choking, drew me out onto the sidewalk along the Danforth past Greek kids whispering into phones on patios, me slouching invisibly toward the Fruit King and then down past the park again, the streetlights singing like cicadas in the wires overhead, now just an occasional lit window in these homes, here a chandelier glinting in a living room, there some blue cathode shadows flickering in an upstairs bedroom. A porch light glancing off yellowy bricks.

I could go home if I just stepped straight across this street instead of turning, but after two decades here, every doorway has a narrative, and now this corner holds a new knife that twists each time I go by — so what do I do but turn, and it's only seven houses in from the corner, five from the lane, on the south side, an open porch with flower pots out front, the sprinkler hissing softly into the neighbour's grass, the maples overhead, or maybe elm — anyway, branches arching like a cathedral as I

stop and stare up at the house, the seventh house. Just standing and looking, nothing more. And asking, how can a place where you can't walk a block ungreeted, where your life is gloriously tangled with hundreds of other lives, where even another street crime or the arrival of more fast food can't stop you feeling that this is a good spot — how can even this place become so sour over a few months, seventy-four days, because of the wantonness of just one person?

And I shove my sticks and bag under the hedge, away from the street and the eyes of the woman and the dog, and now I step down the cracked concrete between the houses, my stride measured and firm and my footfalls shrouded by sirens from the south. The scent as I move into the gloom — I don't get how the flowers can sometimes smell so strong you'd swear it was a chemical plant down on the lake, or old air from the day. Air with things hanging in it, heavy with human truths, nasty facts about what wives might say and then what they softly do, how words can mislead and fool you until you have to go figure things out for yourself, and so yes,

you slide between the two houses and through the back gate which as usual stands open, careful not to knock against the recycling, and you move by feel and enter now into the utter dark of the backyard, where the scent is strong and where you can see, where you can see through the shade that the light is on in the upper back bedroom, the room that used to be your daughter's room and now is being used for something else, since it's near midnight and there's no way your daughter can be awake even though she's thirteen this year.

And there's a shadow on the shade, someone standing and moving across in front of the window, and the hand clenches at your stomach and throat, and here even at midsummer there's no noise, nothing from the streets and the square and fountain, nothing, no, nothing at all except the scraping, the breathing of an animal close by, and the rank humid vegetation of the alley, and you, your chin now lifted like a supplicant, as she moves high above you behind the shade, stretching back to coax, to summon and guide another hand, an arm, a second silhouette.

Then you hear again the hissing, you smell the lake, taste the chemicals on your tongue, feel the sweat on your skin chill as the wind brushes the dark over your head. The light goes out. Above, around you is black. It's home.

## To Gerrard, With Love

*Sarah Elton*

Somehow, I managed to see Mumbai before visiting Gerrard Street, in my own city. So off we went, cousin Adil behind the wheel, you in the front, and me sinking into the backseat of the Honda Accord, straining my neck like a child to see out the window. My first glimpses of Gerrard Street East were through the tinted glass of a car. Neon signs screaming PAAN, DVDS, HALAL; lights from restaurants and grocers and boutiques shining into the dark July night; more lights illuminating the curb-side stalls, selling barbecued corn and chaat just as in Juhu. Lights so bright that the grey film on Adil's car windows could not dampen the glare.

We parked near the crosswalk and stepped into the humid night. Sticky and hot — so Toronto, or should I say Bombay? I was *depaysé*, as the French say — geographically dislocated — I was unsure where exactly you had taken me. This was not my familiar Toronto. We were in search of paan — my first ever. Adil led the way,

more excited than either of us, I think; he was looking forward to watching me stuff my virgin mouth with betelnut, paan leaf and coconut.

We walked side-by-side not hand-in-hand — unmarried men like you didn't walk holding hands with the likes of me on Gerrard Street — but your arm hung so close to mine as we wound our way through the sidewalk crowd that I could feel you too were overheating. I gawked at bejewelled saris on thirty-year-old mannequins in store windows and pounds and pounds of fake gold glistening from shop displays. I didn't know that I could buy an eggplant at midnight in Toronto, or a bunch of fresh coriander, or a case of mangoes, or a pot for frying samosas. I'd never smelled grilling corn in the city or watched a streetcar glide by to a bangra beat.

Ismail's was open. Adil preferred him to Baldev, the Gerrard Street paanwalla who was so famous I'd even read about him in the *Toronto Star*. Inside Ismail's, there was hardly room to move between crates of tea and dates and customers waiting for their midnight fix. *Once you're hooked*, Adil explained, *it's hard to break*

*the habit.* Two men worked quickly behind the counter, pulling out wet shiny paan leaves, a deep green colour, then spreading a chalky white paste on them and filling them with nuts, rose paste, candy-coloured sprinkles. Adil grabbed a bottle of Vimto from the cooler and I drank the syrupy purple liquid as we waited our turn.

Outside, our mission accomplished — three paans wrapped in silver foil — we lingered on the sidewalk, not really saying anything, soaking up the atmosphere. You stuffed the whole paan in your mouth, your cheeks bulging like a chipmunk's. I carried my little triangular package in the palm of my hand back to the car. Only when I was sitting in the backseat again, and we were making our way downtown, did I unwrap it. Slowly, I peeled the silver paper away from the corner and nibbled at the leaf, licking the pink rose paste that oozed out its side.

Sometimes these days when we are driving along Gerrard Street East, as we often do with two kids in the backseat, to run an errand, to have a dosa, to visit the grandparents, I remember my first trip to Gerrard Street's Little India. The time-travel machine in my mind takes me back. I can taste the paan, and feel the car moving across Lakeshore towards the CN Tower, silhouetted by moonlight.

# Soucouyant
*David Chariandy*

He carried a red toolbox which he normally kept locked underneath our bunk bed. We walked to a secret edge of the bluffs near the back of our home, and we slid — stepped down the slope of clay; holding on to brush and radically leaning trees and even thistles when a fall suddenly threatened. We reached the shore and walked east until we got to that place where a fenced sewer pipe from the old factory blocked us from going farther. A gull was perched on the inside lip of the pipe, its feathers puffed up and ragged and its legs forking a trickle of water that moved like oil. We climbed over the fence and sewer pipe, and did ten minutes of wobbly walking along the stones and washed up trash until we got to a place where you could squint your mind and imagine that you were elsewhere. The wet skins of lake-smoothed stones. The bones of driftwood bleached by the sun. The dense silence of the bluffs towering above. And of course, the great lake with its unmarred horizon.

We sat on driftwood and ate our sandwiches immediately, taking a bite of banana with each bite of peanut butter, the way Father once showed us. After this, my brother unlocked his toolbox and showed me what he hid from everyone else. Books. A battered Gideon Bible, perhaps stolen from a nearby car motel. A book entitled *Surviving Menopause* by one Philip C. Winkler, MD. A Finnish cookbook with the cover ripped off. A very old leather-bound book written in some strange but beautifully sinuous script. Another book that merely listed chemical compounds following some obscure principle of organization. Other strange choices too. And why not? Why shouldn't a poet know a lot and draw from all languages and meanings? My brother took his books one by one out of the box and placed them carefully on the stones. He removed a real fountain pen and a notebook with handmade paper, the sort all rough with invitation. He sat there not writing but as if he were just about to write, and he held that pose for a long time before me.

I don't remember my brother ever writing anything that day. I remember him pointing out to me the smeared toothpaste of clouds upon the sky and the guerrilla art of bird shit on the rocks. I remember him describing the oatmeal of lake scum amid the constellations of trash and plastic bottles that had washed up on shore. I remember my brother fishing a packet of chewing tobacco from his coat pocket and how he found in the trash around us a juice bottle chipped at the rim but good enough. I sat there with my brother well into the arcing afternoon, chewing and spitting. I never spoke to him about Mother's condition or Father's increasing distress because we were talking about poetry that day and mindful of things far greater than our personal circumstances and fears. I remember the bite of the wind on my face and the endless steel of the waters. I remember feeling light and almost dizzy with an exultation only partly due to the tobacco. I remember watching our spit rising in the bottle, all swirling amber and leather in the sun. That stuff so precious.

## Letter from the Beaches

*Harry Bruce*

A nice, middle-aged lady who grew up near Balmy Beach tells me about her childhood out there, and somehow the matter of Cherry Beach comes up. "Oh, Cherry Beach," she says, without realizing how quaint she sounds. "We never *mentioned* Cherry Beach."

Cherry Beach, don't you know, is a place where naughty young men from the outside world come to do bad things to girls and, even though my friend has not lived anywhere east of Yonge Street for almost half a century, I think the gentle snobbery of her remark identifies her forever as a Lady of the Toronto Beaches.

So I remember her as I slope eastward, along the boardwalk at Balmy Beach. Some hail fell this morning, and I can smell snow in the wind. There are few outsiders here now, and this whole stretch of waterfront belongs once more to the ducks, the cold gulls and the people of the Beaches.

The air down here has always held a memory of cottages, and I expect to see a hammock or an old canvas canoe on someone's lawn. The leaves fly south like flocks of big, yellow butterflies and drop on the lake; the noisy wind celebrates the clear fact that The Summer People have gone.

The life-saving ring and the red, three-pronged pole look vaguely like stage props and the advice beside them is both unseasonal and somehow absurd. "In case of drowning notify Toronto Harbour Police. Phone EM 3-6488."

Two very purposeful women in brown trench coats stride by, keeping step like soldiers. An elderly man and a boy who's barely old enough to walk play soccer with a blue plastic ball. They're doing more giggling than kicking. A shockingly pretty little girl, with long, curly hair, blue jeans, and a green tunic, pushes a stroller that holds another baby boy through the piles of leaves.

These, I'm sure, are all people of the beaches, but it's possible that the dejected-looking man, alone on a green park bench, is an outsider who's come down to the water to think something out. On a cold day, the only people who are likely to travel very far to reach the lake are those who want to make an important decision, or recover from some emotional battering, or just suffer a bit.

At four o'clock on a rainy morning in March I drove down to Cherry Beach (well I'm from St. Clair and Yonge so I can mention Cherry Beach)

because my first child, a boy, had just been born, and I wanted to stop shaking. But from the way this fellow is slumping there — with his back against the city coat-of-arms that says "Industry, Intelligence, Integrity" — I calculate that he's just a nice young man who's said a hard thing to his wife and that pretty soon he'll go home and say he's sorry.

Now the boardwalk ends and, for a couple of hundred yards, there's a wide beachful of stones, dry oak leaves and big, silvery driftwood. At the far end of the beach, there's a chilly-looking apartment building, a white one with black trim, designed perhaps by some Swede.

I remember that on the exact site of this building there used to be a patch of wild grass, and that the grass grew so long and this corner of the beach was so dark that, on a soft night in August of 1954, I stretched out there with a girl who lived in a big, wooden house that faced the lake and, for several hours, no one knew where we were.

Farther east I find the R.C. Harris water purification and pumping plant, where some children are sliding down the grass on pieces of cardboard. It is a singularly weird joint and reminds me of a film about Brasilia. It sits up there on these green, geometric hills — a huge, empty place that hides mysterious machines and seems to perform its gigantic duties without human assistance.

Through one window, I see ranks of round, green, humpy pumps. They look like giant snails and they hum in an evil way. Through another window, I make out cement pillars, and acres of flat water — two shiny indoor lakes lying there in the shadows. All in all, the R.C. Harris plant looks like the kind of place where some foul character tries to do in James Bond but, below the windowsill, the information of two little people of the beaches restores reality: "Diane was here. So was Angie."

# TORONTO WEST

# On Christie Pits
*Carole Corbeil*

I love the way the sky opens up above Christie Pits so that you can see a huge swath of it. In the evening, golden light bursts through pink sunset clouds. On sunny days, I've seen the stark and slightly terrifying blue skies of suburbia that I associate with childhood.

But when you go down into the Pits, the feeling changes completely; suddenly you're in a green shelter that's very comforting. You're in a valley. Sometimes walking through the Pits is like swimming in an aquarium, or prancing in an amphitheatre. The space seems to affect the way people play there. Whether they're playing baseball or soccer, the players move as if they're at the Dome, as if thousands of eyes are upon them.

Maybe I just love it because it's associated with my daughter's childhood, with tobogganing and skating and swimming and T-ball, with watching her grow from babyhood to seven years old. Without her, Christie Pits would have remained just a weird name that conjured up something charred and abandoned. I now know that the Pits has a long history with some pretty ugly chapters in it, but what amazes me about its current incarnation is how well it still works as a playground, how much life it holds on any given day.

I often end up riding my bike on this narrow dirt path on the rim of the Pits. Last summer, there was a group of guys who hung out on a bench by the little wading pool and played African drums. One evening, as I was riding, the sound of those drums echoing around the Pits was pure magic. You could see how the beat affected everyone in the park, the swift rhythm all the players go into, the way it brought smiles to people's faces. It was as if the pulse of all our lives became audible for one moment, there in the green bowl, beating through the hands of those drummers.

## subzi bazaar
*Anand Mahadevan*

Walking south of Bloor on Dufferin Street, one is presented with two choices. To the right is the Dufferin Mall anchored by one of Canada's busiest Wal-Marts, a prodigiously stocked No Frills supermarket, and scores of generic mall stores squeezed cheek-to-jowl with their backs to the city. To the left, a large grove of trees flanks an outdoor ice rink and a grassy pathway hosting a weekly farmers' market. Beyond them are a basketball court, soccer fields, and extensive children's play areas.

My family immigrated to Toronto when I had just finished high school. My brother and I were primed for change, and my parents for an unwelcome mid-life crisis. Now, a decade later, when we walk down Dufferin Street, the family splits. My brother and I typically turn left into the quiet green of the park while my parents seek the markdown prices and bustle of the mall teeming with people. Our split is symptomatic of this city's influence on our immigrant personalities and fuelled by the possibilities we see on either bank of this asphalt river.

On a Thursday afternoon, I coax my father over to Dufferin Grove Park to buy vegetables at the organic farmers' market. We have a long history of shopping for vegetables together. My warmest memory from my childhood in India is riding pillion on my father's well-scratched old Vespa scooter to Shivaji Market. The women from farming families around the region converged on this open air *subzi* bazaar to set up stalls, laying their produce in neat pyramids on wet gunny sacks, the edges of their vegetable castles secured by wicker baskets filled with onions and potatoes. Even today I can slip into the memory of colours, textures, smells, and above all the noises of vendors crying out the names of their vegetables in Marathi, Hindi, Gujarati, and Urdu.

Naked forty-watt bulbs hanging from a metal mesh illuminated tomatoes too ripe to be contained in their red skin, water globules sprinkled by sun-leathered hands to simulate dew on crisp green spinach, glossy aubergines

the colour and size of purple eggs nestling among fragrant nests of cilantro, a giant pumpkin carved with an ancient machete, and cauliflowers, drumsticks, turnips and eddoes piled in heaps. *Subzi*, vegetables, picked in the darkest hours before dawn and in my child's imagination, pilfered from a secret world.

In bringing my father to this farmers' market in Dufferin Grove, I am again that child stealing from the past to evoke a lost past here in Toronto. Even as I let farmer Ted talk me into buying green cymling, wrangling a recipe to cook this unfamiliar vegetable, I want my father, inspecting fuzzy peach-like tomatoes and deep-orange Hubbard squash, to remember those Saturday mornings in India when a brash dad had all the answers for a wide eyed boy. Here in Toronto, these new vegetables scare him rather than provoke his curiosity. Later when we drink from a jug of organic cider (from Timmins) under the shade of a large maple, he points to the large bunches of basil, mud still clinging to their roots, stuffing my bags and asks:

"What do you do with them?"

"Pesto."

He gives me a blank look.

"Like chutney," I explain.

He nods and after another glug of cider notes, "Too expensive."

I remark that dirt has filled the grooves of the fingers and caked under the fingernails of the farmer shop-keepers here, hoping he will remember Shivaji Market.

"Let's shop at the mall," he announces, "Very hygienic and cheaper too. It's air conditioned as well."

He loves the interconnectedness of bargain and bustle at the mall. It's busy because it's cheap; the tautology only firms his belief. As we walk in the constancy of light and conditioned air through row upon row of plastic-covered merchandise, he gestures to the welcome hallmarks of western triumph. I remember the comic sadness of watching my parents run into the mall to escape the cold of Toronto's winter as, over-warm in their winter coats, they left a dripping trail of melting snow from aisle to aisle sharing knowing

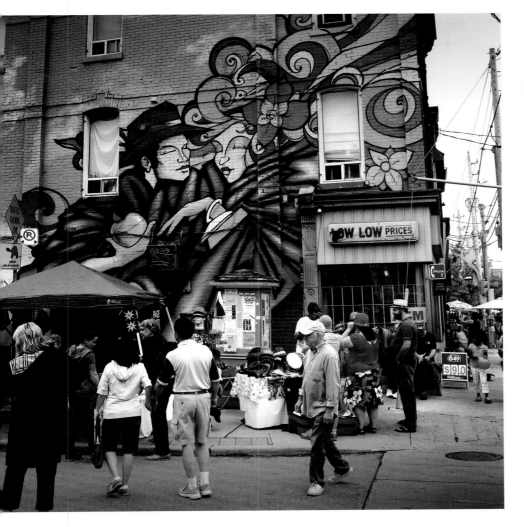

looks of sympathy with other immigrants from the tropics.

"This is a bazaar," he announces as we line up at the cash register.

He looks at me, expecting some reply, but the crowds have made me sullen.

It is only when we cross Dufferin Street again that it hits me. We have both been trying to evoke the same memory in the other. Whilst I remember the freshness of vegetables and their taste from Shivaji Market, my father remembers the haggling and the crowds. And in his oblique look, does he also worry about what I have lost in coming to this city? I smile at him as I take his arm for the long walk home.

## Around St. Helens

*Makeda Silvera*

Up St. Helens, then along Bloor to Lansdowne, then east past St. Clarens, Emerson, Margaretta, Brock and Patricia, I walk along streets of two- and three-storey houses. This is not the Annex or the new Queen Street West, or Dufferin Grove and these houses have no ornate woodwork inside. Often little is known of their histories. For generations though, these houses have been home to working-class immigrants. I was one of them.

JUNE 1980

Angie and I were both from the Caribbean and in our early twenties. We shared a bed-sitter on St. Helens. She worked as a pharmacist's assistant in a musty drugstore at the corner of Spadina and St. Clair; I was at York University, an undergraduate in the equally musty sociology department. At day's end, we couldn't wait to get back to our solid working-class neighbourhood. Most of our neighbours were Italian or Portuguese, but there were also other Europeans and a sprinkling of South Asians, Canadian-born blacks, and born-here whites.

All week Angie and I looked forward to Friday night at the Room at the Top, a Caribbean hotspot. We didn't have far to go, half a block to the northeast corner of Bloor and Lansdowne. The old building still stands, an indomitable grand dame, but the Room has given way to Le Sunset. We'd get dressed up, me in tight red jeans, red high heels to match, Angie in a low-cut black, backless dress, her lips painted red to match her fingernails, her high heel shoes so tight that her poor toes cried out for mercy.

From the Room's wide-open windows, music called out to passers-by; sometimes the police would come in response. Many Friday nights, reaching heaven seemed easier than climbing those steep stairs, and we'd stop halfway to catch our breath. Then into the Room, where we'd order a drink or two to loosen up, then sit out the slow songs waiting for the band to get to reggae, calypso, R&B. Waiting for our favourite musicians wearing jeans and sporting

Bob Marley-style dreadlocks, to take the microphone and whisper *Welcome dawtas, welcome*, knowing they spoke only to us.

The Strip — Bloor between Lansdowne and Dufferin — held few other attractions. There was Dale's Restaurant where we sometimes stopped for a beer and fries; a hole-in-the-wall South Asian restaurant that swept us in with its spicy aroma; and just past the Room, a Chinese restaurant. We'd stop there, order take-out, and once home, listen to reggae, trying out the latest dance steps between bites of spring rolls. The neighbourhood was friendly, with many little family-run shops where people knew you, so although there were druggies in the alleyways, it was a good place to call home.

JUNE 2008

Early afternoon and humid. Clouds are forming where just minutes ago the sky was crystal blue. I'm sitting in Ciro's, a restaurant once frequented by druggies and hustlers, and streetworkers wanting to help both. Now Ciro's is Ciro's House of Imported Bier. It's airy, freshly painted in designer colours, sports a back patio, and offers beer beginning at $8 a bottle from Thailand, Sri Lanka, India, Trinidad, Belgium ... I pass on the menu — and the prices — but I could have ordered calamari, pad Thai, or teriyaki. Instead, I'm thinking *Bloor and Lansdowne at these prices?* Grudgingly, I order a Kingfisher beer.

Through Ciro's vast window I look out at the Bank of Montreal. In front of the bank, and along Lansdowne Avenue, part of the street has been given over to beds of plants. It's pretty but I worry that it means gentrification and that working-class people, especially single-parent families, will find it harder to buy — and keep — a home here. Back in the 1970s and '80s my grandmother was a steady customer of that bank, as was much of the neighbourhood. Just west of the bank, the Paradise Lounge, a strip club, sits next to a church. That the sinners and the saved have lived side by side for decades is testament to the neighbourhood's live-and-let-live attitude. Across the street is a new and huge Value

Village, which I'm told, draws shoppers from miles away as well from the neighbourhood.

More customers walk into Ciro's, two women, one in her late forties, the other in her late twenties or early thirties, both sweat-streaked and tanned, the younger one in a T-shirt and deep-cut shorts, her arms sleeved with intricate tattoos. Our eyes catch. As she moves to the music, she smiles with her hips. I smile, then look into my beer. Maybe they're mother and daughter. Maybe not. They touch each other carelessly, and their laughter fills Ciro's.

Before long, another couple comes in. The woman has on a yellow leather jacket and a short, stained white skirt, the man is unshaven, dressed in black track pants and a T-shirt saying "Las Vegas" on the front. Probably bought at Value Village. He reeks of stale alcohol and cigarettes. They ask for coffee and a beer and are given the menu. After one look at it they walk out, but not before shouting, *Fucking asshole! Fuck you, man!* Before they can cross the street to Coffee Time the clouds become dark balloons and as the couple run, the rain blasts them.

I order another drink. Ciro's plays breezy jazz, the perfect counterpoint to the coming thunderstorm.

The two women chatter about gardening listing the hardiest and therefore most successful perennials, and make plans to paint their front porch. They're not mother and daughter; now it's clear that they recently bought a home on St. Clarens.

Heading east, I pass Dale's Restaurant, filled almost to capacity by its regulars. Beer is $3.00.

I walk down St. Clarens, then Margaretta, then Emerson. Yes, some houses have changed hands: there are new shrubs, new trees, new flowers. Still solid working-class homes, their owners seem to be fairly recent immigrants who carefully look after their new homes. Tomatoes, beans, callalou, and corn grow in one front yard. Another has bold sunflowers standing guard. There are rooming houses too, inhabited by small-time thieves and drug addicts. Some of the women wear their addiction like a badge.

Most everyone can lay claim to the neighbourhood. There's a Bengali grocery

stacked with sacks of rice, spices, and trays of ready-to-eat aloo parathas; Ethiopian restaurants are ready to serve you chicken or lam wat, with injera (a flat bread, almost mandatory with Ethiopian meals); Middle Eastern kebabs are for sale and South Indian take-out; a Jamaican restaurant offers oxtail, cowfoot, ackee and salt fish; two Trinidadian roti shops. There's an Indian shop, its shelves stacked high with rolls of cloth for saris. Tony's Billiards has given way to a pawnshop, the first of three I counted on my walk, and Western Union and other cheque-cashing outlets dot Bloor. Crown Furniture is still there, long the neighbourhood store of choice. Put money down on a bedroom or living room set, take it home, and make a payment to Crown every week.

The House of Lancaster, a notorious strip joint is still there and so is Duffy's Tavern across the street. There are beauty shops and barbershops for all complexions and types of hair. At the corner of Brock and Bloor, a pizza chain has moved in, but it rarely seems to have customers apart from high school students rushing in for a quick lunch. Unlike the Annex, or even the new Queen Street West in Parkdale, the neighbourhood has no majestic old trees, no outdoor cafes, no beautiful people. But it is a solid community, one that mixes residential housing with small businesses, most of which have established clienteles and are run by people who know their customers by name.

I stop at the House of Cheung at Emerson and Bloor, a favourite of mine when I lived on St. Helens, and am warmly welcomed by the owners. It's clean, beer is $3.50 and the food is good and cheap. The owner talks softly to an argumentative regular who wants to dispute the limit on his tab. *Chuuh. Wha'appen Missa Cheung, yuh tink is mi a rob you? No, no, I know you pay ... is the Missis.* I'm thinking, what the hell? He understands? Ah, Jamaica meets Hong Kong. A druggie walks in, his pit bull on a leash beside him. He wants to use the washroom but is not allowed in. The phone rings for take-out orders. A Chinese family arrives and orders a sit-down dinner, followed by a couple who look Latin American.

I worry for the people of this neighbourhood. I worry that urban renewal will as it has so often, turn out to be urban removal and destroy far more than it improves.

The sun has come out, it's a beautiful evening. As I near Dufferin, I look down the side streets and see more gentrification. The intersection is busy with cars, buses, bicycles, young people of all hues and shades laughing, babies in strollers, people rushing off.  I pass by New Horizons Towers — a retirement home and part of the neighbourhood for decades. An old woman is sitting on a bench in front of the building eating an ice cream cone, watching the traffic. I stand there, I watch, and I smile.

# The Wireless Microphone
*Joe Fiorito*

Mary tied the green paisley scarf in a loose knot at her throat and buttoned her navy blue coat. She was wearing heavy clothes in spite of the heat because the coat was her on-air signature, like Pierre Berton's bow tie or Larry King's suspenders; such are the demands of television, and she had a job to do.

Today was Saturday; as usual, the people would be buying bread on Roncesvalles, and the Pope would be speaking in front of the Polish credit union. Mary always did the colour commentary.

Ioannes Paulus II was in the habit of asking the merchants on the avenue to lower the price of bread and sausage on the weekend. "The Holy Father," thought Mary, "always thinks kindly of the poor." Not every one could hear his words, but she could.

She had been chosen personally for the weekly broadcast because the Pope was aware of the many ways she had suffered: first her job,

and then her home and finally her children, and the children had been taken rudely. Not even the Pope knew where they were.

Mary checked herself in the mirror. She was ready now. Her lipstick was the brightest red, her cheeks were ripe with blush, her eye shadow was green; the silver crosses pinned to the lobes of her ears dangled as she moved her head; not a distraction, but a kind of moving punctuation.

She locked her door and headed for the corner, walking past the closely-clipped lawns and gaudy banks of flowers in the shadow of the old horse chestnut trees. The heat of the sun was molten gold and there was a film of sweat on her upper lip. She could not help it and she hoped the camera would not see. She found it hard to breathe the thickening air. She would not let that affect the work she had to do.

As she neared the drugstore at the corner, the crowd was flowing up and down the street like a river running in two directions. She was not late. His Holiness never started speaking until Mary showed her microphone.

She took up a position by the drug store

where she could see him and where, from past experience, she knew the camera could see her. The crowd was concerned with window-shopping. The people were laughing and talking.

Mary thought the crowd was weak and unaware of miracles; that is the nature of the crowd, but it is the nature of the individual to be strong in spite of everything, and Mary was strong.

She saw men and women with loaves of rye bread in plastic bags. In their arms they also cradled fat sausage wrapped in butcher paper, dry smoked fish, pale dumplings, bottles of dill pickles, tubs of head cheese. She saw innocent children with sugar on their lips, biting into bland and soft sweet paczki. The paczki made her hungry. She took the wireless microphone from her purse and, in a soft and loving voice, began to set the scene.

A man stopped in front of her, listening to the sound of her voice. He peered in her face and blocked her view. He seemed not to see the microphone, nor to understand that she was live to air.

She described the crowd and she described the man, who could not understand a word she said because he could not speak Polish. Mary thought he was a fool. He had neither bread nor sausage in his arms. She gripped the microphone tightly in her fist.

After a time, the man moved on.

Now Mary could see directly into the heart of the Pope, and his thoughts were as clear to her as if they had been written in ink on clouds in the air. She heard him say that the price of bread would rise again and again because the people were weak, and the hearts of the hungry people would soon be filled with sorrow. She repeated what he said for the sake of her listeners.

The Pope watched Mary. She could feel his gaze. He was strong and tall and still and wise and his arms were outstretched, like a father calling to his children. Mary stood on the corner, listening to his sweet and holy voice and whispering into the wireless microphone.

# High Park, by Grenadier Pond
*Dennis Lee*

Whatever I say, lady
it is not that
I say our lives are working — but feel the
ambush of soft air — , nor that our
rancour & precious remorse can be
surrendered merely because the earth has taken
green dominion here, beneath us
the belly of grass is real; and lady
it is not that
lovers by the score come sporting
fantasies like we had     strolling
bright-eyed past the portulaca — we could
whisper messages, they would be
snarls in our own blood;
and I am
bitter about our reconciliations, we panicked, we
snowed ourselves each time. So lady
it is not that
I hanker for new beginnings — confession and
copout, we know that game, it's as real as the
whiskey, the fights, the pills.

And I do not start this now because the grass is green,
and not because in front of us the
path makes stately patterns down the slope to Grenadier and all the
random ambling of the couples hangs
like courtly bygones in the shining air;
the old longing is there, it always will but I will not
allow it.
But there is
you, lady. I
want you to
be, and I want you.
Lie here on the grass beside me,
hear me tie my tongue in knots.

# Fugitive Pieces

*Anne Michaels*

When my parents came to Toronto, they saw that most of their fellow immigrants settled in the same downtown district: a rough square of streets from Spadina to Bathurst, Dundas to College, with waves of the more establish rippling northward towards Bloor Street. My father would not make the same mistake. "They wouldn't even have the trouble of rounding us up."

Instead, my parents moved to Weston, a borough that was quite rural and separate from downtown. They took out a large mortgage on a small house by the Humber River.

Our neighbours soon understood my parents wanted privacy. My mother nodded a hello as she scurried in and out. My father parked as near as he could to the back door, which faced out onto the river, so he could avoid the neighbour's dog. Our major possessions were the piano and a car in decline. My mother's pride was her garden, which she arranged so the roses could climb the back wall of the house.

I loved the river, though my five-year-old explorations were held in close check by my mother; a barrage of clucks from the kitchen window if I even started to take off my shoes. Except for spring, the Humber was lazy, willows trailed the current. On summer nights, the bank became one long living room. The water was speckled with porch lights. People wandered along it after dinner, children lay on their lawns listening to the water and waiting for the Big Dipper to appear. I watched from my bedroom window, too young to stay out. The night river was the colour of a magnet. I heard the muffled thump of a tennis ball in an old stocking against a wall and the faint chant of the girl next door: "A sailor went to sea sea sea, to see what he could see see see ..." Except for the occasional slapping of a mosquito, the occasional shout of a child in a game that always seemed dusky far, the summer river was a muted string. It emanated twilight; everyone grew quiet around it.

My parents hoped that, in Weston, God might overlook them.

One fall day, it would not stop raining. By two in the afternoon it was already dark. I'd spent the day playing inside; my favourite place in the house was the realm under the kitchen table, because from there I had a comforting view of my mother's bottom half as she went about her domestic duties. This enclosed space was most frequently transformed into a high-velocity vehicle, rocket-powered, though when my father wasn't home I also set the piano stool on its side and swivelled the wooden seat as a sailing ship's wheel. My adventures were always ingenious schemes to save my parents from enemies; spacemen who were soldiers.

That evening, just after supper — we were still at the table — a neighbour pounded at the door. He came to tell us that the river was rising and that if we knew what was good for us we'd get out soon. My father slammed the door in his face. He paced, washing his hands in the air with rage.

The banging that awakened me was the piano bobbing against the ceiling beneath my bedroom. I woke to see my parents standing by my bed. Branches smacked against the roof. It wasn't until the water had sloshed right against the second-storey windows that my father agreed to abandon the house.

My mother tied me in a sheet to the chimney. The rain hit; needles into my face. I couldn't breathe for the rain, gulping water in mid-air. Strange lights pierced the wind. Icy tar, my river was unrecognizable; black, endlessly wide, a torrent of flying objects. A night planet of water.

With ropes, a ladder, and brute strength, we were hauled in. As if released from the grasp of searchlights from the shore, when our house plunged into darkness, it was swept, like every other on the street, fast downstream.

We were fortunate. Our house was not one of the ones that floated away with its inhabitants still trapped inside. From high ground I saw erratic beams of light bouncing inside upper floors as neighbours tried to climb to their roofs. One by one the flashlights went dark.

Shouts flared distantly across the river, though nothing could be seen in the pelting blackness.

Hurricane Hazel moved northeast, breaking dams, bridges and roads, the wind tearing up power lines easily as a hand plucking a stray thread from a sleeve. In other parts of the city, people opened their front doors to waist-high water, just in time to see an invisible driver backing their floating car out of the driveway. Others suffered no more than a flooded basement and months of eating surprise food because the paper labels had been soaked off the tins in their pantries. In still other parts of the city, people slept undisturbed through the night and read about the hurricane of October 15, 1954, in the morning paper.

THE ROYAL
ONTARIO
MVSEVM

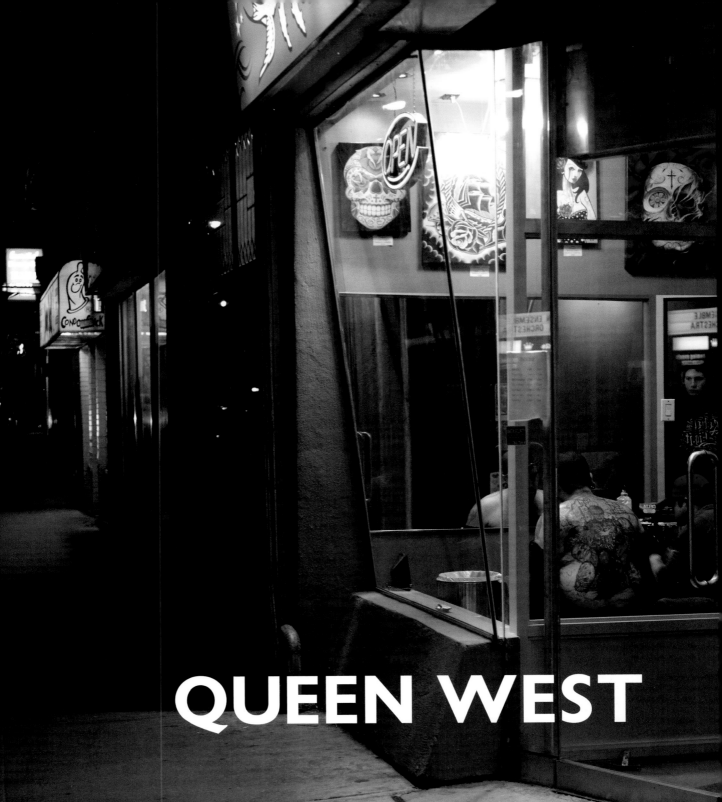

QUEEN WEST

## Lunatic Villas
*Marion Engel*

In 1967, to celebrate Canada's hundredth
birthday and to give the woman something to
do, a broker named Morgan Wickwire bought
his wife a street in Toronto.

In terms of the streets other people were
buying, it was not a very large one. In terms of
the neighbourhoods others were choosing, he
did not choose well. His "charming cul-de-sac,"
as it was subsequently called in real-estate
advertisements, consisted of a dozen houses
facing each other in two rows like broken teeth,
bounded on the south by a hydro substation,
on the west by a mattress factory, and on the
north by a neighbourhood where no one has
spoken English since 1926. Still, Morgan and
Wilma Wickwire thought, for a while, that they
had a bargain, as indeed they would have had
the wind of development blown west instead of
east; and Rathbone Place did, in the end, achieve
some of Morgan's aims: it kept Wilma busy,
provided Morgan with a larger tax loss than he

had dreamed of, and survived to be christened
Ratsbane Place by Mick and Melanie Ross, thus
escaping mediocrity forever.

Two of the owners refused to sell, but
permission was obtained from one, the lady
who ran the Finnish rooming house, to
sandblast her house and remove her front
porch. The other, the owner of the hardware
store on the corner, was adamant about
remaining faithful to dirty brick, but since he
had his shop attached to his house so that it
faced politely to the east, it was easy to detach
him from the development. Three of the houses,
already condemned, seemed beyond repair.
Two — one on each side of the street — were
removed to give owners access to the hovels' back
yards by means of a narrow right-of-way that
condemned them eternally to Volkswagens. This
left Wilma Wickwire six houses and a wreck to
play with, and soon enough she was supervising
crews of groggy-eyed dew-worm pickers as they
heaved rotten window frames and rusted sash
weights into bulk loaders. She had decorated
many houses in the past, but never had the

satisfaction of starting quite so close to the beginning. It was like unravelling knitting. She began with buoyancy and quickly learned the vocabulary of Rathbone Place.

Like much of the "near west" of the city, as she liked to call it, the street had been thrown up in a hurry during some kind of real-estate boom that preceded the First World War. The wiring dated from 1913; so did the plumbing, except for the extra toilets and kitchen sinks that had been installed in every available room in the immigrant fifties. None of the owners, who had, after all, been overtaken by war, Depression and more war when their houses still smelt of new pine, had seen fit to make any changes other than converting their furnaces from coal to gas. There were fading Sicilian marriage wreaths over some of the doors and mezuzah marks in archways; alas, the pine had never been good, and the fireplaces were of a period ten years ahead of Wilma Wickwire's time: the art-deco revival was too late to help her.

But, as everyone said, you could say a lot about Wilma — she landscaped Number 8 before she brought the bulk loader in to sit on the new turf — but you couldn't say she wasn't a worker. Although she did not fail to notice that the mattress factory was attractive to rats, she did succeed in getting ivy started up its ugly walls. She bossed and stripped and shivered and plunged; by Christmas she had worked so hard and learned so much about heating, plumbing and electricians that she collapsed in her ski lodge at Collingwood and raved for some time about party walls and by-law restrictions. It was a month before she was on her feet again, shivering in the house she kept for an office, staring at blueprints and samples of wallpaper. Her designer was complaining about the houses.

"They're just not interesting," he said.

"Don't give up on me, Hal."

"If you'd bought in the east end you'd have got some space. How do you expect me to work with fourteen feet wide by sixty feet long and no stained glass?"

"Stain some, darling. Everything is possible. You were the first one to say it."

"The soil is all coal dust; you'll have to do stone sets instead of grass."

Wilma, who had been idly calculating the cost of four new furnaces and four rewirings if they all cost as much as Number 6's, merely muttered, "Brilliant, darling," and went back to her scribbling. She wasn't paying Hal: Hal was paying off innumerable cocktail parties.

Wilma looked back at the figures and knew that, however well brokers are paid, the only thing to do now was cheat. She spent the next two weeks at bankruptcy warehouses and insurance brokers' outlets. She went to wholesale houses and bought enough velvet and braid to please Scarlett O'Hara. She reminded her brother-in-law that he owed her some money and could pay it off in plumbing. She ordered appliances on her Eaton's credit card, dug from her basement chiffoniers, escritoires, washstands, dry sinks, breakfronts and kitchen tables, chipped speckled pottery, fern stands, wicker chairs, violin cases, butler's tables, brass hooks, half-broken Tiffany shades, stone crocks, pots and innumerable porcelain doorknobs —

the kinds of things she found irresistible at country auctions. She looked over the collection and knew at last what her husband really thought of her.

But she was made of strong stuff: she did not give up. Her children complained that she smelled of turpentine and her husband complained of the food: she was flushed with the effort of turning defeat into victory. With the aid of Hal's plans, striped wallpaper, and all the gilt rope she could lay her hands on, Number 11 became a Regency bijou. Number 8, which had been lived in, unpainted and unannealed, by the same old woman between 1913 and 1966, when she died there, was dusted, sanded, vacuumed (and there is an enormous feeling of satisfaction, Wilma found, in running an industrial vacuum over a coal bin) and lit so brilliantly that the workmen could not complain about their fear of rats. While they were knocking holes in walls for wiring, she was painting with buttermilk paint and applying a homemade stencil to the kitchen. While they groaned and wrenched at drains, she ran wild over wicker with

aerosol cans of white paint and sewed cushions. Number 8 got mottled brown doorknobs, except on the insides of closets. Hal, meanwhile, supervised the conversion of the remaining condemned house into a dream of skylights, catwalks and cathedral ceilings, reducing a six-room house to the size of a very smart bachelor apartment. It needed no doorknobs at all; it had very little in the way of doors.

At the end of March, just before her note with the trust company regarding the purchase of the houses fell due, she called a friend, victim or heroine also of a thousand cocktail parties, editor of a women's magazine, and asked her around for a drink. Without covering up her mistakes (she had papered one room before the electricians worked on it; she had begun to remove all the verandahs before she realized that Number 4's was attached to Number 6's), she stuck to her principal guns and played — not even faint-heartedly, but knowing that although she would never make a profit she must keep Morgan Wickwire at all costs — the role of victorious woman.

"I don't know how the hell you're going to sell them, Willy. The back bedrooms are just too small."

"Nurseries, darling," not confessing that the heat hardly reached the back at all.

"Have you put them on the market?"

"There's an ad going in on the weekend."

The editor frowned. "I never do a straight promo, you know."

Wilma made a move to indicate that she thought such things were shocking.

"But I'm kind of interested in all this activity. Let's see through your Old Ontario house again. You've done a fair job on that. The one with the cathedral ceiling's too small, you'll never get rid of it. I wish you could have laid hands on some bigger ones, like the ones Doug Swan's been working on St. Nicholas Street. Still, that's out of your class. These were tacky little houses to begin with, weren't they? But there's the hardware store, and the Italian place up there doesn't look bad for bread and veg: you might do it. What are you asking?"

"Thirty," Wilma said firmly.

"If I was a real bitch I'd ask for a cost-accounting on that. Still, you tore down two, didn't you? At twenty-two you might do something."

They went over Old Ontario again. The editor shuddered at the long, narrow bathroom, which wasn't quite modernized by a long sink full of ferns.

"Saunas are going well these days, but I suppose these places would fall apart in the steam. Tell you what: I've got a staff member who's come into some money and is looking for a place. She's been living in some God-awful studio on Spadina, a place so arty the Children's Aid nearly took the kids away. I don't know how she's going to squeeze four kids into those three rooms but I'll send her around. She knows a lot of people, too: might come up with someone else. Give her a break, though, eh? I don't pay her that much. She's called Harriet Ross, and I'll tell you her story some time."

Which is how Harriet Ross, and Sim, Melanie, Ainslie and Tom's Mick came to christen the Wickwires' expensive toy Ratsbane Place. It didn't come to be Lunatic Villas, however, until it had met Vinnie and Winnie and Sylvia and Roger, Michael Littlemore and the twins, Madge and Adge, Elaine and Pen, and Marshallene, Bob the Painter and his friend Fred, the people from Saskatchewan and oh ... all the others.

It took some time for the street to reach this height; first Sylvia had to buy Number 7 in order to install her wheelchair ramp and her aviary; and meet and marry Vinnie at the Bird Fanciers' Association; and even before that, the trust company fell into receivership so that two houses were sold for the price of one to Harriet, who, to avoid the embarrassment of having two front doors, made a two-storey flat out of Number 8, which she rented then and still does, to cover taxes and utilities, to her friend Marshallene. And Adge had to buy Number 9 and die, but not until her great orange tomcat, Rudolph, had ravaged the aviary; then, before Tom's Mick was even big enough to break a window, Harriet made the mistake of marrying Michael Littlemore and the twins appeared; Adge was mourned but Roger bought her house,

adding another realist to the block. What the people from Saskatchewan had besides mystery was eventually tragedy, but who could then have known? The gaps remained, the hardware store remained, but the Finnish boarding house ended with the harsh life of its owner and was remodelled and sold and resold and resold. Bob the Painter bought the corner store when the Italian grocer retired, and kept the Salada tea letters but silvered the inside of the window, so he could paint unobserved, which was spiteful but not quite, because he was Bob Robbins whom they loved. Hal did what he could with the house beside Harriet, but that was resold and resold as well. The new people all seemed to want larger cars and a neighbourhood that summered up north instead of noisily under its grape arbours. And the neighbourhood lacked, in addition to a library, it is true, a non-ethnic butcher, silence and a mailbox. Some of these difficulties Roger assuaged by getting them all involved in city politics. A city magazine wrote the place up as "trendy"; Roger said it could hardly be trendy when the twins went to the bathroom on his lawn. Harriet fired her housekeeper and spent the money she saved on a psychiatrist and a downstairs john. The people from Saskatchewan remained silent and Bob Robbins scratched a very small hole in the silvering on his window so Mick could stand and watch him paint.

By 1979 the houses had settled as far as they were going to for a while, and the owners had settled down. Harriet's tribe was no longer a band of fiendish infants, Vinnie and Sylvia had given up sleeping together and were concentrating on breeding chattering lories and macaws, and Roger had given up a number of committees, though not the effort to procure a library, and become curiously domestic. Marshallene gave up her second marriage and returned permanently to the street with a case of Scotch, and two quiet young couples who were devoted to their children and needed Harriet's to babysit them had moved into the ever-changing houses. The place no longer looked new and trendy. It looked comfortable, and more or less was: in short, it was ready for Mrs. Saxe.

Curtis Smith 1962-1999
Lindsay Bruce Payne 1955-1999
Daniel Stephen Bennett 1958-1999
Jim Walsh "Siamby" 1971-1999
Cory Mousseau 1966-1999
David Lenart 1958-1999
Natara Gladue 1972-1999
Gilles Beaulne 1960-1999
Kevin Fortune 1964-1999
Jose Arturo Mariscal 1944-1999
Luis Gabriel Cerdas 1954-1999
Lennon Lan T. Ngo 1955-1999
John D. Pallas Grumholdt 1941-1999
David François Dinning 1948-1999
Ray "Dodi" Lavigne 1951-1999
Anne Marie Penney 1963-1999
Deborah Fulton -1999
Chester D. Myers 1945-1999
Michael Paul Coughlan 1959-1999
Ron Loignon 1954-1999
Don Gaul 1959-1999
Rick Johnson -1999
Richard W. Brown 1955-1999
Curtis Newhook 1960-1999
Kenneth M. Bernard 1966-1999
James Doug Heden 1956-1999
Peter Johnson, aka "Peaches"
1949-1999

Benoit Grenier -1999
Médard Michel Léger 1947-1999
Mark Borge Christensen 1959-1999
Alan Repol 1956-1999

# 2000

Doug Jenkins 1963-2000
Don Derepanchuk 1962-2000
Vincent Lamontagne 1965-2000
Timothy Robert Turner 1949-2000
Grant Keable 1957-2000
Randy Innes 1950-2000
Wayne P. (Sam) Clark 1955-2000
Paul Romyn 1961-2000
Sid Kemp 1957-2000
James McMurray 1926-2000
George Shaver 1942-2000
Waldemar Dymowski 1958-2000
Lloyd Sykes 1963-2000
Chistian Hébert 1960-2000
Danny Chase 1956-2000
Peter MacKay 1960-2000
Glenn Small 1963-2000

Claude Journeau
Raymond McCart
Craig Reid
Michael Wayne Wardman 1965-2000
Larry Read 1955-2000
Paul D. Nicholas 1965-2000
Richard E. Phinney III 1960-2000
Terence Beal 1959-2000
Bob "Red Cross" Sullivan 1957-2000
Alec W. Friedman
Todd Vincent 1963-2000
Eric John Otto 1957-2000
Taras John Ilkiw 1963-2000
Michael Harding 1964-2000
Guy Lamirande 1963-2000
Louis Kokoros 1949-2000

# A Gift of Mercy
*Timothy Findley*

When Minna Joyce first laid eyes on Stuart Bragg, she told herself to remain calm. This was back in 1975 when she was still in her waitress phase and working for a man whose name was Shirley Felton. Shirley ran what Minna called The Moribund Cafe on Queen Street West. It was really called the Morrison Cafe, because it was in the Morrison Hotel — a rummy dive for drunks and crazies, now defunct, on the north-east corner of Shaw and Queen. Minna had been working there since late July of the previous year and the reason she gave for taking such a job was that she had to keep her eye on the Queen Street Mental Health centre, just across the road.

"You never know, my dear," she had said to one of her park-bench friends, "what they'll do behind your back." Also, there was the vaguest hope that her mother — newly remarried Mrs. Harold Opie — might drive by one day and find her cast-off, screwed-up daughter working behind the counter in The Moribund Cafe — drop dead of shock and thus spare the world the continued menace of her presence. "And that, my dear, would be worth the price of admission!"

As to why Mrs. Harold Opie — the ex-Mrs. Galway Joyce — might be adrift at all on Queen Street, Minna Joyce could imagine. Perhaps her cool stability was really less than it seemed and she was looking for yet another masochist crazy enough to marry her. Galway Joyce and Harold Opie had both been mad enough to do so — and, from what Minna knew of her mother's most recent marriage, Mister Opie was already on the way out the door. But whatever the reason might be, Minna Joyce was content to believe in its probability and dreams of its eventuality.

Now, in the depths of winter, Stuart Bragg had just walked through the door and Minna — who was leaning down to place a cup of coffee and a plastic spoon beneath the vacant stare of one of the Moribund's regular customers — felt the draught and looked up to see who might have entered.

There he was, and her body held its breath while her mind went racing.

A blizzard was going on outside and Bragg had brought it with him through the door. His hair was white with snow and he wore a long, black coat. The storm raged up against the plate glass window at his back and the way it blew, it looked as if it had pursued him, eager to engulf him.

Bragg had the look of one who bore a message — lost and uncertain as to whom the message must be given.

*Me*, said Minna's mind. *He's come here looking for me.*

But of course, he hadn't. He was just another stranger from Queen Street and Minna was quickly reconciled to believing that was good enough. Strangers were her speciality and those who were pursued by storms and demons made the best strangers of all. She herself had once been pursued by storms and demons, and, even now, she was still in the process of firing at them over her shoulder — her aim perfected after many years of practice. Only three or four remained at her heels, and, of these, the most persistent were her love of dark red wine and her passion for the written word. This latter was a demon flashing sentences before her eyes with incomprehensible speed — and whose sibilant voice was lower than a man's.

Bragg's eyes searched the restaurant for someone he could trust. Minna was used to this look. She saw it every day, when strangers walked in and were confronted by the faces of the regulars — the rummies and the drugged-out kids, the schizoids and the dead-eye retainers whose job it was to sweep the snow and rake the leaves at the Queen Street Mental Health Centre. Bragg evaded all these people — caught Minna's eye and turned away from her.

*Wait*, she wanted to say to him. *I can help you.* Minna recognized the look in his eyes of unrequited sanity — the look of someone terrified of the light in a world lit up with stark bare bulbs. He even squinted, placing his hand along his forehead. Minna stepped forward — but Shirley was already marching down the counter.

"Yeah?" Shirley said to Bragg — using his dishrag, polishing the soiled Formica countertop, rearranging the packs of chewing gum piled beside the register. "What can I do you for?"

Minna listened, breathless.

*Please don't go away*, she was thinking. *Don't go away before we've made contact.*

"I need to make a call," said Bragg. "Have you got a telephone?"

"Sure I got a telephone," said Shirley, "but it ain't for public use. You want a coffee instead?"

"Thank you, no," said Bragg. "I really do need to make a call." He was eyeing the telephone behind the counter just the way a man who is starving eyes food on someone else's plate.

"Sorry," Shirley told him. "I got a policy here: no calls."

"Where, then? Where can I find a telephone?"

"'Cross the road in the Centre. Maybe there's a pay phone there."

"Thank you," said Bragg. And he turned to go.

*No*. said Minna. *You mustn't. We haven't met.*

But he was out the door and the storm was about to have its way with him.

Minna closed her eyes. Why were the lost so beautiful? She couldn't let him go.

"Wait!" she heard herself calling.

Shirley turned in her direction. "What the fuck's with you?" he said to her. "Didn't I tell you no one yells in the Morrison Cafe?"

But Minna was already reaching out for the handle of the door and barely heard him.

Out on the street she looked both ways and hurried to the corner.

"Wait!" she shouted. (What if her mother could see her now?)

Everything was white before her and blowing into her eyes. Peering through the snow, she saw the lights were about to change and she ran out, flat against the wind with her apron clinging to her legs like something desperate, begging to be rescued. Suddenly, there she was on the other side of Queen Street, blindly grabbing for the long, black sleeve of the departing stranger.

"Stop!" she yelled at him. "Stop!"

He turned, alarmed and tried to brush her off — but she dug her fingernails into the cloth and pulled up close to his arm.

The man was truly afraid of her; the look on his face was unmistakable and one she had seen a dozen times before. What had he done that she should have followed him — attacked him in such a panic?

"Please," he said, attempting to be civilized. "Don't."

There she was with her hand on his arm — a perfect stranger, standing in a blizzard out on Queen Street, wearing nothing but an apron over a magenta uniform — and *Minna* traced in thread across the pocket of her breast. And her hair was blowing against her face and he thought: *she's mad as a hatter — and beautiful as anyone I've ever seen.*

"All right," he said — giving in because it was so evident she wouldn't let go until she'd had her way. "Tell me what's wrong."

"Your name," she shouted at him — each word blown away in the wind. "Tell me your bloody name."

"What?" he shouted back at her. "What?"

Several people, fully cognizant of where they were and what they might be witnessing out in front of the Queen Street Mental Health Centre, huddled on the corner waiting for a streetcar. The way this man and woman were holding on to one another, they looked as if they were locked in a deadly struggle. But she was only waiting for his answer and he was only trying to prevent her from being swept away in the Queen Street traffic.

"Please," she shouted at him — right into his ear. "I have to know who you are!"

Bragg stepped back and stared at her as best he could through the storm. She was holding back the strands of her flowing hair and it was only then that he saw that she was smiling; laughing at her own audacity.

"Oh," he said. "I see."

Very slowly, he grinned, and three months later they were married.

# Squeegee Kid
*Raymond Souster*

I'm in downtown afternoon traffic,
Queen and Bathurst, going west,
the usual one-lane crawl.

A squeegee kid
appears from out of nowhere
at my wide-open window.
"Want your windshield washed?"

"No thanks," I tell him,
but seeing I'm fully stopped,
he quickly sprays it anyway,
saying a little louder,
"This one's on the house,
it's going to be a great afternoon."

I don't know what to say,
but would have at least managed thanks,
but he's barely stroked the water off
before the traffic
starts moving ahead of me,

and a car even honks behind,
with the kid gone all at once,

and I hit the gas, thinking
if this is a great afternoon for him
then I'll have to try damn hard
to make it a great one too for me.

# Gently Down the Stream

*Ray Robertson*

All right, the park.

On a typical springtime or summer-time or even late fall evening, the park, Sorauren Park, is a living thing: screaming packs of six-year-olds chasing around a single, elusive soccer ball; little league baseball teams decked out in brightly coloured jerseys coughed up by neighbourhood businesses; babies in carriages like little popes in their little popemobiles going for fresh-air rides; and a loose circle of grown-ups and their dogs gathered together in the middle, near the drainage grate.

Mary and I don't have kids and don't even know the names of the other dog owners who come to the park every night like us, just like they don't know ours. Dog owners know other dog owners by their dogs' names. Here comes Rocky and his mum, you'll say. Or, Did I tell you Bracken's dad was ahead of me in line today at the beer store? He bought a twelve-pack of Amsterdam Blonde.

Tonight, a November drizzle steadily turning into a cold, autumn rain, there's just us, the dog people — Fraser and his dad, the big cop wearing his York weight belt as usual over top of his sweaty grey track pants and PROPERTY OP TORONTO POLICE DEPT. sweatshirt; Lucille and her mum, the redhead from Quebec who's always complaining in broken English between drags on her cigarette how unfriendly Torontonians are; and Rover and his mum and dad, Casey and her family, and Hunter and his parents. And me and Barry, Mary at a friend's art opening. And somebody new whose dog I don't even know.

The woman is tall and thin and strawberry blond, her bright blue eyes the perfect facial accessory. Her hair is long and loose and hangs in ringlets that she pushes away from her face with one hand while being tugged around our little circle by her border collie puppy yanking on the other. Lucille's mother is saying something about how in Montreal people work to live, not live to work, when the woman's puppy pulls her my way on the far edge of the crowd. I'm glad there are the dog people — Barry spends most of his time with me and Mary, so it's good for him to have some quality time with his own species — but I'm not good at saying nothing, a prerequisite for standing around in the middle of a park with a bunch of strangers in the rain.

Naturally, the puppy goes right for Barry's pecker and starts slurping away like a hungry calf to a cow. Less than half Barry's size, all he has to do is stick his head underneath and turn it sideways and — Action! — instant doggie porno heaven. Then Barry disengages himself and returns the favour, if with some difficulty. Of course. I've yet to run into an attractive woman walking her dog when I'm out with Barry and not have the situation almost instantly degenerate into a sloppy canine sixty-nine. Only the puppy not being big enough yet to accommodate a reciprocal lap job saves me that particular embarrassment this time around.

"Omar, will you stop that," the woman says with what I think is an English accent, the puppy going back for seconds now, she pulling at the dog's leash with both hands to little effect.

"Barry, come," I say in my best alpha dog baritone, and Barry follows me a few feet further away from the crowd. The woman's leash looks expensive, long and thin and made of polished brown leather, and she gives the puppy the slack

he needs to quickly find several other willing partners back in the inner circle.

"I wish I could get him to listen to me like yours listens to you," she says.

The accent *is* English; like most people who aren't really from anywhere, accents impress me, make it sound like there's more to what someone is saying than there likely is. This is my theory as to why most documentaries are narrated by the British.

"He just turned ten," I say. "Yours will slow down. That's why nature made puppies so cute — so people don't kill them."

The woman sweeps some of her hair off her face and smiles, not just with her mouth, but with her eyes. I like looking at beautiful women and think everyone should — just like I believe that no one should go more than a month without watching the sun come up, that a life without the Beach Boys' *Pet Sounds* in it doesn't make sense, and that everyone, regardless of any dietary or ethical concerns, should make a point of occasionally washing down a fat slice of pizza, the greasier the better, with an ice cold can of Coke

Classic. But looking isn't the same as flirting, so I cut my eyes from hers to the ground.

For some reason I'm stunned at how incredibly green the grass is. I know it's just because of the sewage stream running directly underneath this section of the park, which is also why the grass is so much longer and thicker, but it's so brightly green, it's like it's almost glowing. There's no way, part of me is saying, that the accumulated shit of six or seven blocks of houses can be responsible for something so ridiculously alive. There's just no way.

"Any tips, then?"

I look up. I have to think for a moment. "Use a firm voice," I say, "the lower the better. Let him know who's in charge. Dogs want discipline, they want to be told what to do. Even puppies."

The woman turns toward her dog and the group. "Omar, come," she says, more loudly than before. The puppy stops sniffing Hunter's ass long enough to raise its ears, but a moment later is back at it. "Omar, come," she repeats, surprisingly deeply, this time even louder, jerking the leash at the same time. Omar recovers from the jolt of being yanked from his feet, shakes his head a couple of times, and jogs over to where we are, his little white tail wagging. The woman smiles at me again.

"Beverly," she says, offering her hand.

"Hank," I say, taking it.

## My Little Box
*Emily Pohl-Weary*

Almost my entire life has been spent within the grid of Toronto's west end. Walk out of my childhood home, turn in one direction and skyscrapers bite the sky, turn in the other and a scar-like expressway extends forever, separating the city from the dirty lake and the evils of small-town Ontario. My neighbourhood isn't lovely, in any conventional sense of the word. It's all neon-bright colours, stinky garbage, crumbling brick, and grey cement. But if you know how to look, beauty emerges from the clutter.

Someone once described Parkdale as a scribble on the edge of our country's biggest city. It's an urban no-man's land, home to a mélange of out-patients from a mental health centre, new immigrants, crack addicts, and struggling artists. Growing up here, I learned to appreciate the things people warn you about, like grime, smog, haphazard growth, and crazy people. Now, given a choice between serene sameness or hectic density, I'll always choose the latter. I'd rather schlep my sorry ass around on crowded streetcars, with sweaty businesswomen in polyester suits breathing fishily down my neck, than live an enclosed bubble existence.

For one thing, there's a relief in knowing nothing's truly private. No one bothers to keep up the facade of flawlessness, because we live on top of each other, and experience our personal moments in a public forum. No man or woman is an island — not even if they desperately want to be — in a tightly packed community. It's virtually impossible not to interact with strangers, even on the way to the corner store.

There was one man who sat on our corner for most of my childhood years, oblivious to the choking summer heat or the bitter cold of February. He rocked back and forth endlessly, with his hands over his face, whispering his traumas under his breath. We never spoke a single word to each other, and I really have no clue whether he even saw me through his fingers. But in a strange way, I'll always be grateful for the sight of him there, next to the

Queen streetcar stop, because when I saw him, I always knew I was home.

He's just one of the memories that follow me around. My best friend lived in the duplex upstairs from us. She had a guinea pig and the coolest Barbies, showed me how to light cigarette butts with a magnifying glass, and made me practise dance routines to Madonna and the *Rocky Horror Picture Show* until I pretended to hear my mother calling for dinner. She was a great teacher of all things naughty and make-believe and secret. Years ago, she moved away, became an exotic dancer, one of those girls who writhe in cages at dance clubs.

There's also the ghost of storyteller Rita Cox, a local librarian, who told the best Anansi the Trickster stories I've ever heard. She's gone on to become a Citizenship Court Judge and receive the Order of Canada. Back when she was in Parkdale, she saved a million dress-up costumes for kids in the basement of the library branch. Each year, she would round us all up, dress us in our favourite outfits, and march us over to celebrate the carnivalesque Children's Caribana

by the lakeshore. Because of her, I fell in love with steel bands, and the gorgeous music that can be made from the lid of a garbage can or an empty oil drum. Their pings, clangs and bongs dance in my head to this day.

I'm not saying all my memories are good. Once, I saw a man have a heart attack on the street, within spitting distance of two beat cops, who did nothing until I screamed at them to call an ambulance. Apparently, he was overdosing.

In my area, a person's life is both worthless and priceless at the same time. Cops busted down all the tenants' doors during a raid on a boarding house down the block from our house, and the Old Bird Lady happened to be standing on the other side, about to flip the lock to let them in. Her family was the flock of pigeons she fed every afternoon, and she missed them dearly while she struggled to recuperate from the ensuing concussion. I was the only one who brought her flowers. That kind of experience helps you put things into perspective.

Despite that, Parkdale makes me feel like I'm being hugged whenever I'm outside. Probably

because someone's always watching. I know the landscape so well that maps are superfluous. It's impossible to get lost. I feel my way around with my eyes half-closed — sometimes reading a book or singing along to music on my headset.

I love shortcuts and alleys filled with graffiti. Some people pay to go see fine art at a gallery, but I just head to my neighbourhood's shadowy places. There's no question of safety. Sticky situations are easy to handle by making eye contact, picking my nose, giving the finger, ducking into a corner store or hailing a cab.

When I travel just twenty blocks in any direction, I get disoriented. North is no longer up, south isn't down. Things are further apart, more uniform, less familiar. If I go just a bit further, and blink for a moment, when I open my eyes I've shifted into a parallel universe.

In some ways, flying through space seems more appropriate than taking the subway out to Lawrence Park. I miss the sound of a thousand voices with different accents, the strains of every kind of music floating from open windows and tricked-out Honda Civics. The city is a constant symphony of honking, cell phones and tires screeching.

So I always return to the downtown core with a sense of relief. While forays outside my little box are enlightening, nothing beats familiarity. Besides, a mental chasm exists between the urban and the suburban, between hectic chaos and artificial order. We are shaped by our environments. I am a child of the city.

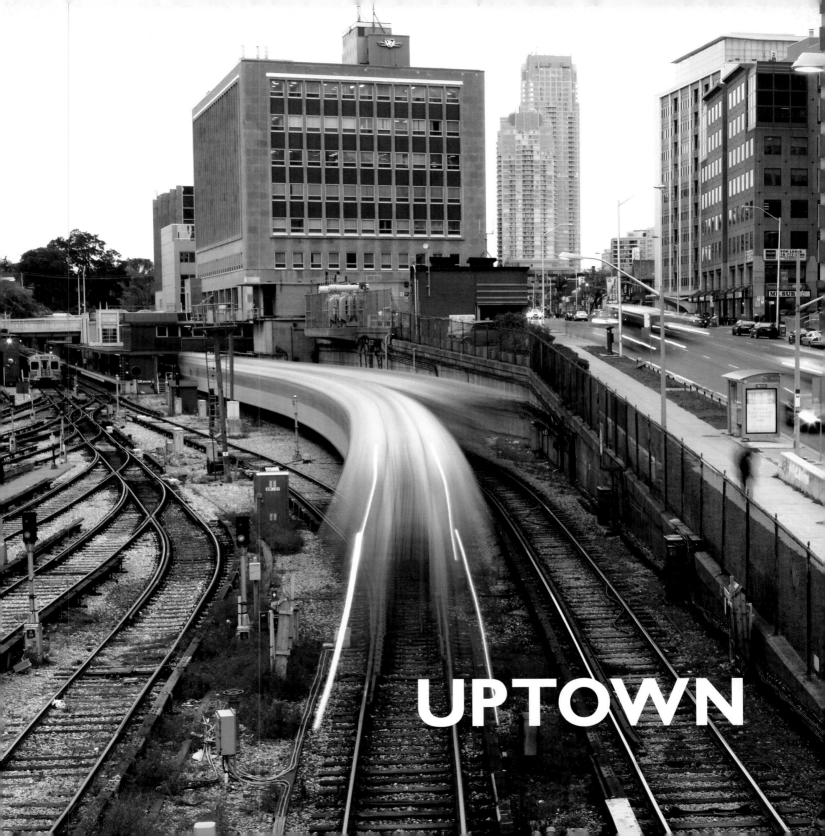

UPTOWN

## Minus Time

*Catherine Bush*

Paul and I sat in the backseat while my mother drove down Avenue Road, downtown to the planetarium where we were going to meet my father and see a star show called *Red Giants and White Dwarfs*.

"You know how the telephone was invented by Alexander Graham Bell?" My mother's voice had an intensity that made even impersonal things seem urgent. "He was originally from Scotland, except now the Canadians and Americans keep fighting over him. Well, the television was also invented by a Scotsman, did you know that? It's true, even though the Americans say they invented it. They didn't. I think there must be something about small northern countries, that's what I think."

"Why?" Paul asked.

"People need to invent ways to communicate," she said. We were just below St. Clair, slowing at a traffic light, when she turned and pointed across the street at an old, low-rise apartment building. "That's where Nana and Grandad were living the year I was born." I craned backward to see. The building had a glass front door, a tiny lawn in front of it. She'd never told us this before. Sometimes I forgot my grandparents had ever lived in Canada, because as long as I had known them they had been living in a tiny town in Scotland, thousands of miles away. And then the light changed, and as we sprang forward, I swivelled around again because I didn't want to miss the huge hill that I loved. The road dropped away in front of us, the whole city spread below us, the grey concrete stump that was the beginning of the CN Tower visible in the distance. The Tower was going to be the tallest freestanding structure of the world, with a huge communications antenna at the top.

"OK," my mother said, "it's just after the last Ice Age and we're on the shore of Lake Ontario, because all the run-off water from the glacier has swollen the water level in the lakes until they're huge and high and this is where the lake begins. Look out now, we're going over the edge, we're diving into the lake, we're heading into the

underwater city, and it's a good thing we brought our flippers and oxygen masks, because we're almost on the lake bottom." She grinned at us and we shrieked the way we always did as the car sped down the steep hill of the old lake, hurling us forward like a roller coaster.

"It's the Ice Age," I shouted. "We're on top of the ice. And there are mastodons." We had seen a movie like this in school, about a man who travels through time as he canoes across the lake.

"That's right," my mother said. "There are mastodons grazing at Yonge and Bloor." Between the tops of the bank towers and the Bay department store they grazed, hundreds of feet tall, bigger than any other animal that ever existed, swaying their huge, shaggy heads and enormous tusks from side to side.

She often told us stories like this, stories about the layers of things, how an ordinary rock from Minnow Lake, where we went for two weeks every summer, contained particles that had been in existence since the beginning of time, just as

the jittery static on our own TV set could be traces of energy travelling across space from the earliest days of the universe. What you saw was not always what it seemed.

As we reached Bloor Street, a few stray flakes of snow began to fall, glancing across buildings, over cars, over the black snow encrusted at the curb. The museum with its huge stone arches rose on the far side of the street and spread south toward the white bulb of the planetarium. "Look," my mother said, "there he is, do you see?" A tall man in a dark suede jacket stood on the sidewalk, holding a soft-sided briefcase, sandy hair straying over his forehead.

"Wave, Helen. Roll down your window and yell." The planetarium gleamed like a half-moon, half-globe, and my father's eyes changed suddenly as I opened my window and my mother veered toward the curb. He hurried toward us, circles of snow dissolving on his dark jacket, his arms opening wide to gather us in.

## VE Day on the Yonge Street Hill

*Harry Bruce*

Victory in Europe Day occurred when I must have been ten, going on eleven, but I do not remember it well. I do remember that another kid and I walked far downtown in the sunlight and the spring dust and the small-town excitement of Yonge Street and that, somewhere down there, a news-dealer was wearing a suit of shining armour and giving away his papers.

I remember we got tired at last and decided to hitch-hike home like soldiers, and that an old round-shouldered car stopped for us. I remember that a middle-aged man was driving; that a dark, quiet, compassionate-looking woman shared the front seat with him; that she reached back to open a rear door for us; and that there was an extremely pretty little girl in the back seat. The car smelled like an old curtain, and the little girl smelled like a little girl.

I remember that, all the time we crept up past the flags of Yonge Street, all the time we moved north with the dizzy cheering and the pure breeze of May pouring through the open windows of that car that was as old as my own life, during that whole time, we three kids were jabbering away, the woman kept her hand on the man's shoulder, and the man just looked straight ahead.

Then we were in the middle of the Yonge Street hill, just south of the spot where radio station CHUM would one day raise its studios, and we said this-is-where-we-get-off-because-we-live-on-Farnham-Avenue, and the man at the wheel turned and tried to smile good-bye but, I remember, he was crying. Had he lost a son in the war that was just now over? Had he been overseas himself and now — here, in his pre-war car, under the sudden peacetime sunshine and among the red, wooden streetcars and the golden dandelions of Yonge Street — was he remembering dead friends and terrible times? Or was he just a man who cried when he was happy?

## Stones

*Timothy Findley*

We lived on the outskirts of Rosedale, over on the wrong side of Yonge Street. This was the impression we had, at any rate. Crossing the streetcar tracks put you in another world.

One September, my sister, Rita, asked a girl from Rosedale over to our house after school. Her name was Allison Pritchard and she lived on Cluny Drive. When my mother telephoned to see if Allison Pritchard could stay for supper, Mrs. Pritchard said she didn't think it would be appropriate. That was the way they talked in Rosedale: very polite; oblique and cruel.

Over on our side — the west side — of Yonge Street, there were merchants — and this, apparently, made the difference to those whose houses were in Rosedale. People of class were not meant to live in the midst of commerce.

Our house was on Gibson Avenue, a cul-de-sac with a park across the road. My bedroom window faced a hockey rink in winter and a football field in summer. Cy, my brother, was a

star in either venue. I was not. My forte, then, was the tricycle.

Up at the corner, there was an antique store on one side and a variety shop on the other. In the variety shop, you could spend your allowance on penny candy, Eskimo Pies and an orange drink I favoured then called Stubby. Stubby came in short, fat bottles and aside from everything else — the thick orange flavour and the ginger in the bubbles — there was something wonderfully satisfying in the fact that it took both hands to hold up to your lips and tip it down your throat.

Turning up Yonge Street, beyond the antique store you came to The Women's Bakery, Adam's Grocery, Oskar Schickel, the butcher and Max's Flowers. We were Max's Flowers. My mother and my father wore green aprons when they stood behind the counter or went back into the cold room where they made up wreaths for funerals, bouquets for weddings and corsages for dances at the King Edward Hotel. Colonel Matheson, retired, would come in every morning on his way downtown and pick out a boutonnière from

the jar of carnations my mother kept on the counter near the register. Once, when I was four, I caused my parents untold embarrassment by pointing out that Colonel Matheson had a large red growth on the end of his nose. The "growth" was nothing of the sort, of course, but merely the result of Colonel Matheson's predilection for gin.

Of the pre-war years, my overall memory is one of perfect winters, heavy with snow and the smell of coal- and wood-smoke mingling with the smell of bread and cookies rising from The Women's Bakery. The coal-smoke came from our furnaces and the wood-smoke — mostly birch and maple — came to us from the chimneys of Rosedale, where it seemed that every house must have a fireplace in every room.

Summers all smelled of grass being cut in the park and burning tar from the road crews endlessly patching the potholes in Yonge Street. The heat of these summers was heroic and the cause of many legends. Mister Schickel, the butcher, I recall once cooked an egg on the sidewalk outside his store. My father, who was

fond of Mister Schickel, made him a bet of roses it could not be done. I think Mister Schickel's part of the bet was pork chops trimmed of excess fat. When the egg began to sizzle, my father slapped his thigh and whistled and he sent my sister, Rita, in to get the flowers. Mister Schickel, however, was a graceful man and when he placed his winnings in the window of his butcher shop, he also placed a card that read: *Thanks to Max's Flowers one dozen roses.*

The Great Depression held us all in thrall, but its effects on those of us who were used to relative poverty living on the west side of Yonge Street — were not so debilitating as they were on the far side in Rosedale. The people living there regarded money as something you had — as opposed to something you went out and got and they were slower to adjust to what, for them, was the unique experience of deprivation.

I remember, too, that there always seemed to be a tramp at the door: itinerants asking if — for the price of a meal, or the meal itself — they could carry out the ashes, sweep the walks or pile the baskets and pails in which my father

brought his flowers from the market and the greenhouse.

Our lives continued in this way until about the time I was five — in August of 1939. Everyone's life, I suppose, has its demarcation lines — its latitudes and longitudes passing through tune. Some of these lines define events that everyone shares — others are confined to personal — even to secret lives. But the end of summer 1939 is a line drawn down through the memory of everyone who was then alive. We were all about to be pitched together into a melting pot of violence from which a few of us would emerge intact and the rest of us would perish.

## From the highest window of
## my house on Winnett

*Erin Mouré*

From the highest window of my house on Winnett
This one, behind the cedar,
I wave my *adieux* with a scrap of white linen
To my poems heading out toward Lake Iroquois.

And I'm neither glad nor glum.
It's the fate of poems, I figure.
I wrote them and must present them to the denizens of Toronto,
because what else can I do
Like the flower can't fake its colour
Or the river hide its current
Or the tree claim it can't bear fruit.

There they are, poems, already at Vaughan Road, trudging to
the bus stop, and I feel a kind of pang
Unexpected, but physical.

Who knows who'll read them.
Who knows what hands they'll fall into.

Flower, I was cut out for being seen with the eyes.
Tree, my fruit must be taken by mouth.
River, all my water flows outward, away from me.
I give in, and feel a bit happy,
The joy of someone who's just tired of being sad.

Go, go, git!
The tree falls yet its bits litter the parking lot.
The petals droop but the flower's dust is forever.
The river enters sea and its water recalls a window on Winnett.

I pass by and dwell: my *whoosh*
against yours.

# In the Winter Before the War
*Phil Murphy*

And is there dancing still at Casa Loma?

I suppose there must be; that grand old fake castle, the white elephant that rears its architectural absurdities on the Toronto skyline, would have to be kept standing somehow — and it's not much use for anything else, is it? I mean, when you have this place with a room big enough to let a whole regiment sit down to dinner, what else could you do but hold dances in it? Besides, no matter how dilapidated or down-at-heel the old monstrosity may grow, there will always be a kind of seedy grandeur about it, an aura of long-ago-and-far-away graciousness that will make it a fitly romantic setting for the awakening of love's young dream ...

Ah, Casa Loma! Just to roll those syllables on my tongue now — yes, even now all these years later and all those miles distant — brings back to my nostrils the scent of face-powder and the chaste floral perfumes girls wore then, mingled with the smell of French chalk from the floor and 2-in-1 shoe-polish from my Oxfords. In the mind's eye, I see a huge room, with walls that tower stonily up to the height of three ordinary stories, a vast floor that is a veritable prairie of parquet, thronged with long-vanished archetypes, clean-cut, decently dressed, well behaved scions of the North Toronto middle class, moving sedately together. In memory's ear, I hear the liquid golden cascade of sound from a saxophone tuning up, under my shoe soles I feel the floor slip and slither as I slide into my own fumble-footed version of the two-step, galumphing along to half-remembered snatches of half-forgotten tunes — is that "Blue World" or "The Singing Hills"? I might be dancing as I used to dance in those days, as I did on *that* date, that first-and-last date with the lovely Zandra, on a far-off winter's night in the Toronto of the late nineteen-thirties.

Now I feel again the warmth of her svelte young waist through the pale-blue cashmere of her sweater-back, the closeness of her blond head under my cheek, the softness of her bosom's

swell against my chest, the *rightness* of the way her small right hand nestles in my left out there at arm's length. I remember the flash of inspiration I felt as I brought our joined hands in to snuggle against my shoulder while I gave her fingers a gentle caress and lowered my lips to murmur in her ear a tag from Browning, from a poem we'd been studying together in class not long before: "Your soft hand is a woman of itself, And mine the man's bared breast she curls inside."

I sensed her cheeks grow hotter as she blushed and turned her head away — that word "breast" had been too much for her, especially as it was beginning to be obvious that Zandra would be (as we said in those days) *well endowed*.

The innocence of it! The sheer innocence of that nineteen-thirties world — an Andy Hardy, a Deanna Durbin world, a world where sneaking a puff on a stolen cigarette was the equivalent of a whole course of cocaine, where a glimpse of a girl's stocking-top was as arousing as full-frontal nudity would be today. Yes, we were innocent then, innocent about a lot of things — not just about sex, but about money and class and violence. For we believed, then, that we were growing up — or had grown up — into a world where there would be no more war (the League of Nations had abolished it, you see), no more depressions (F.D. Roosevelt had practically got that fixed), no more class distinctions (Mackenzie King had passed laws to wipe them out), no more sexual hypocrisies or hang-ups (Dr. Freud had the answer to all that, didn't he?).

Back on the dance-floor, we innocents applauded politely as the number finished, and then the band — could it have been Trump Davidson's outfit? — swung into something faster, more intricate, "In the Mood," perhaps: too fast for my home-grown dance style, anyway. I raised my eyebrows at Zandra in polite inquiry and we retired to the edge of the floor.

# A Memoir of Merton Street
*Camilla Gibb*

MERTON STREET: 1972

It is August and we are eating Kentucky Fried Chicken in the backyard full of dandelions. We (mother, father, two kids and cat) have just moved from England to the New World — 543 Merton Street, a small wood-frame farmhouse circa 1900 that backs onto Mount Pleasant Cemetery. The house has a big front porch and a sloping red roof and cost $28,000. It needs a lot of work, but Dad, who is not only poor, but cheap, is fortunately also resourceful and hugely talented. He's got big plans.

The house needs rewiring, replumbing and reroofing. There is a crawl space of a basement, the building isn't insulated and the garden is a jungle. For six years we live in a building site. There is a perpetual film of sawdust on the floor, there are inevitably paintbrushes decomposing in stinking mason jars in the sink.

Dad does do most of the major jobs, though we will always see our breath on winter mornings because the house will never be insulated and I will always believe that houses are buildings to be shared with squirrels and raccoons. I will grow up believing a man is not a man unless he has at least one black fingernail.

My brother and I love living in a building site. My mother prefers the results to the process. Mum weeds and plants and makes pies out of the sour cherries that we pick from the trees in the backyard. She paints the kitchen blue, lays linoleum and carpet. With most of the basics done, Dad gets more creative. He carves a door out of a wall on the second floor, adding a deck upstairs. He refinishes the basement — turns a concrete hole into a sophisticated den with "mood lighting." He makes built-in closets for the bedrooms and bookshelves for the living room. He installs a bay window in the dining room, which overlooks the huge lot of our neighbours — Ed and Glenda from St. John's. Ed is the cremator at the cemetery. The rambling farmhouse on the huge lot is a perk of his otherwise not-so-perky job.

Dad transforms our backyard — all 30 by 175 feet of it. There is a new back porch with steps down to a brick patio and a perfect lawn, beyond which a stone path winds underneath a grape arbour suspended between the "playhouse" and swing set he has built. Further still are the gardening shed and two concrete-bound beds — one for vegetables (tomatoes, zucchini, squash), one for rhubarb and strawberries and fruit-bearing bushes (raspberry, gooseberry and red currant). Finally, a row of ferns lines the stone cemetery wall, and beyond that lies a whole other world.

I don't really register that there are dead people over that wall. We think of it as the place where peacocks roam freely, occasionally landing in our backyards. It is the place where our cats attend their school while we are at ours. Beyond the cemetery wall, Furry (indulge me, I was two when I named her) is the vice-principal, and the neighbouring cats, Chocolate and Ice Cream, unruly student and science teacher respectively.

MERTON STREET: 1978

Dad has moved out, taking half the furniture with him. I'm unusually attached to the furniture; almost all of it followed us in a crate from England and it seems in the rootless New World to represent our continuity and past. Many of our neighbours also come from elsewhere. They are first generation — Finnish, Italian, German, Greek. My friend Serena, down the street, is from Palestine. "What's that?" I ask her. "It's sort of like a country," she says. Her mother makes pita bread on Thursdays. Warm white pockets cover every surface in their house. I make sure that it's a Thursday before I agree to go over after school.

Without Dad there won't be any more structural changes; without Dad, Mum is free to decorate as she likes. These are Laura Ashley days — she painstakingly papers my bedroom walls with delicate deep rose flowers. It is beautiful and I feel very grown-up. Her sewing machine is in my bedroom — so is the record player. We don't have a television until our neighbour, who feels sorry for us, gives us a little

box with a six-inch screen. My mother, brother and I watch *The Beachcombers* followed by *The Irish Rovers* on Sunday nights.

Mum buys Dad out of his half of the house and raises the two of us on her own. Ed offers to take my mother on a tour of the crematorium. Perhaps because she is lonely, or perhaps because she is polite, she says yes. That year, my brother, who is eight, brings my mother a wreath for Mother's Day. "I know where you got this," she says, though not without gratitude. He doesn't understand how she could possibly know or why knowing might be a problem. We don't know anybody dead. Where others see death we see flowers.

MERTON STREET: 1986

We are teenagers. Poor Mum. The cemetery is now the place where we smoke our first cigarettes and have our first gropes. Ed the cremator is gone. The cemetery has sold the house to a developer, and they have levelled their old farmhouse and erected a row of massive townhouses that uses up every possible inch of available space on the lot. Our beautiful bay window now looks onto a brick wall. The light is gone. Mum's clematises have been destroyed. It's definitely time to move.

Our once relatively inexpensive street is becoming gentrified. Growing more middle class by the year. It's the mid-eighties and the market is going crazy. An inspector reports that the wiring is dodgy, the roof needs replacing, all the wooden structures in the backyard are rotting. All Dad's handiwork seems to be falling, rather poignantly, to bits. Still, it's a multiple-offer situation. My mother doesn't take the highest bid though, because she has a suspicion that another developer is behind it. She wants to ensure the survival of our home; she wants to know it will be loved in the way we have loved it.

She teaches me something very valuable. Something about the unquantifiable: about preservation and continuity. We have a past now — we have roots in a New World.

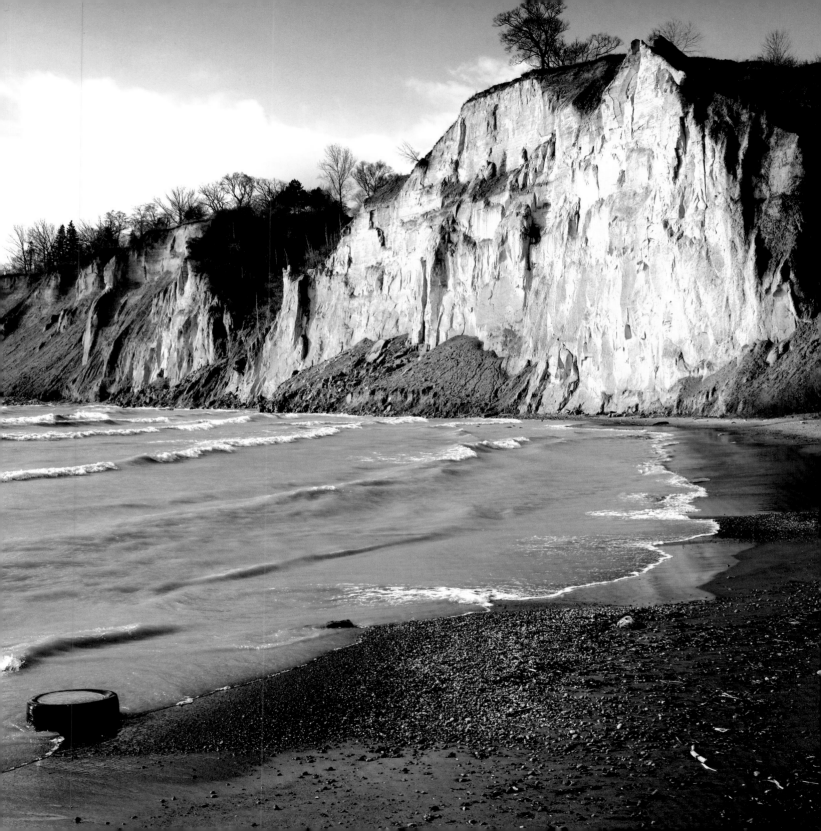

## Green Rain

*Dorothy Livesay*

I remember the long veils of green rain
Feathered like the shawl of my grandmother —
Green from the half-green of the spring trees
Waving in the valley.
I remember the road
Like the one which leads to my grandmother's house,
A warm house, with green carpets,
Geraniums, a trilling canary
And shining horse-hair chairs;
And the silence, full of the rain's falling
Was like my grandmother's parlour
Alive with herself and her voice, rising and falling —
Rain and wind intermingled.
I remember on that day
I was thinking only of my love
And of my love's house.
But now I remember the day
As I remember my grandmother.
I remember the rain as the feathery fringe of her shawl.

## Tapka

*David Bezmozgis*

Goldfinch was flapping clotheslines, a tenement delirious with striving. 6030 Bathurst: insomniac, scheming Odessa. Cedarcroft: reeking borscht in the hallways. My parents, Soviet refugees but Baltic aristocrats, took an apartment at 715 Finch, fronting a ravine and across from an elementary school — one respectable block away from the Russian swarm. We lived on the fifth floor, my cousin, aunt, and uncle directly below us on the fourth. Except for the Nahumovskys, a couple in their fifties, there were no other Russians in the building. For this privilege, my parents paid twenty extra dollars a month in rent.

In March of 1980, near the end of the school year but only three weeks after our arrival in Toronto, I was enrolled in Charles H. Best Elementary. Each morning, with our house key hanging from a brown shoelace around my neck, I kissed my parents goodbye and, along with my cousin Jana, tramped across the ravine — I to the first grade, she to the second. At three o'clock, bearing the germs of a new vocabulary, we tramped back home. Together, we then waited until six for our parents to return from George Brown City College, where they were taking an obligatory six-month course in English — a course that provided them with the rudiments of communication along with a modest government stipend.

In the evenings, we assembled and compiled our linguistic bounty.

Hello, havaryew?
Red, yellow, green, blue.
May I please go to the washroom?
Seventeen, eighteen, nineteen, twenny.

Joining us most nights were the Nahumovskys. They attended the same English classes and travelled with my parents on the same bus. Rita Nahumovsky was a beautician who wore layers of makeup, and Misha Nahumovsky was a tool-and-die maker. They came from Minsk and didn't know a soul in Canada. With abounding

enthusiasm, they incorporated themselves into our family. My parents were glad to have them. Our life was tough, we had it hard — but the Nahumovskys had it harder. They were alone, they were older, they were stupefied by the demands of language. Being essentially helpless themselves, my parents found it gratifying to help the more helpless Nahumovskys.

After dinner, with everyone gathered on cheap stools around our table, my mother repeated the day's lessons for the benefit of the Nahumovskys and, to a slightly lesser degree, for the benefit of my father. My mother had always been an exceptional and dedicated student, and she extended this dedication to George Brown City College. My father and the Nahumovskys came to rely on her detailed notes and her understanding of the curriculum. For as long as they could, they listened attentively and groped desperately toward comprehension. When this became too frustrating, my father put on the kettle, Rita painted my mother's nails, and Misha told Soviet anekdoti.

## Canada Geese and Apple Chatney

*Sesanarine Persaud*

Yuh think is three cents we go though! Well I ain't gat no wuk yet and Hermit just pick up a thing in a factory. Although he just get he landed, money still small. Almost a month and I ain't get nothing, then I walk in a factory at Steeles and Bathurst desperate — and get tek on. The supervisor want a forklift operator. Man I neva drive a donkey-cart yet muchless forklift. I tell the man, with experience, I could manage dhe forklift, anything. Lucky for me the forklift break down, and the forklift driver who didn't show up, turn up next day. The supervisor find wuk for me packing boxes. And next two weeks bam, Writerji turn up in the apartment lobby. He dhe last man to land in Canada before Canadian immigration decide yuh gat to get visa from Guyana, too much Guyanese fulling up Toronto. We bunking on dhe ground, can't afford a bed or even mattress, in a room and squeezing cents.

Hermit trying to get a name and number for Writerji.

Well, Writerji waiting fuh he name and number but he ain't wasting time. He want learn about Toronto and Canada. He find library and reading up about Canada, about trees and birds. Whenever we go out anyway he pointing out birch, spruce, oak, cedar, weeping willow, pussy willow, ash, he pointing out bluejay, redstart, sparrow, starling, cardinal. He teking walk in park — yuh want know which park? Is at Eglinton and Jane street — Eglinton Flats. Autumn coming and Writerji want experience Canadian fall — colours radiant over all dhem trees. Geese coming in to land sweet sweet like plane. Every afternoon he coming home and writing poems. A night he writing a poem and suddenly he buss out one big laugh. He seh we thinking money scarce and cutting we tail and food all over dhe place. All them geese nice and fat, heading south fuh winter. He seh if is Guyana yuh think all them duck could deh so nice and lazy all over dhe place, preening themself like majesty and nobady own them,

and people starving? And other people feeding them bread and fattening them up fuh we!

He seh why we don't catch some a dhem geese and stock up for winter. Them geese heading south to get away from the cold and now is dhe right time. And he tell we how in England dhem bai do dhe same thing and some Trini writer name Selvon write about this thing in a book call *Lonely Londoners*. Hermit remember he hear this someway but he laugh and seh nobady neva write this — and how he know? Tell yuh the truth, I see them geese and I thinking same thing — how dhem bais in Guyana woulda done wuk them down.

"Is how I know? I'm a writer man!"

"So Hermit is Gandhi like Gandhiji and yuh is Writer — like Writerji," I buss out one laugh.

Well Hermit still ain't believe that this thing write down so Writerji and we gone to St Dennis library near Weston Road and Eglinton corner and he get Hermit to borrow *The Lonely Londoners* and *Ways of Sunlight* by Sam Selvon. As soon as we get home he find the page and start read how hunger washing Cap tail and

Cap decided to ketch seagull and eat them. We laugh good. And dhat is how he get name dhe Writerji. From dhat night we call he Writerji. But he done plan this thing. We could buy expire bread, and night time head down to Eglinton Flats Park. Them Geese sleeping right next to a little culvert and all over the grass behind them trees. Two a-we could catch ducks and one man swipe dhe neck. Hermit get excited. He want try this thing. Well is me and Hermit end up catching all them ducks and geese. I holding them and Hermit swiping them neck. All Writerji doing is holding bag and keeping lookout. Just like he since schooldays. He always thinking up something and me and Hermit doing the wuk. A trunk full a ducks in large double garbage bags. We skin them when we get home. Writerji saying we ain't stupid like Cap and we dispose of them feathers and skin real good. Nobody could catch we. Well them geese taste good.

Hermit seh next weekend let we take some fuh Prem and Kishore. They apartment overlooking Morningside park and them maple

trees flaming with colours. Writerji want tek a walk in the park and see this thing near. I want see to — was mih first autumn — but I playing I ain't care before them bai start laugh at me and call me Newfie and Pole and Balgobin-come-to-town. Writerji ain't care about who laugh he, he want see this thing close, hold them leaves. So we laughing he, asking if he really want size up more geese because it gat geese in that park. We teking a drink on a picnic table in the park and Writerji disappear. Next thing he coming back with he hand full a them small sour apple. He can't believe all them apple falling on the grass and wasting. People wasteful in Canada he muttering over and over. Writerji want help to pick some nice green apple on them tree. Why? He thinking just like how yuh use green mango, or bilimbi, or barahar to make achaar and chatney why not green apple. And right then mango scarce in Toronto, cost a fortune. Them days was not like nowadays when you gat West Indian store every corner. Them days you only get fruits from the West Indies when anybody coming. But that apple-chatney taste good with them geese we bring for Prem and Kishore. Writerji didn't make no chatney though. He gat all dhem ideas but is me, Hermit and Prem and Kishore in they apartment making apple chatney! Not three cents dhat bai Writerji.

## Banana Boys
*Terry Woo*

It usually takes a half-hour to take the subway up to Finch, the northern-most station on the Yonge line. After that, another twenty minutes by bus across a dull suburban plain, and then a five-minute walk home. I repeat all of this in reverse in the morning, and then reverse it again the following evening. It never ends.

I saw Shirley on tonight's train, probably coming back from evening classes. I see her only occasionally — she transfers to a Scarborough-bound bus at York Mills station. Sometimes we nod to each other, sometimes we ignore each other. Sometimes I pretend I'm asleep. Sometimes she does.

Tonight, we just nodded, and buried ourselves in our respective textbooks. It's just as well. We rarely talk, and when we do, the subject of Rick never comes up. We used to talk about Rick more when I was still in university, about his ... issues. These days, I guess it's moot — he's probably doing amazingly well in his world of mega-finance. Rick always does amazingly well in everything.

When I got home, Mom and Dad were watching a Chinese soap opera on tape, borrowed from my uncle. Tape seventy-nine out of a hundred billion — that's the way it is with Chinese soap operas. My younger sister, Jen, was out, probably with her new boyfriend.

"*Ah bao*," Mom called from the family room, in Cantonese, "get an orange from the kitchen and peel it for yourself."

"Yes'm."

Unlike Rick, I had what you would call an unremarkable childhood. I did well in school, played the piano (which I hated), went to Chinese classes (which I also hated) on Saturday mornings instead of watching Wonder Twin powers activate. My dad came to Canada in the sixties for a PhD and a job, and we've lived in Thornhill, a suburb north of Toronto, pretty much all my life. I'm a *jook-sing*, born and raised, growing up a middle-class, suburban Canadian under the shelter of corporate health, dental, accident insurance plans. Dad's a chemist

for a major pharmaceutical company, a quarter-century man, gold watch and all. Mom is a classy woman with a degree in Chinese literature — not too useful over here, except for quoting ancient Chinese proverbs whenever she yells at me.

When I was riding high in high school and first-year university, my mom would talk about me in such glowing terms, to my relatives and my friends. "It's like I've built and fashioned a model," she used to say, "and every so often I have to step back and look at it proudly, inviting everyone else to do the same."

Yeah, I thought, often at the cost of making the children completely miserable. The Chinese have this thing called *mien ji* (face); it gives parents prestige if their kids perform well in school, work, or anything else. If unchecked, the "face game" can spiral into a somewhat sadistic pastime for Chinese mothers, who mercilessly compare the accomplishments of their "fashioned models," showing-off to friends, one-upping neighbours, cowing their children, stealing their childhoods. At age eight, for example, I was dragged kicking and screaming to piano lessons (*piano lesions*, as I later referred to them), presumably because every other Chinese parent in the community made their kids do the same thing. To cajole me into playing, my mom told me this story of the piano store owner's son (who, as I recall, was walking out of the store carrying a huge bag of hockey equipment) when we went there to purchase the Great Oak Satan.

"Don't wanna play," I sulked, like the ungrateful brat I was.

And then she explained to me how the son had resisted taking piano lessons, and now that he was too old he regretted it. The classic ethnic guilt trip which, as was revealed to me a few years ago, was also a bald-faced lie.

So I folded like a cheap road map. Every Thursday night, instead of watching *Cosby*, *Cheers* and *Family Ties*, I was brought to the musty old house of my musty old piano teacher, Mrs. Blatchford, to do minuets and scherzos and other boring stuff from composers long dead and buried.

Even worse was the practising. Lord, I hated the practising. I hated being stuck in front of the Oak Satan every day at four p.m., sighing as I gazed longingly outside at the sun, the sky; most of my Canadian friends playing baseball or road hockey or some such.

But the absolute worst was when my family had guests over. "Oh *Mi*-koh! [faking surprise as I slinked past the living room] Come sit down and say hello to uncle and auntie! Say! [faking spontaneity] I have an idea! Why don't you play something on the piano?" And all the guests would then look at you like ferrets marking a field mouse for dinner.

And you'd groan like the ungrateful *jook-sing* that you were, but you'd do it under the threat of a knuckle in the head. So you'd play and your parents' "face" points would be jacked up by a few hundred or so. All the other guests would clap politely, secretly planning, to slap their kids in leg irons when they got back home. And the wheel would turn once again. It seemed like a particularly vicious game of Keep Up With the Joneses, or, in my specific case, the Wongs: "Ah,

Rick has played piano for six years ... he skipped a grade and took two Conservatory exams in six months ... has won awards ... recorded albums ... will play at Carnegie Hall/Wembley Stadium/the Kremlin next Tuesday." *Argh*.

When I reached age fifteen, I was given the choice to continue, or quit. I dropped the goddamn thing like a searing hot potato. And to this day, my mom insists they were making me play the piano because it disciplined me, helped me develop my memory, as well as my leadership skills. Not only that, it was supposed to improve my slapshot, make me immune to rickets and make my breath fresh and minty.

A number of years later, I picked up the guitar. I loved it — and I still do — because *I* picked it up and started playing it, unforced, uncajoled. My mom is pretty fond of saying "Ah, you can only play the guitar so well because of the musical background piano lessons gave you." I usually snort in response, but she's probably right.

# BIOGRAPHIES

**Howard Akler** was born in Toronto in 1969. He is the co-author of *Toronto: The Unknown City*. His novel *The City Man* was nominated for the 2006 Toronto Book Award.

**Robert Thomas Allen** was born in Toronto in 1911. He wrote fourteen books, countless articles, and won the Stephen Leacock Memorial Medal for Humour two times. He lived from 1911 to 1990.

**Eric Arthur** was an architect and writer in Toronto. In 1964, he published *Toronto: No Mean City*, an illustrated book that tells the story of how Toronto developed from village to metropolis.

**Margaret Atwood** is the author of more than thirty-five internationally acclaimed works of fiction, poetry and critical essays. Her tenth novel, *The Blind Assassin*, won the 2000 Man Booker Prize. Other honours include the Governor General's Literary Award, the Italian Premio Mondello, the Giller Prize, and the IMPAC award. She is a Fellow of the Royal Society of Canada. Margaret Atwood grew up in the Leaside neighbourhood of Toronto and today lives in the city with writer Graeme Gibson.

**Margaret Avison** was a celebrated poet who won the Governor General's Literary Award two times and the Griffin Poetry Prize. She lived from 1918 to 2007.

**David Bezmozgis** is the award-winning author of *Natasha and Other Stories*. His writing has appeared in magazines such as *Harper's*, *The New Yorker*, and *The Walrus*, and has been anthologized in *Best American Short Stories*, 2005 and 2006. He won the 2005 Canadian Jewish Book Award. He lives in Toronto.

**Earle Birney** was a poet who was celebrated for using everyday cadence of speech in his poems. He served in the Canadian Armed Forces in World War II and later won the Governor General's Literary Award two times. He first lived in this city while studying at the University of Toronto. Birney died in 1995.

**Shaughnessy Bishop-Stall** has hitchhiked from Canada to Costa Rica, picked olives in Spain, and built a shack from scrap lumber on the edge of Lake Ontario, an experience that became the basis for his first book, *Down to This*. His non-fiction has appeared in *Saturday Night*, the *National Post* and *The Globe and Mail*. He was the Knowlton Nash Fellow at Massey College at the University of Toronto.

**Dionne Brand** is a writer and poet who has won the Governor General's Literary Award, the Pat Lowther Memorial Award (for Poetry), the Griffin Poetry Prize and the Toronto Book Award. She holds a University Research Chair at the University of Guelph where she is a professor.

**Harry Bruce** is an award-winning author and journalist whose latest book is titled *Page Fright: Foibles and Fetishes of Famous Writers*. Bruce was born in Toronto in 1934 and worked for numerous Toronto newspapers and magazines before moving to Nova Scotia where he lives today.

**Catherine Bush** was born and raised in Toronto, the daughter of a physician and a museum volunteer. She is the author of three novels, including *Claire's Head*,

which was chosen as a Best Book of the Year by both *The Globe and Mail* and *The LA Times*. Her non-fiction has appeared in numerous publications including *The New York Times Magazine*. She lives in Toronto.

**Juan Butler** has been called an underground novelist. He wrote three books: *Cabbagetown Diary*, *The Garbageman and Canadian Healing Oil* which was shortlisted for a Toronto Book Award in 1975. Born in England in 1942, he died in 1981.

**Stephen Cain** is the author of three poetry collections — *American Standard/Canada Dry*, *Torontology*, and *dyslexicon* — and a collaborative series of micro-fictions written with Jay MillAr. He lives in High Park from where he commutes to his job at York University

**Barry Callaghan** is an author, painter and poet. He has written more than a dozen books and translated books of poetry. He was the winner of the inaugural W.O. Mitchell Award for a body of work, and has won the CBC Fiction Prize, the Foundation for the Advancement of

Canadian Letters Prize for Fiction, the Pushcart Prize, and many others. He is the son of Morley Callaghan. He lives in Toronto.

**David Chariandy** was born and raised in Toronto. His first novel, *Soucouyant*, won the ForeWord Magazine Book of the Year Award for Literary Fiction. Chariandy now lives in Vancouver where he teaches at Simon Fraser University.

**Matt Cohen** published almost thirty books including the Governor General's Literary Award-winning *Elizabeth and After* and a series of children's books written under the pseudonym Teddy Jam. In 1998 he received the Toronto Arts Award for writing. He lived from 1942 to 1999. There is a park at the southeast corner of Bloor Street West and Spadina Avenue named for him.

**Carole Corbeil** was an award-winning arts journalist and novelist whose first novel, *Voice-over*, won the Toronto Book Award. She wrote for the *Globe and Mail* and the *Toronto Star* and contributed to periodicals including *This Magazine*,

*Saturday Night*, and *Canadian Art*. She lived from 1952 to 2000.

**John Cornish** is the author of *Sherbourne Street*, which was published in 1968.

**Andrea Curtis** is the author of *Into the Blue: Family Secrets and the Search for a Great Lakes Shipwreck*, which won the Edna Staebler Award for Creative Non-Fiction. She is also an award-winning magazine writer and editor whose work has appeared in anthologies and publications that include *Dropped Threads 3*, *Toronto Life*, *Chatelaine*, *This Magazine* and *Utne Reader*. She lives in Little Portugal in a house full of boys.

**Sarah Dearing** has written two novels, the second of which won The Toronto Book Award.

**Mazo de la Roche** was the author of the *Jalna* novels, a series that was very popular in Canada and the United States. De la Roche spent some of her childhood in downtown Toronto, living on John and Victoria Streets and attending Parkdale Collegiate. She died in 1961.

**Pier Giorgio Di Cicco** is a poet who has been called the founding father of Italian-Canadian writing. He was Toronto's Poet Laureate between 2004 and 2007. His most recent book is *Municipal Mind: Manifestos for the Creative City*. He now lives north of the city.

**Rishma Dunlop** is a poet, fiction writer and academic whose work has won awards and has appeared in numerous books and journals. She is an associate professor in English at York University.

**Sarah Elton** writes for publications like *Macleans* and *The Globe and Mail* and is the food columnist for CBC Radio One's *Here&Now*. Her book, *Locavore*, is forthcoming. She sits on the board of PEN Canada. Sarah was born in Toronto and lives in Riverdale with her husband and two young daughters.

**Marian Engel** was a Toronto author who won the Governor General's Literary Award for Fiction in 1976 and was the first chair of the Writers' Union of Canada. Her novels include *Bear*, *The Honeyman*

*Festival*, and *Lunatic Villas*. She lived in West Toronto and died in 1985.

**Shirley Faessler**'s stories have appeared in magazines like Tamarack Review and reflect immigrant Jewish life in Toronto.

**Cary Fagan** is the author of four novels and two collections of stories. He has won the Toronto Book Award and has received many honours for his children's books. His fiction has been published in Canada, the United States, and Germany. He lives in Toronto.

**Timothy Findley** was an award-winning author whose books include *The Wars*, *Not Wanted on the Voyage*, and *Spadework*. He received the Governor General's Literary Award, the Trillium Book Award, and the Toronto Book Award. As a child, he lived in Rosedale. Findley lived from 1930 to 2002.

**Joe Fiorito** is an author of both fiction and non-fiction and is a city columnist for *The Toronto Star*. He lives in Parkdale.

**Diana Fitzgerald Bryden** is the author of two books of poetry, *Learning Russian* and

*Clinic Day* and the novel *No Place Strange*. Her poems have appeared in various publications and anthologies in Canada and the United States.

**Judy Fong Bates** is the author of a collection of short stories, *China Dog*, and a novel, *Midnight at the Dragon Café*. Her stories have been broadcast on CBC Radio and published in literary journals and anthologies. She lives in Toronto.

**Cecil Foster** is a journalist and novelist. He has been a reporter for various newspapers, including *The Toronto Star* and *The Globe and Mail* and has worked at the CBC. He is the author of two novels *No Man in the House* and *Sleep On, Beloved*. He lives in Toronto.

**David Gilmour** is a novelist and writer who has worked in the media as a film critic and talk show host. He lives in Toronto.

**Hugh Garner** grew up in Cabbagetown and, at sixteen, left school to become a copy boy for *The Toronto Star*. He served in the Spanish Civil War and the Second

World War before returning to the city to eventually start his literary career. He lived from 1913 to 1979.

**Camilla Gibb** was born in London, England, and grew up in Toronto on Merton Street. She is the author of three novels, numerous short stories, articles, and reviews. She has won the Trillium Book Award, the Toronto Book Award, and was the recipient of the CBC Canadian Literary Award for short fiction in 2001. Camilla Gibb divides her time between Toronto and London, England.

**Graeme Gibson** is the author of three novels. His latest book is *The Bedside Book of Birds*. He is a past president of PEN Canada and the recipient of both the Harbourfront Festival Prize and the Toronto Arts Award. He has been a council member of World Wildlife Fund Canada and is chairman of the Pelee Island Bird Observatory. He lives in Toronto with writer Margaret Atwood.

**Katherine Govier** immortalized Toronto's Brunswick Avenue with her 1985 collection, *Fables of Brunswick Avenue*, which began with the now famous line: "Everyone lives on Brunswick Avenue sooner or later." She is the author of eight novels and three short story collections. She has won the Toronto Book Award, the Marian Engel Award, and was given the Distinguished Alumni Award by the University of Alberta. She lives in Toronto, within walking distance of the Annex.

**Barbara Gowdy** is a novelist who grew up in Don Mills of the 1950s. She has written numerous books and has won the Governor General's Award and the Trillium Book Award.

**Steven Hayward** is the award-winning author of three novels including his new book, *In A Fallen World*. He was born in Toronto and raised in Richmond Hill and now divides his time between Toronto and Colorado Springs where he teaches at The Colorado College.

**Gratton Gray** wrote for Maclean's in the 1950s.

**Maggie Helwig** is a poet and novelist; her latest book is *Girls Fall Down*. She lives in downtown Toronto.

**Lawrence Hill**'s latest novel, *The Book of Negroes*, won the overall Commonwealth Writers' Prize and the Rogers Writers' Trust Fiction Prize. Hill is the son of a black father and a white mother who came to Canada from the United States. Growing up in Toronto in the sixties, Hill was influenced by his parents' work in the human rights movement.

**Hugh Hood** was a novelist, essayist and university professor who authored more than thirty books. He lived from 1928 to 2000.

**Helen Humphreys** is a poet and novelist. She has won the Lambda Prize for fiction and her novel *Leaving Earth* won the Toronto Book Award.

**Daniel Jones** wrote poetry before turning to prose, publishing five chapbooks before his death in 1994. A novel he wrote about Toronto's punk scene was published posthumously.

**Clifton Joseph** is a dubzz/poet-at-large and a writer for newspapers, magazines, radio, and television. He lives in the Oakwood and Eglinton area.

**Wayne Johnston** is a writer and novelist who has won the Charles Taylor Prize. His most recent book is titled *The Custodian of Paradise*.

**Joseph Kertes** is the author of many books including *Gratitude*. He is currently Humber College's Dean of Creative and Performing Arts where he founded the distinguished creative writing and comedy programs. His first novel, *Winter Tulips*, won the Stephen Leacock Award for Humour. He lives in North Toronto.

**Crad Kilodney** used to write fiction and sell his books on the streets of Toronto. He retired in 1995.

**Raymond Knister** was a novelist and poet. He wrote the novel *White Narcissus* in 1929 while living in a cottage on Hanlon's Point. He lived from 1899 to 1932.

**Irving Layton** was a poet and writer who, as a child, emigrated from Romania to Montreal. His writing career started in student journalism and, during the McCarthy era, he was blacklisted from entering the United States for his left-wing views. He won the first Governor General's Award for his poetry and the Canada Council's Senior Arts Fellowship. He died in 2006.

**Dennis Lee** is a poet who writes for both children and adults. He has won many awards including the Governor General's Award for Poetry and a Toronto Arts Award for lifetime achievement.

**Elise Levine** is the author of *Driving Men Mad* and *Requests and Dedications*. Her fiction has appeared in *The Journey Prize Anthology*, *Coming Attractions*, and *Concrete Forest*.

**Dorothy Livesay** was a journalist, writer and poet who explored both the political and the personal in her prolific body of work. She won the Governor General's Literary Award two times and the Queen's Medal. She lived from 1909 to 1996.

**Don Lyons** published *Yorkville Diaries* in 1984.

**Anand Mahadevan** is an author drawn to writing about the lives of individuals in the margins. His first novel, *The Strike*, is currently being adapted for the stage.

He has taught creative writing at the University of Toronto and Humber College. He lives in the Bloor-Lansdowne area.

**J.V. McAree** was a journalist who grew up in Cabbagetown in the early 20th century.

**Anne Michaels** is the author of two collections of poetry as well as the acclaimed novel *Fugitive Pieces*. She has won the Commonwealth Writers' Prize (Americas) and the Canadian Authors Association Writing Award for her poetry. *Fugitive Pieces* won the Orange Prize, the Books in Canada First Novel Award, the Trillium Book Award and was adapted into a major feature film. Her latest book is titled *The Winter Vault*.

**Kim Moritsugu** has written four novels set in Toronto including *The Glenwood Treasure*. She leads a walking tour of North Rosedale for Heritage Toronto and teaches creative writing through The Humber School for Writers. She has lived in Rosedale, Trinity Bellwoods, and the Annex, and currently resides in Moore Park.

**Erin Mouré** is a poet who also works as a freelance editor, translator, and communications specialist in Montreal. She lived for a year in Toronto where she wrote *Sheep's Vigil by a Fervent Person*.

**Phil Murphy**'s memoir of life on the Toronto Islands was written over a number of years, some chapters appearing in *Saturday Night*.

**Rabindranath Maharaj** has written several novels and short story collections including *A Perfect Pledge*. He is an instructor with the University of Toronto School of Continuing Studies and lives in Ajax.

**Stephen Marche** is the author of *Raymond and Hannah* and *Shining at the Bottom of the Sea*, a literary anthology of an invented country. He lives within walking distance of Trinity Bellwoods Park.

**bpNichol**, born Barrie Phillip Nichol, was an internationally renowned writer and poet who worked in a wide range of genres, from sound poetry to comic-book art to musical theatre to the children's television show *Fraggle Rock*. Today, bpNichol Lane is located in the Annex, running parallel to Huron Street, south of Bloor just north of Robarts Library.

**Michael Ondaatje** is a novelist and poet whose work includes *The English Patient* which jointly won the Booker Prize for Fiction. He has won the Governor General's Award four times, the Giller Prize, and the Commonwealth Writer's Prize, among many honours. He lives in Toronto.

**Charles Pachter** is a noted visual artist and author of two children's books. He has lived in Chinatown for several decades.

**Gianna Patriarca** is the author of five books of poetry. In 2001, her poems were adapted for the stage at the Canada Stage Berkley Street Theatre. She was born in Ceprano, Frosinone, Italy and emigrated to Canada in 1960 as a child.

**Sasenarine Persaud** is an essayist, short story writer, novelist, and poet and the author of many books. He has won the K.M. Hunter Foundation Award as well as several fellowships. He invented the term Yogic Realism to describe his literary aesthetic. He lives in Tampa, Florida.

**Emily Pohl-Weary** is an award-winning author who has published five books, including two novels, a poetry collection, an anthology about female superheroes, and a biography. She published *Kiss Machine* magazine for more than eight years and recently founded the Parkdale Street Writers, a writing group for street-involved youth.

**Michael Redhill** is a poet, playwright, novelist and essayist as well as the publisher and one of the editors of the literary journal *Brick*. He has won the Toronto Book Award and the Carol Tambor Best of Edinburgh Award. He lives in France.

**Nino Ricci** is the author of four novels, the first of which, *Lives of the Saints*, won many awards including the Governor General's Award and the W.H. Smith/Books in Canada First Novel Award. He lives in Toronto, east of the Don Valley.

**Ray Robertson** is the author of five novels and a collection of non-fiction, *Mental Hygiene: Essays on Writers and Writing*.

**Michael Rowe** is an award-winning journalist and essayist, and a political blogger for *The Huffington Post*. He has won the Lambda Literary Award and the Spectrum Award.

**Piali Roy** has written for a variety of newspapers and magazines. Her radio documentaries, prepared for *Ideas* on CBC Radio One, have twice been awarded by the South Asian Journalists Association in New York. She lives with her husband and daughter in Riverdale.

**Charles Sauriol** was a naturalist who fought to save the Don Valley from development. His valley homestead was expropriated to make way for the parkway; his second home suffered the same fate. He spent more than 20 years writing a history of the valley and published a magazine on the topic titled *The Cardinal*. He died in 1995.

**Shyam Selvadurai** is the author of two novels and the editor of the anthology *Story-wallah: Short Fiction from South Asian Writers*. He has won the W.H. Smith/ Books in Canada First Novel Award and the Lambda Literary Award. He lives in Toronto.

**Makeda Silvera** is the author of two short story collections and the novel, *The Heart Does Not Bend*. She was born in Jamaica and has lived in Toronto for many years in various neighbourhoods including Jane and Finch, Queen and Dufferin, and her favourite, Lansdowne and Bloor.

**Elizabeth Simcoe** described colonial life in Upper Canada in her diaries that were published posthumously. She was the wife of John Graves Simcoe, the First Lieutenant Governor of Upper Canada. She lived from 1796 to 1850.

**Patrick Slater** was the purported author of the novel *The Yellow Briar*, an autobiography of Irish Canadian life that was a bestseller in the 1930s. However, after publication it was revealed that Patrick Slater was a fictional character, and the true author of the book was a criminal lawyer in Toronto named John Mitchell.

Mitchell himself led a tempestuous life, spending time in jail for misappropriating his clients' funds. He went on to write several other books before he died in 1951.

**Raymond Souster** has spent decades capturing the sights, sounds, and people of Toronto in his poetry. He won the Governor General's Award in 1964. He is co-founder of Contact Press, publishing dozens of books in the fifties and sixties from his home in west Toronto, all while working at the CIBC until his retirement in 1985.

**Rosemary Sullivan** is the author of eleven books. She has won many awards including the Governor General's Award for Non-Fiction, the Canadian Author's Association Literary Award for Non-Fiction, and the Toronto Book Award. She teaches at the University of Toronto where she holds a Canada Research Chair in Biography and Creative Non-Fiction and is director of the MA Program in English in the Field of Creative Writing.

**Scott Symons** was a writer born into a prominent Rosedale family. Best known

for his iconoclastic novels *Place d'Armes* and *Civic Square*, he held positions with the University of Toronto and the Royal Ontario Museum before living in self-imposed exile in Morocco.

**Mike Tanner** is the author of three books. He is also the operations Manager for Toronto's North by Northeast Music & Film Festival and a consultant specializing in business communication. Sometimes, he can be spotted playing bar gigs with his band, the Circumstantialists. He lives in Riverdale with wife Robyn and son Flynn.

**Ernest Thompson Seton** was celebrated for his animal stories set in the Don Valley, *Wild Animals I Have Known* and *Two Little Savages*. When he was young, he lived for a period in a self-built cabin in the valley that inspired him. He died in 1946.

**M.G. Vassanji** is the author of nine books. He was awarded the Harbourfront Festival Prize in 1994 and has won the Giller Prize two times. Born in Kenya and raised in Tanzania, he lives in Toronto with his wife and two sons.

**Carleton Wilson** is a poet, writer, editor, book designer, and typographer. He edits a poetry imprint with Nightwood Editions and is the publisher and general editor of Junction Books, his own small press. He won the E.J. Pratt Medal in Poetry in 1998. He lives in the Junction.

**Terry Woo** is a Banana Boy, also the title of his first novel. He has drifted from Toronto, Seattle, New York, and San Francisco.

Page 385. Bronze Fastwurms Woodpecker
     Column at the Toronto Convention
     Centre.

Page 394. The Gladstone Hotel on Queen
     Street West.

Page 395. Sign along the Queensway near
     Roncesvalles Avenue.

Page 396. Bloor streetscape at night
     showing the Royal Ontario Museum
     addition by Daniel Libeskind.

Page 400. Interior of the former Don Jail.

Page 401. A park along the Esplanade in
     the St. Lawrence neighbourhood.

Page 402. The famous façade of the former
     Sam the Record Man store at 347 Yonge
     Street.

Page 403. Our Lady of Lourdes, on
     Sherbourne just north of Wellesley.

Page 409. Looking south past the historic
     John Street Roundhouse towards the
     condos on the waterfront.

Page 410. The Royal Theatre at 608 College
     Street.

Page 255. The Don Valley.

Page 260. The Queen Street Viaduct
straddles the Don River along Queen
Street East and bears the phrase
"*THE RIVER I STEP IN IS NOT
THE RIVER I STAND IN*," a public
art installation completed in 1996 by
Eldon Garnet.

Page 262. The *Dreamwork of the Whales*
wooden sculpture at Little Norway
Park at the foot of Bathurst Street.

Page 263. A Toronto Island ferry.

Page 264. Waterfront by the R.C. Harris
Water Treatment Plant

Page 272. The swan ride at the Centreville
Amusement Park, Centre Island.

Page 273. Spiral gateway leading to
Manitou Beach in Toronto Island Park.

Page 282. The 120-year-old Queen City
Yacht Club on Algonquin Island.

Page 285. Looking east along St. Clair
Avenue, the "Corso Italia," towards
Dufferin Street.

Page 296. Sunnyside Bathing Pavilion.

Page 299. East of Regatta Road on Unwin
Avenue looking northwest towards
downtown.

Page 300. Ashbridge House.

Page 301. Dufferin Park.

Page 306. Dock at the waterfront of the
Sunnyside Bathing Pavilion.

Page 309. Restaurant in Little India on
Gerrard Street.

Page 312. University of Toronto's Hart
House Library.

Page 315. The Brick Works.

Page 316. The R.C. Harris Water
Filtration Plant in the Beaches
neighbourhood.

Page 317. The Bloor Street Bridge over the
Humber River Valley.

Page 321. The intersection of Parliament
and Carlton streets in Cabbagetown.

Page 329. A High Park barber shop.

Page 335. An art gallery on Queen Street
West.

Page 336. Windows over the original
Avenue Road entrance to the Royal
Ontario Museum.

Page 337. Queen Street at night.

Page 344. AIDS Memorial at Cawthra
Square Park.

Page 349. Graffiti at Dundas Street and
Spadina Avenue.

Page 352. Toronto's first urban beach,
part of Toronto's master plan to
revitalize the waterfront.

Page 359. The train trestle through David
Balfour Park, just east of Shaftesbury
Avenue.

Page 360. Ossington Street wall art.

Page 361. Subway tracks looking north
towards Davisville subway station.

Page 367. The abandoned Guild Inn in
Guildwood Park.

Page 375. The Scarborough Bluffs.

Pages 102–103. The basement of Kensington Market's Anshei Minsk Synagogue, one of a few remaining downtown *shuls*.

Page 107. The back of the St. Francis of Assisi Church from a neighbouring lane, near Grace Street and Mansfield Avenue.

Page 108. A former store on Roncesvalles Avenue.

Page 123. The Toronto Transit Commission's Russell (Connaught) Carhouse at Queen Street East and Connaught Avenue.

Page 127. Trucks parked beneath the Gardiner Expressway at the CNE Grounds.

Page 128. The mosque at 182 Rhodes Avenue, Coxwell and Gerrard.

Page 134. University of Toronto's Medical Sciences Building.

Page 138. The Museum subway station.

Page 139. The south facade of the Frank Gehry-designed addition to the Art Gallery of Ontario.

Page 150. The College Street West neighbourhood.

Page 151. A store on Gerrard Street East in Little India.

Page 162. Looking south on Croft Street from Harbord Street.

Page 170. Convocation at University of Toronto.

Page 182. Toronto Island Park.

Page 183. A Yorkville clothing store.

Page 193. "The Rock" in Yorkville: a 600-tonne piece of Canadian Shield relocated to the park on Cumberland Street.

Page 201. The Ward Island ferry dock.

Page 202. The Beach Motel on Lakeshore East at Parklawn Road.

Page 203. A Rosedale estate.

Page 215. The rainbow tunnel beside the Don Valley Parkway at Lawrence Avenue.

Page 216. A Rosedale estate.

Page 222. The former Rosedale train station clock tower.

Page 227. A Cabbagetown storefront on Parliament Street.

Page 228. Typical Cabbagetown houses.

Page 235. The Daniel Lamb House at 156 Winchester Street in Cabbagetown.

Page 238. Windows of Maple Leaf Gardens at Carlton and Church streets, home to the Toronto Maple Leafs hockey team from 1931 to 1999.

Page 241. The Prince Edward Viaduct, completed in 1918, with a lower deck that foresaw the inclusion of the Bloor-Danforth subway forty years later.

Page 242. The Princes' Gates at the Canadian National Exhibition.

Page 243. Before the addition of the award-winning Luminous Veil suicide barrier in 2003, the Bloor Street Viaduct ranked as the most fatal standing structure in the world with over 400 suicides.

# THE PHOTOS

Page ii. One of the murals introduced in Regent Park in 2009 as part of the "Living Space" exhibit.

Page iv. Graduate House at Harbord Street and Spadina Avenue, built at the St. George campus in 2000 to provide accommodation for University of Toronto graduate students.

Page xiv. Looking north on Yonge Street to Dundas Square in Toronto's downtown.

Page xix. The Toronto skyline from Algonquin Island.

Page xx. The Cherry Beach Lifeguard Station.

Page 1. The Toronto skyline.

Page 2. City Hall.

Page 8. The Zanzibar Tavern (or "The Zanz," as it's called by regulars) is a long-running Toronto drinking establishment and one of the last remnants of the original "Yonge Street Strip." It features female dancers.

Page 15. Historic Fort York.

Page 16. Canoeists at the annual Paddle the Don event in May.

Page 17. The interior of the former Brick Works building.

Page 19. The Brick Works.

Page 29. The Royal York Hotel.

Page 33. Yonge Street.

Page 34. Ireland Park, the site of the Toronto Irish Famine Memorial. It is located on the south-east corner of Bathurst Quay on the Toronto waterfront.

Page 36. The CN Tower reflected off of one of Mies van der Rohe's financial district TD Centre buildings.

Page 40. Looking south along Yonge Street through the railway overpass towards Rosedale.

Page 44. Toronto's financial district.

Page 48. City Park Co-operative, 484 Church Street: an apartment building in the Church Street "Gay ghetto."

Page 53. Signs of a demolished building cling to the side of 233 Church Street.

Page 56. The financial district.

Page 62. St. Michael's Cathedral at Shuter and Church streets.

Page 65. The Sharp Centre for Design at the Ontario College of Art and Design.

Page 68. The Museum subway station.

Page 78. The mural painted by artist John Hood in 1993 on the Toronto Sun Building at 333 King Street East depicts two hundred years of historic events in the city of Toronto.

Page 83. The rear of a house in Kensington Market neighbourhood.

Page 84. The Ontario Veterans' Memorial at Queen's Park.

Page 94. Chinatown at Dundas and Spadina streets.

Page 99. St. Andrews Street, Kensington Market.

# PERMISSIONS

Reprinted with permission of House of Anansi Press.

Excerpted from *Consolation* by Michael Redhill. Copyright © 2006 Caribou River Ltd. Reprinted by permission of Doubleday Canada.

"On Toronto Itself" by Nino Ricci © 1992. Published in *Toronto Life* (November 1992). Used with permission of the author.

An excerpt from *Where She Has Gone* by Nino Ricci © 1997. Published by McClelland & Stewart Ltd. Used with permission of the publisher.

Excerpt from *Gently Down the Stream* by Ray Robertson. Published by Cormorant Books, 2005. Used with permission of the publisher.

Excerpt from *Moody Food* by Ray Robertson © 2002. Published by Doubleday Canada. Used with permission of the author.

Excerpt from *Other Men's Sons* by Michael Rowe. Published by Cormorant Books,

2007. Used with permission of the publisher.

"Bharati" by Piali Roy © 2009. Used with permission of the author.

"Spring 1956, How It All Started" from *Remembering the Don* by Charles Sauriol. Excerpt printed with permission from Dundurn Press Ltd. Copyright 1981.

From "Mister Canada" by Shyam Selvadurai. First published in *Tok. Book 1*, 2006. Copyright © 2006 Shyam Selvadurai. Used with permission of the author.

"Around St Helens" by Makeda Silvera © 2009. Used with permission of the author.

"Adrift" from *The Yellow Briar*, by Patrick Slater, originally published by MacMillan & Co., 1966.

Excerpt from *Mrs. Simcoe's Diary*, by Elizabeth Simcoe, first published by MacMillan Canada, 1965.

"Rainy Evening Downtown" by Raymond Souster is reprinted from *Collected Poems of Raymond Souster* by permission of Oberon Press.

"Elizabeth Smart: A Presence in the Annex" by Rosemary Sullivan © 2009. Used with permission of the author.

Excerpt from *Civic Square* by Scott Symons © 1969. Published by McClelland & Stewart Ltd. Used with permission of the author's estate.

"The House, The Home" by Mike Tanner © 2009. Used with permission of the author.

Excerpt from *Wild Animals I Have Known*, by Ernest Seton Thompson, first published by McLelland & Stewart, 1991.

Excerpt from "4" from *No New Land* by M.G. Vassanji © 1991. Published by McClelland & Stewart Ltd. Used with permission of the publisher.

"Late Autumn in the Annex, 1997" by Carleton Wilson. © Carleton Wilson. Used with permission of the author.

# ACKNOWLEDGEMENTS

I would like to thank all the writers who contributed to this project. Their vision of the city is inspiring. Their literature breathes life into our streets.

The Toronto Public Library is a fabulous resource, an archive of our city's literature. Without the library, this book would not have been as fulsome, nor perhaps even possible. Libraries give soul to a city and, to be noted duly, are publicly funded. Thanks TPL.

I relied heavily on three great sources of information about the city's literature: Greg Gatenby's *Toronto*: *A Literary Guide*, *The Oxford Illustrated Literary Guide to Canada*, and Amy Lavender Harris's online *Imagining Toronto* project.

Thank you to Jess Atwood Gibson, Margaret Atwood and Graeme Gibson for supporting this book right from the start.

Thanks to Marc Côté for his enthusiasm and vision; and to Barry Jowett, Tannice Goddard, Lindsay Gray, and Angel Guerra at Cormorant; to Kevin Robbins for his view through the lens; to Rosemary Sullivan for her many suggestions; to Piali Roy; and to my agent, Margaret Hart.

A big thanks to my family, particularly to my parents Jacqueline and Peter Elton. To Anisa and Nadia for sharing me with the book. To Amtu and Nurdin Karimjee for their culinary support. And of course, much love and gratitude to Kumail.